A SPIRIT OF PROGRESS
ART DECO ARCHITECTURE IN AUSTRALIA

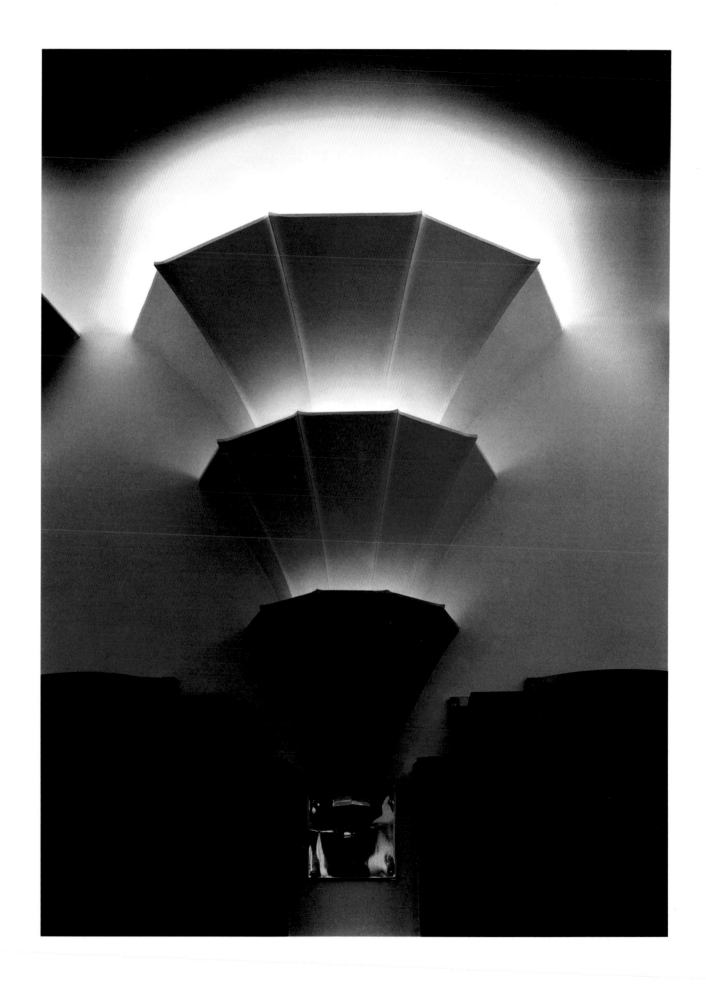

A SPIRIT OF PROGRESS
ART DECO ARCHITECTURE IN AUSTRALIA

PATRICK VAN DAELE

ROY LUMBY

CRAFTSMAN HOUSE
G+B ARTS INTERNATIONAL

Distributed in Australia by Craftsman House,
Tower A, 112 Talavera Road,
North Ryde, Sydney, NSW 2113
in association with G+B Arts International:
Australia, Canada, China, France, Germany, India,
Japan, Luxembourg, Malaysia, The Netherlands,
Russia, Singapore, Switzerland, United Kingdom,
United States of America

ISBN 90 5703 67 11

Editor Marah Braye
Design Caroline de Fries
Printer Kyodo Printing Co., Singapore

Frontispiece: Former MLC Building, 1938
Corner of Martin Place and Castlereagh Street,
Sydney, New South Wales

CONTENTS

Acknowledgments 7

Preface 9

Chapter One ART DECO ARCHITECTURE IN AUSTRALIA 12

Chapter Two OFFICE BUILDINGS 66

Chapter Three COMMERCIAL BUILDINGS 86

Chapter Four PUBLIC BUILDINGS 104

Chapter Five DOMESTIC ARCHITECTURE 118

Chapter Six INDUSTRIAL 146

Chapter Seven RECREATION 164

Chapter Eight CINEMAS 190

Bibliography 220

List of Plates 222

Index 226

This book is dedicated to my parents
PATRICK VAN DAELE

ACKNOWLEDGMENTS

Special thanks to Suzie Lloyd, President, Society Art Deco Victoria for her constant moral support and positive attitude throughout this project and also to Caroline de Fries and Marah Braye of Craftsman House. Thanks to Mary Nilsson, President, Art Deco Society, New South Wales; Vyonne Geneve, President Art Deco Society, Western Australia; Ian Johnson, A.R.A.I.A., Hobart, Tasmania; Professor Ian Sinnamon, Brisbane, Queensland; Ian Shenk, Adelaide, South Australia.

PATRICK VAN DAELE

The assistance of the following persons in generously providing information and assistance in the writing of the essay was invaluable. My special thanks go to Ran Boydell, Marah Braye, Kevin Cork, Vyonne Geneve, Carol Hardwick, Rod Howard, David Rozenker-Apted and Linda Smith.

ROY LUMBY

PREFACE

'It is that which you have never seen before you most easily recognise.'
DIANE ARBUS

I have spent the best part of one and a half years, starting in the autumn of 1995, photographing and documenting Art Deco heritage architecture. It came about while coincidentally photographing a picture theatre in Sydney's Kings Cross. I was fully aware of it being an Art Deco building as I have always had a great fascination for the art of the 1920s and 1930s – a time of change and social upheaval in every area of people's lives.

As we are nearing the end of the twentieth century, scholars and academics have been busy assessing what has been created, or what is left of it, in the last one hundred years. Revivals have already come and gone, especially so in fashion and music, where the 1950s and 1960s prove to be enduringly popular because it is felt that something truly original was created by popular culture.

So it was in the inter-war period when genuine social, economic and political forces at work in the fields of architecture and the related applied arts required a radical new form of self-expression, and thus contributed to the consolidation of Australian modernism. When I subsequently examined the processed film of the picture theatre mentioned above, I was rather pleasantly surprised by the sculptural and plastic qualities of the building framed in a perfect geometric composition.

I became intrigued and decided to make further inquiries about the current state of Australian Art Deco architecture. Although three Art Deco appreciation societies were in existence which had already undertaken pioneering research, I could not find that much information was available.

The mainstream of high art is usually well documented in its own time. But a period style, best evidenced in the minor arts of architectural decoration and interior design, often has to wait until a generation grows up to discover that a large area of visual experience exists but nobody can tell them anything about it.

I felt a sudden urge of duty to bring out into the open all this sumptuous, decorative splendour to remind Australian people of their magnificent, recent and modern history.

This urge took me on an epic journey around Australia and in the process I discovered a tale of genuine Australian history told through the eyes of architects and interior designers covering the period from 1926 to 1940 and some buildings designed before, but constructed after, the Second World War.

Given the sheer numbers of such buildings and their quality, I soon reached the conclusion that Art Deco architecture was not a frivolous fantasy for eccentrics, but rather a mainstream style used by prominent architects.

RIALTO THEATRE, CIRCA 1925
West End, Brisbane, Queensland
Represented in low-relief ornament above the box office, the two faces of Greek drama – Comedy and Tragedy – are symbolic of the future of many Art Deco buildings around Australia.

Architecture is interesting to photograph because it is the most undervalued of all art-forms, hence the frequent anonymity of architects. However, it is the artform which most powerfully shapes our lives in the walls around us and the urban landscape we see every day. The photos which appear in this book hide many secrets if one cares to look.

From my artistic point of view it is the asymmetry used by architects of the late 1930s that proved to be the most fertile area and the most challenging to capture on film, with the photographs providing a new layer of interpretation and thereby giving fresh meaning and relevance to the designer's intentions. As opposed to the first phase of Art Deco, which relied on classical design motifs and required 'straight' photography, it was the period of Cubism, Constructivism and Futurism, with its abstraction, distortion and simplification, in which I found most inspiration to create an analysis of visual perception as I pleased.

However, I had to ensure that I was not compromising the subject too far, for the dividing line between pictorial photography and my imaginative interpretation is often blurred throughout. This effect is further enhanced by those prints I have hand-tinted using a palette of pastels consistent with colour schemes of the period.

A celebration of modernism, Australian Art Deco architecture expressed in many ways a structural bravura and has remained a favourite of interior designers and postmodernist architects alike.

This book is a tribute to those professionals and dedicated craftspeople who embraced and applied modernist ornamentation with great vigour in terrazzo flooring, ceramic tiles, ornamental brickwork, graphic design, plasterwork, lighting fixtures and neon signage, murals and mosaics, stained glass, sculpture, bronze and grillework, wooden veneers and richly ornamented building facades.

One cannot undertake a project of this nature without taking a stand on conservation issues, which today are fraught with money and politics.

While working on this project, several buildings were either under threat of demolition, some were demolished right before my eyes and others were simply standing in limbo. Whilst in Brisbane, Queensland, I encountered the sad fate of the Rialto Picture Theatre (plates 181–183).

At the time of writing, even the future of the Sydney icon Luna Park is uncertain. The refurbished Luna Park lost up to one-third of its patronage after a campaign by some residents living above the park resulted in a court ruling restricting the operations of the roller-coaster ('The Big Dipper') – the park's key drawcard. Twelve months after it closed, Luna Park remains fenced off and silent, and is once again beginning to decay.

It is certainly my aim to elevate Art Deco architecture in Australia to full heritage status. Art Deco is still either misunderstood or ignored by the architectural history books in Australia and, being only sixty years old at best, it is often used as an argument in favour of demolition. Those buildings in prominent locations, which have survived the devastating onslaught of the 1960s and 1970s, are now under enormous commercial development pressures. I hope this book will be a valuable extra tool for those people fighting to protect all the items featured in it and the other three hundred or so buildings which did not make it past the cutting room floor.

While I look forward to the artistic developments of the twenty-first century, it is my pleasure and privilege to present A Spirit of Progress: Art Deco Architecture in Australia.

PATRICK VAN DAELE

PHOTOGRAPHER'S NOTE

All the photographs in this book (except plate 14, 4 x 5 large format) were taken with Zenza Bronica 645 ETR, 40 mm, 65 mm, 200 mm lenses and an assortment of filters on Fujichrome Velvia, ISO 50 and Ilford ISO 50 black-and-white film. All shots were tripod mounted and only available light was used. Some prints were hand-coloured using Marshall photo-oil colours and pencils. Plate 127 is provided courtesy of the Fairfax photo library.

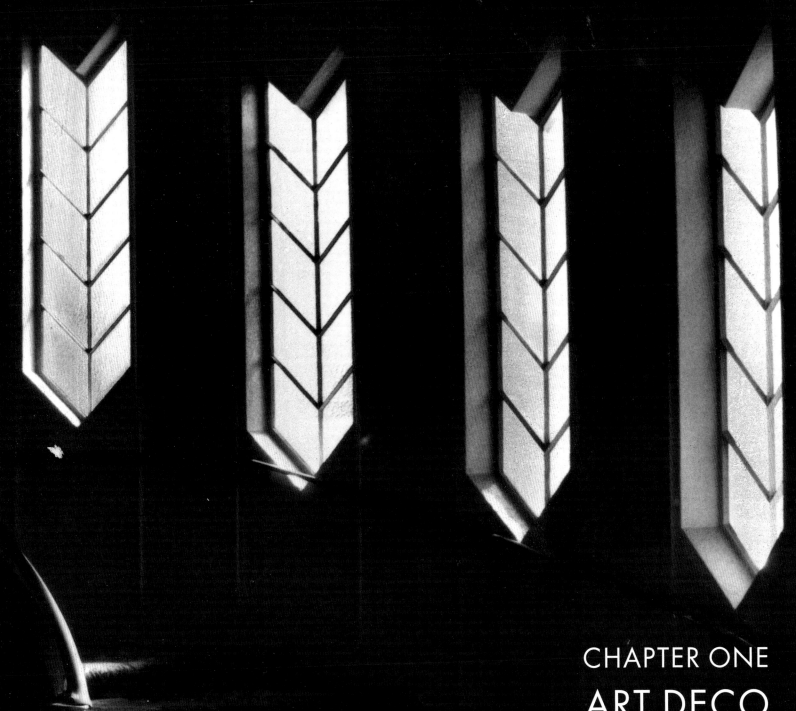

CHAPTER ONE

ART DECO
ARCHITECTURE
IN AUSTRALIA

BY ROY LUMBY

Both of my parents grew up and came to maturity in Sydney during the 1920s and 1930s – the period which has since been termed 'inter-war' – and were married at the very end of it, in late 1939. They were never more than moderately comfortable for most of their lives, so wedding presents and furnishings from the date of their marriage were carefully maintained, and in many cases treasured, for a very long time. Thus my sister and I grew up in the 1950s and 1960s surrounded by artefacts from this period – sleek metal lamps, fat, bulbous lounge chairs and the colourful geometries of ceramics by Clarice Cliff, Carlton Ware and Royal Doulton. In short, we were surrounded by representative examples of the Art Deco style. Perhaps these environs favoured an interest (which I started to develop in the 1970s) in Sydney's architecture of the 1920s and 1930s, particularly those buildings which bore evidence of the influence of Art Deco. At this time, many of these buildings were disdained by architects and historians alike, but my ever-burgeoning enthusiasm was encouraged by travels across the United States – in many ways, the home of Art Deco architecture. Comparing what I was accustomed to in Sydney with what I saw in America only reinforced an opinion that the Australian product was no mean contribution to the repertoire of a diverse and truly international aesthetic phenomenon. This essay attempts to introduce and describe some of the wealth of architecture influenced by the Art Deco style, not just in Sydney but throughout Australia. If, at times, it dwells on works in Sydney, Melbourne and Canberra, this is because I am more familiar with these parts of the country than others. It is not intended to suggest that the architecture to be found in other centres is less worthy of attention. And, if in the following text a few buildings are described for which there are no accompanying photographs, this simply reflects the broad scope of Art Deco architecture in Australia, and the forbearance of the reader is respectfully requested.

▼ ▼ ▼

A brief sketch of the period – a general overview which omits much of the particular – shows that life in Australia during the 1920s and 1930s was marked by economic turmoil and a generally conservative outlook. Although the traumatic events of the First World War, which had propelled an isolated outpost of English civilisation into the international arena, continued to reverberate across the country over the next decade and beyond, Australian life during the 1920s was staid, looking towards Britain and the British Empire rather than to other parts of the world. This was mirrored in patterns of migration, which reinforced the predominantly Anglo-Saxon population and discouraged new settlers from other parts of the world. By the end of the decade both Sydney and Melbourne had populations in excess of one million people, and held about one-third of the nation's population. This was despite moves to settle people on the land, an experiment which proved almost tragically unsuccessful,[1] so that as well as an increase due to immigration, the population of the major cities was bolstered by a drift of people from the rural interior. The suburbs around the cities consolidated and spread ever outwards, reflecting the development of local manufacturing which was able to tap into the infrastructure and work force available in the cities. Personal mobility became easier, with the middle class increasingly able to afford a motor car, once only the privilege of the wealthy. Increasingly, listening to the radio or phonograph and going to the movies became a part of everyday life, with the cities, many suburbs and country towns boasting their own cinemas. Much of this entertainment was of American origin, causing a degree of distress and concern amongst the ruling classes.[2] No doubt it increased an uneasy awareness of the possibilities of a modern lifestyle bolstered by material abundance. The recently created Commonwealth, too, became a solid reality when the new Parliament House in Canberra opened on

1. Stuart Macintyre, *The Oxford History of Australia Volume 4: 1901–1942 – The Succeeding Age*, Oxford University Press, Melbourne, 1986, pp. 207–211.

2. ibid., p. 206.

9 May 1927, and Federal politics transferred from Melbourne to the fledgling city. This was reinforced by the increased presence of air travel, which brought the various parts of the country closer together and Australia closer to the rest of the world.

The decade was one of uneven prosperity, racial tensions, political conservatism and industrial unrest – which belies its reputation as one of prosperity and frivolity. An underlying conservatism protected the nation against undesirable aliens, controlled morals through censorship and resisted the advanced artistic movements of other parts of the world.[3] The massive national debt incurred by participation in the First World War was exacerbated by continued borrowing from overseas during the decade to finance public works and develop services. Although the war had given great impetus to local manufacturing, the country was still dependent on primary production for much of its wealth, and in turn this depended on overseas markets. Consequently, as export prices fell at the end of the 1920s and money from overseas became increasingly difficult to borrow, Australia slid into Depression.[4] Indeed, times had been tough on the land throughout the decade, and for unskilled or semi-skilled workers things became appreciably more difficult from about 1927.[5] Ironically, local experiments with Art Deco architecture, synonymous with the massive economic boom of the 1920s in America, were starting to take place just as economic conditions worsened.

The Depression caused great hardship throughout the country, reaching its lowest ebb in mid-1932 when more than thirty per cent of the nation's work force was unemployed. Some parts of the country fared a little better than others. One instance of this could be seen in the building industry. Construction activity in Sydney fell off to a greater extent than in any other State capital (it was not until the end of the decade – 1938, in fact – that it reached parity with activity in Melbourne).[6] Unemployment was greatest in the cities, and within the cities the hardest hit areas were those where the hard core working class lived. Local councils provided some relief work, ranging from the construction of bridges and roadworks to parks, recreational and beautification schemes. Still, these years were marked by several momentous events, such as the inauguration of a telephone service between Perth and the eastern States in December 1930, the opening of the Sydney Harbour Bridge in March 1932 and, several months later, in the worst of the Depression, the foundation of the Australian Broadcasting Commission.

By about 1936, the worst effects of the Depression had eased, although full recovery and employment did not return until the outbreak of the Second World War. Post-Depression prosperity was reflected in the increased pace of construction in cities and towns, and was accompanied by gains in manufacturing output. The 1930s also witnessed a degree of cultural and social maturity not evident in the previous decade.[7] The country, or more particularly Sydney, celebrated its sesquicentenary in 1938 and four years earlier, in 1934, Melbourne had celebrated its centenary. The character of the cities reflected the changes taking place during the 1930s. For instance, mid-decade Sydney was perceived to have become more assured and self-confident than it had been in the

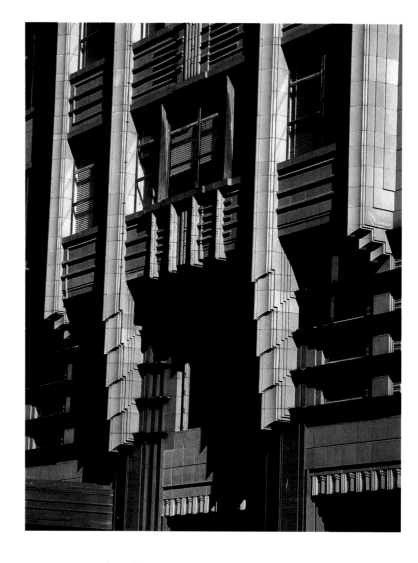

PLATE 1
TRANSPORT HOUSE
(FORMERLY RAILWAY HOUSE), 1936
19 York Street, Sydney, New South Wales
Architects: H. E. Budden and Mackey
Awarded Sulman Medal and RIBA Medal
This outstanding building is distinguished by its green terracotta cladding, designed to overlap in a manner redolent of the machine age and to exploit fully the colourful, malleable and tactile qualities of this versatile material. Its horizontal fenestration was unique for such a large office building in Sydney at this time, and it was the first fully air-conditioned office building erected by a government body.

3. ibid., p. 227.
4. Henry Pook, *Building a Dream? A Social History of Australia in the Twenties*, Oxford University Press, Melbourne, 1987, p. 92.
5. Macintyre, op. cit., p. 251.
6. Peter Spearritt, *Sydney Since the Twenties*, Hale and Iremonger, Sydney, 1978, p. 57.
7. Macintyre, op. cit., p. 314.

1920s. Leslie Rees wrote in *The Home*: 'Returning to Sydney after nine years, the last six of which have been spent in Europe, mainly London, I am impressed by the realistic character of Sydney's city-hood. In its exterior aspects, Sydney lacks the provincial imitativeness which one had been warned against. It has vitality coming from within, flair, an air of *le dernier cri*.'[8] It also exhibited a somewhat American flavour: 'American institutions have touched the city. Milk bars, or soda fountains, fruit-juice stalls and light lunch restaurants have become popular … Throughout the suburban districts, gasoline stations … have sprung up. One … even rejoices in the name of "Ye Auto Drive Inn".'[9] Popular restaurants were given such names as 'The Californian' and 'Monterey'. Still, the local flavour of life remained undimmed: 'Australians have acquired the happy faculty of working to live rather than living to work … Business men take time for morning and afternoon tea, served in their offices, yet the work gets done.'[10] Needless to say, this return to the relative normality of the late 1920s was halted by the outbreak of war in 1939. And all of these events and happenings coincided with the consolidation and maturing of the Art Deco style within Australia and the stylistic complexity which accompanied experimentation with other modern architectural styles at this time.

What, then, was this Art Deco style which spread across a geographically large but sparsely populated continent? From the mid-1920s, an exciting and dynamic aesthetic from overseas began to infiltrate the consciousness of architects in Australia. This style originated in France in the first decade of the twentieth century, was subsequently embraced by designers in the English-speaking world (particularly the United States), and metamorphosed into what is now generally thought of as Art Deco.

There are almost as many definitions of what constitutes the Art Deco style as there are books on the topic. Essentially, it arose out of developments in design which took place after the rich curvilinear style of the late nineteenth and early twentieth centuries – known as 'Art Nouveau' – had waned. In a strict sense, the term 'Art Deco' is relevant only to French decorative arts created between the first decade of this century and the late 1920s. Its apotheosis coincided with the staging of the Exposition Internationale des Arts Décoratifs et Industriels Modernes, held in Paris between April and October 1925.[11] The term 'Art Deco' is generally acknowledged to have derived from the name of this exposition and was popularised in the late 1960s.[12] In its widely accepted sense, it has been allowed to embrace many of the aspects of decorative art and design which were current in the years between the two world wars. According to the noted authority, Alastair Duncan, Art Deco was the last of the 'truly sumptuous' styles.[13] It was an extension of the voluptuous curvilinear Art Nouveau style, most particularly in the areas of ornament, craftsmanship and its use of fine materials, and continued to develop after the 1920s, surviving the Depression.[14] Indeed, there is clear evidence to suggest that elements of the style were still valid even in the late 1950s.

Although there was a French Art Deco architecture, it does not appear to have been particularly extensive.[15] Its major manifestation was at the Exposition Internationale des Arts Décoratifs et Industriels Modernes. There had been several calls in the first decade of the century for an international exhibition of decorative art to stimulate French artists and manufacturers into producing practical, inexpensive and modern objects. However, the exposition did not eventuate, and the initiative was re-established after the end of the First World War. Finally, the year 1925 was selected for the staging the exposition and, in the most general terms, the exposition was planned to demonstrate French superiority in design in the face of competition from other countries, notably Germany. Works on display were intended to exhibit originality and modernity above all else – a condition written into

8. Leslie Rees, 'Sydney After 9 Years', *The Home*, July 1936, vol. 17, no. 7, p. 24.

9. W. Robert Moore, 'Capital Cities of Australia', *The National Geographic Magazine*, December 1935, vol. 68, p. 671.

10. ibid.

11. A thorough analysis of French design in the first three decades of this century and the development of the Art Deco style is to be found in Nancy J. Troy's, *Modernism and the Decorative Arts in France*, Yale University Press, New Haven, 1991.

12. This is attributed to Bevis Hillier in his seminal book, *Art Deco*, Studio Vista, London, 1968, reprinted 1973.

13. Alastair Duncan, *Art Deco*, Thames and Hudson, London, 1988, p. 7.

14. ibid.

15. ibid., p. 175.

invitations sent to foreign nations asking for their participation. The site chosen was located in the centre of Paris, amongst the established infrastructure of the city. This necessitated the construction of temporary pavilions rather than permanent buildings and contributed to the theatrical atmosphere of the event.

The pavilions erected at the exposition would have comprised the most concentrated group of buildings erected in the Art Deco style in France. The architecture was generally regulated by axially composed symmetry and rather traditional, neoclassical forms overlaid with consciously modern embellishment. The copious quantities of decorative detail were predominantly sculptural, such as panels in relief and metalwork. Since the pavilions were only intended to stand for six months, most were constructed of reinforced concrete over timber framing, on top of which a 'multitude of components of plaster, glass and wrought iron components were applied'.[16] Other countries were also represented at the exposition, although most displayed pavilions which did not deviate too far from traditional designs. There were a few exceptions. For instance, the Dutch pavilion mirrored the brick architecture of the Amsterdam School; the Polish pavilion was a geometric, modern interpretation of provincial architecture; and the French-African pavilion was based on native forms interspersed with representations of the local flora and fauna.[17] More avant-garde styles appeared, albeit in very restricted numbers. The Russian pavilion – a striking example of Constructivist architecture designed by Constantin Melnikov – incorporated a workers club into its fabric. Abstracted geometric forms were included in Robert Mallet-Stevens's Pavilion de Tourisme, anticipating trends of the 1930s. And Le Corbusier's Pavilion d'Esprit Nouveau, hidden away as it was at the instigation of the exposition authorities, pointed to the direction in which French architecture and design would head after 1925.

The United States, although asked, officially declined to take part but, nevertheless, many Americans keenly observed all that was on display. Consequently, designers took up the decorative motifs of the exposition of 1925 with alacrity, for Parisian origins gave legitimacy to architects trained under the French-based Beaux-Arts system. The resulting works were richly decorative, fusing the ornamental and the exotic into what has been termed 'the last great decorative style'.[18] The immediate impact of the exposition on American architecture lay in the area of applied decorative ornament rather than in any rethinking of basic architectural forms.[19] In the past three decades, certain aesthetic manifestations of inter-war architecture which evolved in America and which were influential in other countries have been classified under the useful, if elusive, catch-all of 'Art Deco'. The Art Deco style did not affect the program of buildings, generally being applied to types which already existed, nor did it influence planning. It did, however, affect the exteriors of buildings and, of course, their ornament both externally and internally.

American Art Deco architecture went through two successive stages of development: the first a geometrical and angular phase generally associated with the 1920s which derived its visual vocabulary from the exposition and reflected 'the dominance of the triangle and "T"-square coupled with stylised classic derived ornament, and the second reflecting the French curve and compass'.[20] This second curvilinear and streamlined phase was prevalent in the 1930s.

American Art Deco was associated with machinery, most specifically that of transportation, and by the late 1920s elements of the style were almost universally embraced by commercially successful architects. Its ornament was applied to the surface of the building, not as an integral part of it – patterning was linear and two-dimensional. Decoration was repetitive and gave the appearance of having been produced by mechanical means. A standard repertoire of decorative motifs included simplified versions of classical patterns

16. Patricia Bayer, *Art Deco Architecture*, Thames and Hudson, London, 1992, p. 38.

17. Frank Scarlett and Marjorie Townley, *Arts Décoratifs 1925: A Personal Recollection of the Paris Exhibition*, Academy Editions, London, 1975, pp. 40 and 47.

18. Ada Louise Huxtable, *The Tall Building Artistically Reconsidered: The Search for a Skyscraper Style*, Pantheon Books, New York, 1984, p. 39.

19. David Gebhard, 'The Moderne in the U.S. 1920–1941', *Architectural Association Quarterly*, July 1970, vol. 2, no. 3, p. 7. Gebhard, although acknowledging the term 'Art Deco', preferred the use of 'Moderne', and split it into two phases – the Zigzag Moderne of the 1920s and the Streamlined Moderne of the 1930s. Much of the following discussion is based on Gebhard's definitions and descriptions in this article.

20. ibid.

21. These sources are explored in Cervin Robinson and Rosemarie
 Haag Bletter, *Skyscraper Style: Art Deco New York*, Oxford
 University Press, New York, 1975, pp. 48–60 and 64–67.
22. ibid., pp. 60–64.
23. ibid., p. 13.
24. Richard Guy Wilson, 'Architecture in the Machine Age', *The
 Machine Age in America 1918–1941*, Richard Guy Wilson,
 Dianne H. Pilgrim and Dickran Tashjian, Harry N. Abrams, Inc.,
 New York, 1986, p. 174.
25. Donald Leslie Johnson, *Australian Architecture 1901–51: Sources
 of Modernism*, Sydney University Press, Sydney, 1980, p. 86.

(such as paired spirals, sea shells, leaves and flowers) which were often combined with geometric shapes (such as circles, chevrons and triangles). Human and animal figures were flattened and stylised. The Paris exposition, however, was not the only source of inspiration to influence American architects. Their rich and eclectic architecture of that time incorporated elements of several other sources. From Europe came the geometries and detailing of German Expressionist and Dutch brick architecture, aspects of modern Viennese design and even ideas from the set designs of avant-garde films.[21] Exotic and ancient cultural traditions also may have played their part, such as those from the American south-west, pre-Columbian Mexico and Central America, and ancient Egypt.[22]

By the mid-1930s, the geometries of the previous decade had been all but superseded in the United States by curves and planar surfaces – the so-called 'Streamlined Moderne'. The shift took place because of several factors, such as an increasing acceptance of European modernism and a celebration of speed exemplified by the machine – most particularly the aeroplane – as a symbolic resource. It may also have come about because of the influence of the drawings of the modernist German architect, Eric Mendelsohn, often reproduced in the United States during the 1920s, and the realm of science fiction, increasingly popular in the 1920s with its imagery and ideology of the future.[23] Finally, and perhaps most importantly, was the rise of the professional industrial designer – figures such as Norman Bel Geddes and Raymond Loewy had established studios by the end of the 1920s. Indeed, Bel Geddes has been credited with providing the major impetus for architectural streamlining in the American architectural vocabulary.[24] Generally, this streamlined Art Deco adopted the nautical imagery of the International Style; however, decorative elements from the previous phase often enlivened these sleek and sometimes austere structures.

▼ ▼ ▼

How and why did these developments in architectural style affect Australian architecture? Australian architecture at the beginning of the 1920s was relatively conservative, relying on the example of Britain and the United States for precedent. The influence of the latter was particularly striking at this time on the dominant house type and office building type, namely the California Bungalow and the Commercial Palazzo. Both were American idioms accepted in the previous decade. Several factors worked to introduce new ideas into Australian architecture. Put succinctly, the three key agents were architects who came from abroad to practise in Australia (such as Walter Burley Griffin), Australian architects who travelled overseas, and the architectural press.[25]

Although architects migrating to Australia from other countries, most particularly Britain, brought valuable experience and knowledge with them, locally born architects who were steeped in local conditions and then travelled abroad were probably more instrumental in translating and communicating what they saw on their return home. The more prosperous amongst the profession travelled to further their professional knowledge, journeying to Britain and America – some even studied and gained degrees at universities whilst away. A number of young architects who had survived the battlefields of Europe remained abroad to advance their studies in England and travelled around Europe to see what was happening there in the world of architecture. This was of great benefit when they returned home, their experience broadened by what they had seen outside Australia. Some architects were sent abroad to study particular building types by their clients, who desired to have the most modern building possible and recognised the benefits of their architects seeing at first hand what was happening overseas. Clients who encouraged this

were quite diverse. For instance, the Principal Architect of the Department of the Interior, E. H. Henderson, travelled abroad on behalf of the Commonwealth Bank;[26] Colonel Spain, of Spain and Cosh in Sydney, undertook a research trip to the United States for the newspaper *The Evening News;*[27] and in 1929 in Melbourne, Harry Norris was sent by the firm of G. J. Coles to Europe and America to observe the latest trends in the design of chain stores before finalising his documentation for the new Coles store in Bourke Street, Melbourne. In fact, Norris travelled overseas annually between 1928 and 1941, working for a time in America, and his very strong awareness of American architecture was clearly reflected in his work.[28] During the Depression, those who could afford it travelled abroad in search of employment not available at home (mostly to Britain, as fares were relatively inexpensive).[29] Finally, from the mid-1920s, the most brilliant architectural students were actively encouraged to travel abroad by the profession through the medium of scholarships and awards. Their reports were published in the local press; in the 1930s, this group was the most vocal proponent of modern architecture.

Architectural training, too, gained momentum at home with the establishment, in 1919, of the first Chair of Architecture in the country under Leslie Wilkinson at the University of Sydney, and the Architectural Design Atelier at the University of Melbourne. Although a professional education had been available in these two cities prior to this, a more academic approach was now available. Wilkinson demonstrates the influence a migrant could have. He arrived to occupy the Chair of Architecture in August 1918, having left a successful career in England to do so. He recognised the similarities between the climates of Sydney and the Mediterranean and introduced a domestic architecture which reflected this. It became an important part of Australia's architectural repertoire and remains valid to this day. Wilkinson also introduced to the country full-time architectural courses which stressed intellectual and aesthetic education ahead of technical training.[30] Courses at technical colleges and even Wilkinson's newly introduced course were general-ly similar to those in America and Britain, emphasising the need to observe the architecture of the past and rely on it as the basis for design.[31] Effectively, architects were trained in the traditions of the European past, but the Architectural Design Atelier broke away from this tradition to teach design by the 'trial and criticism' method, resulting in student works which were more advanced than those coming out of the offices of the profession.[32] Formal training was available in other States, but university degrees equal to those in the two largest cities came somewhat later. For example, because of the relatively small size of the profession in South Australia, the system whereby students were articled to practitioners and supplemented this with evening technical classes at the School of Mines held sway until after the Second World War.[33]

▼ ▼ ▼

Why would an Australian architect, relatively remote from the major centres of architec-tural foment, have adopted this decorative style? The writings of the major Sydney architect, C. Bruce Dellit, which appeared in magazines and newspapers, may provide some insight into this.[34] Dellit, born in 1900, is considered to be one of the outstanding exponents of the Art Deco style. His architecture was the product of a Sydney Technical College education, plus a year spent studying design at the University of Sydney in 1919, followed by work in the established firm of Spain and Cosh. Here, his assurance and precocity allowed him responsibility for the design of major Commercial Palazzo–style office buildings during the 1920s. Dellit never travelled overseas but appears to have subscribed to foreign journals, such as the American *Pencil Points* and the English *Architectural Review.*[35] Dellit was

26. 'The Commonwealth Bank, Sydney: Its Architectural Importance', *Building*, 12 April 1933, vol. 52, no. 308, p. 45.

27. 'The Modern Newspaper Office in Sydney: The "Evening News" Building', *Architecture*, June 1926, vol. 15, no. 6, p. 11.

28. Carol Hardwick, The Influence of Art Deco on Architecture in Victoria, Master of Architecture thesis, University of Melbourne, 1980, p. 35.

29. David Saunders, '... so I decided to go overseas', *Architecture Australia*, February–March 1977, vol. 66, no. 1, p. 22.

30. J. M. Freeland, *The Making of A Profession*, Angus and Robertson, Sydney, 1971, p. 277.

31. Ian and Maisy Stapleton, 'C. Bruce Dellit 1900–1942 and Emil Sodersten 1901–1961', *Architects of Australia*, ed. Howard Tanner, The Macmillan Company of Australia, 1981, p. 121.

32. Hardwick, op. cit., p. 31.

33. Michael Page, *Sculptors in Space: South Australian Architects 1836–1986*, The Royal Australian Institute of Architects (South Australian Chapter), Adelaide, 1986, p. 154; Freeland, op. cit., pp. 212–13.

34. Articles by Dellit included:
 – 'Modern Movement in Design', *Art in Australia*, third series, 15 August 1934, no. 55, pp. 67–69;
 – 'Modern Architecture – Whither is it Leading?', *The Sydney Morning Herald*, 13 July 1936, p. 17.
 – 'The Future Psychology of Architecture', *Architecture*, 1 August 1936, vol. 25, pp. 190–191.

35. Andrew Stuart-Robinson, The Architecture of C. Bruce Dellit, Fine Arts Essay, University of Sydney, 1976. The equally important Melbourne-based architect, Marcus Barlow, was another who remained at home and gained much of his inspiration from American journals, particularly *The Architectural Record* and *The Architectural Forum*. See Hardwick, op. cit., pp. 40–41.

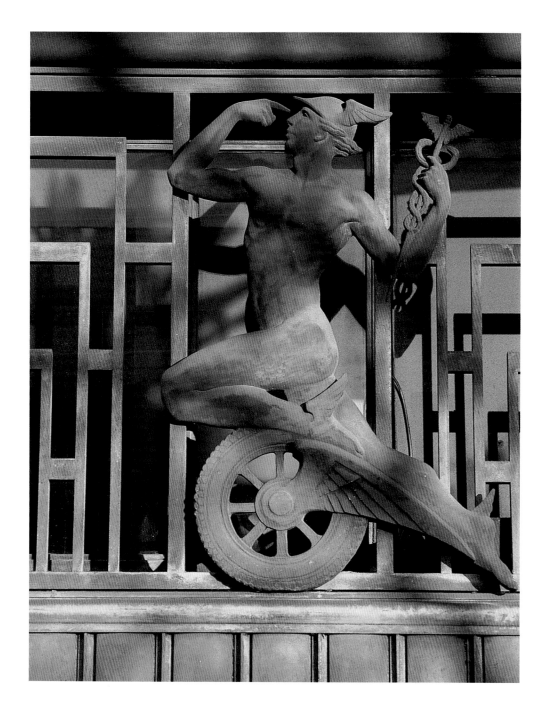

PLATE 3
FORMER TRANSPORT HOUSE, 1938
Corner of Macquarie and Phillip Streets, Sydney,
New South Wales
Architects: H. E. Budden and Mackey; relief
sculptures of Mercury designed by Rayner Hoff
This building was designed with an unusual external
expression – the Macquarie Street facade is in the
stripped classical style, whilst the sides of the building
appear as horizontal functionalist elements and the
Phillip Street facade is distinguished by vertical Art
Deco components. A rather classical sculpture of
Mercury, or Hermes – the ancient god whose duties
included the protection of road travellers – is to be
found above the entries on Macquarie and Phillip
Streets, and underscores the pervasive classical
influence which coloured Art Deco design.

enthusiastic about new building technology and materials and believed these could liber-
ate an architect's creative potential. He also believed that the fine arts, such as painting or
sculpture – which he termed 'the handmaidens of architecture' – were essential to create a
humane architecture. As a result, the fusion of science, technology and the arts was per-
ceived by him to be something of an imperative. Ideally, this aim was to be achieved whilst
looking over one's shoulder at the achievements of the European architectural tradition:

> Bring Michelangelo back to life and present to him modern facilities. Go further and recall
> Bramante, De'Lorme, Mansart and the masters of classical antiquity. Imagine modern mater-
> ials and methods in the hands of these masters working under the extravagant patronage of
> ancient nobility! Here indeed is a picture worthy of one's thoughts. Why then should not the
> men of modernity, already enriched by the masterpieces of creative thought of past ages,

go to work in a healthy way in sympathy with scientific progress and weave into the foundations of the past and steadily work upwards to new artistic heights, and by the aid of modern science reach beyond our present dreams to artistic creations as yet undreamt of.[36]

Dellit was quite explicit as to which building types this was appropriate: 'It is the great public structures demanded for the future progress of man, factories, office buildings, administrative blocks and so on, that the great synthetic creations of science should be used in architectural efforts.'[37] These thoughts, far from being an example of an original home-grown philosophy, echo those of American architects practising during the 1920s and 1930s. For instance, the important New York architect Ralph Walker, who was responsible for some of the greatest Art Deco architecture constructed in that city, wrote:

For the first time in the history of architecture we have at our disposal means and methods of building that are uninhibited in their possibilities. Our ways of construction are the most flexible in the long struggle to span space, and new forms are coming into existence that are strange to our sense of fitness, although they gradually become part of it ... In looking forward to a new architecture, the ideas of the use of materials that have held in the past will be slowly discarded, and new materials or uses will come into effect ...[38]

Dellit's Anzac Memorial in Hyde Park, Sydney (plates 74 and 75), represents a concrete achievement of this philosophy. The building was erected between 1932 and 1934 to commemorate the sacrifice of all from New South Wales who had served in the First World War. Its stepped cubic architecture derives from the classical past, yet it also represented the advent of new technology with its reinforced concrete structure, tall amber windows – etched using the then new process of gravé – and its statuary executed by the very important sculptor Rayner Hoff and made from synthetic stone (only recently introduced into Australia). The innovation of the building extended even further, for over its severe classical skeleton an Art Deco fabric was draped, embodying in a dramatic and explicit way the loss and the sentiments of the public. Art and science came together meaningfully in one of the supreme artefacts of the Art Deco style in Australia.

Australia, as might be expected given its unimportance in the world of design, was not invited to contribute to the Exposition Internationale des Arts Décoratifs et Industriels Modernes, although several influential Australians managed to visit it. Amongst these were Professor Leslie Wilkinson from the University of Sydney and Ernest Wunderlich, one of three brothers responsible for the firm of Wunderlich Limited, a prominent local manufacturer of pressed metal, architectural terracotta and other building products. Wunderlich recorded some of his impressions, part of which were as follows:

It is a pleasure show like all French Exhibitions ... full of novel conceits and, but for the modern sculpture, which is uniformly vile, pleasing and striking. In furniture and interior decoration, especially in lighting effects, many ideas could be picked up. Even when the designs are *outré* they always are artistic and possess a cachet of their own ... though some of the pavilions are brazen innovations on what we would consider artistic fitness, they are strikingly original and attractive so long as sculptural details are not too closely examined. Some of the 'cubist' wall decorations – well, they are the dizzy limit![39]

As a result of Wunderlich's visit, his firm included Art Deco–inspired motifs in its product range and Australia's streets became shaded with deep awnings that were lined with geometrically patterned pressed metal. George Paterson and Ralph Ferris were the two people largely responsible for Wunderlich Limited's Art Deco products.[40] In 1929, the firm introduced its Wunderglaze range (a process similar in appearance to leadlighting whereby

36. C. Bruce Dellit, 'Modern Movement in Design', op. cit., p. 69.
37. C. Bruce Dellit, 'Modern Architecture – Whither is it Leading?', op. cit.
38. Ralph T. Walker, 'A New Architecture', *The Architectural Forum*, January 1928, vol. 48, pp. 1–4.
39. Ernest Wunderlich, *All My Yesterdays: A Mosaic of Music and Manufacturing*, Angus and Robertson, Sydney, 1945, pp. 93–94.
40. Susan Bures, *The House of Wunderlich*, Kangaroo Press, Sydney, 1987, pp. 110–116.

copper, instead of lead, was deposited over glazed panels assembled with fine copper caming in an electrolytic bath) – glass and copper were fused together into a strong and impervious unit. Wunderlich was not the first to make use of this process – it was introduced by Brooks Robinson and Company in Melbourne – but Wunderlich's product did find its way into a large array of standard glazed panels, as well as purpose-made domes and light fittings. Fine examples of the latter were displayed in the company's showrooms in Redfern, Sydney, which opened in December 1929 but have since been demolished. This early Art Deco interior graphically displayed Ernest Wunderlich's enthusiasm for what he had seen in Paris four years earlier. Amongst its rich beauties were eight columns clad in glazed terracotta (coloured a restrained yellow ochre), which were inlaid with fragments of metallic gold and capped by tall, fountain-like capitals of hammered bronze. Steel sheet, stamped into a wealth of geometric and curvilinear volute-like patterns, lined the ceiling and the grid of beams which broke it into a series of regular bays. Wunderglaze windows in a faceted sunray motif formed a clerestory around the showroom. At the intersecting points of the grid, massive Wunderglaze electroliers were hung to create fractured displays of cascading light. It was a marvellous showcase for Wunderlich's many products and, for many people, would have been a tantalising and exciting introduction to the new style. In addition, Wunderlich Limited was instrumental in establishing local production of architectural terracotta in Australia. Its first plant commenced operation in 1924, and over the next fifteen years Australia's cities were enhanced by numerous facades clad in Wunderlich's terracotta. Needless to say, during the 1930s a strong Art Deco presence developed.

Unlike the overseas press, the local journals did not accord the Paris exposition much coverage. The stylish Sydney-based society journal, *The Home*, was the most positive, providing editorial and photographic coverage. As for the architectural press, the most extensive reporting, if it could be called that, appeared in the influential magazine *Building* (also published in Sydney). Its response was negative and indicates why it took some time for the more advanced forms of modern architecture to find acceptance in this country. Apart from condemning the new work emanating from such countries as Holland, Sweden, Germany and France, it found much, although not all, of the architecture at the exposition absurd.[41] For all that, over the years the journal published many photographs of overseas architecture and articles from foreign publications, and in doing so broadened local awareness.

If Australians followed overseas precedent at a distance, they generally ignored it at close quarters. The work of such a valuable local resource as Walter Burley Griffin seems to have been largely ignored by the architectural community. Burley Griffin had given up a promising career in the United States to come to Australia after winning the competition held in 1912 for the design of Canberra. His decorative architecture, with some similarities to the work of Frank Lloyd Wright, was based on a different philosophy from that of the Art Deco style, although having superficial similarities to it (plates 15, 123 and 127). Burley Griffin, along with his wife, Marion Mahoney, was instrumental in bringing a modern architecture to Australia, but this premature exemplar remained isolated and appreciated by relatively few practitioners.[42]

The adoption of the Art Deco style in Australia reflected a small time lag in acceptance. The major exemplars of the style – New York's fabulous skyscraping office towers and apartment blocks – were erected largely between 1925 and 1931;[43] those in Sydney were erected between 1934 and 1941. Because of this, the style represented different conditions in different places. In America, it was associated with the boom years and prosperity of the 1920s, whilst in Australia it was associated more with the years of post-Depression

41. Florence M. Taylor, 'Freak Architecture: Its Contempt for Sentimental Association and Correct Principles', *Building*, 12 October 1925, vol. 37, no. 218, pp. 74–75.

42. Donald Leslie Johnson, *Australian Architecture 1950–51: Sources of Modernism*, p. 131. According to Johnson, Australian architecture's 'modern movement' began in 1914 when Griffin opened his practice in Melbourne.

43. Cervin Robinson, 'Buildings and Architects', *Skyscraper Style: Art Deco New York*, Cervin Robinson and Rosemarie Haag Bletter, Oxford University Press, New York, 1975, p. 5.

recovery and a degree of optimism (which Americans found in streamlined forms). Art Deco did not penetrate the architectural consciousness of every State at the same time. Initially, it appeared in the major centres of Melbourne and Sydney, with the first documented experiments with the style appearing in Melbourne. The pioneering building is very likely to have been the Melbourne residence known as 'Holmwood' in East St Kilda, which was renovated in 1926. The renovations included a bathroom and bedroom which clearly owed a great debt to the Paris exposition of the year before. Although the identity of the designer is not known, the interiors have been attributed to the interior designer at the Myer Emporium.[44] In New South Wales, early experiments in the style appeared in entries for architectural competitions, such as those submitted by the young firm of Fowell and McConnel in the first part of 1928 for the town hall at Manly (in suburban Sydney). Although somewhat neoclassical in form, certain details and elements betrayed the influence of the Art Deco style. Although placed first, it was not built.[45] Experiments with aspects of Art Deco architecture began to appear in built form around 1929 and 1930.

Art Deco architecture did not arrive as an isolated phenomenon. For instance, in New South Wales, or more particularly Sydney, it reached a relatively wide public at the very end of the 1920s through such commercially driven activities as the Burdekin House Exhibition and through the promotional activities of such department stores as David Jones. The Burdekin House Exhibition is of interest because it demonstrates the role taken by serious artists in the introduction of modern design into Australia. The exhibition, held during October 1929, was a display of antiques and artworks in a colonial mansion of the same name in Macquarie Street. The antiques were on show in the lower levels of the house, while several rooms situated on the top floor were devoted to the latest trends in interior design. Quite a few of Sydney's major artistic personalities, including Hera Roberts, Margaret Preston, Thea Proctor, Leon Gellert, Adrian Feint and Roy de Maistre, as well as the young architect Henry Pynor, contributed designs for furnishings and room layouts. The rooms comprised a European sitting room displaying Japanese influences, two separate men's studies, a man's bedroom and a living room. Much of the furniture showed the direct influence of items which would have been on show at the Paris exposition, and much of it was made by the department stores Beard Watson and Company and Anthony Hordern's. This formed an interesting parallel with the Paris exposition, where the major Parisian department stores contributed a great deal. Leon Gellert, in a catalogue accompanying the Burdekin House Exhibition, explained the underlying philosophy of the rooms, stressing the relationship between modern design and the past:

> Modern interior decoration ... eliminates all that is unnecessary and is in agreement with the whole world-movement towards simplification as exemplified in modern dress, modern architecture, modern art, modern hygiene, town-planning and constructional engineering. Furthermore, it gives ample scope for the application of colour. Its furniture is based, and obviously so, on the simple primary forms – the cube, the prism, the cylinder, the cone, the pyramid, the sphere – and restricted variations of these forms. An analysis of the greatest examples of architecture in the world's history discloses that they have achieved their purpose through the judicious use of these elementary shapes. Modern dress, which insists on severity and more definite vertical lines, is provided with the ideal background in the modern interior setting ...[46]

Amongst all the commentary, the editorial of *The Home* expressed the most pleasure at what was shown. Whilst acknowledging its origins and experimental nature, it also recognised the important role that women played in the acceptance of Art Deco into Australia (although perhaps in terms that would not be acceptable today):

44. Hardwick, op. cit., p. 54.
45. 'Municipality of Manly: Architectural Competition for New Town Hall and Municipal Offices', *Architecture*, 1 April 1928, vol. 17, no. 4, pp. 75–77.
46. Leon Gellert, 'The Modern Interior Decoration', *The Burdekin House Exhibition Catalogue*, Committee of the Burdekin House Exhibition, Sydney, 1929.
47. 'The Case for Modernity: Modern Furnishing Designs at Burdekin House', *The Home*, 1 November 1929, vol. 10, no. 11, pp. 53–54.

Two or three enterprising firms have made the various pieces of furniture from Continental designs or adaptations of those designs ... These modern rooms cannot be regarded altogether as final. They merely contain suggestions for those who would seriously examine the new idea ... The hundreds of visitors to Burdekin House have only too eagerly asked the question, 'Where are the modern rooms?' With a cry of relief they have almost leaped up the stairs. The chief enthusiasts have been women. Bowing to each seasonal demand of fashion, their lives are largely made up of changing their minds. And it was enlightening to observe the manner in which wives bitterly fought against the prejudices of their more conservative husbands ...[47]

– who were obviously repelled by the latest in men's lairs! The Burdekin House Exhibition underscored two of the factors contributing to the introduction of the Art Deco style in

PLATE 4
Mc WHIRTERS – DEPARTMENT STORE, 1931
Corner of Wickham and Brunswick Streets,
Fortitude Valley, Queensland
Architects: Hall and Phillips
This building is enhanced by a richly decorated
corner featuring dramatic polychrome terracotta by
Wunderlich Limited, and continues to be a prominent
local landmark.

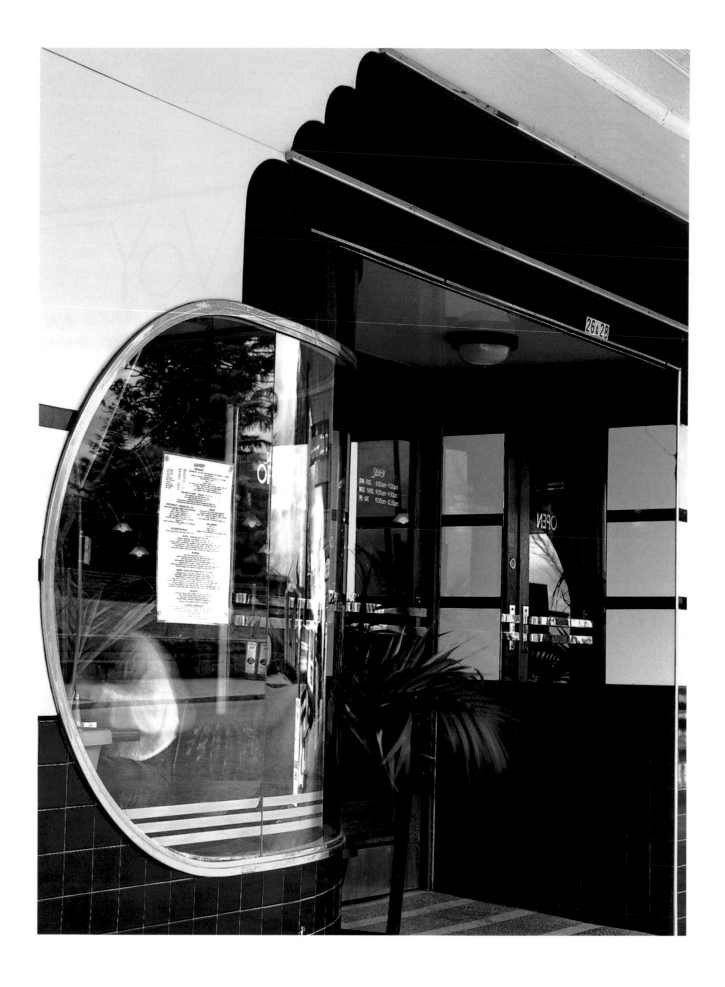

Australia. These were the active role played by women as interior designers and the active promotion of fashionable merchandise by the metropolitan department stores. The role of women was most important in the widening public acceptance of a modern aesthetic related to design during the inter-war period.[48] Such artists as Thea Proctor and Hera Roberts offered advice on interior design and there were several women who were influential in popularising modern design for the home. They included Margaret Jaye, who established a studio in 1925, Molly Grey, who returned to Sydney from travels in Europe and America in 1934, and the most well known of all, Marion Hall Best.[49] The fine arts mirrored this in the images of the modern city produced by women artists, many of whom used scenes of the contemporary city – transportation, city life, the urban fabric – as a visual resource. It has even been suggested that the inter-war city was imbued with a self-consciously feminine modernity, for modern life offered women a new participatory freedom beyond the traditional confines of home and family.[50]

The department stores were another agent of advancement. Again taking Sydney as an example, there was a veritable chain of stores reaching from Circular Quay through the city and along Broadway to Victoria Park at Glebe. Although well established before the 1920s, during the inter-war period they acted as a focus for social activity and, in addition to a vast array of merchandise, offered superior restaurants and cafeterias, popular cultural activities and entertainments. Successful mail-order services ensured that rural customers were not neglected.[51] Indeed, the department stores 'so dominated the retail trade of New South Wales in the 1920s and 1930s that few fashion trends or urban changes could take place without [their] active involvement'.[52] Of all the stores, David Jones played a prominent role in the dissemination of modern design. In 1922, the graphics of its advertising gave consumers an early and local example of Art Deco colour and illustration.[53] At the end of the 1920s, it took modern design directly to the streets with striking window displays of the latest spring clothes for 1929. The windows were designed by H. W. Bindoff, display manager for the store, who had visited Europe and America prior to designing them. When interviewed, Bindoff expressed some surprise at the response of Sydneysiders to the design of the displays: 'Curiously enough, in spite of their isolation from European centres, they seem to be ready for it. These windows have called forth more general approval than anything I have so far done. It is most encouraging to find that it appeals to Australians and makes me feel that we are not so much a backwater as some people would have us think …'[54] Other stores also encouraged consumers to consider modern design. In 1927 Grace Bros tentatively promoted Art Deco furniture decorated by Thea Proctor and Roy de Maistre, along with Parisian fabrics,[55] whilst early in 1928 Beard Watson and Company advertised imported French furniture and reproductions of objects seen at the 1925 Paris exposition.[56] At the beginning of 1930, another store, Bebarfalds, displayed a series of period and modern rooms, which included imported modern furniture and Lalique light fittings from Paris.[57] This situation, whereby department stores assumed the role of agents of change, mirrored a similar situation in America. There, from 1927 onwards, such stores as Lord and Taylor and R. H. Macy in New York staged a 'profusion' of exhibitions and displays across the country in the wake of the Paris exposition.[58]

▼ ▼ ▼

Following the American precedent, geometric and fully resolved Art Deco buildings appeared in Melbourne in the early 1930s, and in Sydney as the worst effects of the Depression began to ease, around 1933. Streamlined curves appeared in 1936, the same year that major Art Deco office towers were being completed in Sydney. When aspects of

PLATE 5 (opposite page)
COFFEE SHOP IN THE SAVOY THEATRE COMPLEX, 1937
6–32 Katoomba Street, Katoomba,
New South Wales
Architects: Guy Crick and Bruce Furse
Streamlined style has been achieved at this popular meeting and dining place in the Blue Mountains, west of Sydney. This coffee shop is part of a building which contained a cinema, a ballroom, a series of six shops along the street, and which replaced an earlier theatre. The shop fronts were finished with up-to-the-minute materials, including black-tiled stallboards, extensive glazed display windows with curved corners framed in monel metal, decorative hampers and patterned coloured terrazzo entry porches.

48. Peter McNeil, 'Decorating the Home: Australian Interior Decoration Between the Wars', Art and Australia, Summer 1995, vol. 33, no.2, pp. 222–224.
49. ibid., pp. 226–227.
50. Stephanie Holt, 'Woman About Town: Urban Images of the 1920s and 1930s', Art and Australia, Summer 1995, vol. 33, no.2, pp. 234–235.
51. Howard Wolfers, 'The big stores between the wars', Twentieth Century Sydney: Studies in urban and social history, ed. Jill Roe, Hale and Iremonger, Sydney, in association with the Sydney History Group, 1980, pp. 23 and 25.
52. ibid., p. 28.
53. Art in Australia, third series, 1 August 1922, no. 1, n.p.
54. 'Modern Art in Window Display at David Jones', The Home, 2 September 1929, vol. 10, no. 9, pp. 54–55.
55. Advertised in The Home, 1 April 1927, vol. 8, no. 4, pp. 50–51.
56. The Home, 1 February 1928, vol. 9, no. 2, p. 53.
57. 'Furniture and Decoration – Bebarfalds Display', Building, 12 April 1930, vol. 46, no. 272, pp. 62–64.
58. Alastair Duncan, American Art Deco, Thames and Hudson, London, 1986, p. 23.

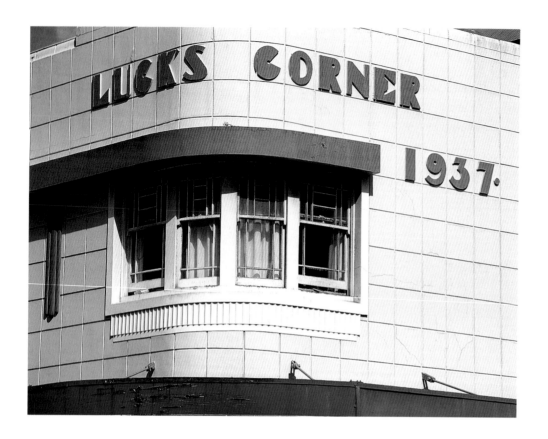

this idiom began to appear they were tellingly characterised by the expression 'continental curves'. That is, this second strand of local Art Deco architecture was readily identified with the latest trends in Europe.[59] As the decade progressed, the style appeared in other State capitals and in country cities and towns. In Western Australia, for instance, the various historical and regional influences which informed its architecture in the 1920s were increasingly supplanted in the years after the Depression by the arrival of the Art Deco style,[60] and Art Deco, as well as other modern architecture, reached Brisbane, Adelaide and Hobart in these years. Of course, Art Deco architecture was not confined to the major cities. A number of country towns were infused with the style, and in some, such as Proserpine in Queensland and Launceston in Tasmania, it still forms an important part of their character.[61]

PLATE 6
LUCK'S CORNER, 1937
Corner of George and Paterson Streets,
Launceston, Tasmania
Architect: Thomas Tandy, Jnr
This building shows that the Art Deco style was not confined to major urban centres in Australia but penetrated into the regional areas where it was subject to some local interpretation. The facade is made interesting by the unusual device of an inscribed grid over the cement-render finish and contains well-integrated graphics. Luck's Corner was commissioned by Gordon Luck, a butcher who established his business in the building, and to this day it still houses a butcher's shop.

The fledgling city of Canberra was a special case. The Federal Capital Commission was set up under John Butters at the beginning of 1925 as a statutory corporation vested with public assets and the power to collect revenue and raise loans. Impetus for the growth of the city came when at the beginning of 1926 the commission was advised that the central office staff of the Commonwealth Public Service would be transferred from Melbourne by mid-1927. This initiated an explosion of house construction consisting of free-standing, single-storey dwellings based on some twenty-two types designed to avoid visual monotony.[62] The provisional Parliament House, designed as a temporary structure but only superseded in the late 1980s, was officially opened in 1927, and a spate of commercial, public and government buildings was completed over the next few years. The buildings most strongly displaying the Art Deco style were monumental public structures, with architects from Melbourne and Sydney responsible for a number of these. All were informed by symmetrical compositions and stripped classical forms and proportions over which elements of the Art Deco style were applied in judicious locations to impart some degree of modernity. This reflected the architecture of both the Federal and municipal governments in the United States during the 1930s, which were responsible for some of the finest stripped classical works in that country.

With a style deriving so much of its impact from decoration and ornament, it is worth examining the extent to which Australian Art Deco architecture developed its own decorative elements. Much of the decorative detail enlivening so many Australian buildings of the 1930s belonged firmly to the ranks of the conventional motifs and vocabulary associated with the Art Deco style and derived from an overseas precedent. Because it was applied to a greater or lesser degree to all types of buildings, from commercial to residential, a degree of consistency and cohesiveness pervaded Australia's built environment. One decorative resource architects only occasionally drew upon to locate their design within a specific

context was that of native flora and fauna. Notable instances of this can be found in several parts of the world, such as the Canada geese gracing the entry porch of Vancouver's Marine Building at 355 Burrard Street (designed by architects McCarter and Nairne and completed in 1930), and the stylised and abstracted American eagles which adorned many public buildings in the United States. Perhaps the most extraordinary example of a building which derived its decorative imagery from an entire region is the Seattle Tower (formerly Northern Life Tower) at 1218 Third Avenue, Seattle, designed by the architectural partnership of A. H. Albertson, Joseph Wilson and Paul Richardson. It conformed to the familiar stepped configuration of so many American office buildings and was clad in brick which shaded in tone from dark to light as the building rose to its full height. The building was designed with a powerful metaphorical content:

> One Sunday last winter when the Northern Life Tower was emerging from the ground, Lake Washington, which adjoins Seattle, lay under a panoramic play of light. From a bluff above the lake the waters of the far shore glistened in silvery whiteness in response to the pale sun hidden from the observer by a lowering sky immediately overhead. The nearer waters of the shore below were as dark as the rain laden clouds above and from the nearby shore to the farther side the gradation was striking – like an artist's graded water color wash laid down on a four-mile stretch, foreshortened. Here was the cue for the shading of the brickwork of the Northern Life Tower.
>
> And over the Lake … stood the Incomparable, the Great Rainier of both heaven and earth sweeping upward in strength and power, forest blue-black at the base, softened at the timberline and paled by the haze up into the eternal whiteness of the snow crown in the skies. Why not grade the brickwork like the shading water of the lake or the black to white sweep of the great mountain? After all, inspiration interprets environment and this would be better done if environment were the mother of inspiration. [63]

Australian architects were somewhat hesitant to employ local flora and fauna as a means of decorating and adding meaning to buildings. Although motifs such as waratahs and kangaroos had been readily translated into architectural terms at the time of Federation, around the turn of the century, in the 1920s and 1930s this was not the case. The young Sydney architect Kenneth McConnel was exceptional in that he recognised that Australia's plants and animals were still worthy of study. Unlike more traditional architects who were content to draw somewhat indiscriminate inspiration from the past, McConnel preferred a less limiting approach. He thought it far better to design ornament specifically for an individual building rather than apply stock motifs and details, and recognised that a great potential existed to adapt the many beautiful motifs inherent in local flora and fauna for the decoration of architecture.[64] Despite this, McConnel rarely made use of them. The outstanding instance where he did is on the exterior of the building designed for the British Medical Association at 135–137 Macquarie Street, Sydney, which he executed in association with Joseph Fowell. Completed in 1930, amongst its repertoire of external statuary are two fully three-dimensional and very round koalas clinging somewhat nervously to one of the setbacks towards the top of the building.

Another architect in Sydney who introduced elements of wildlife into the decorative program of at least one of his buildings was Emil Sodersten. Flannel flowers, banksias and other plant forms, modelled by Rayner Hoff and cast in bronze, grace the sides of the black granite entry porch to his City Mutual Life Building at 66 Hunter Street, Sydney, completed in 1936. Discreet bronze koalas supported handrails in Hennessy, Hennessy and Co.'s 1939 Prudential Building in Martin Place, Sydney: 'snuggling coyly beneath the main railing', they added a 'little touch of sentiment in modern commercialism [which] is particularly

59. 'Continental Curves Characterise the Facade of New Hotel Erected at Broadway, Sydney', *Decoration and Glass*, 1 January 1937, vol. 2, no. 9, p. 42.

60. Ian Molyneux, *Looking around Perth*, Wescolour Press, Perth, 1981, p. xviii.

61. Elizabeth Vines, *Streetwise*, The National Trust of Australia (New South Wales), Sydney, 1996, p. 20.

62. Ken Charlton and Rodney Garnett, *Federal Capital Architecture: Canberra 1911–1939*, National Trust of Australia (Australian Capital Territory), 1984, p. 15.

63. A. H. Albertson, 'Inspired By Nature', *The American Architect*, February 1930, vol. 137, no. 2580, p. 34.

64. K. H. McConnel, 'The Trend of Present-Day Architecture in Sydney and Abroad', *Architecture*, 1 June 1930, vol. 19, pp. 424–427.

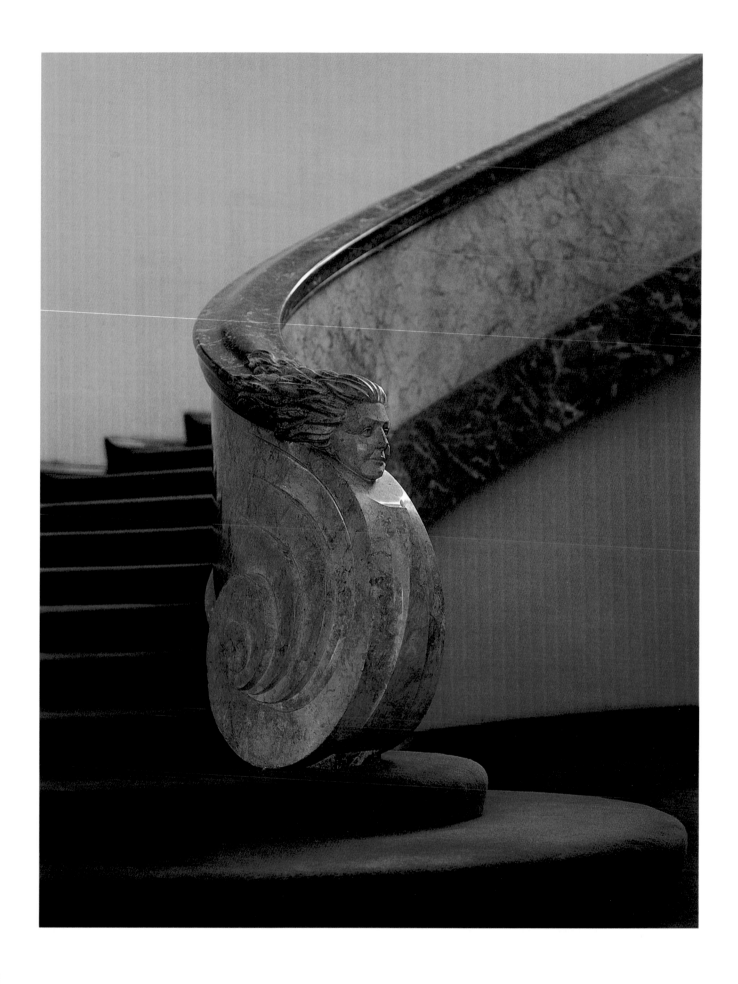

attractive and … imparts an Australian character to the structure'.[65] The Prudential Assurance Company was an English concern; the building no longer exists, having been demolished to make way for a taller, although less distinguished successor.

In Melbourne, instances of local fauna employed as decoration included the koalas, kangaroos and emus on the building for the Australasian Natives Association in Queen Street, designed by architects Marsh and Michaelson and completed in 1939, and the grand house 'Burnham Beeches' in Sherbrook Forest designed by architect Harry Norris and completed in 1933. Amongst the wealth of decorative details at 'Burnham Beeches' are overlapping diamond-shaped panels containing quite realistic possums and koalas (plate 109). Further afield, the crematorium chapel at the Karrakatta Cemetery in Karrakatta, Perth, was distinguished by finely moulded plaques which featured gumnuts and banksias by the noted artist Edward Kohler. The building was designed by the major architect Reginald Summerhayes in 1936. It no longer exists, having been demolished in 1990 amidst much public outcry.

The one building which exemplifies the use of Australian wildlife as an important element of its decorative program is the Australian Institute of Anatomy in Canberra, designed by W. Hayward Morris assisted by Robert Casboulte and completed in 1930. It now houses the National Film and Sound Archive. Animal and plant motifs are woven skilfully into the building fabric. On the exterior, the capitals of pilasters between windows and colossal columns forming part of the porch to the main entry consist of goannas intertwined with waratahs and ferns (plate 71). The surround to the main entry is decorated with a continuous band of stylised frill-necked lizards contained within chevron-like triangles. A courtyard on the opposite side of the building is framed by a gracious loggia. Above the arcade forming the loggia, the heads of wombats contained within circular plaques scowl down at those enjoying the gardens within the courtyard. Inside, the symmetrically planned building is organised around a large central foyer. This space is covered by a large leadlight-glazed laylight, in the centre of which floats a slightly stylised platypus (plate 67). Pilasters lining a pair of museums are inset with bronze plaques cast in the form of naturalistic depictions of different animals.

If Australian flora and fauna received scant attention as a means of imparting regional character to buildings, then the artwork of Aborigines was virtually ignored. The important Sydney-based artist Margaret Preston responded to the challenge posed by adapting indigenous native art forms but in a decidedly non-architectural context. In 1930 Preston advised artists and designers to disregard the meaning behind Aboriginal artefacts and artworks and only borrow line, masses and colouring to produce 'civilised primitive' work.[66] This reflected the practice of a number of American designers and architects, who found a rich source of imagery and reference in the art and architecture of native North American and pre-Columbian cultures.[67] Architects in New Zealand, too, found inspiration in traditional Maori motifs, as was demonstrated in the Bank of New Zealand Building by architects Crichton, McKay and Haughton, and the Ministry of Transport Building by architect E. A. Williams in Napier (both constructed in 1932). Here, the Maori motifs were incorporated into decorative friezes, lintels and cornices.[68]

Two rare instances where Aboriginal themes appeared occurred in Canberra. In the courtyard of the Australian War Memorial, a regularly spaced series of sculptured bosses representing idealised native fauna is punctuated by the heads of Aborigines, whilst the former Australian Institute of Anatomy, in addition to its wealth of ornament derived from fauna, incorporates tiled spandrel panels in blue and green, decorated with motifs not unlike those found in Aboriginal bark paintings (plate 69). Within the building, the

PLATE 7 (opposite page)
'MAHRATTA', 1941
Upper North Shore of Sydney, New South Wales
Architect: Douglas Agnew
'Mahratta' is a substantial two-storey house with a conventional texture brick exterior. Originally built for Mr T. A. Field, it later served as a training centre for one of the large banks and has since changed hands. The interior of the house is enlivened by some imaginative decorative detail, including a wide and sweeping curved stair with a solid balustrade terminated by a mythical nymph whose tresses stream in the breeze above an enormous volute. This part of the stair is made of scagliola, an old technique by which plaster mixed with marble dust, pigments and sizing replicated stone. Although the technique dates back to the fifteenth century, it was an innovation in Australia during the 1930s.

65. 'The New Prudential Building, Sydney', *Building*, 24 June 1939, vol. 64, no. 382, p. 19.
66. Nancy D. Underhill, *Making Australian Art 1916–49*, Oxford University Press, Melbourne, 1991, pp. 188–89.
67. This topic is dealt with in some depth in Carla Breeze, *Pueblo Deco*, Rizzoli, New York, 1990.
68. Peter Shaw and Peter Hallett, *Art Deco Napier: Styles of the Thirties*, Reed Methuen, Auckland, 1987, pp. 36–37.

patterned marble floor of the entrance foyer also recalls Aboriginal art.[69] Aborigines as a motif in themselves were included in the decorative fabric of the Manchester Unity Building in Melbourne, where they appeared in small tableaux in the cornices above the lift doors on the ground floor and in the first floor shopping arcade and boardroom cornices. Otherwise, the lack of interest expressed in Aboriginal art reflected the disdain with which this part of the community tended to be held at the time.[70]

Generally, the 1920s and 1930s was an eclectic period within the realm of Australian architecture, but the use of the Art Deco style embraced and made consistent the visual environment in the 1930s. This gave it a particular relevance because the close time frame in which it developed was the time in which architects were experimenting with conscious expressions of modernity. So, a sleek office building or shop was related to a proud civic structure because of a common grounding in decoration, massing and the direct use of materials. It is true to say that, as in other parts of the world, many of the finest examples of Art Deco architecture in Australia are to be found in commercially oriented buildings or those built with profit in mind, such as office buildings, shops, cinemas, flats, factories and pubs. However, there are certainly outstanding exceptions to this in other types of buildings which, although not necessarily Art Deco works, nevertheless incorporated elements of the style into their fabric. Instances include houses and buildings with a public or monumental purpose, such as crematoria and town halls. It is therefore appropriate to examine how the Art Deco style might have been applied to the various categories of buildings constructed between the wars. For the sake of comparison and simplification, these have been broadly defined as office buildings, commercial buildings, public buildings, domestic buildings, industrial structures, buildings for recreation, and cinemas.

▼ ▼ ▼

The centres of Australian towns and cities, if not transformed, were certainly enhanced by a veneer of modernity with the construction of new office buildings during the 1930s. Their decorations and finishes contrasted strikingly with the more traditional styles amongst which they rose. The work force which inhabited the smart new office buildings was predominantly male in the early 1930s, representing five out of every seven office workers.[71] A particular standard was required in dress. Collars and ties were expected to be worn all day by men, whilst women wore suits or a neat blouse and skirt. Executive positions were a male preserve, with women's work generally relating to typing and secretarial duties. Some companies expected great loyalty from their employees and insisted on a strict code of conduct both within and outside the office, effectively imposing their will upon private lives. One's tenure with a concern could well be for life, but any movement up through the ranks necessitated a great deal of work and single-minded commitment to the firm.[72]

Of all the building types that incorporated the new visual style, the office building has been considered the most Art Deco. Indeed, the style was perceived to enjoy a special relationship with the tall office building which was thought by some American critics to *be* modern architecture.[73] Edwin Morris wrote that the style was interpreted not so much as a style but as 'a method of design for high office buildings. There is its home. The strong vertical lines and the ascetic sparsity of decoration, which are two salient features of the style, are perfectly suited to the skyscraper ...'[74] It was certainly not a new building type, having developed in Chicago and New York from the second half of the nineteenth century. However, in the 1920s it came to represent modern American business and architectural innovation in the eyes of many people.

In America, the skyscraping Art Deco office tower was essentially a phenomenon of the 1920s. Business and the businessman were accorded a special status in the early part of this century.[75] The United States saw the rise of the large corporation as the principal unit of organisation within its economy in the 1920s, and this was mirrored in the corporate office building becoming a focus of civic pride. The office building established a 'cutting edge', defining standards which other building types were to follow. Major architectural practices chased after commissions for office buildings and many of the most accomplished 'worked almost exclusively for corporate clients, blurring the previous generation's distinction between work that, on the one hand, was "serious" or "artistic" and on the other, work that was "ephemeral" or "commercial," while simultaneously elevating pragmatic considerations to the level of art.'[76] In a very real sense, these tall monuments to the money-making processes were perceived as spectacular advertisements proclaiming the triumphs of an egalitarian prosperity based on industrial efficiency.[77]

Australian office buildings were indebted to the American office building in several ways. The design of the American office building in its turn reflected a number of influences and constraints. Local city ordinances were one. The most important of these was the zoning ordinance introduced in New York City in 1916. This controlled the type of development which took place in various parts of the city and also regulated the external form of buildings. Because larger and larger buildings were being erected close to one another, a detrimental effect on natural light and air and also on fire safety was accruing, consequently reducing the letting potential of many buildings. In an effort to overcome this, the zoning ordinance established a formula which allowed a building to rise straight up from the street alignment to a height determined by the width of the street. From there, it was compelled to 'slant backwards' in conformity with an imaginary line projected from the centre of the street. The architectural response to this was the familiar stepped massing so characteristic of the Art Deco skyscraper. Other cities across America introduced regulations, but the massing of the New York skyscraper spread across the country and imparted a degree of similarity to every commercial centre.

The exterior expression of the American skyscraper was influenced by a small number of prototypes. One was a civic building, the Nebraska State Capitol, designed by the prominent architect Bertram Grosvenor Goodhue. Designed as an entry for a competition held during 1919 and 1920, it featured a low base surmounted by a tall tower. The concept embodied in this scheme encouraged other architects to conceive their skyscrapers as freestanding towers, as three-dimensional forms within the city. Goodhue also had definite ideas on the placement of ornament on a building. He thought that it was important as a mediating device, enhancing the interest of a structure and guiding the eye through such aspects of a building as mass and proportion. Ornament also served to clarify the meaning of a building, describing its function and purpose.[78]

Another architectural competition contributed to the way in which architects resolved the external expression of skyscrapers. This was the Chicago Tribune Competition of 1922. The winning scheme, by Raymond Hood and John Mead Howells, was based on English Gothic precedent and intended 'not so much to secure an archaeological expression of any particular style as to express in the exterior the essentially American problem of skyscraper construction, with its continued vertical lines and its inserted horizontals'.[79] In Australia, the example of this building was to be translated several years later with D. T. Morrow and Gordon's 1930 Grace Building in Sydney (plate 36) and Marcus Barlow's Manchester Unity Building in Melbourne (1932). Of greater import to American architects, however, was the Finnish architect Eliel Saarinen's loosely Gothic second-placed scheme,

69. Charlton and Garnett, op. cit., p. 44.

70. Bill Gammage and Peter Spearritt (eds), Australians: 1938, Fairfax, Syme and Weldon Associates, Sydney, 1987, pp. 47–125. See Part Two for a discussion of the position and treatment of Aborigines during the 1930s.

71. Ralph O. Phillips, 'The Skyscraper in Sydney', Bachelor of Architecture thesis, University of Sydney, 1931, p. 43.

72. Lenore Layman and Gail Reekie, 'Working for Elders', in Gammage and Spearritt, op. cit., pp. 317–318.

73. Edwin Bateman Morris, 'Our New Public Buildings', Architecture, June 1934, vol. 69, no. 6, p. 318.

74. ibid.

75. Cass Gilbert's 1913 Woolworth Building in New York, for instance, was christened 'the Cathedral of Commerce'.

76. Robert A. M. Stern, Gregory Gilmartin and Thomas Mellins, New York 1930, Rizzoli, New York, 1987, p. 30.

77. Harvey Wiley Corbett, 'The American Radiator Building New York City', The Architectural Record, May 1924, vol. 55, pp. 473–477.

78. Richard Oliver, Bertram Grosvenor Goodhue, The Massachusetts Institute of Technology Press, Cambridge, Massachusetts, in association with the Architectural History Foundation, New York, 1983, p. 25.

79. John M. Howells and Raymond M. Hood, 'The Tribune Tower, Chicago', The Architectural Forum, October 1925, vol. 43, no. 4, p. 185.

80. R. W. Sexton, *The Logic of Modern Architecture*, Architectural Book Publishing Company, Inc., New York, 1929, p. 68.

81. Granville Wilson and Peter Sands, *Building a City: 100 Years of Melbourne Architecture*, Oxford University Press, Melbourne, 1981, p. 146.

for this was thought to be a unified design which fully resolved an appropriate skyscraper exterior. This was achieved by integrating its stepped massing by projecting vertical piers between windows which continued above the lines of parapets. The terminating device at the top of the building was convincingly integrated into the composition as well, thus establishing a firm precedent for other architects to follow.

The final major influence which contributed to the Art Deco office tower was specific ornament. As described above, this was derived from the wealth of material presented at the Paris exposition of 1925 and from other European sources. It was applied in similar locations to those found in previous building styles associated with the tall office building and so created a link with the past by rephrasing these conventions. At the time, ornament was considered to be an important part of architecture, related to expression of structure, building function and individuality of expression. It was also closely related to materials, each of which 'suggested' the correct design of ornament by its intrinsic nature.[80] Indeed, in buildings of similar type and massing, ornament could well be the only element to impart a distinctive identity.

The resulting buildings were typically tall towers rising from a base covering the entire site and employing setbacks to suit the circumstance of their locations. Decoration was concentrated at key locations – that is, at the base of the building and at the main entry, and at the top of the building where fanciful spires and steppings created a dramatic silhouette against the sky. The buildings were designed to be read at different levels – as objects from a distance, as part of a mass of buildings from the street, and at close range, where their eye-catching detail and decoration aimed to seduce the passer-by. Within, impressive and richly embellished lift lobbies and foyers flattered the visitor and tenant by surrounding them with luxurious finishes and atmospheric lighting. The entire building acted as an advertisement for its owner and established a prestigious image for those fortunate enough to be tenants. This, then, was essentially the model for Australia's Art Deco office buildings.

In Australia, office building design in the 1920s was dominated by the Commercial Palazzo style, imported from America around 1910. The salient characteristics of this traditionally oriented style included a pronounced base with a well-defined main entry, a relatively restrained shaft of office floors and a strongly defined termination at the top of the building, almost invariably a projecting cornice. This style lingered into the 1930s and fine examples could be found in all the major State capitals, as well as in such smaller cities as Newcastle and Tamworth in New South Wales. Height limits effectively meant that city centres retained 'a gracious atmosphere of scale, good manners and quiet dignity'.[81] In Sydney, a height restriction of 150 feet (45.72 metres) was imposed by the City Council as early as 1908 and consolidated some four years later as a result of concerns about the capabilities of fire-fighting equipment to cope with tall buildings and the aesthetic impact that these might have on the city's skyline. The restriction allowed for decorative towers and the like to carry a building up another 50 feet (15.24 metres) – as long as these were not 'habitable'. The height of buildings in Melbourne was restricted to 132 feet (40.23 metres) and no office towers in any city or town across the country exceeded the height of those in the two major centres.

From 1926, architects moved away from the Commercial Palazzo style and began to experiment with the Commercial Gothic and Art Deco styles. It appears that the first manifestations of the Art Deco style as applied to office buildings took place in Sydney. Robertson and Marks's Hardie House (formerly Asbestos House) at the corner of York and Barrack Streets, construction of which began in 1927, simplified the Commercial Palazzo idiom to a severe vertical expression and placed terracotta decoration in an elementary

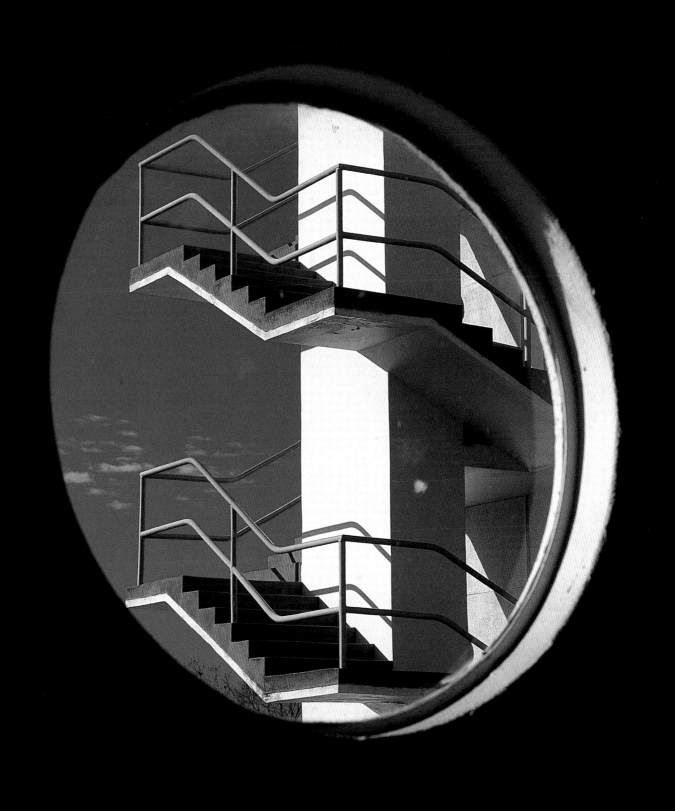

Art Deco form in the strategic locations of entry and parapet. The first stage of the building was completed in mid-1929. A little more than a year later, the Grace Building, on the corner of York, King and Clarence Streets, and Fowell and McConnel's British Medical Association (BMA) Building in Macquarie Street were completed. The BMA Building was the first office building in Sydney to demonstrate fully a complete understanding of the American Art Deco skyscraper. The American precedent which both displayed was appreciated by contemporaries: 'Sydney's two latest buildings, the B.M.A. … and Grace Bros. … are the first two local examples that can be said to really follow the dictates of skyscraper and modern American architecture generally …'[82]

The exterior of the BMA Building reflects the American precedent in that it is organised with a prominent entrance, positioned in the very centre of the ground floor, a shaft of virtually identical floors, and stepped massing at the top of the building. It is clad in polychrome terracotta, cream in tone above a dark base, and modulated by means of faceted bays which cantilever out over the street and create patterns of shadow across the facade. A somewhat eclectic program of decoration enlivens the building. As well as the aforementioned koalas, it includes gargoyles beneath the cantilevered bays and, at the summit of the building, knights with shields emblazoned with the symbol of Aesculapius, the traditional founder of medicine. At the foot of the building sit British lions, also bearing shields. Two discreet fountains, a characteristic Art Deco motif, are also incorporated low on the facade. The spandrel panels are decorated with strapwork, hinting at Tudor England, and contain small perforations which allow ventilation into the rooms behind. Richly panelled lobby spaces lead into an impressive lift lobby, beyond which is a large timber-lined meeting room. In effect, the BMA Building encapsulates many of the distinguishing features of the Art Deco buildings which were to follow, such as stepped massing, a well-defined entry, imposing internal spaces and a decorative program which announces the meaning of the building to the passer-by.

Melbourne saw its first Art Deco office towers completed a short time afterwards. One of the most exciting was the tower in Collins Street known as Howey Court, which was designed by Marcus Barlow and completed in 1931. Regrettably, this fine building has been demolished. Located in the middle of a city block, its slender facade consisted of vertical bands of windows separated by slender mullions and wide piers. It stepped symmetrically at the top and was crowned by a tall tower embellished with decorative panels. A flag-pole rose triumphantly above all. At ground level, a shopping arcade ran through the building. Its ceiling was the finest of any building in the country, a shimmering riot of plaster chevrons and repetitive faceted and fractured geometries. Although gone, another marvellous arcade by Barlow survives in the Manchester Unity Building completed only a year or so later. Its rich marble walls and moulded plaster ceilings are laden with an extensive decorative program representing the activities of the insurance company that erected it. These activities are undertaken by heroic muscular figures, including depictions of manual labour and representations of modern transportation machinery. Also featured are vignettes of the building itself – sunbursts, stylised plants, conventionalised volutes and other elements straight from the Paris exposition (plates 37 and 38). Amidst this almost encyclopaedic and fabulous embellishment there was even a place for the newly completed Sydney Harbour Bridge.

The Depression halted the construction of new office buildings in Sydney for several years, but they continued to go up in Melbourne. In 1936, several fine edifices were completed in Sydney, signalling the return to a degree of prosperity. Three in particular stand out and exemplify the Art Deco office building in Australia. These are the former ACA

82. *Building*, 12 April 1930, vol. 46, no. 272, p. 47.

Building (now Charles Plaza) at the corner of King and York Streets, designed by Hennessy, Hennessy and Co., the Rural Bank Building in Martin Place (which has been demolished), attributed to Peter Kaad under the supervision of the bank's architect Frank W. Turner, and the former Railway House (now Transport House) at 19 York Street, designed by H. E. Budden and Mackey. A fourth, the exceptional City Mutual Life Building at 66 Hunter Street, Sydney, designed by Emil Sodersten, stands somewhat outside the Art Deco camp and presaged the next few years.

The former ACA Building, although located on a busy corner, is oriented towards King Street. Here, its theatrical entry forms a tall and dramatic void in the centre of the facade and firmly echoes the example of the American office building. The two highest storeys are stepped back from the rest of the facades in the best American fashion and help to emphasise the tower which erupts above the line of the parapet. The tower, located high above the main entry, adds height and enabled the building to be read as a noticeable element in an otherwise uniform skyline. The appearance of height is reinforced by narrow vertical bays of windows separated by piers – a typical fenestration device of the 1930s – and by jagged finials at the tops of the piers rising above the parapet to form a zigzagging rhythm across the skyline. Its decorative detail firmly belongs to the geometric Art Deco idiom and includes complex faceted heads above the first-floor windows, linear motifs inscribed into the synthetic stone and the stepped massing of the tower. Major public spaces inside the building are located on the ground floor and include a small shopping arcade – a rarity in a Sydney office building of the 1930s – a lift lobby and an assurance chamber. A chamber such as this, for the transaction of business at a public level, was a relatively common feature in office buildings and many were amongst the finest spaces to be found at this time. When completed, the shopping arcade consisted of eight small shops with large shop windows trimmed in monel metal, echoed by metallic strips on the walls above. The ceiling was broken up by beams which were decorated with restrained mouldings. The floor was of rubber, a common finish of the period, in marbled red tones which continued into the lift lobby directly beyond the main entry in King Street. The lobby's walls were lined in black marble relieved by stainless steel strips, carried through into the adjacent assurance chamber and, as a contemporary description reveals, was considered 'surely one of the finest in any building in the Commonwealth. The ornament is modern in treatment and the combination of black marble counters and black marble around the chamber to dado height, upon which is superimposed walls of deep cream and coffered ceiling in which the ornament is picked out in deeper tones, leaves nothing to be desired.'[83]

In the same year Hennessy, Hennessy and Co. completed a very similar, although slightly smaller, ACA Building in a mid-block location in Queen Street, Melbourne. It is perhaps more elegant than the Sydney building because its mid-block siting has resulted in a more balanced exterior. Unlike the building in Sydney, it remains substantially as built.

The Rural Bank Building was prominently situated on the newly extended Martin Place (the connection to Macquarie Street was made in 1935). In retrospect, it can be seen to have been built, at least in part, as a symbol of the economic recovery of New South Wales after the hardships of the Depression. The building's assured massing was coupled with subtle external colour grading; the synthetic stone cladding rose above a polished stone base – characteristic of many inter-war office buildings – and graded from a dark reddish hue at second-floor level to a light cream tone at the top of the building. The building's mass was modulated by a centrally positioned light-well facing Martin Place and vertically grouped windows. Although electric lighting was commonplace, natural light in office space was perceived as eminently desirable and so devices such as light-wells were frequently

83. 'The A.C.A. Building, Sydney', *Building*, 12 February 1936, vol. *57*, no. 342, p. 16.

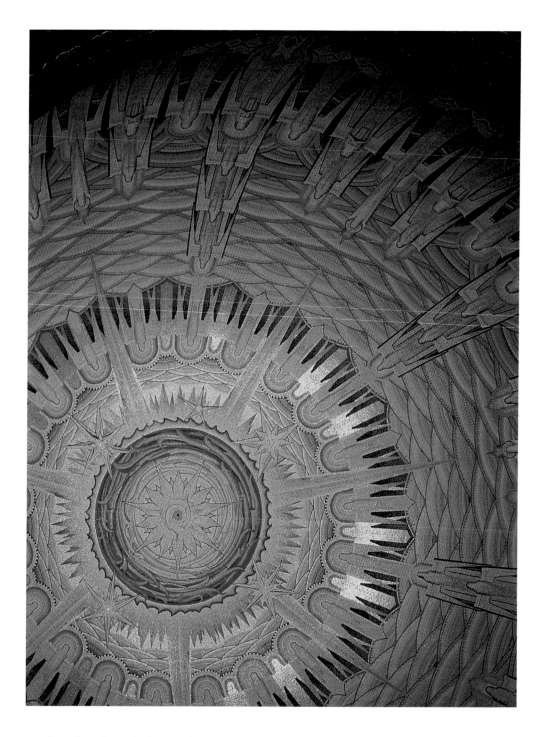

employed to obtain light in awkward situations. As with the ACA Building, it was treated to a tall tower which rose above the light-well and concealed mechanical equipment. The decorative program of the building reinforced the theme of a 'rural' bank and included rams' heads, cornucopias spilling abundant fruits, sheaves of wheat and motifs derived directly from the standard Art Deco repertoire.

The former Railway House was no less colourful than the Rural Bank, but it was rather less subtle. It remains remarkable for the asymmetrical and horizontal disposition of its facade – clearly reflecting the distribution of office space and vertical circulation behind it – and the extraordinary colour and detailing of its terracotta cladding (plate 1). One possible precedent for the design of the facade may have been a small building in Little Collins

Street, Melbourne, known as Yule House. This was completed in 1932 and designed by architects Oakley and Parkes.[84] The facade of Yule House consists of horizontal bands of windows and spandrels with a vertical tower at one end ascending a short way above the line of the parapet. It, too, is clad in terracotta. The sculptural geometric ornament at the base of the vertical component of the facade of Railway House is some of the finest Art Deco detailing created in this country and a tribute to the technical skills of Wunderlich Limited. The exterior of the building is something of a metaphor, its horizontal lines suggesting to contemporary observers the motion of a train speeding to its destination, whilst the distinctive green colouring was that chosen by the Department of Railways as its corporate identification.[85] Colour is used equally effectively inside. Each office floor consisted of space on either side of the building accessed by a central corridor. On each level, the corridor was lined with different coloured tiles, ranging from green, buff and brown to yellow and mauve.

Emil Sodersten's beautiful and assured City Mutual Life Building stood out from its contemporaries in a number of ways. Its exterior is organised around a tower which rises above the street corner on which it is located. Along both street frontages the facade ripples in a series of refracting zigzags created by cantilevering windows out over the street in a series of triangular bays – it was claimed that the bays reduced the build up of heat from the sun and also allowed for greater expanses of natural light. This results in a building which is intrinsically decorative yet functional and dynamic, changing as the moving sun creates scintillating patterns of light and shade (plate 27). In addition, the building was technically advanced, being the first privately constructed office tower in the country to be fitted with air-conditioning.[86] A dramatic black granite porch right on the street corner contrasts with the glass and sandstone of the facades and invites the visitor inside. In its day, it was considered one of Sydney's finest spaces, the grand assurance chamber extending through two storeys, with monumental scagliola-faced columns, semi-circular ends and a spectacular plaster ceiling incorporating the company's logo at one end. The boardroom of the building, only a couple of floors above, is characteristic of many such spaces from this time, lined with richly polished timber panelling broken at regular intervals by scagliola pilasters. It is still intact today.

Many new towers rose in both Sydney and Melbourne until the beginning of the 1940s, but as the 1930s progressed the design of office buildings became less overtly Art Deco and more monumental and restrained – very likely due to the increasing awareness of European modernism and the infiltration of curvilinear and streamlined forms. Two buildings erected in Melbourne after 1936 illustrate the stylistic diversity which was in the air. Harry Norris's 1937 Mitchell House, at the corner of Lonsdale and Elizabeth Streets, commands its prominent site (plates 32 and 33). Its sleek horizontal lines and sweeping curved corner are, like Railway House, counterpointed by a vertical tower, in this case located asymmetrically on the Elizabeth Street facade. The expression of horizontality is assisted by cantilevering floors out to the building lines, so freeing them from columns. A subsidiary vertical element neatly terminates the Lonsdale Street facade. The exterior of the building is covered in cement render, grooved to accentuate the horizontality of spandrels and also the verticality of piers. Gill Sans lettering along the lower part of the Elizabeth Street facade and elsewhere on the building adds another decorative note.[87] By contrast, Marcus Barlow's Century Building of 1939, located at 125–133 Swanston Street, Melbourne, exemplifies verticality. Its gleaming white terracotta cladding rises uninterrupted, separating narrow bays of windows, but falls short of the parapet line. At the corner, the piers burst above the top of the parapet to support a blocky square mass which forms a base for a severe lantern (plate 30).

PLATE 10 (opposite page)
AUSTRALIAN WAR MEMORIAL, OPENED IN 1941
Anzac Parade, Campbell, Australian Capital Territory
Architects: Emil Sodersten in association with John Crust (both Sydney-based); mosaics in the Hall of Memory by Mervyn Napier Waller
The coupling of Sodersten and Crust was the result of a competition held in 1926, in which the entries of the two architects were considered of such a high standard that they were invited to collaborate on the final building. In 1937, Mervyn Napier Waller, one of Australia's foremost artists from the inter-war period, was invited by the Australian War Memorial Board to design the stained-glass windows and mosaics for the Hall of Memory in the memorial. The theme of the ornament in the hall's dome represents the ascent of the spirits of the fallen, symbolised by simplified winged coffins whose shapes are reminiscent of Egyptian mummies.

84. According to Donald Leslie Johnson, this was a seminal building which influenced the design of a number of buildings erected in Melbourne during the 1930s. See Johnson, *Australian Architecture 1901–51: Sources of Modernism*, op. cit., pp. 96–97.

85. 'Railway Building, Wynyard, Sydney', *Building*, 12 June 1936, vol. 58, no. 346, pp. 21–22.

86. Extensive and very comprehensive descriptions of this building were published in *Building*, 12 October 1936, vol. 59, no. 350, and *Decoration and Glass*, 1 November 1936, vol. 2, no. 8.

87. Graeme Butler, 'Mitchell House', *Historic Environment*, 1981, vol. 1, no. 3, p. 22.

The construction of Art Deco office buildings in other capitals and towns took place in the second half of the 1930s, but not to the same degree as in Sydney and Melbourne. In Hobart, it found ample expression in the 1938 Hydro-Electric Commission Building at the corner of Davey and Elizabeth Streets by A. and K. Henderson (plates 43 and 44). Here, the pronounced verticality of the windows balances a long and relatively low mass which is stepped at its upper levels. One unusual decorative feature is the series of discs spaced at regular intervals along the lowest parapet, reminiscent of electrical insulators.[88]

In Perth, the style is represented by such buildings as Devon House at 729 Hay Street and the Gledden Building on the corner of Hay and William Streets. The former has been aptly described as a miniature skyscraper. Indeed, its minute scale is belied by the complexity of solid and void in the abstracted design of its fenestration and contrasts with the florid and very conventional Art Deco panels at the top of the building.[89] The latter, designed by architect Harold Boas and completed in 1937, is equally confident. It is situated next to Devon House but scaled in a more conventional manner, so that a lively juxtaposition results. Its vertically composed facade is capped by a slender tower with a faceted conical roof high above the street corner.

Although the influence of the style was not widespread in Adelaide's office buildings, some notable examples appeared. These include Kenneth Milne's Security House (formerly Kelvin House) on North Terrace, where the classical expression of the facade is enlivened by characteristic Art Deco modulation and details, and the elegant and restrained stripped classical Bank of New South Wales Building on the corner of North Terrace and King William Street. This building was designed by the partnership of Philip Claridge, Colin Hassell and Jack H. McConnell, built by Woods Bagot and completed around 1938.[90] Perhaps Adelaide's most overtly Art Deco office tower is the Savings Bank of South Australia, located on King William Street, designed by McMichael and Harris, and completed in 1940. Although its coursed ashlar cladding and substantial base recall the earlier Commercial Palazzo style, vertical bays of windows and stepped elements above the main entry and at the top of the building firmly tie it to the Art Deco tradition.

Office buildings could also be found in country towns. For instance, two very representative buildings from opposite ends of the Art Deco spectrum were built in a pair of New South Wales towns. The extraordinary Elmslea Chambers in Montague Street, Goulburn, was designed by the architect L. P. Burns and completed in 1934. The building is essentially conventional, a monumental two-storey building with a pitched roof, the facade of which is regulated by monumental pilasters supporting an entablature and high parapet. However, the spandrel panels beneath the windows erupt in a riot of polychrome terracotta and are filled with curling volutes, sunrays, wave-like patterns and conventionalised birds, flowers and tendrils. Above the main entry, a haughty ram's head looks down on all who enter (plates 47 and 48). By contrast, Manufacturers House at the corner of Peel and Bourke Streets in Tamworth is an assured essay in late 1930s horizontality. Its slightly recessed, curved corner ties together horizontal bands of windows, emphasised by the use of light-toned bricks between the windows and in the corner element which contrast with darker bricks elsewhere in the building.

It should be noted that the planning and services of office buildings remained the province of rational design and economics. The Art Deco style was important both externally and as part of interior decoration – serving a rhetorical purpose – but was always subservient to the pragmatic. Intentionally or not, in retrospect it is quite possible to perceive that the use of the Art Deco style in office buildings and other commercial structures fulfilled

PLATE 11 (opposite page)
FORMER AUSTRALIAN CORPS OF SIGNALS (NOW OCCUPIED BY THE AUSTRALIAN ARMY BAND), 1935–1936
29 Albert Road Drive, Albert Park, Victoria
Architect: J. MacKennal, Works Director, Department of the Interior
During the 1920s and 1930s speed became an obsession as artists and designers sought ways to express it. The leaping gazelle represented both grace and mobility, positive characteristics to give some hope during the dark years of the Depression.

88. An Architectural Guide to the City of Hobart, The Royal Australian Institute of Architects (Tasmanian Chapter), Hobart, 1984, p. 37.
89. Molyneux, op. cit., p. 64.
90. Page, op. cit., p. 184.

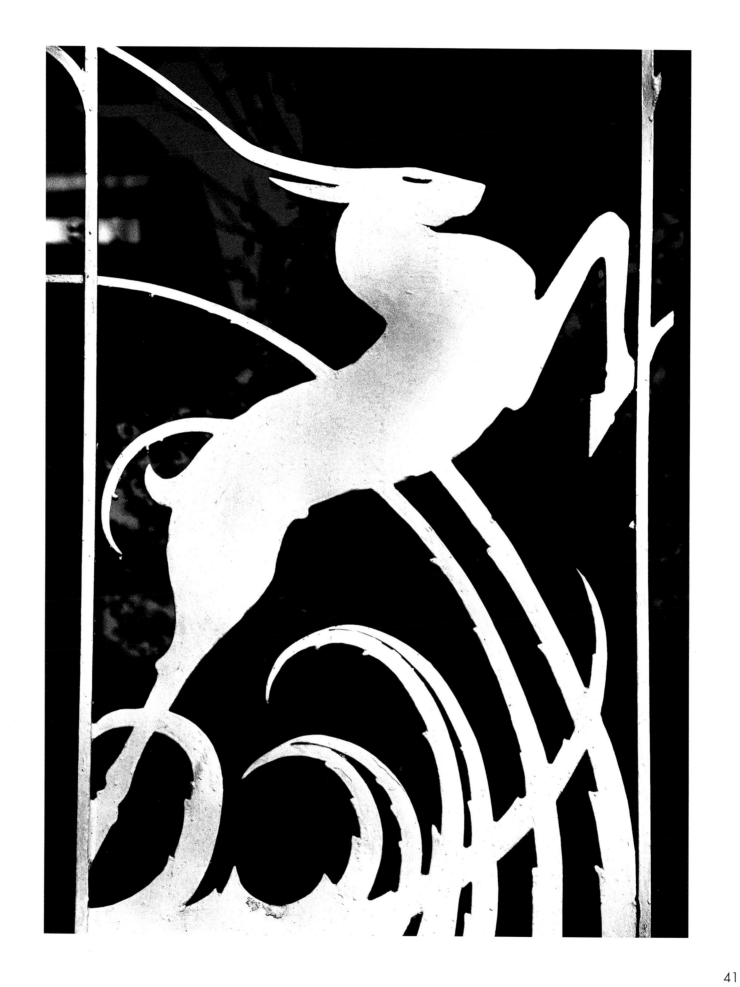

an important role in representing a return to prosperity and responsible financial management during the 1930s in Australia. This parallels the optimism of Streamlined Moderne in America and contrasts with the role in that country of Art Deco, which was associated with the unrestrained economic activity of the 1920s.

▼ ▼ ▼

The smaller scale of commercial buildings, no less pragmatic than office buildings, was also suited to the Art Deco style. Indeed, the marketable and modern Art Deco style was admirably suited to shops and retail premises. The city or town centre was the main environment for shopping. Suburban shops catered for the necessities of life, whilst outlying rural districts were served by mail order from large department stores.

An early example of the Art Deco style in retail architecture was to be found in Melbourne. This was the former Coles store at 299–307 Bourke Street, designed by Harry Norris. In 1929, Norris was sent to Europe and America by the building's owners, G. J. Coles, to investigate the trends in chain store design before the documentation on the store was completed.[91] The building was opened in 1930. Externally, it was fairly restrained, hinting at the Commercial Gothic style in pink terracotta. Inside, however, colourful tiling on the walls and columns of the cafeteria dazzled the visitor with its strong geometries and vibrant hues. Regrettably, the building is now in the hands of another owner and the tiling has been radically reduced.[92]

Department stores erected by the old retailing firm of David Jones in Sydney exemplify the rapid change of architectural style which took place during the inter-war period. The first, located on Market Street between Elizabeth and Castlereagh Streets, was designed by architects Budden and Mackellar and opened in 1928. It epitomises the refinement and reduction of classicism which took place during the 1920s, its spare exterior relying on proportion rather than rich embellishment. Some ten years later, the company opened another store diagonally opposite, on the corner of Market and Castlereagh Streets, designed by architects Partridge and Mackellar. This represents a triumph of sleek horizontality, with bands of aluminium-framed windows sweeping around the corner in a graceful curve. Almost the only reference to Art Deco is to be found in its awning, which cascades down the street, matching the fall of the pavement; its fascia, lined in aluminium, is fluted in a series of parallel lines. Just about the only thing these two buildings have in common is sandstone cladding. In the period between, Budden and Mackellar had designed another building for David Jones, just across from the Sydney General Post Office (GPO), finished in 1935. It has since been demolished. In some ways it was even more audacious than the 1938 building, for it presented an extensively glazed facade to the street, contained in little more than a grid of richly toned brickwork.

Fine, large Art Deco stores were built in other parts of the country. Perhaps the very finest was that constructed as Buckley and Nunn Men's Store in Bourke Street, Melbourne (plate 58). This outstanding building was completed early in 1934 and designed by the firm of Bates, Smart and McCutcheon. The building was designed as an extension to existing premises. Externally, it consists of large shop fronts separated by a wide passage leading into the building. The facade above consists of a centrally placed grid of tall steel-framed windows separated by stainless steel mullions and contained within a wide surround of dull black terracotta. In the entablature above the uppermost windows, three polychrome terracotta panels depict gentlemen of fashion in various costumes – sporting attire (represented by a golfer), evening dress and walking dress. Each is displayed to advantage against stylised geometric backgrounds in which gold and blue hues

91. Carol Hardwick, 'Art Deco Architecture', *This Australia*, Winter 1982, vol. 1, no. 3, p. 17.
92. Fortunately, much of the tiling was captured on film and published by Carol Hardwick in the article referred to in note 91.
93. Wunderlich Limited advertisement, *Building*, 12 February 1934, vol. 53, no. 318, p. 38.
94. 'Keeping In Step With Progress: Buckley & Nunn's Men's Store', *Building*, 12 February 1934, vol. 53, no. 318, p. 24.

predominate. Black porcelain spandrels are enriched by a zigzagging motif of stainless steel punctuated by enamelled bronze plaques. When built, stainless steel lettering announced the name of the store above the shop fronts and on high within the parapet.[93] Despite the effects of atmospheric attrition, the facade retains much of its freshness to the present day.

Within, one of the most dramatic features of the new building was the lifts. There were three in all, the doors of which are surrounded by a black marble architrave inlaid with chrome-plated steel and enhanced by a tooled surround. The architrave is stepped up over the central doors, echoing the step in the parapet of the building and so providing a degree of continuity between the interior and exterior. The lift-car interiors were rather charmingly described in a review published when the building was first completed:

> Because custom requires that mirrors be placed in lifts to enable people to take an interest in themselves and forget that they are being whisked up and down, lift cages have become veritable dressing rooms, where ladies can see whether the right amount of powder is on their noses, or gentlemen can see if their ties are straight. Buckley and Nunn appreciating that psychology, have furnished their lifts with huge Golden Ray mirrors from top to bottom and on all sides … A wood inlay of 3320 pieces of Queensland maple and Victorian blackwood has been inserted … A little ventilating slip in the ceiling carries artistry a stage further. The two decker light is the only plain surface so as not to vie with the ornate finish.[94]

Nearby, the well-established firm of Myer extended its existing premises in the latest style (plates 55–57). This part of the building, at 314–336 Bourke Street, was not particularly tall but quite long. In an effort to combat this, the facade was divided into bays of windows tightly spaced between vertical piers, and at the centre stepped up to give some extra height.

A ubiquitous form of the commercial building was built in many suburban areas and in country towns. It was usually a simple, single-storey building fronted by a comparatively elaborate facade consisting of an extensively glazed shop front, very often with a recessed porch paved in colourful terrazzo and protected by a deep awning with Wunderlich pressed metal soffit and perhaps linear decoration in the fascia. Above, a parapet in brick or cement render – or perhaps a combination of both – concealed a simple, corrugated iron roof. The parapet was often broken up and given interest by shallow piers, decorative panels, Art Deco flutings, mouldings and steppings, and finials applied to the parapet wall. A fine example is the Pellew and Moore building facing Blende Street and Argent Street, Broken Hill, New South Wales, but examples of this simple commercial architecture can be found in towns and suburbs throughout the country. Sometimes an upper floor contained office space and so a row of windows was inserted beneath the parapet. Lettering was often incorporated into the design of the facade to reinforce its stylish modernity and set it apart from its neighbours (plates 6, 59 and 60).

Many existing shops were given a new lease of life through a fit out and a new shop front. This gave the designers an excuse to experiment with new materials and fashionable colours. Staid precincts were enlivened by incidents of bright ceramic tile, glistening opaque glass (such as Vitrolite), shiny metals (such as stainless steel and monel metal), durable porcelain enamel panels and curved display windows with geometric leadlighting above the main display window (plates 5 and 63). On the floor of the porch into the shop, small mosaic tiles or simple patterns formed from terrazzo were also added (plates 64a, 64b and 66). Of course, the same materials and effects were put to good use in new buildings, as well.

Visually, one particular institution managed to link many of Australia's towns and urban

PLATE 12
MCMURRAY FAMILY MAUSOLEUM, 1938
Waverley Cemetery, Waverley, New South Wales
Shown here in its archetypal form, the ziggurat structure was the most recurring decorative device in Australian Art Deco architecture, appearing not only in monumental structures but in towering office buildings and apartment houses, church spires and bridge pylons, and even in doorways to modest houses.

areas in the 1930s. This was the Commonwealth Bank, the branch buildings of which were designed by the Department of the Interior (plate 65). Basically designed in the stripped classical style, their monumental and spare masses were decorated with fine and conventional Art Deco motifs, usually situated around doorways and above windows. Although really very similar to each other, a marvellous diversity was achieved by ingeniously varying proportion and some aspects of planning and by exploiting asymmetry. Although many have been sold to private owners, enough remain in reasonably intact condition to allow an appreciation of their modest triumph. Other banks made use of a consistent style of architecture for their branches during this period, but none seems to have achieved such consistency in the use of a modern architectural idiom.

In a sense, the Commonwealth Bank buildings, erected by a government-run instrumentality, were almost public buildings, notwithstanding their commercial nature. The public realm during the inter-war period was, however, represented by a diverse range of building types serving a wide array of interests and purposes. It included celebrations of death and war (as witnessed by war memorials and crematoria), expressions of municipal pride (such as town halls and government buildings), and buildings to accommodate serious social necessities (such as hospitals and schools).

▼ ▼ ▼

Even today, many towns and cities throughout the country contain a memorial to the dead of the First World War. They range from tablets serving as a role of honour to cenotaphs consisting of a stark classical column on a spare stone pedestal or a stiff white statue of a soldier staring rigidly across the townscape. In the State capitals are to be found the so-called national memorials, such as Melbourne's academically classical Shrine of Remembrance, located off St Kilda Road on the southern side of the Yarra River and dedicated by the Duke of Gloucester on 11 November 1934. It was designed by architects Philip B. Hudson, Wardrop and Ussher, and reflects the inspiration of Periclean Greece.[95] Brisbane's memorial, designed by Sydney architects S. H. Buchanan and Cowper, and completed in 1930, is no less classical. However, the touch of Art Deco is a little more evident in the memorials erected in other capitals. In Adelaide, a giant concave stone arch set into a heavily rusticated and stepped surround contains stylised winged figures grasping swords, in front of which are realistic bronze figures in various poses. The sculpture, by Rayner Hoff, represents 'youth laying its emblem of sacrifice before the winged spirit of Duty'.[96] The memorial resulted from a competition which was adjudicated in early 1927, and was designed by Woods, Bagot, Jory and Laybourne Smith.

The hand of Rayner Hoff is also to be found in Sydney's Anzac Memorial, located at the southern end of Hyde Park (plate 75). Here, the various arms of the Australian Imperial Forces (AIF) – the army, navy, air force and army medical corps – are rendered in monumental statuary placed on and within the building. A hierarchy of massive cast stone figures on the exterior of the building starts with relief panels below the springing line of the great arched windows. Buttresses on each side of the building are terminated by brooding seated figures depicting the uniforms and representations of each of the units of the AIF. At the corners of the superstructure, almost at the summit of the memorial, sombre heroic figures of a naval commander, nursing matron, air force officer and lieutenant of infantry stand guard. Within the Hall of Memory, the major space within the memorial, the figures are repeated in bas-reliefs high up on the walls. In this case they are seated, heads bowed, in front of a procession of nude figures representing the march of the dead. The familiar Art Deco sunrise found its way into the building. In the windows it is engraved in the glazing

95. Ambrose Pratt and John Barnes, *The National War Memorial of Victoria*, 3rd edn, W. D. Joynt, Melbourne, 1936, p. 9. It was claimed by Pratt in his introductory essay that the building was 'the purest, the most majestic and the most perfect example of classical Grecian Architecture the world contains' (p. 10).

96. *Building*, 12 February 1927, vol. 39, no. 234, p. 68.

and, in what is probably the most extreme piece of Art Deco stylisation in the country, in the decorative skyscraper-like finials piercing the windows at their base.

In Canberra, the Australian War Memorial was opened in 1941. Emil Sodersten and John Crust collaborated on the design. Its severe pavilions are arranged around a court which contains a reflecting pool, the approach of which is flanked by tall pylons. High loggias look down on either side of the court. At the foot of the low walls which serve as balustrades, regularly spaced bosses realistically depict the heads of animals and Aborigines. At one end of the court rises the domed, almost Byzantine Hall of Memory. Within, the dome is lined with a glass mosaic by Mervyn Napier Waller in a complex design which includes stylised doves and a frieze of black swans. Beneath, the tall arched windows of the hall are filled with stained-glass windows, again by Waller, depicting heroic figures representing the armed forces. Waller executed these major works between the years 1952 and 1958. Although the Australian War Memorial is not overtly informed by the Art Deco style, its restrained references to it relate it to the other monumental and public buildings of the inter-war era.

▼ ▼ ▼

One unusual manifestation of Art Deco architecture is to be found in several crematoria which were constructed during the 1930s. Although the first crematorium in Australia was built in the early years of this century, in New South Wales the first cremation took place in Sydney only in 1926.[97] By the mid-1940s, there were twelve crematoria across Australia, with Sydney containing four, Melbourne two and six other capitals and cities being served by one each.[98] Of particular architectural interest is a series of three buildings designed by the firm of Louis S. Robertson and Son of Sydney, consisting of a crematorium at Woronora, at the southern edge of metropolitan Sydney, opened in 1936; another at Beresfield to the west of Newcastle, opened in 1937; and the last at Botany cemetery in the Sydney suburb of Matraville, opened in 1938 (plates 91–93). All three were consistently designed as spare and rectilinear exercises in stripped classicism, dominated by a slender tower around which chapels and the various appurtenances deemed necessary for such a facility radiated. Individuality was imparted to each by the judicious placement of very con-ventionalised Art Deco motifs in discrete panels. These effectively contrasted with the clean planes and simple colonnades which characterised the architecture of the buildings.

An equally modern crematorium was erected at the Karrakatta Cemetery in Perth, dating from about 1936. This was designed by the architect Reginald Summerhayes. Not unlike the New South Wales examples in its neoclassical formality, its restraint was given warmth by extensive areas of brickwork relieved by stucco decoration. In addition a hint of skyscraper forms was to be found in the stepped chapel windows. Unfortunately it has been demolished.

▼ ▼ ▼

The 1930s was marked by an outburst of civic pride represented by the construction of town halls in towns and suburbs throughout the country. The styles chosen to clothe these municipal adornments varied from a free version of classical architecture, such as Joseph Plottel's 1935 building in Hyde Street, Footscray, to the stripped classical, such as Rudder and Grout's 1938 Petersham Town Hall on the corner of Crystal and Frederick Streets (plates 77 and 78), to streamlined Art Deco, such as that used for the City of Port Adelaide. One of the most striking public halls of the 1930s was erected in Oberon Street, Oberon, a small town in country New South Wales. It was designed by architect Virgil Cizzio and

97. Sue Zelinka, *Tender Sympathies*, Hale and Iremonger, Sydney, 1991, p. 48.
98. P. Herbert Jones (ed.), *Cremation in Great Britain*, 3rd edn, The Pharos Press, London, 1945, p. 157.

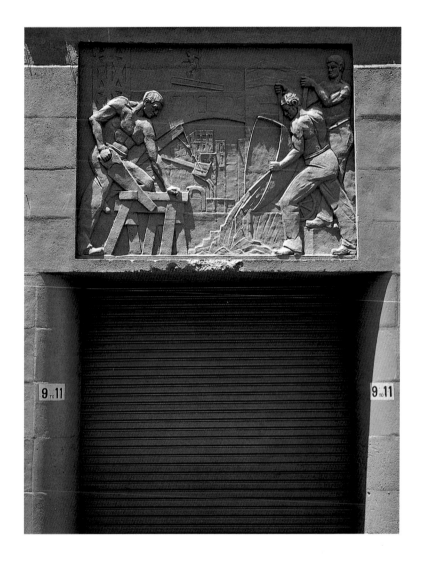

completed in 1937 (plate 84). Although essentially a large shed, its impressive street front consists of a complex mass of rectangular shapes which step in both plan and elevation towards a squat central tower. This is given emphasis by the introduction of a partially vaulted section and culminates in a tall slender finial rising above the rest of the building. At one side of the facade, the vaulted section is balanced by a curved screen of glass brick.

A series of Art Deco town halls graced the environs of Perth and country areas of Western Australia, such as the Narembeen Public Hall of 1939, designed by Powell, Cameron and Chisholm,[99] William G. Bennett's Applecross and Beverley Town Halls and Eales and Cohen's Guildford Town Hall in suburban Perth. Queensland, too, was endowed with some fine halls. Outstanding buildings with references to the Art Deco style include Rockhampton Town Hall in Bolsover Street, Rockhampton, by architects Hockings and Palmer, opened on 24 May 1941,[100] and the Johnstone Shire Council's Shire Hall in Rankin Street, Innisfail, designed by R. Hill and A. J. Taylor and opened on 1 July 1938.[101] These buildings were generally typified by an impressive front with a fine porch and foyer spaces, presenting a suitable image of civic confidence to the populace. Behind, the exterior of the building was somewhat more prosaic, housing large public assembly spaces. These could, however, contain overt references to the Art Deco style missing from the outside of the building. An instance of this is found in the Petersham Town Hall. Here a large space, capable of seating one thousand people, is embellished with plaster grilles, ceiling mouldings and metal and glass light fittings worthy of an up-to-date cinema.[102]

▼ ▼ ▼

No other city in the Commonwealth was as well provided with buildings to serve government and national institutions as Canberra (plate 87). Virtually all were characterised by symmetry in plan, elevation and detailing, with low, horizontal massing and prominent central elements giving focus to the main entry. The buildings were informed by a strong classical presence. One of the finest examples of this is the building erected at a cost of £72,392 – a respectable sum of money in those days – to house the Australian Institute of Anatomy. The institute had been founded in 1922, after the comparative anatomy collection built up by Sir Colin MacKenzie was presented to the nation. MacKenzie (1877–1938) was known as an eminent orthopaedist, comparative anatomist and philanthropist. During the First World War, he began to consolidate his earlier research on the comparative anatomy of Australian fauna. At the end of the war, he converted part of a house in St Kilda into a laboratory and museum, which he subsequently named the Australian Institute of Anatomical Research. From this time he devoted himself to research on Australian animals. In 1920, MacKenzie was granted occupancy of about thirty-two hectares at Healesville, outside Melbourne, for the purposes of a field station, and in 1923 he offered the vast collection of specimens built up from his work at St Kilda and Healesville

to the Australian Government. In October 1924, it was formally gazetted as the National Museum of Australian Zoology by an Act of Commonwealth Parliament and was to be housed in Canberra. MacKenzie was its first director and professor of comparative anatomy.[103]

The construction of a building to house the museum was not a high priority during the early days of the formation of the nation's new capital city. Indeed, the provisional Parliament House was only opened in 1927 in time to receive Parliament, newly relocated from Melbourne. However, in 1928 jurisdiction of the museum passed to the Department of Health.[104] A new building was designed by W. Hayward Morris in association with Robert Casboulte and completed in 1930, amongst the last of the projects carried out by the Federal Capital Commission.[105] Today, it enjoys great popularity as the National Film and Sound Archive. The building is symmetrically planned, with a central foyer flanked on either side by two museum spaces which extend through two floors and are ringed by mezzanines with wide windows just below the ceiling. It also includes a theatre and other subsidiary spaces. Apart from its wealth of decoration based on native fauna and Aboriginal art, mentioned earlier, it includes fine metalwork in radiator grilles and large ornamental light fittings hanging in the museum spaces (plates 68 and 70). The interior is reflected externally in the main facade, which essentially consists of a tall columned porch projecting out between two long pavilions. Tall bays of windows separated by slender fluted pilasters act as transitional devices from the open porch to the solid and austere configuration of the pavilion ends.

It was uncommon to find essential public buildings, such as hospitals and schools, designed in the Art Deco style. These buildings tended to be traditional in style or else form important opportunities for experiments in European modernism (plate 86). The most important of these took place in Melbourne under the jurisdiction of the firm of Stephenson and Turner. Arthur Stephenson specialised in the design of hospitals, and from 1927, after a journey to America to observe the latest trends in hospital design, began to modify his concepts of rational planning and design.[106] After another trip in 1932, to America and Russia, his aesthetic underwent a shift towards European modernism.[107] From then, the hospitals designed by this firm were marked by a clear and rational aesthetic expressed in simple surfaces and characterised by an almost trademark use of long horizontal balconies with curved ends. However, Stephenson was also responsible for what may be the finest hospital informed by the Art Deco style in the country. This is St Vincents Hospital in Melbourne, situated on Victoria Parade in Fitzroy and completed in 1934. Its complex stepped massing is enhanced by brickwork laid in normal bond and in decorative patterns and coursing. It grades in tone from dark red at the base of the building to light reddish-brown at the top. Small geometric plaques of terracotta-studded wall surfaces and projecting terracotta balconies create an effective foil of texture and shape.

On the other side of the continent, in Perth, another building related to the needs of the infirm – the Royal Western Australian Institute for the Blind – was no less confident in its exploitation of Art Deco devices. The building was designed by the office of the Principal Government Architect, E. P. Clare, and officially opened on 28 July 1937. Situated at 134 Whatley Crescent, Maylands, the building is designed as a central tower with two flanking pavilions linked to the tower by recessed wings and a characteristic paladin format. The facade is unified by a continuous sculpted concrete frieze running across the top of the building which incorporates a wave motif, popular with Perth's architects in the 1930s. The main doorway, located at the foot of the central tower, is surrounded by a vigorous architrave made up of bold chevrons, whilst a panel beneath the window above the doors is filled with the characteristic curling volute arranged in staggered rows. A showroom in the

99. A description of this building appears in *Waltzing Moderne*, March–April 1995, vol. 8, no. 3, pp. 8–9.
100. Fiona Gardiner, *Register of Significant Twentieth Century Architecture: Queensland*, pp. 54–55.
101. ibid., pp. 42–43.
102. 'The Petersham Town Hall', *Building*, 24 August 1938, vol. 62, no. 372, p. 35.
103. Monica MacCallum, 'MacKenzie, Sir William Colin (1877–1938)', *Australian Dictionary of Biography 1891–1939*, vol. 10, ed. Geoffrey Searle, Melbourne University Press, Melbourne, 1986, pp. 306–307.
104. ibid., p. 307.
105. Charlton and Garnett, op. cit., p. 44.
106. Wilson and Sands, op. cit., p. 136.
107. Donald Leslie Johnson, *Australian Architecture 1901–51: Sources of Modernism*, p. 138.

building, still well maintained, was intended to display products manufactured by the institute and repeats decorative motifs found on the exterior of the building.[108]

As with hospitals, so too with schools. Schools served as 'laboratories' for architectural experimentation. Indeed, Norman Seabrook's Macpherson Robertson Girls High School of 1934, located in Melbourne, was one of the seminal modern buildings in the country and clearly showed a debt to the Dutch architect W. M. Dudok.[109] Schools in other States, if not traditionally designed, also reflected the influence of European modernism. For instance, the Ogilvie High School, acknowledged as one of the finest early modernist buildings in Tasmania, is marked by a restrained horizontal aesthetic and rounded stairwells enclosed by glass blocks. This localised interpretation of the architecture of Germany's Erich Mendelsohn was designed by the Public Works Department and completed in 1938. It is located in New Town Road, New Town, a suburb of Hobart.[110] However, in Canberra, several stripped classical school buildings erected during the 1930s were overlaid with particular Art Deco embellishment. The foremost of these was the former Canberra High School, now part of the Canberra School of Art. Located on Childers Street in the city centre, it was designed by the Department of the Interior and completed in 1940 (plate 85). It was ultimately intended that the school provide for 760 students (it initially catered for 480) and accommodate a gymnasium, assembly hall, sports pavilion and a caretaker's residence.[111] The building is planned to receive the maximum amount of sunlight and consists of a long, two-storey main block terminated at each end by semi-circular bays. Two perpendicular wings extend from the rear of the building. A tower in the middle of the main block rises above a projecting, rusticated porch and acts as a compelling vertical focus. Restrained decoration is situated around the entry and tower, reflecting common Art Deco practice. Three streamlines run along the parapet, whilst spandrels are decorated with a curious wedge-shaped form.

▼ ▼ ▼

Schools may have catered for the education and mental growth of the young and hospitals for the well-being of the community, but for the individual much of life in the 1920s and 1930s inevitably focused around the home. Although the inter-war era has in retrospect become, rightly or wrongly, associated with a veneer of glamour and sophistication – assisted and embodied by the visual trappings of the Art Deco style – in reality it seems for many people to have been dominated by the quest for home ownership. One's own home was seen as eminently desirable, and the dream was celebrated in sentimental popular songs and verses:

> Half-way down the Street of Dreams,
> By the chestnut tree,
> Where the yellow lamplight streams
> On the clover's sea;
> Half-way down the street of dreams,
> Next that white house, see?
> There's a little cottage brown
> Waits for you and me.[112]

In the latter part of the 1930s, about three-quarters of the population lived in a free-standing house and of these around sixty per cent were either owned by the occupants or else mortgaged to them.[113] The 'Street of Dreams' was realised by less than half of its residents.

108. Vyonne Geneve, 'The Royal W.A. Institute for the Blind to Celebrate its 100th Anniversary in 1995', *Waltzing Moderne*, August–September 1994, vol. 7, no. 4, pp. 6–7.
109. Donald Leslie Johnson, op. cit., p.103.
110. *An Architectural Guide to the City of Hobart*, op. cit., p. 5.
111. 'Canberra High School, Acton, Canberra, A.C.T.', *Building*, 24 June 1940, vol. 66, no. 394, p. 15.
112. Mary Carolyn Davies, 'Street of Dreams', *Safe Home Planning*, Bebarfalds Limited Home Planning Bureau, Sydney, 1927, frontispiece.
113. Maisy Stapleton, 'Emoh Ruo', in Gammage and Spearritt, op. cit., p. 129.
114. Macintyre, op. cit., pp. 220–221.
115. John R. Brogan, *101 Australian Homes Designed by John R. Brogan*, Building Publishing Company Limited, Sydney.

The inter-war house was marked by diminishing circumstances. After the First World War, fewer homes were staffed by servants, so as a consequence their size was reduced, with more compact planning eliminating the long hallways and picturesque nooks so beloved of the Edwardians. As well, tentative moves towards open planning were evident as openings between living areas became wider and encouraged the flow of space through the dwelling. Increasing numbers of furnishings were built in – glass-fronted cabinets next to fireplaces or dividing one room from another, wardrobes and hygienic fitted kitchens saved space and eased the burden of cleaning. Whilst husbands travelled ever further to work from new subdivisions surrounding the cities, wives were expected to stay at home and nurture the children of families whose size was smaller than in the past. Women were not expected to work once marriage had taken place and only did so if economic necessity dictated it. Labour-saving machinery, such as the vacuum cleaner and electric iron and, for the well-off, the washing machine and refrigerator, may have made life easier, but expectations about domestic management and child rearing effectively bound women to the home.[114]

PLATE 14
BURRINJUCK DAM – THE SPILLWAY,
ALTERATIONS CIRCA 1930
West of Goodradigbee, New South Wales
Designed by the engineers of the Department of
Water Resources in association with the Department
of Public Works
Dams were one of the great engineering feats of the
1930s in Australia, as well as in other parts of the
world, and were made possible by advances in
modern technology. Much of their purposeful beauty
resulted from collaboration between engineers and
architects. Dams are reminiscent of several aspects
of the Art Deco style because of their streamlined
geometric forms and enormous surfaces enlivened by
incised banding. Large-scale components – bridges,
gantry cranes, intake towers, locks, turbines and
machinery – gave these industrial projects a futuristic
and utopian look.

The most characteristic house type of the 1920s was the bungalow. The California Bungalow, which had first appeared as a serious choice in the middle of the previous decade, was notable for its dominance, and imparted a homogeneous quality to the streets of acres of new subdivisions that sprang up on the outskirts of Australian cities and towns. Its ample gabled roofs, brick and timber construction, leadlight windows and verandahs with solid piers and heavy balustrading represented the pre-eminent and ubiquitous architectural presence in the cities. However, more than other building types, except possibly shops, dwellings ran the gamut of the fashionable styles of the day, such as Old English, Mediterranean, Spanish Mission and Georgian Revival. Like the Art Deco style, some of these were imports from America, such as the California Bungalow and Spanish Mission styles, while the Georgian Revival and Old English dwellings reflected the ties which England – 'home' or the 'old country' – still held for many. The Old English style in particular, with its rather incongruous blend of dark half timbering over red textured brick, seemed to appeal to the more prosperous, and could be found in many affluent suburbs around the country. Of course, many houses were built which managed to combine disparate elements from a number of styles. The usual result of this was lively, rather disjointed dwellings which may have expressed personal taste but did not always demonstrate an understanding of architectural principles.

Then, as now, many people did not employ the services of an architect. Builders copied existing houses, borrowed ideas from published sources such as architect John R. Brogan's *101 Australian Homes*[115] or developed their own repertoire of houses. And it was not only builders and the public who encouraged a degree of conservatism in the design of houses. Major architects such as C. Bruce Dellit and Emil Sodersten, who produced some of the country's most important exercises in the Art Deco style, expressed the view that a traditional image of home and hearth was appropriate for dwellings, whilst modern architecture such as Art Deco was applicable to commerce and the workplace.

The figures of two architects practising in Sydney stood out in the search for an appropriate architecture for the Australian house, one that did not necessarily embrace an Art Deco aesthetic. These were Leslie Wilkinson and William Hardy Wilson. In general terms, Wilkinson thought that an architecture which adopted aspects such as those found in the Spanish Mission style and the domestic architecture to be found in the region of the Mediterranean was appropriate for the sunny hot clime of Australia. Characteristic of his work were courtyards and loggias, informal massing, sensible orientation to take advantage of sun and shade, and subtle colour-washed walls which provided an effective foil to indigenous vegetation and weathered to give a mellowed appearance of permanence and age. Wilkinson's houses were also informed by Georgian architecture, examples of which already existed in diminishing numbers in New South Wales and Tasmania. The second of these architects, William Hardy Wilson, is probably better known now for his discovery and publications on Australia's colonial Georgian architecture. However, his exploration of the Georgian Revival style, derived from his first-hand observations of American colonial architecture and subsequent documentation of colonial buildings after his return to Australia, resulted in a Georgian Revival which was informed by the architecture of the past that he considered to be a valid Australian tradition. Most of his important houses were built in the years prior to the First World War and made extensive use of elements of Georgian architecture, such as multi-paned windows, panelled doors and the classical orders. His houses echoed colonial dwellings, being simple rectilinear buildings with hipped roofs, sometimes verandahs and chimneys with colonial caps.[116] In the post-war years, the firm of Wilson, Neave and Berry was set up and designed many buildings (not just houses) in this refined Georgian style. A third figure, Walter Burley Griffin, introduced radical concepts in the planning and design of dwellings, but these progressive concepts remained ignored outside a limited circle.

The bungalow remained remarkably durable and during the 1930s its form evolved to become simple and astylar. It could also be overlaid with details from other architectural styles, combining materials in unlikely and striking combinations. The verandah remained as a vestigial loggia, often enclosed with a low balustrade wall, at the front of the house. For very many houses the intrusion of Art Deco was restricted to decorative elements and minor items of hardware such as cornices, light fittings, windows, electrical switches and door handles (plate 112).

Occasionally a residence was built containing many elements of the Art Deco style. The most outstanding of these is probably 'Burnham Beeches' at Sherbrook Forest, in the Dandenong Ranges on the outskirts of Melbourne (plates 107 and 108). It was built for Alfred Nicholas and his family. Nicholas was an eminent merchant and philanthropist. During the First World War, he began to work with his brother George, a pharmacist who had developed a pure aspirin after the war had cut off German supplies of this important pain-killer. Their business continued into the 1920s as Nicholas and Company and, despite initial financial hardships, by 1925 was expanding into European markets and by 1927 into Asia. Their success enabled them to make large endowments to charities, Melbourne hospitals and universities throughout the country. The strains of business became increasingly telling during the 1930s and Alfred spent more time pursuing his horticultural and agricultural interests. As well as the gardens around 'Burnham Beeches', he established gardens at Carnbrea in Auburn, importing seedlings, shrubs and staff for both. Nicholas died at 'Burnham Beeches' in 1937.[117]

'Burnham Beeches' was designed by architect Harry Norris and completed in 1934. To contemporary observers, it immediately evoked modern machines – an aeroplane just

landed on the hillside or, from some angles, 'the towering bulk of a great grey battleship with turrets, mast and searchlight all complete'.[118] The house is three storeys and constructed from reinforced concrete. This 'wonder house in the hills' was apparently designed to capture the 'spirit of the hills' in which it is situated and fresh air, sunlight and views.[119] This is achieved by a long and basically rectilinear plan, with many rooms opening onto wide, open balconies and terraces. The living rooms on the ground floor and bedrooms on the first floor open onto sun-rooms and in any case vast areas of glazing flooded the spaces with light and sunshine. In later years the house was used as a research and development centre for Nicholas and Company and the estate divided; a large part of the garden was donated to the local shire and became known as the Alfred Nicholas Memorial Gardens.[120]

From the mid-1930s, 'continental curves' began to appear increasingly in houses. The broad and generic characteristics of these modern houses included a jutting curved bay, efficient horizontals (such as projecting sills and canopies above openings), the ubiquitous rounded corner, tubular metal railing and circular 'porthole' windows. Other properties included shallow pitched or flat roofs, or more commonly a high parapet partially concealing a conventional hipped and tiled roof. Favoured external finishes were brick or painted cement render and sometimes the contrast between the two was exploited to highlight contrasts of texture and colour. The more daring dispensed with timber-framed windows and installed crisp steel-framed units. Houses of this type were described in the popular press, where their kinship to the modern ocean liner was recognised (plates 111 and 116).[121] This mode lasted beyond the 1930s, as examples continued to be constructed well into the post-war years of the late 1940s and into the 1950s. Diverting and noticeable as these sometimes self-consciously up-to-date houses may have been, they represented a relatively small number of those built in the second half of the 1930s.

These streamlined shapes and forms infiltrated into the vocabulary of more conservative construction which lingered well into the post-war years. Otherwise conventional dwellings were treated to canopies over windows, parapets concealing little more than guttering, curved corners and windows, porthole windows and stepped chimneys. The last were particularly common in Melbourne, where they were christened with the rather appropriate epithet 'waterfall'. This expression was extended to the configuration of the house, where the familiar 'triple front' configuration so beloved of many post-war houses became termed a 'waterfall front' when combined with curved corners.[122] Many large houses with similar characteristics were built in suburban Perth in the years before and after the Second World War in areas such as South Perth, Dalkeith and Mt Lawley, to name only a few.

As an expression of modernity became more acceptable on the exterior of the house, so too did it appear inside. As has been amply noted elsewhere, kitchens and bathrooms reflected most immediately the impact of modern idioms and became more efficient and hygienic. Bathroom walls were tiled in fashionable colours and sometimes daring, stepped skyscraper motifs appeared in contrasting hues (plates 104 and 106). Vitreous fitments such as spouts, towel rails and toothbrush holders harmonised with the tiling. Kitchens endeavoured to represent the acme of efficiency with fitted joinery and integrated cupboards and benches. Benchtops could be made from terrazzo and sinks of porcelain or stainless steel. Ceramic tiles or sheet materials patterned to resemble tiles – such as 'Tilux' – lined the walls against work areas. Floors could be covered in rubber sheet or linoleum. A sleek electric or gas range assisted in the preparation of family meals, and eating nooks saved space and made for efficient serving at meals. However, refrigeration remained firmly within the province of the well-to-do until the prosperity of the 1950s. The laundry, too, was still relegated to the outside of the house.

116. Phillip Cox, 'William Hardy Wilson 1881–1955', in Tanner, op. cit., pp. 98–101.

117. John M. Wall, 'Nicholas, Alfred Michael (1881–1937) and George Richard Rich (1884–1960)', Australian Dictionary of Biography 1891–1939, vol. 11, ed. Geoffrey Searle, Melbourne University Press, Melbourne, 1987, p. 19.

118. W. E. J. Harrison, 'Burnham Beeches: A Wonder House In The Hills', The Australian Home Beautiful, 1 March 1934, vol. 12, no. 3, p. 9.

119. ibid., p. 7.

120. Wall, op. cit., p. 19.

121. 'Marine Influence in a Sydney Home', The Sydney Morning Herald, 30 September 1937, p. 24.

122. Robin Boyd, Australia's Home, Penguin Books Australia, Melbourne, 1968, p. 100.

123. 'Melbourne Takes to Flats', *The Home*, 1 April 1936, vol. 17, no. 4, p. 30.

124. Richard Cardew, 'Flats in Sydney: the thirty per cent solution?', *Twentieth Century Sydney: Studies in Urban and Social History*, ed. Jill Roe, Hale and Iremonger, Sydney, in association with the Sydney History Group, 1980, p. 69.

125. Spearritt, op. cit., p. 70.

126. ibid., p. 72.

127. Maisy Stapleton, 'Between the Wars', *The History and Design of the Australian House*, ed. Robert Irving, Oxford University Press, Melbourne, 1985, pp. 134–135.

128. 'Adereham Hall', *Glass*, 1 September 1934, vol. 2, no. 1, p. 24.

129. ibid., pp. 27–28.

The major manifestation of the Art Deco style in residential buildings was to be found in the ever-increasing numbers of flat blocks constructed during the 1930s. Of all the cities it was Sydney that witnessed the greatest expansion of this type of dwelling. One contemporary observer, wryly commenting on the traditional rivalry between Australia's largest cities, went as far as to write that '[f]lats … were immoral, natural although horrid growths in an Americanised modern Babylon like Sydney, but not to be tolerated in Melbourne'.[123] Although not an entirely new phenomenon in Sydney, having first emerged as a viable dwelling type in the first decade of this century,[124] it was during the inter-war period that they became an enduring feature of its metropolitan fabric. During the 1920s, the majority were built in the city of Sydney (with a particular concentration in the vicinity of the Darlinghurst–Kings Cross area), and in half a dozen or so harbourside and oceanside municipalities. This was consolidated after the Depression had started to ease. Indeed, the construction of flat buildings in the mid-1930s was observed to indicate the revival of more prosperous times.[125] As well, flats spread to other parts of the city, mostly being situated in localities served by suburban railway links. They comprised about forty-one per cent of all dwellings erected between 1933 and 1941 and more than twice as many were built in this period in Sydney than in Melbourne.[126] Large blocks of flats tended to be peculiarly associated with Sydney in the 1930s and even today the character of Potts Point and Elizabeth Bay is remarkably informed by this inter-war presence.

The variety of buildings ranged from small buildings of two or three storeys, with flats grouped around a central stair and corridors, to towers of ten or more floors served by electric lifts. Reaction to them was mixed. Opponents thought them undesirable as family dwellings and the cause of overcrowding and an increase in traffic volume. However, many buildings were constructed as a viable dwelling alternative for more prosperous middle-class occupants. The Astor, for example – finished in 1923 – was built as a cooperative venture so that its flats were owned by those living in it.[127] However, virtually all the flats erected in Sydney until the post-war years were tenanted.

Many of the flats aimed at the higher end of the market were remarkably well equipped. Sydney's 'Adereham Hall' in Elizabeth Bay Road, Elizabeth Bay, was one of the first tall Art Deco apartment blocks to be completed in Australia. It was designed by Gordon McKinnon and Sons and finished in 1934. Its distinctive stepped parapet, punctuated by decorative sunbursts, has in recent times earned it the epithet 'Gotham City'. More importantly, when completed it was the epitome of luxurious flat life and established a standard which was not surpassed over the next few years. On the ground floor, a sleekly modern entrance hall and lounge greeted the visitor, complete with the comfort of an open fireplace for the chillier months. There was also a caretaker's flat on this level and one for servants' quarters; domestic service was therefore available at call and obviated the need for maids' quarters in the tenanted apartments. This was obviously a building for the comfortably off, with little or no stigma attached to the fact of renting. In all, there were twenty-five flats over nine storeys, reached by a fast elevator operated by uniformed staff. A typical flat was, if not larger, as large as many suburban residences and contained a living room, hallway, dining room, breakfast room, kitchen, two bedrooms, two bathrooms and a spacious balcony. A contemporary description of the kitchen reveals what was, in effect, state of the art:

> A review of the kitchen discloses a modern self-contained room with blue and white tiled walls, built-in cupboards with leadlight doors, and here lies evidence of the careful attention which has been given to the requirements of the tenant. The sink, complete with terrazo [sic] top, chromium-plated hot and colt [sic] water faucets, is situated immediately beneath wide,

clear glass windows, which permit the entry of plenty of sunlight and fresh air. There is little or no necessity for any extra furniture in this room, as all such requirements are catered for by the built-in cupboards, stove, and Frigidaire.

> The stove ... is coloured in tones blending with the colour scheme of the rest of the room. It is conveniently sized and placed in a position which is inconspicuous when not in use, yet easily accessible when required.[128]

The refrigeration was operated from a central plant, thus offering benefits in operating economy and maintenance. The flats were centrally heated and flooded with light, natural by day and electric by night. The building's roof commanded extensive views across the city and the harbour and a garden provided attractive surrounds for those wishing to partake of the view. A communal laundry was also situated on the roof of the building (although those attending to the prosaic chore of washing their clothes were not privileged to this view). Down below, a boat house and swimming pool took advantage of the building's proximity to the harbour, whilst a garage block housed the tenants' cars.[129]

In Melbourne, blocks of flats tended to be smaller. One of the characteristic types which developed there consisted of a two- or three-storey building, U-shaped in plan, arranged around an open landscaped court. 'Bedford Court' at 109 Nimmo Street, Middle Park, was a fine example of the type. If tending towards modernism, with smooth walls, corner windows and curved balconies, its designer nevertheless succumbed to the lure of Art Deco by introducing horizontal lines into the wall surfaces and a complex stepped panel above the vertical windows that illuminated the stairwells. Of course, not all of Melbourne's flats were of the courtyard type. Amongst the large number of fine blocks erected in that city is 'Tiberius', on the corner of Albert and Eastern Roads, South Melbourne. Its exterior massing reflects the influence of European modernism, but it is punctuated by extensive Art Deco motifs and images. The parapets are broken by massive angular pediments in several places which cascade down into the walls in a series of shallow steps. The building also contains much fine wrought iron in somewhat unlikely juxtaposition. Lamps bracketed off walls are decorated with sea-horses, whilst the pedestrian gates are enlivened by wavy lines, spiralling forms and a deer startled by a generalised feline (plate 118). The security grille at the main entry repeats the linear motifs of the gates and includes nude male and female figures pouring water into a shallow basin. Behind the female figure a tall flame rises from a tripod, whilst a small tree behind the male balances the composition. Another striking block called 'Brookwood Flats' – located on Queens Road – was decorated with striking and very representative Art Deco zigzags, volutes, fountains and the like, applied to its sleek streamlined forms.

Of course, Sydney and Melbourne were not the only centres to witness the construction of flats as an alternative to conventional housing. Flats were built in all the capitals; in Brisbane the use of the Art Deco style appears to have been less overt than in other parts but, nevertheless, elements of it were used in such buildings as 'Coronet Flats' in Brunswick

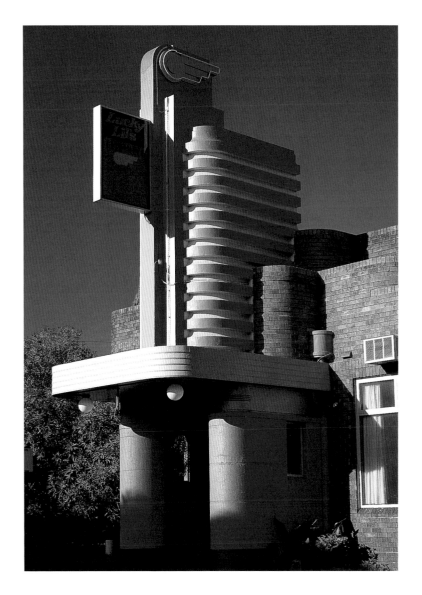

PLATE 16
PETERSHAM INN, 1938; EXTENDED IN 1940
Corner of Parramatta Road and Phillip Street, Petersham, New South Wales
Architects: Rudder and Grout; extension by L. J. Soden
One of the hotels which exemplified the prodigious burst of hotel construction in New South Wales during the second half of the 1930s was the Petersham Inn, which replaced an Edwardian hotel on the site in 1938 and was then extended in 1940. The extension, by architect Leslie Soden, was designed to contain a lounge area and a 'wintergarden' on its roof. Its facade is dominated by the horizontally striated tower, capped by a winged volute.

Street, New Farm, and a rather eclectic and romantic group of three buildings given the names 'Ravenswood', 'Casa Del Rio' and 'Casa Del-Mar' in Bowen Terrace and Moray Street, New Farm.[130]

A fairly large number of flats was also built in Perth and other parts of Western Australia.[131] One of the most impressive blocks, if not the most Art Deco, was designed by the firm of Hennessy, Hennessy and Co. in association with Reginald Summerhayes. Known as 'Lawson Flats' and located in Sherwood Court, it was completed in 1937. Smaller blocks were built in areas such as West Perth and Cottesloe. The concept of the 'minimum flat' managed to spread across to the other side of the continent, as shown in a proposal of 1936 by the architect Harold A. Krantz for a three-storey block in Perth containing sixty-two bed-sitting units and communal bathrooms.[132]

A few cities outside the capitals also experienced some flat construction. Newcastle, to the north of Sydney, boasts a large number of substantial blocks from the 1930s, perhaps none finer than 'Segenhoe' at 50 Wolfe Street, designed by the Sydney architect Emil Sodersten. This tall block is distinguished by its irregular and faceted massing which ensures a maximum of sunlight and air into each apartment. Even smaller cities managed to build some. For instance, Goulburn, another town in New South Wales, amongst its other treasures is graced by a three-storey block in Auburn Street which manages in its unassuming way to impart a metropolitan air to its surrounds.

Flats also formed a kind of laboratory for advanced modern architecture in Australia which ventured far beyond the decorative modernity of the Art Deco style (plates 8 and 9). These early experiments in modern architecture were markedly successful in Melbourne and are perhaps exemplified in a block called 'Cairo Flats'. The block, designed by architects H. Vivian Taylor, Soilleux and Overend, is located in Nicholson Street, Fitzroy, and was completed in December 1936. It conforms to the characteristic courtyard type found in this city and is planned as a two-storeyed U-shape around an established garden. Externally, it is distinguished by flat roofs serving as terraces, cantilevered, reinforced concrete access balconies, a dramatic curved and cantilevered stair, pipe railings and red clinker bricks which contrast with the narrow yellow cement-finished sun balconies which extend out from each flat. Originally, there were twenty bed-sitting flats and eight one-bedroom flats; perhaps coincidentally there were eight garage spaces. Walls and ceilings were finished in a golden buff colour, their junction a simple curve rather than a conventional cornice to form an homogeneous surface. Floors were of polished timber. Kitchenettes contained a small gas stove, steel-edged sink, what was termed a 'hot cupboard' beneath the stove, ordinary cupboards and a diminutive dining alcove just for two.[133] In Sydney, an early excursion into very modern flat design took place in 1936 with the completion of 'Wyldefel Gardens' in the inner-city suburb of Potts Point. This scheme, designed by the architect John R. Brogan who was better known for his adept versions of Old English architecture, brought 'the very best of modern Continental home-planning to our already lovely Harbour shores'.[134] It was apparently conceived by its owner, W. A. Crowle, who, impressed by a similar scheme he had seen near Oberammergau in Germany, determined to build a version of it on his sloping site in Sydney. It survives to this day in good condition and consists of some twenty residential units stepping down the hillside in two blocks. The roofs of several of the dwellings serve as terrace gardens for the dwellings immediately above. The aesthetics of the exterior clearly reflected the European precedent – ample steel-framed windows (with those on curved corners bent to follow the curve), tubular-pipe railings and simple planar wall surfaces. Unlike 'Cairo Flats', this was a development for the well-off and a communal spirit was fostered by the luxuries of a tennis court and swimming pool.[135]

130. Gardiner, op. cit., pp. 288–293.

131. As at September 1994, seventy-five blocks of flats had been listed in the *Inventory of Significant Buildings of the 1930s in W.A.*, compiled by the National Trust of Australia (W.A.), Heritage Council of Western Australia and the Australian Heritage Commission.

132. 'Perth "Minimum" Flats', *Decoration and Glass*, 1 July 1936, vol. 2, no. 3, p. 15.

133. Philip Goad, 'Best Overend – Pioneer Modernist in Melbourne', *Fabrications*, June 1995, vol. 6, pp. 111–112.

134. 'Wyldefel Gardens', *Decoration and Glass*, 1 July 1936, vol. 2, no. 3, p. 8.

135. ibid., p. 9.

▼ ▼ ▼

One of the most important factors contributing to Australia's economic recovery during the 1930s was the growth of local manufacturing, made all the more impressive because there had been no expansion of exports in the period between 1932 and 1938.[136] This expansion was of course reflected in the construction of new factories and plants and the enlargement of existing facilities. Like many of the other buildings of the 1930s, industrial buildings reflected most clearly the clean, efficient lines of modern architecture (plates 122, 124, 125 and 128). In many cases, a very modern street frontage housing administrative staff concealed a large enclosure at the back clad in minimal and inexpensive materials. Nevertheless, the image of the company as a progressive concern able to afford to keep up with the times was succinctly advertised to those driving or walking past. Whole districts were consumed by manufacturing, such as Waterloo and Alexandria in Sydney, where streets of stylish brick or cement-rendered facades concealed massive sheds behind. Occasionally, the exteriors of industrial buildings were decorated with panels of relief sculpture, admittedly not forming a large part of the decor but nevertheless welcome. Themes were, naturally enough, glorifications of industry and manufacturing and included such motifs as heroic workers, cogs, pistons and other machine parts (plate 13).

Some major engineering works took place at this time, including the series of beautiful dams erected in New South Wales to improve water supply in the State (plates 138–145), and transportation works, such as Sydney's underground railway and the Sydney Harbour Bridge (plate 133). Whilst these marvellous schemes may not have been directly inspired by the Art Deco style, nevertheless they shared some kinship with it, for they were infused with a clean efficiency which celebrated modern technology no less than did the decorative effusions of skyscrapers and cinemas.

At the other end of the spectrum, inexpensive roadside style came about with the proliferation of service stations. Although humble and prosaic buildings, they still managed to provide imaginative architecture at low cost. The ubiquitous Spanish Mission style which seemed to find its way into so many of them in the 1920s and early 1930s gave way to a streamlined and modern architecture during the 1930s. Relatively few have survived in an intact state, let alone as functioning entities (plates 134 and 136).

▼ ▼ ▼

Of course there was time for leisure as well as work and, even then, Australia was notable as a nation fond of outdoor recreation and sport, with activities such as cricket, football and racing cutting across class boundaries.[137] However, much leisure-time activity took place within the home and may have taken the form of playing cards, reading or listening to the wireless or to music on the gramophone or piano. Friday night and the weekends were the principle leisure times, in many cases spent receiving or visiting friends and relatives. As only about one in five families owned a car, the roads remained fairly free of traffic congestion when family outings were contemplated.[138] Many suburbs and towns were graced by one particular source of recreation which was outside the domestic realm – the local pub.

The hotels, or pubs, of the inter-war years took shape as a direct result of legislation which had been introduced in the first two decades of this century. The initial legislation was designed to reduce the numbers of pubs and improve the quality of facilities offered to patrons. Subsequent laws, introduced during the First World War, seriously curtailed the hours of trading. In New South Wales, Victoria and South Australia, trading ceased at

135. ibid., p. 9.

136. The Hon. F. P. Kneeshaw, Introduction to Chapter 10, 'Manufacture', *Australia 1788–1938*, produced by Oswald L. Ziegler, Simmons Limited, Sydney, September 1938.

137. Macintyre, op. cit., p. 322.

138. John Rickard, 'For God's Sake Keep Us Entertained!', in Gammage and Spearritt, op. cit., pp. 347–48.

6.00 p.m., whilst in Queensland, Western Australia and Tasmania pubs were able to remain open until 9.00 or 9.30 p.m.[139] In addition to these severe limitations, publicans were increasingly competing with novel forms of popular entertainment which did not exist or at best were only in a rudimentary state prior to the war. These included such diversions as radio, the gramophone, movies and the tabloid press.[140]

Planning remained fairly constant in these buildings between the wars. Generally of two or three storeys, the ground floor contained a large public bar and a smaller saloon bar. The latter tended to be a little more salubrious and offered the luxury of seating. In the public bar, the efficiency ruthlessly imposed by the hours of opening translated into a large bar area with ample space surrounding it. By the mid-1920s, the Australian pub had moved away from being a building in which bars were only a small part of the building fabric to one in which they formed the major component. Pubs tended to be all-male preserves and women were neatly corralled into what was euphemistically termed the 'Ladies' Lounge'. In less affluent parts of cities these could fulfil a social role and the local women gathered there. Home drinking increased in this period and subsequently many hotels were provided with special departments for bottle sales. Apart from the sale of alcohol, the licensing laws determined that pubs should house other facilities and insisted on a number of bedrooms for the rest of the weary (the breweries largely responsible for the construction of the pubs usually endeavoured to keep these to a minimum). Other spaces included dining rooms and lounge areas for the use of those actually staying in the hotel.

If the planning of pubs remained more or less constant over the two decades, then their external appearance certainly did not. It was believed that the buildings provided one of the best vehicles for advertising and so should be comparable to other commercially oriented architecture (plates 146–154). The breweries employed a number of architects, skilled practitioners who consistently managed to produce variety and individuality in what were essentially inexpensive buildings prescribed by the same planning requirements. The architects remained safely in work as long as they were able to keep up with the latest trends and show imagination in their work.[141]

The breweries were amongst the few who built during the Depression. Many city, suburban and country pubs were rebuilt, modified or constructed anew. At this time, the conservative classicism of the 1920s gave way to the bright geometries and vibrant colours of the Art Deco style, which enjoyed a brief vogue from about 1933 to 1936. At the end of 1936, the commercial viability of the new streamlined forms was abundantly proved by the completion of stylistically advanced hotels – such as the Hotel Broadway, located on the street of the same name in inner Sydney and designed by the major architect of pubs, Sidney Warden. This cleanly designed building, with its bands of contrasting brick tones, curved corner and smart terracotta lettering proclaiming its name incorporated into the parapet, neatly encapsulated trends and its precedent was quickly adopted by other architects. As the 1930s progressed, pub exteriors became simpler and, at times, more rectilinear, reflecting the influence of European architects, such as the important Dutch architect W. M. Dudok.

Because there were literally hundreds of pubs built or refurbished throughout city and country in the 1930s, it is worth investigating how architects were able to instil variety and individuality within the tight constraints imposed upon them. Certainly the breweries' insistence that the buildings act as an advertisement may have helped. If a particular building was located on a street corner then this could be emphasised by means of a tower or by recessing a part of the mass of the building, thereby dominating the corner and attracting the eye of the passer-by. The treatment of the ground floor and upper floor (or floors) was

PLATE 17 (opposite page)
GATEWAY, 1935
Alfred Street, Milsons Point, New South Wales
Artistic concept: Rupert Browne
Bright, pulsing neon signs were the kinetic pop art of the day and, as illustrated here, the gate previewed attractions to come. It was probably the only privately owned piece of advertising spanning a public thoroughfare anywhere in Australia, and was allowed by the North Sydney local council as a gesture of gratitude towards nearby Luna Park, whose construction had given employment to more than one thousand men during the Depression.

139. J. M. Freeland, *The Australian Pub*, Melbourne University Press, Melbourne, 1966, p. 178.

140. ibid.

141. Charles Pickett, *Refreshing! Art off the Pub Wall*, Allen and Unwin, Sydney, in association with Powerhouse Publishing, Sydney, 1990, pp. 42–44.

quite different, but they were invariably segregated by the presence of a wide awning above the ground floor providing shade and protection from the weather. The underside or soffit of the awning was lined with geometrically patterned pressed-metal sheeting from Wunderlich.

The appearance of the ground floor was relatively uniform. It was almost invariably faced in colourful ceramic tiles, generally of a light tone such as cream or a light biscuit colour, relieved by contrasting bands of figured or plain tiles in such colours as orange, green, black or deep brown – individually or in combination. Pragmatically placed openings pierced the walls and large, painted advertising posters were arranged between doors and windows. Above the awning, by contrast, architects strove to give each building distinctive character. Upper levels were well-balanced compositions of horizontal and vertical elements given prominence by projecting or recessed courses of brickwork or else by contrasting brick colours and bands. Brickwork was very much associated with a domestic character and, with the newly fashionable textured brick, was imaginatively exploited in a manner which has not since been equalled. Dark voids resulting from balconies and shadows resulting from subtle projections all assisted in varying and enlivening masses. Decorative towers or piers acted as a visual 'centre of gravity' and arrested the eye. Colour and textural contrast were achieved by the introduction of other materials, such as terracotta, cement render and metals. One very common characteristic was stylish, modern lettering which pronounced the name of the hotel and was skilfully incorporated into the parapet or the towers to form an intrinsic part of the external architecture. Flag-poles or finials were sometimes used to provide a compositional accent.

Within, the uniformity of the ground-floor exterior was reinstated and remained relatively static throughout the decade. As with the outside, the walls of bar areas in many pubs were tiled (plate 156). Only luxurious hotels in important localities were given the luxury of stained timber panelling. The vertical face of the bar was tiled, as was the floor which sometimes incorporated a margin of rubber around the bar. It is worth noting in passing that this somewhat relentless use of ceramic tiles was not restricted to hotels but was also a common part of many office buildings, particularly in the public corridors on upper office levels. In the public bar, a freestanding or 'island' counter was favoured to facilitate rapid and efficient service. Very often, it was given some sort of curved treatment and effectively modulated what could be a fairly large open space. The shape of the bar could be repeated in the ceiling, where a deep bulkhead dropped down in a series of stepped tiers echoing the curves of the counter. Gleaming metal and glass shelves were suspended from the underside of the bulkhead to conveniently hold bottles. Artificial illumination provided an excuse for the architect to display some ingenuity. In some instances, it was incorporated into the structure of the building where, wrapped around columns, it created the illusion of an interior supported by shafts of light. At other times, it was concealed to flood the ceiling with the indirect light so favoured during this period.

Upstairs, the bedrooms contained basic fittings, such as a wardrobe, a bed or beds, a dressing table and a wash basin. Other bathing and sanitary facilities were communally shared. Only the large city hotels sported the convenience of integrated bathrooms. A lounge area was often provided for guests and was frequently made more luxurious by the installation of a fireplace. It contained comfortable seating and writing tables. In some pubs, the publican's wife was responsible for the selection of loose furnishings, such as curtains, rugs, even chairs and bedroom furniture, and whenever this happened the trade press reported her admirable, if not exquisite, taste.

By the end of the decade many improvements in the standard of pubs had taken place

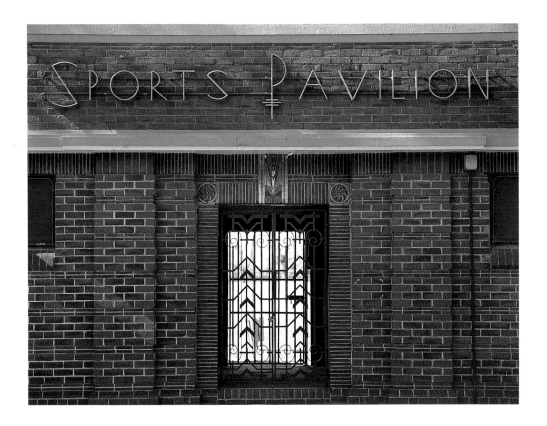

PLATE 18
SPORTS PAVILION
Princess Park, Royal Parade, Parkville, Victoria
Architects who made use of the Art Deco style
exploited the intrinsic character and qualities of the
materials they chose for their work. This pavilion amply
demonstrates this fact, with its imaginative and
colourful brickwork, decorative wrought iron gates
and cast concrete mouldings – all of which culminate
in the stylish and up-to-date lettering.

142. Charlton and Garnett, op. cit., p. 41.

and this was reflected by increased patronage. Their interiors were regarded as bright and cheerful, offering the amenity of a 'cool resort' in summer and warm cheer in winter.

▼ ▼ ▼

Whilst pubs may have offered the opportunity to be sociable indoors, sporting facilities gave the opportunity for outdoor camaraderie and even the possibility of healthy exercise. During the 1920s and 1930s, the 'cult of sun-worship' became firmly entrenched. On the coast, crowds flocked to beaches where surf clubs and pavilions provided shelter and amenities. During the 1920s and 1930s, these were typified by a characteristic Mediterranean architecture with light-coloured stucco walls, arcaded verandahs and colourful terracotta roof tiles, but, in line with other building types, their architecture succumbed to the lure of curved corners, flat roofs and stepped massing (plate 168). In suburban and rural localities, swimming pools were constructed in some numbers. One of particularly dignified architectural quality is the Manuka Pool (plates 164 and 165) at Griffith in the Australian Capital Territory (when built, the only swimming pool for a distance of some two-hundred miles). Completed in 1930, it was an exceptional work, a model of rational planning consisting of a rectangular body of water enclosed by high walls and flanked by pavilions containing changing spaces, originally numbering for eighty-six men and forty-one women – apparently considered to be an adequate ratio.[142] The entrance is an elegant stripped classical pavilion with a shallow porch screened by fluted piers; narrow slits of windows on either side are protected by wrought iron grilles. A suitable aquatic character is imparted by sea shell plaques and wave-like patterns in the leadlighted fan-lights and the painted cement-rendered walls, and red, tiled roofs lend a festive, seaside atmosphere to the whole of the complex.

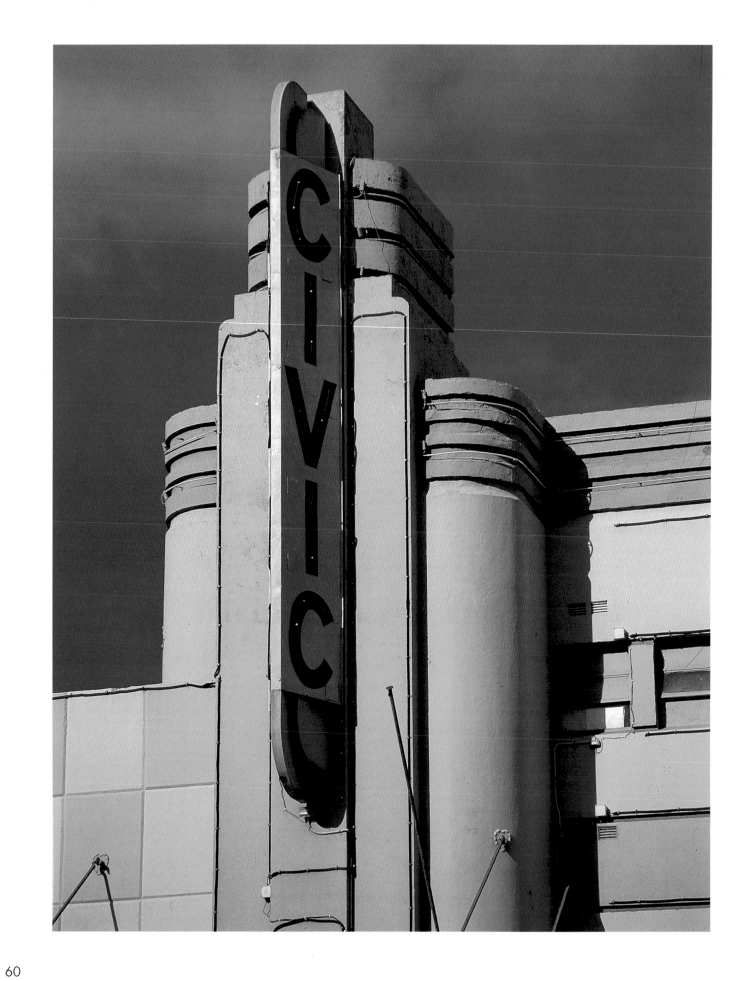

Several swimming pools in Sydney were designed by the firm of Rudder and Grout, which also designed many hotels throughout New South Wales. Erected by local municipal councils, they were exemplified by the North Sydney Olympic Pool (plate 163), considered to be the 'Mecca of Australian swimming' for its first twenty-five years.[143] The pool was constructed on the site used for the workshops and plant for the erection of the Sydney Harbour Bridge and was opened on 4 April 1936. It is positioned to the immediate east of Luna Park and in the very shadow of the massive steel arch of the bridge. The three landmarks strikingly represent the increasingly important links between easy metropolitan travel and organised leisure which were consolidated during the inter-war period. The Olympic Pool also occupied a special place amongst Australia's swimming pools because it formed the stage for the aquatic events at the Empire Games, held between 5 and 11 February 1938. Large swimming pools were erected in other parts of Sydney and elsewhere across the continent, as far afield as Kalgoorlie in Western Australia. The Kalgoorlie pool was the first Olympic-standard pool in Western Australia. Designed by William G. Bennett, it was completed in the late 1930s.[144]

▼ ▼ ▼

Amongst the most eye-catching and consciously modern buildings in towns and the suburbs ringing the larger cities were the cinemas. Apart from pubs and the occasional shops, their modern exteriors contrasted with staid surroundings. In the small town of Scone in New South Wales, for instance, the abstracted geometry and curves of the Civic Theatre of 1938 (by the architects Guy Crick and Bruce Furse), transported a town rich in fine, although conservative, inter-war architecture into a Buck Rogers–ish future utterly unlike anything else along its main street (plates 19 and 185). As might be expected, the regions with the largest populations saw the greatest number of Art Deco cinemas built. One's experience at the cinema varied according to its location. The big inner-city theatres often offered an orchestra and variety acts in addition to movies and the special privilege of a uniformed usher or usherette, armed with a discreet flashlight, accompanying patrons to their seats. However, for many it was their local suburban or town cinema which accommodated their needs. Friday and Saturday nights were the most popular, and indeed, some patrons even maintained regular bookings.[145] The fare on offer was overwhelmingly American – the Australian film industry was continuing in its decline after a promising start decades earlier.

The cinemas of the 1930s were distinguished from their brethren of the 1920s by the characters of their interior and exterior design. The cinemas of the 1920s were marked by the use of period styles and culminated in the grand and lavish atmospheric palaces at the end of the decade. One notable exception to this is Walter Burley Griffin's 1924 Capitol Theatre in Swanston Street, Melbourne. Its geometric exuberance is a reflection of the personal architectural style of its architect, rather than a foray into Art Deco–related mannerisms (plate 187). In Sydney, the architect Henry White dominated the little world of cinema architecture during the 1920s, but it was to be a younger generation, some of whom had worked in his office, who established and consolidated the trends of the following years.

The quality of architecture in the cinemas of the early 1930s made them arguably amongst the finest Art Deco buildings constructed in Australia.[146] Experiments with the geometries of the Art Deco style were the hallmark of these cinemas and, as with other building types, the second half of the decade was distinguished by streamlined curves and sleek curvilinear forms (plates 171–177, 186). Indeed, it has been suggested that the transition in Art Deco architecture from geometry to streamlined curves is best evidenced in the interiors of cinemas.[147] There appears to be a close parallel with developments in the

PLATE 19 (opposite page)
CIVIC THEATRE, 1938
114 Kelly Street, Scone, New South Wales
Architects: Guy Crick and Bruce Furse
A streamlined Moderne cinema by one of the most important firms specialising in cinema design during the 1930s, the facade is designed as a restrained mass relieved by horizontal decoration, and given dramatic focus by this projecting curved tower assemblage, which also contains the name of the cinema. It remains in use today, a rare survivor from a period when the movies were an important part of the lives of so many people.

143. E. C. Mack, Foreword, *North Sydney Olympic Pool 50th Anniversary Celebrations 1936–1986*, North Sydney Municipal Council, Sydney, n.p.

144. Vyonne Geneve, 'Artist of the Month: William G. Bennett (1896–1977)', *Waltzing Moderne*, July–August 1992, vol. 5, no. 4, p. 10.

145. Rickard, op. cit., p. 353.

146. Ross Thorne and Kevin Cork, *For All The Kings Men*, Australian Theatre Historical Society, New South Wales, 1994, p. 15.

147. Howard Tanner, 'Interior Design in the 20th Century', *Historic Interiors*, ed. Maisie Stapleton, Sydney College of the Arts Press, Sydney, 1983, p. 61.

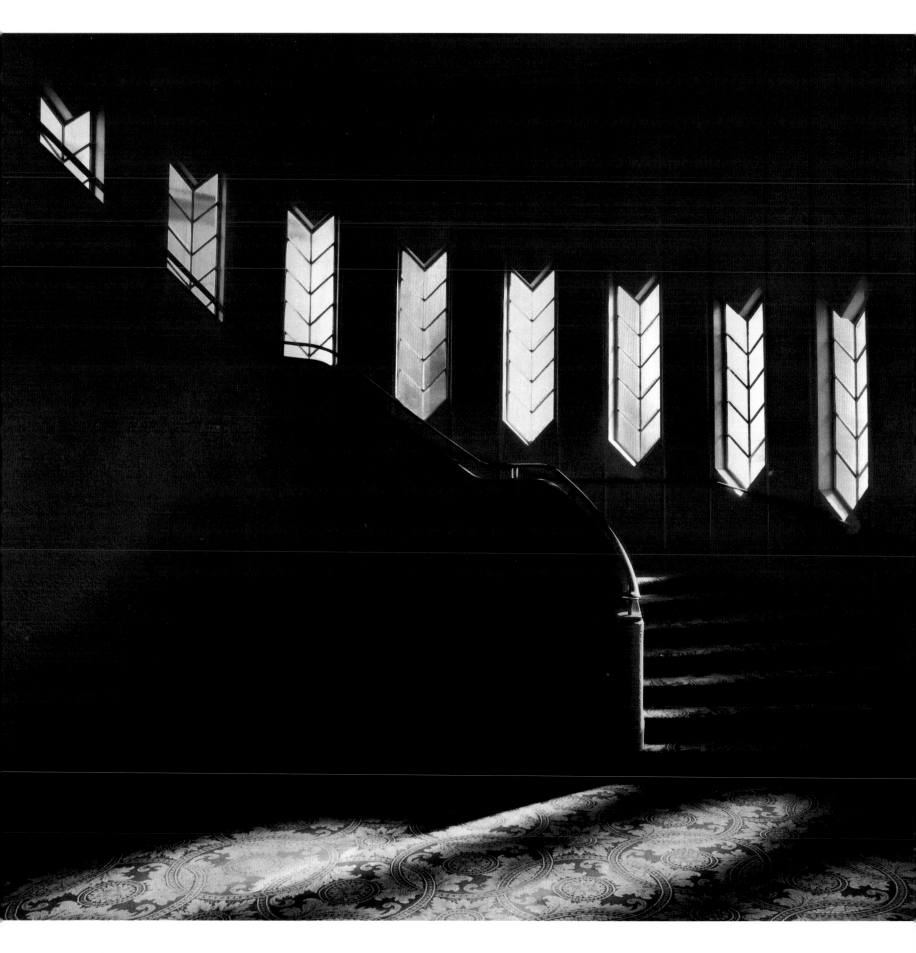

62

design of cinemas in the United States, where experiments with the Art Deco style superseded the era of the lavish picture palace and coincided with the onset of the Depression – and may have had associations with an optimistic movement forwards, away from the hard times: 'Art Deco palaces were an expression of the New World promised by the twentieth century, hoped for with the end of the Depression, and guaranteed by the technology of make-believe.'[148]

One of the earliest Art Deco interiors in Australia was somewhat paradoxically associated with what was possibly Henry White's finest atmospheric cinema, the gorgeous State Theatre in Market Street, Sydney, completed in 1929. In a rich and eclectic mix of spaces, it was one of the ladies' rest rooms that was far and away the most stylistically advanced. This space no longer exists and a contemporary description remains the best way to recapture its unique spirit:

> On the dress circle level the ladies' retiring room is known as the futurist room, and is designed in ultra modern style on severe lines, the triangle being the motif of the whole design, delicately coloured in rose, mauve, grey and cream, relieved with gold and strong reds in the lighting fixtures.[149]

Guy Crick and Bruce Furse were the most popular cinema architects of the 1930s in New South Wales. Crick spent time working in the office of Henry White until it was closed at the beginning of the Depression. Crick and Furse were certainly at the forefront of the streamline cinema movement and their work was to be found throughout Sydney, across New South Wales and even in other States. A contemporary quote, referring to the Kings chain of theatres in New South Wales – generally designed by Crick and Furse – seems applicable to cinemas of the later 1930s in general.

> At each house, there is an atmosphere of intimacy and congenial comfort which must please, while the attractive features of the exterior, invariably futuristic, are highlighted by the architect's guidance on an expertly balanced use of tube lighting in suitable colours.[150]

Comfort, convenience and a touch of spectacle characterised many of the new cinemas. The managers of the Orion at Campsie in suburban Sydney, 'The Theatre of the Stars' (plate 184), amused patrons before commencement of screenings with special lighting effects in the auditorium which ranged from the 'rich red of the sunset' to the 'pale rosy pink of the dawn'.[151] Even more ambitious was the Orpheum at Cremorne by the architect G. N. Kenworthy. The lighting in this cinema was concealed behind richly decorated troughs running along the centre of the ceiling. A cycle of colour was

PLATE 20
PICCADILLY THEATRE,
OPENED 23 OCTOBER 1940
Corner O'Connell and Childers Streets,
North Adelaide, South Australia
Architects: Evans, Bruer and Hall
in association with Guy Crick
This cinema was composed around a prominent curved, fluted corner element with ascending chevron-shaped windows. It allowed natural light to stream into this sweeping, gracious stair which leads directly into a wide foyer, lit indirectly from a wide, flat trough hanging from a smooth ceiling.

148. Maggie Valentine, *The Show Starts on the Sidewalk*, Yale University Press, New Haven, 1994, pp. 78 and 89.
149. Thorne, op. cit., p. 340, quoting *The Sydney Morning Herald*, 5 June 1929, p. 11.
150. Thorne and Cork, op. cit., p. 20, quoting *Everyones*, 16 December 1936, p. 42.
151. 'Orion Theatre, Campsie, Sydney', *Building*, 13 April 1936, vol. 58, no. 344, p. 24.

PLATE 21 (opposite page)
PICCADILLY THEATRE, OPENED 10 MARCH 1938
Hay Street, Perth, Western Australia
Architects: Baxter-Cox and Leighton
The Piccadilly Theatre was Perth's first fully air-
conditioned cinema. Its auditorium is characteristic of
the late 1930s: walls are plain except for horizontal
lines in the plasterwork, which turn into verticals
adjacent to the proscenium, while indirect lighting,
concealed by a series of troughs, subtly enhances the
shallow ornament elsewhere on the ceiling.

152. 'The Orpheum Theatre, Cremorne, Sydney', Building, 12 October
 1935, vol. 57, no. 338, p. 15.
153. Ross Thorne, Cinemas of Australia via USA, Architecture
 Department, University of Sydney, 1981, p. 353.
154. Vyonne Geneve, 'The Vulnerability of Our Art Deco Theatres',
 Kino, June 1989, vol. 28, p. 6.

diffused across the entire ceiling, described in a contemporary report as 'a pale blue light which gradually waves and a warm purple glow follows, increasing into a brilliant red and then to a burst of amber lights which floods the auditorium'. Decorative plaster sunrays radiating from panels in the side walls clarified the intent of the light display.[152] Although modified, this cinema still enjoys a loyal and regular patronage.

In most cinemas, seats were cushioned in sponge rubber which provided comfort to accompany the diversions. Before screenings and at intervals, soda fountains and refreshment buffets tempted patrons with ice-creams and other delicacies. Often a milk-bar was incorporated into the building. Located facing the street, it offered a wide range of delights and was close to movie-goers and any passers-by on the street. It is also worth noting that cinemas were amongst the first buildings in Australia to be fully air-conditioned, both recognising that fresh air was a vital consideration and demonstrating that technological advancement was a commercially viable prospect.

Stylish and beautiful cinemas ranged across the country. Their scale reflected the constraints imposed by local conditions. For instance, in Tasmania, because of its small population, the city cinemas were closer in scale to suburban cinemas on the mainland and most were constructed in the second and third decades of this century.[153] Some of the most exciting cinemas were built in Western Australia and here Perth has special claims, for more cinemas from the inter-war period remain in regular use to the present day there than in any other part of the country. Major architects who specialised in the design of cinemas in Perth included William Leighton and Samuel Rosenthal. Rosenthal is credited with having designed the State's first Art Deco cinema of note, in 1937 – The Radio in country Geraldton. It was commissioned by the Wheat family, whose name is immortalised by stylised wheat-like forms on the facade.[154] Rosenthal designed cinemas in other parts of the State, including Boulder, Kalgoorlie, Bunbury and Fremantle. Few have survived as cinemas. Indeed, many cinemas have been destroyed or no longer perform the function for which they were designed. Some, such as the Orion at Campsie in New South Wales, survive only as spectacular facades in commercial strips. Yet some, all too few, are still very much alive. The Civic in Kelly Street, Scone, still forms an important part of the everyday life of the people in and around this small Hunter Valley town in New South Wales. It is exceptional in that it has been hardly altered and still operates in the way that it was designed.

▼ ▼ ▼

The great tragedy is that many Art Deco buildings, as well as those of other styles from the 1920s and 1930s, are being travestied, demolished or mutilated in the name of modernisation. At the very least, original windows and doors are removed to make way for unsympathetic modern replacements, fine decorative brickwork is cement rendered and beautiful cast stone or terracotta decoration is painted in what are interpreted as 'Art Deco' colours. The result is generally a lurid confection which compromises and demeans the original. Whilst such important groups as the National Trust of Australia and the Australian Heritage Commission increasingly recognise the important architectural qualities of these buildings, there still needs to be a broader acceptance and recognition by the populace at large that these, too, are 'heritage' buildings and an integral part of our past – but they are also part of a vibrant present. It is to be hoped that this essay and the many beautiful photographs which follow will generate more enthusiasm for this most exciting of architectural styles.

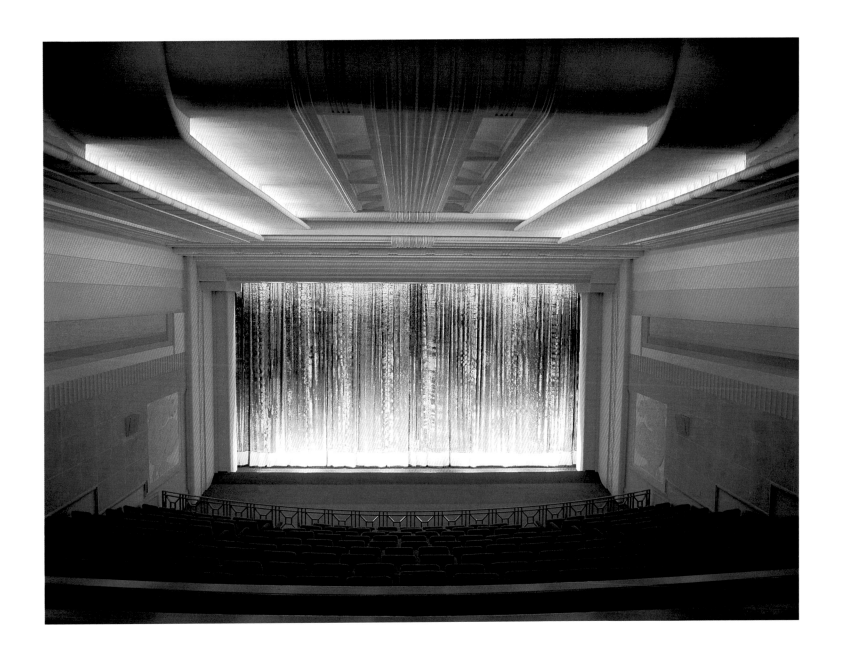

PLATE 22 (opposite page)
AMALGAMATED WIRELESS (AUSTRALASIA)
LIMITED (AWA) BUILDING, 1939
47 York Street, Sydney, New South Wales
Architects: D. T. Morrow and Gordon in association
with Robertson and Marks; decorative mosaics and
relief sculpture by Otto Steen
Until 1961, this slender brick 'skyscraper',
incorporating a dramatic steel tower rising high above
its parapets, was Sydney's tallest building and a
landmark on the skyline. The building illustrates how
the beneficial effects of technological progress were
optimistically perceived. Radio broadcasts were
transmitted from a studio within the building and when
completed it was known as 'Wireless House'.

PLATE 23
AMALGAMATED WIRELESS (AUSTRALASIA)
LIMITED (AWA) BUILDING, 1939
47 York Street, Sydney, New South Wales
Architects: D. T. Morrow and Gordon in association
with Robertson and Marks; decorative mosaics and
relief sculpture by Otto Steen
Otto Steen's mosaic of Pegasus, the company's logo,
in the floor of the porch represents Wireless spanning
the broad oceans, and also appears as a relief
sculpture at the top of the building.

Tall office buildings contributed a veneer of sophisticated corporate affluence to city centres, and with their Art Deco styling convinced contemporaries that Australian cities were indeed modern and progressive places in which to be.

Indeed, in several respects these buildings were truly national in scope, as architects practising in Melbourne and Sydney designed imposing office towers for major insurance companies in a number of centres across the country. For instance, the firm of A. and K. Henderson, based in Melbourne, designed the major branch buildings for the Temperance and General Life Assurance Society (T. & G.), and distinctive white buildings with tall towers stretching high above roofs can still be found across the nation, from State capitals such as Melbourne and Hobart to provincial centres such as Newcastle in New South Wales (plate 45).

Moreover, in at least one instance, an Australian firm designed buildings which were truly international in scope. These were the buildings designed by the firm of Hennessy, Hennessy and Co. for the Colonial Mutual Life Society. Although the idiosyncratic Romanesque composition of these buildings was not overtly Art Deco, their massing and areas of emphasis, such as parapets and entries, were similar to office buildings designed in that style. Examples can still be found in Hobart, Brisbane, Adelaide and Newcastle, as well as smaller branches in provincial cities such as Goulburn in New South Wales. Similar buildings were also erected in New Zealand and South Africa, creating a readily identifiable corporate image.

With their rich exteriors made colourful by terracotta, brick, synthetic stone, natural stone, glass and even painted cement render, each newly completed building was regarded as a civic adornment and a source of pride. Architects imparted individuality to these buildings by combining materials and decoration in a way which has only recently re-emerged in Australian cities – partly due to an examination of Art Deco architecture. In a sense, the office buildings were *the* monuments of the era, tied as they were to the sensitive forces of the economy and business. Decoration communicated the individuality of the corporation, as well as its commitment to progressive practice. Clearly, a company investing in a modern office building was one which had weathered the Depression by means of its responsible financial management – or so it may have appeared. The turrets and towers, eye-catching enough during the day (plate 30), became striking and readily identifiable features high above the streets at night with dramatic floodlighting. As well, some architects were very aware of the potential of neon lighting. For instance, the designers of Sydney's MLC Building (plate 34), Bates, Smart and McCutcheon of Melbourne, seriously proposed that flashing neon signs be placed in the tower atop the building in addition to floodlighting. This does not, however, appear to have taken place.

The buildings were no less assured at street level. A defined base which focused on a prominent and at times spectacular entry ensured that recognition was no problem to the visitor. The Art Deco embellishments accompanying the basic architectural forms created theatrical incidents which enlivened the staid atmosphere persisting in the streets from earlier times.

Continuity was assured between the major parts of interiors and the exteriors of office buildings through the use of related decorative detail and the use of rich materials or imaginative exploitation of simple surfaces. Indeed, areas such as lift lobbies and banking or assurance chambers further reinforced the corporate message of exteriors, with images and vignettes promoting a secure and respectable context for the operations of business carried out within the building (plates 37 and 38).

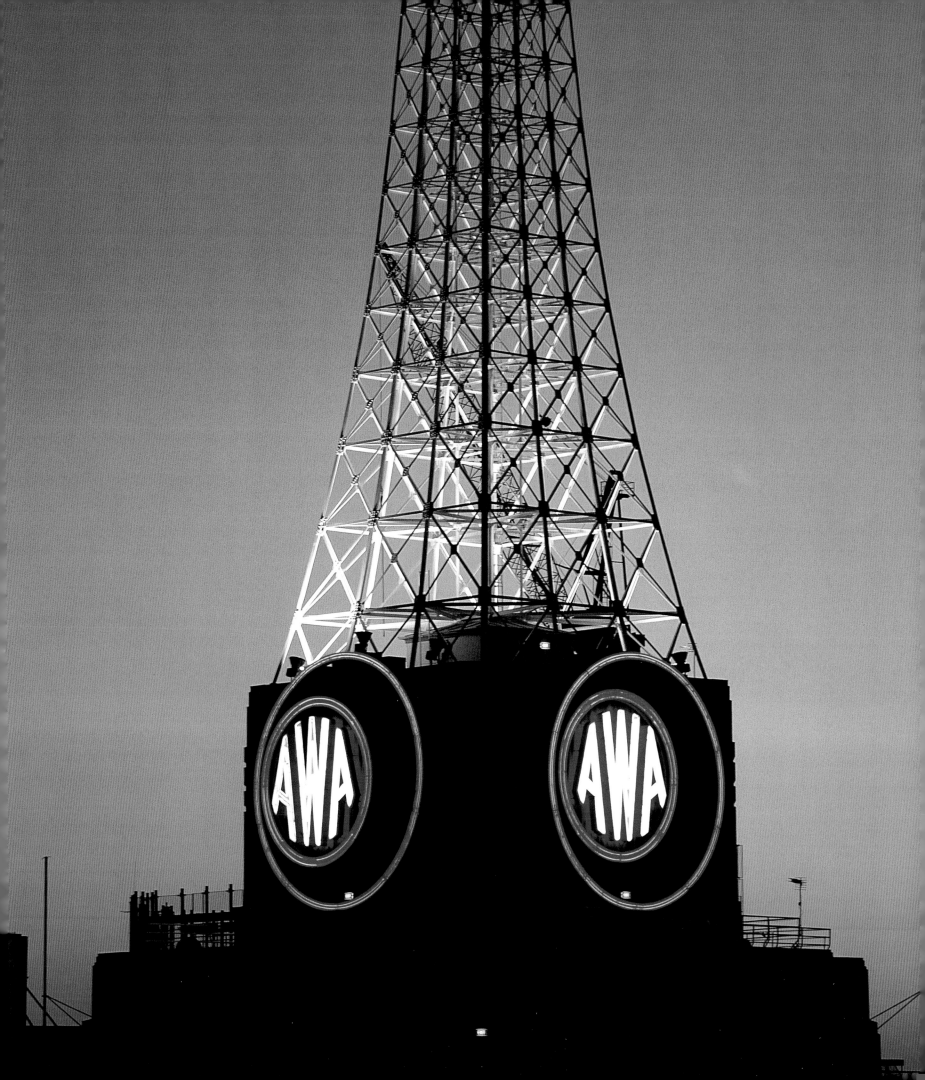

PLATE 24
MUSEUM OF CONTEMPORARY ART (FORMERLY MARITIME SERVICES BOARD BUILDING), DESIGNED CIRCA 1936
George Street North, Sydney, New South Wales
Architects: Maritime Services Board – D. H. Baxter and W. H. Withers; decorative murals and sculpture by Norman Carter, Lyndon Dadswell and R. Emerson Curtis
Although designed around 1936, the building was not completed until 1952 and was officially opened on 10 December 1952.
A late and imposing Art Deco building in a prominent location, it contained an important public space on the ground floor known as the Wharfage Hall.

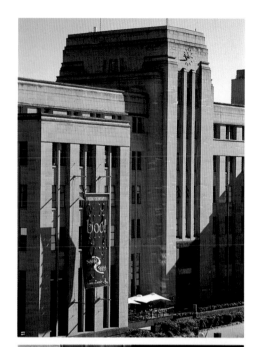

PLATE 25
MUSEUM OF CONTEMPORARY ART (FORMERLY MARITIME SERVICES BOARD BUILDING), DESIGNED CIRCA 1936
George Street North, Sydney, New South Wales
Architects: Maritime Services Board – D. H. Baxter and W. H. Withers; decorative murals and sculpture by Norman Carter, Lyndon Dadswell and R. Emerson Curtis
A light fixture forming part of the external fabric of the Museum of Contemporary Art.

PLATE 26
CITY MUTUAL LIFE BUILDING, 1936
Corner of Hunter and Bligh Streets, Sydney, New South Wales
Architect: Emil Sodersten;
relief sculpture designed by Rayner Hoff
A nationally important office building with a largely intact (although modified) assurance chamber and boardroom. The two major facades are tied together by the corner tower, at the bottom of which is a projecting entry porch. Relief sculptures on the black granite porch are rare examples of local flora used as decoration. The figure group, the logo for City Mutual, is based on a nineteenth-century group of statuary by Benzoni in the Botanic Gardens, Ballarat, Victoria. It was chosen by the company in 1934 as its crest.

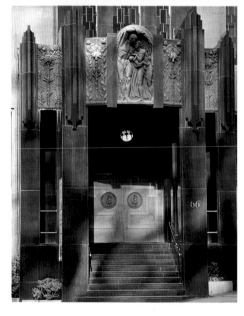

PLATE 27 (opposite page)
CITY MUTUAL LIFE BUILDING, 1936
Corner of Hunter and Bligh Streets, Sydney, New South Wales
Architect: Emil Sodersten;
relief sculpture designed by Rayner Hoff
The striking exterior expression of windows on its Bligh and Hunter Streets corner facades form zigzagging bays across the building. It was claimed that the windows were designed in this fashion to reduce the effects of heat from the sun entering the building, but the dynamic aesthetic which they impart is a unique contribution to Australia's repertoire of Art Deco architecture.

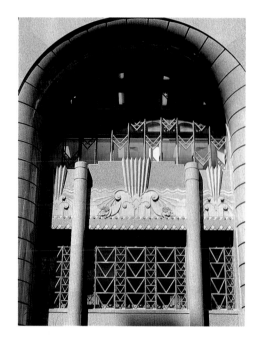 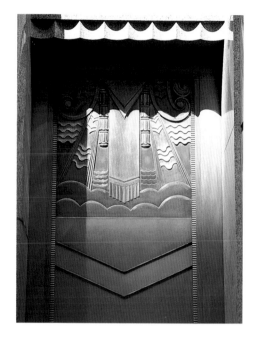 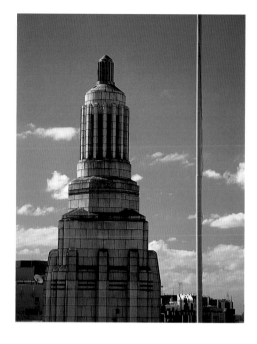

PLATE 28
AFT HOUSE (FORMERLY DELFIN HOUSE), 1940
16 O'Connell Street, Sydney, New South Wales
Architect: C. Bruce Dellit
At ground level, this imposing building dominates
the street with a massive arch of polished granite
which gave access to the banking chamber beyond.
Above the bronze doors, a thematic sculpture known
as *Sunrise Over the Pacific* represented the activities
of the Bank of New South Wales – the building's
owners – to passers-by. Its archetypal Art Deco motifs
described New South Wales ('the Land of Plenty')
and symbolised communications and links with lands
across the Pacific Ocean.

PLATE 29
AFT HOUSE (FORMERLY DELFIN HOUSE), 1940
16 O'Connell Street, Sydney, New South Wales
Architect: C. Bruce Dellit
Sculptural detail of the doors leading to the banking
chamber. The doors pick up on the themes present in
the relief sculpture above and combine images of
modern industry and power – a dynamo – with Art
Deco fronds and dynamic waves.

PLATE 30
CENTURY BUILDING, 1940
Corner of Swanston and Little Collins Streets,
Melbourne, Victoria
Architect: Marcus Barlow
An outstanding office building by one of Melbourne's
foremost practitioners of the period. Its extreme and
pronounced vertical expression, executed in gleaming
white glazed terracotta, is terminated by this refined
tower high above the street corner.

PLATE 31 (opposite page)
NEWSPAPER HOUSE, 1933
247–249 Collins Street, Melbourne, Victoria
Architects: Stephenson and Meldrum; mosaic by
Mervyn Napier Waller
Napier Waller was commissioned by one of
Melbourne's great art patrons, Theodore Fink, to
create a mosaic to cover the first floor of the facade of
the recently remodelled Newspaper House. The
opportunity arose when The Herald and Weekly
Times Group acquired the W. H. Rocke building
and conducted an architectural competition for the
remodelling of the building to provide city offices.
The winning design incorporated the glass mosaic
for which Fink chose a line from Shakespeare's play,
A Midsummer Night's Dream – 'I'll put a girdle round
about the earth' – and is a unique instance of mosaic
work in the context of an office building facade. It
represents a modern and jubilant celebration of
man's potential to use technological advances for
communications, and for material and spiritual
fulfilment.

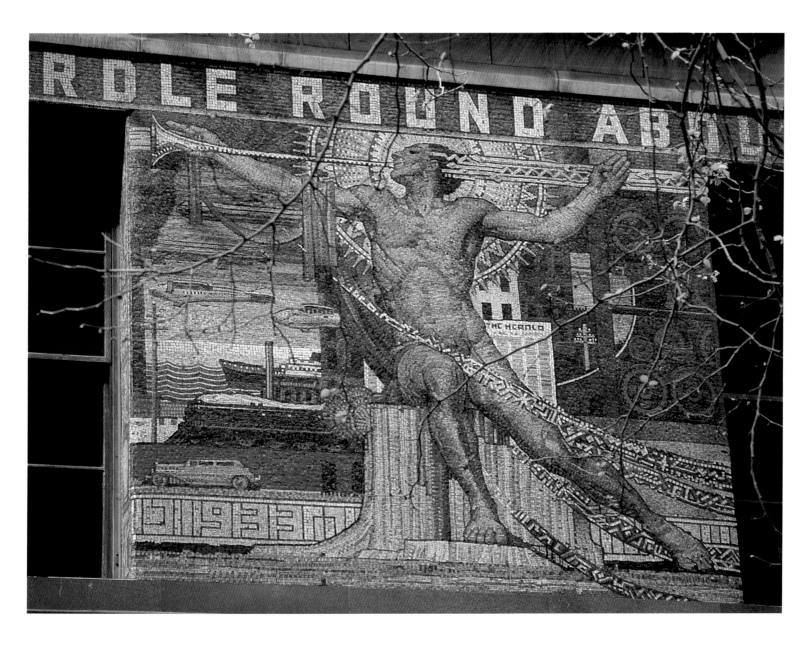

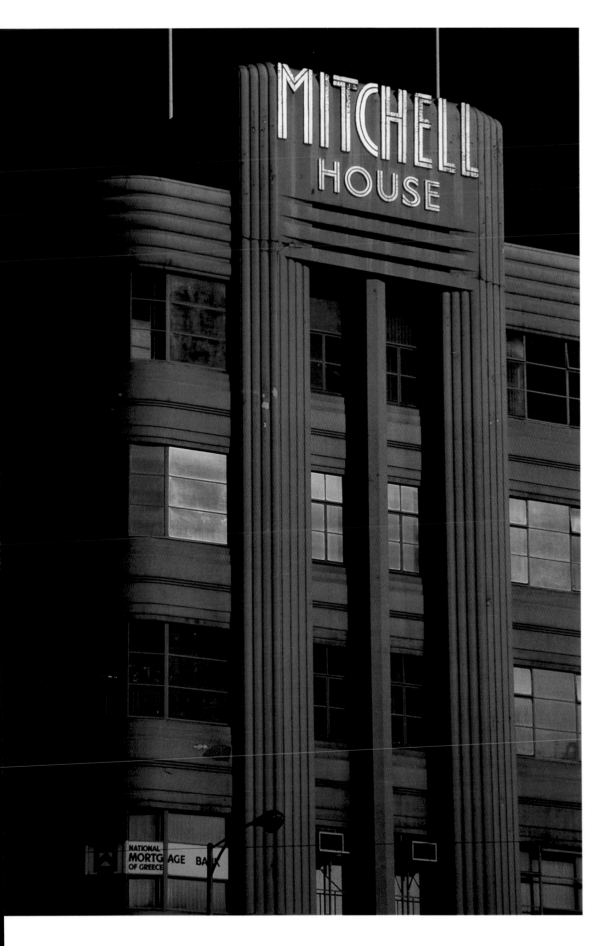

PLATE 32
MITCHELL HOUSE, 1937
Corner of Lonsdale and Elizabeth Streets,
Melbourne, Victoria
Architect: Harry Norris
Rounded profiles predominate on the exterior of this
building and the streamlined forms of Mitchell House
have been traced to the work of the modernist German
architect, Eric Mendelsohn. The horizontal bands of
windows and spandrels terminate on a sculptural
vertical tower element and the name of the building is
carefully integrated in huge Gill Sans lettering below
the parapet of the tower.

PLATE 33 (opposite top)
MITCHELL HOUSE – THE ELEVATOR BANK, 1937
Corner of Lonsdale and Elizabeth Streets,
Melbourne, Victoria
Architect: Harry Norris
The most modern, silent, smooth-running automatic
electric lifts were installed in Mitchell House and
the elevator lobby reflects their presence. It still has
the appearance of the interior of a sleek modern
railway carriage.

PLATE 34 (opposite centre)
FORMER MLC BUILDING, 1938
Corner of Martin Place and Castlereagh Street,
Sydney, New South Wales
Architects: Bates, Smart and McCutcheon;
recent work by Lucas Stapleton
A relief sculpture in the prominent tower above
the corner of Martin Place and Castlereagh Street,
depicting the company's logo 'Strength in Unity' –
a man attempting unsuccessfully to break up a
bundle of rods.

PLATE 35 (opposite bottom)
FORMER MLC BUILDING, 1938
Corner of Martin Place and Castlereagh Street,
Sydney, New South Wales
Architects: Bates, Smart and McCutcheon; recent
work by Lucas Stapleton
The recently installed lift lobby bears scant
resemblance to the original but owes a debt to the
New Victoria Cinema in London. The overwhelming
display of light and seemingly precious materials in
lobby and foyer spaces was often employed to
transform an otherwise bland structure into a source of
great civic pride.

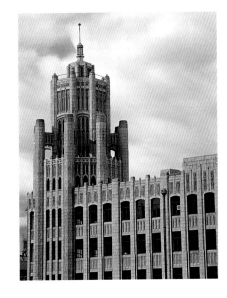

PLATE 36
GRACE BUILDING, OPENED ON 3 JULY 1930
York, King and Clarence Streets, Sydney,
New South Wales
Architects: D. T. Morrow and Gordon
This major Commercial Gothic building, with
extensive use of terracotta on its facades, decisively
marked the break from more traditional architectural
styles and anticipated the imminent arrival of the
Art Deco style in Sydney. Its striking tower is still a
landmark above the corner of King and York Streets.
For a short time, the building housed a store within its
ground floor; subsequently its history has embraced
duty as headquarters for General Douglas Macarthur
during the Second World War.

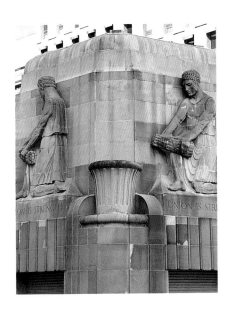

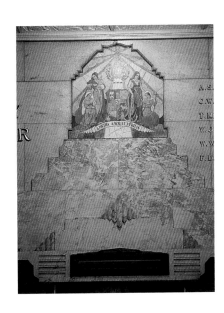

PLATE 37
MANCHESTER UNITY BUILDING,
OPENED ON 1 SEPTEMBER 1932
220–226 Collins Street, Melbourne, Victoria
Architect: Marcus Barlow
Melbourne's 'answer' to the Grace Building also
echoes the influence of American models, such as the
Chicago Tribune, in an assured fashion. The building
was erected for the Manchester Unity Independent
Order of Oddfellows (founded in Victoria in 1840)
and took some eight months to complete – one of the
fastest jobs of construction in Australia in the early
1930s. The rich decoration of the exterior carries into
the public spaces on the ground floor. This decorative
panel, entirely of marble, was executed by William
Train and Company and is one of a series located in
the public corridors of the building, representing the
activities of the Manchester Unity.

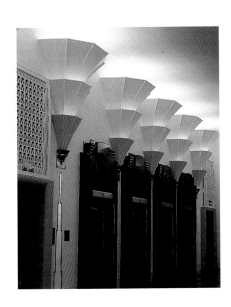

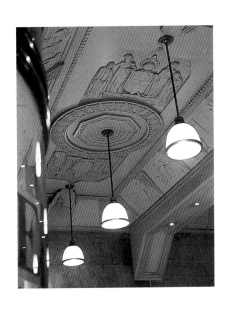

PLATE 38
MANCHESTER UNITY BUILDING,
OPENED ON 1 SEPTEMBER 1932
220–226 Collins Street, Melbourne, Victoria
Architect: Marcus Barlow
Light ornament with low reliefs recording colonial
achievements proclaimed some of the aspirations of
the Manchester Unity and embodied an image of
progress – an important and optimistic artwork in a
time of Depression.

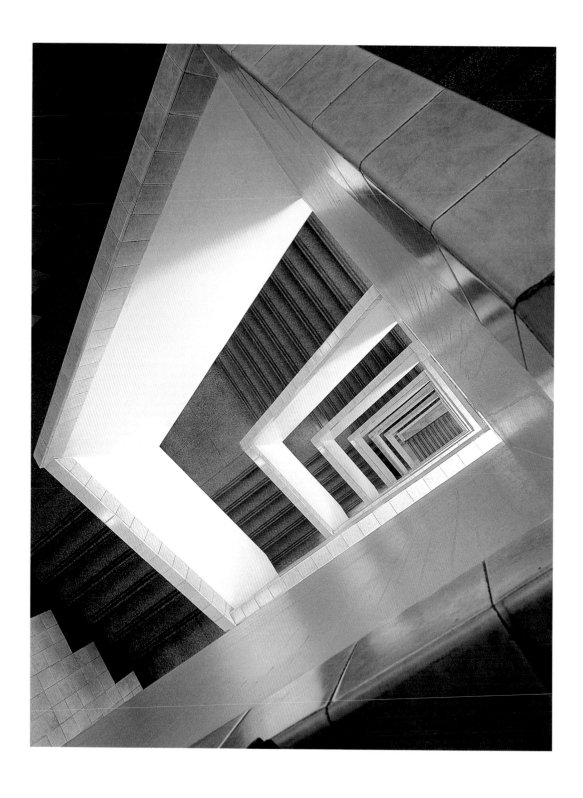

PLATE 39 (opposite page)
**FORMER METROPOLITAN WATER SEWERAGE
AND DRAINAGE BOARD BUILDING, 1940**
339–341 Pitt Street, Sydney, New South Wales
Architects: H. E. Budden and Mackey
Amongst the original fabric of this building still
surviving today is this internal escape stair, which
spirals upwards in a controlled geometric manner.

PLATE 40
**FORMER METROPOLITAN WATER SEWERAGE
AND DRAINAGE BOARD BUILDING, 1940**
339–341 Pitt Street, Sydney, New South Wales
Architects: H. E. Budden and Mackey
The exterior of this building is designed as a series of
sleek parallel lines made up of the solid and void of
windows and spandrels, that sweep around the street
corner in a wide curve. At ground level, a monumental
colonnade of black granite piers marches along Pitt
Street to create a firm base, whilst at one end of the
Pitt Street facade a vertical 'tower' marks the location
of the main entry, as well as lifts and stairs within the
building.

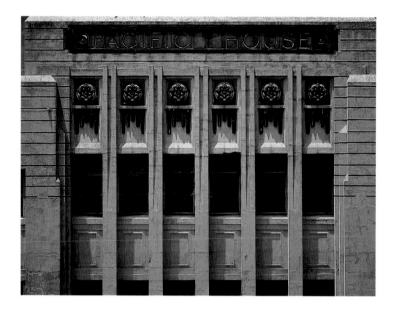

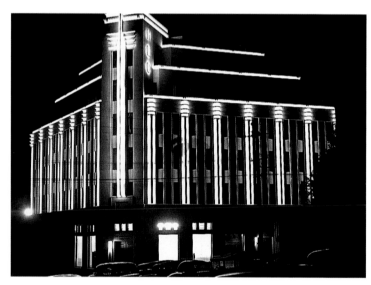

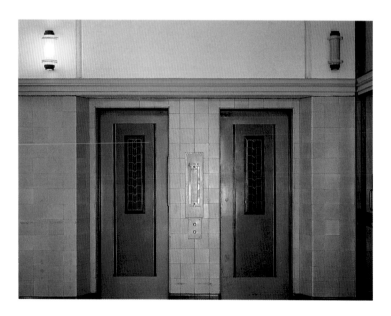

PLATE 41 (left top)
PACIFIC HOUSE, CIRCA 1930
181 Pitt Street, Sydney, New South Wales
Architects: D. T. Morrow and Gordon
This modest office building was amongst the first in Sydney to embrace some of the elements of the Art Deco style into its exterior. These include stepped elements in the building facade and at parapet level, windows separated by continuous vertical piers, and colourful applied geometric decoration (such as these plaques), and draped and reeded forms.

PLATE 42 (opposite page)
FORMER ACI BUILDING, 1941
William Street, Sydney, New South Wales
Architects: Stephenson and Turner
The ACI Building was erected as a showcase for a major manufacturer of glass products, and consequently made much of glass in its finishes – both internal and external. This included an exceptional and extensive use of glass bricks and other glass products, such as brilliantly coloured mosaic tiles and toughened glass, as important architectural elements on the exterior. The original glass bricks have been replaced, but the spirit of the building is still there to entrance the perceptive passer-by.

PLATE 43 (left centre)
HYDRO-ELECTRIC COMMISSION BUILDING, 1938
Corner of Davey and Elizabeth Streets, Hobart, Tasmania
Architects: A. and K. Henderson, Melbourne
Archival photograph courtesy of *The Mercury*, Hobart
This building is an eloquent example of how Art Deco decoration was employed to announce the purpose of a particular building and communicate this to the world at large. The series of discs applied to the heads of window mullions makes witty reference to electrical insulators, and the use of neon tubing as ornamentation is a unique statement. The whole building is almost an expression of 'Electricity as Art'.

PLATE 44 (left bottom)
HYDRO-ELECTRIC COMMISSION BUILDING, 1938
Corner of Davey and Elizabeth Streets, Hobart, Tasmania
Architects: A. and K. Henderson, Melbourne
Skyscraping buildings would, of course, have been impossible without the development of sophisticated and reliable elevator technology. Special care went into the design of elevator lobbies in Australia's office buildings of the 1930s. This lobby, located within the Hydro-Electric Commission Building, is embellished with ubiquitous green-toned tiling.

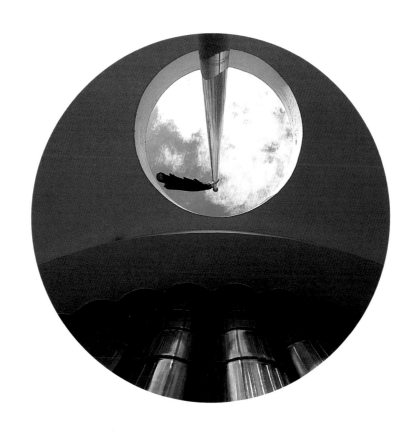

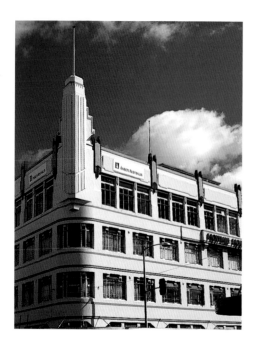

PLATE 45 (opposite page)
T. & G. BUILDING, 1938
115 Collins Street, Hobart, Tasmania
Architects: A. and K. Henderson, Melbourne
This very typical example of T. & G.'s branch offices is
one of several designed for them by this prominent
architectural firm. Its rendered brick facades are
modulated by alternating groups of windows with
wide piers and is characteristic of many Art Deco
office buildings throughout the country. The distinctive
stepped tower, something of a corporate logo, recalls
both the refinement of classical forms which took place
during the 1920s and 1930s and the ziggurat-like
masses of the architecture of ancient cultures.

PLATE 46 (above)
HOLYMAN HOUSE, 1936
52–60 Brisbane Street, Launceston, Tasmania
Architects: H. S. East and Roy Smith (R. S. Smith)
This building was designed for Holyman and Sons,
who managed sea, land and air travel enterprises.
It originally contained a large airport-type terminal
lounge, with deep leather-covered armchairs and
walnut panelling, that was associated with Australian
National Airways. Here, passengers would wait to
be collected for their journey to Launceston airport.
A considerate touch was provided with the inclusion of
a seating alcove located within the external corner of
the lounge to allow passengers a last farewell before
boarding the coach to the airport. The building has
become something of a local landmark, celebrating
the early days of civil aviation and enduring as one
of Launceston's premier Art Deco works.

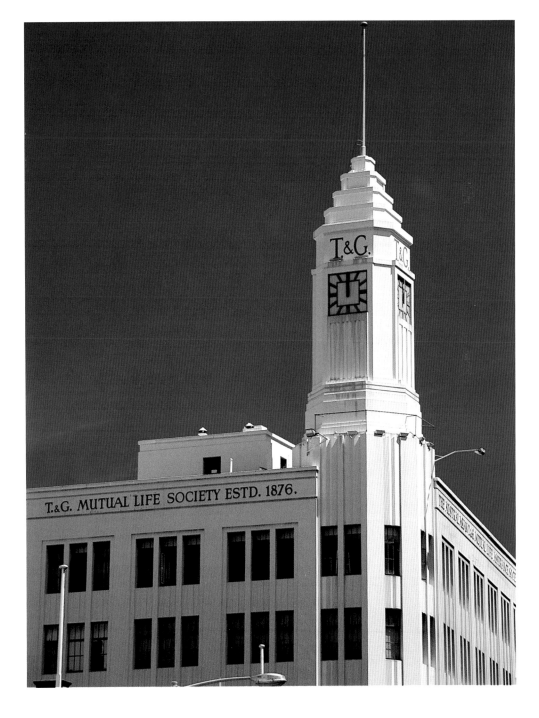

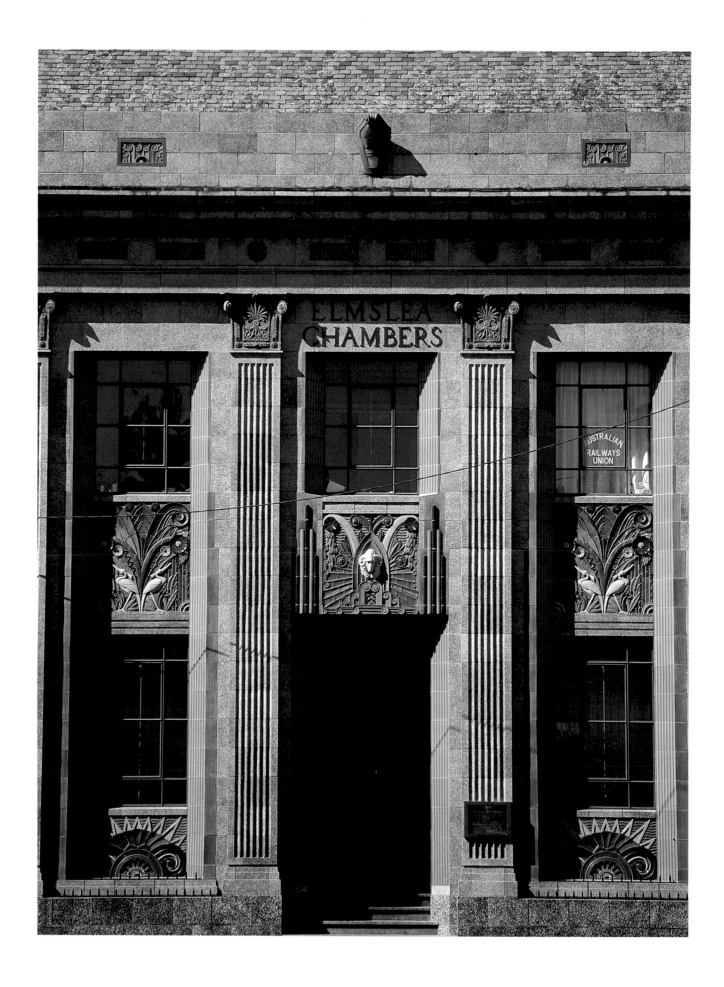

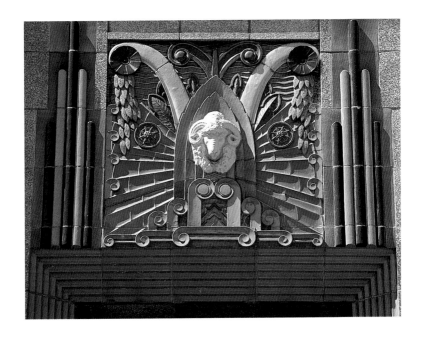

PLATE 47 (opposite page)
ELMSLEA CHAMBERS, 1934
17–19 Montague Street, Goulburn, New South Wales
Architect: L. P. Burns
This outstanding example of polychrome architectural terracotta cladding is a veritable
encyclopaedia of flora, fauna and Art Deco motifs where conventional Art Deco volutes
and zigzagging sunrays share space with stylised flowers and birds. It was erected
for Frank Leahy, a pastoralist and stock dealer with extensive interests. Although the exterior
of the building is basically conservative and neoclassical – regulated by fluted pilasters
supporting a deep entablature in a manner not unlike an ancient temple – it was brought
thoroughly up to date with these richly patterned and coloured spandrel panels.

PLATE 48 (above)
ELMSLEA CHAMBERS, 1934
17–19 Montague Street, Goulburn, New South Wales
Architect: L. P. Burns
The rural motifs on this spandrel panel reflect the country district around the town of
Goulburn, as well as Frank Leahy's pastoral concerns. It combines such elements as gum
leaves and spiralling forms that are reminiscent of merino rams' horns and suggest growth.
The tenacity and durability of glazed terracotta in this rural environment has allowed the
building to appear as fresh and striking today as it did to the townsfolk in 1934.

PLATE 49
FORMER NESCA HOUSE, 1939
Corner of King and Auckland Streets, Newcastle,
New South Wales
Architect: Emil Sodersten
Nesca House was designed as the headquarters of
the City of Greater Newcastle's electricity department,
and is one of the finest inter-war buildings that was
constructed there. Its strong horizontal lines are
counterpointed by a centrally placed tower on the
King Street facade above the main entrance. This
coat of arms, above the entry doors, represented the
activities of the department. The indispensable role
that electricity played in a modern industrial city,
noted for its steel production and in serving a mining
and rural hinterland, informed its iconography.

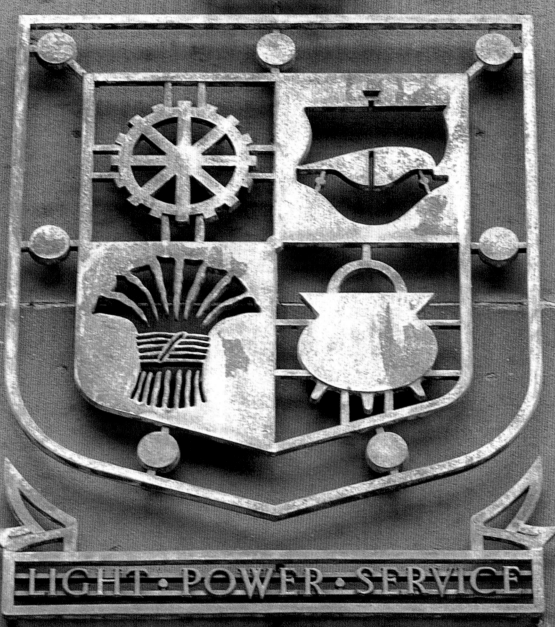

LIGHT · POWER · SERVICE

SHORTLAND COUNTY
COUNCIL

CHAPTER THREE
COMMERCIAL
BUILDINGS

The many commercial buildings lining the main streets of cities, suburbs and towns in Australia consolidated and exemplified Art Deco as the popular style of merchandising in the 1930s (plates 54, 59 and 60). Glossy new materials seduced the eye and stood out from the crowd, whilst the apparently new style of the shop front or facade was easily equated with modern merchandise contained behind the wide glass shop fronts and glazed doors replete with chromium-plated handles and push-bars.

Like the entrances to office buildings, new and colourful shop fronts in hard and gleaming materials injected new life and vigour to shopping environs from earlier times. Ceramic tiles, glass in a variety of types, hard shiny metals, terrazzo and porcelain enamelled steel (all in a wide array of combinations and configurations) stood in stark juxtaposition to older establishments. Sleek structural glass such as Vitrolite found special favour as a relatively economical cladding and contrasted handsomely with polished metals and other materials (plate 63). At times, modish lettering proudly proclaimed the name of the establishment operating from within. Above, vivid textured bricks and clean areas of stucco stood out amongst older neighbours. Any conflict in aesthetic resolution between the two parts of the facade was negated by the heavy awning which overhung the footpath to provide much needed shade in summer and protection from the rain. Even here the influence of Art Deco was apparent and the linings of the undersides of these utilitarian objects were sheathed in a taut skin of pressed metal reflecting Ernest Wunderlich's visit to the 1925 Exposition Internationale des Arts Décoratifs et Industriels Modernes in Paris. Whilst many shop fronts may have concealed a more conservative interior, more than a few were as smart and up to date as their facades. Frequently, office space or even a flat was incorporated in the one or two storeys above a ground-floor shop.

Shopping arcades, although not commonly built in the 1930s, enticed custom by offering quick passage from one street to another. At the same time, attractive modern shops interspersed with mirrors and extensively glazed display cases gave reason for pausing, perhaps for tea or coffee or for an impulsive purchase (plates 53 and 54). Although many restaurants and cafes were constructed, few have survived. Two notable exceptions are the Paragon in Katoomba, New South Wales (plates 50–52), and the dining room in the Myer Department Store in Bourke Street, Melbourne (plate 55). The interiors of the Paragon achieve a degree of luxury by fairly economical means – stepped and fluted plasterwork, panels of engraved mirrors and open fretwork-like friezes – and endure as an institution to the present day. The grander and more sumptuous dining room in the Myer store was an integral part of the additions completed in 1934 (plates 56 and 57). It is better known as the Mural Hall because of the series of Art Deco-influenced mural panels by Mervyn Napier Waller. The murals depict a wealth of themes, such as the Revelation of Fashion, Women in Literature and Drama, and the History of Conveyance and Sea Transport. It remains as one of the outstanding Art Deco interiors in the country.

One aspect of commercial architecture worth mentioning is the series of bank branches constructed throughout the country in the 1930s. Of these, those of the Commonwealth Bank remain the most consistent in quality and use of the Art Deco style (plates 64–65). However, other banks flirted with Art Deco as well, sometimes in unusual combinations. The Bank of New South Wales (now Westpac) built elegant Georgian-style buildings with refined proportions and tiled roofs, often featuring decorative panels in high Art Deco motifs. As well, the Rural Bank in New South Wales (now State Bank) built a series of extraordinary, classically derived buildings which imparted a grave and monumental character to many towns. Discreet Art Deco detailing provided sufficient decorative relief and a touch of human scale.

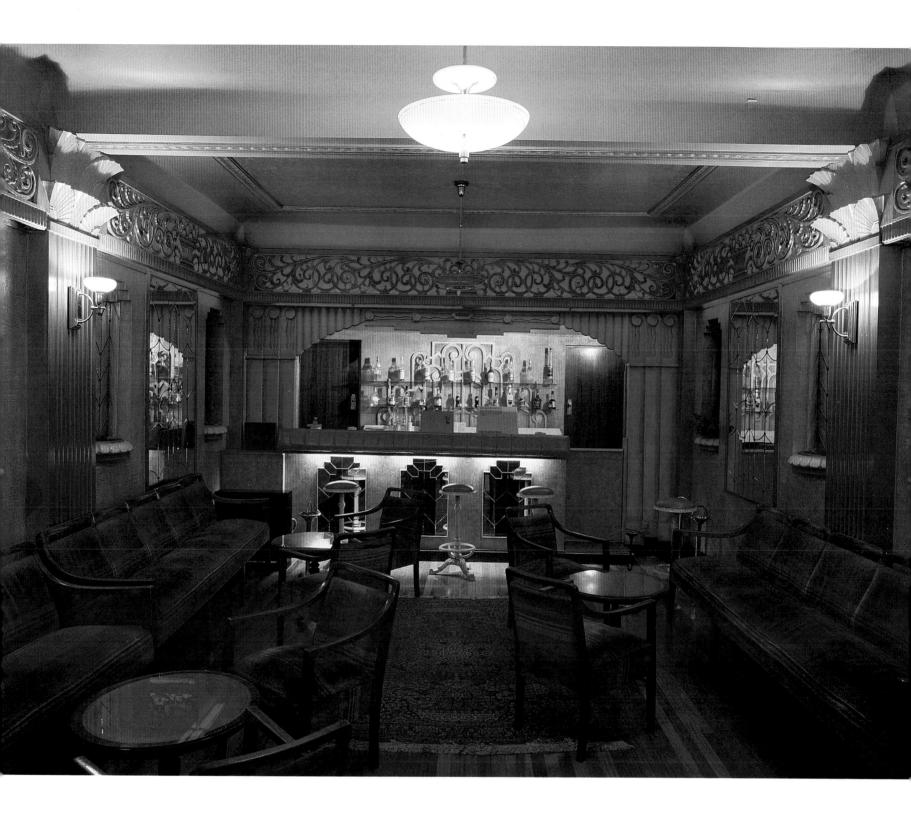

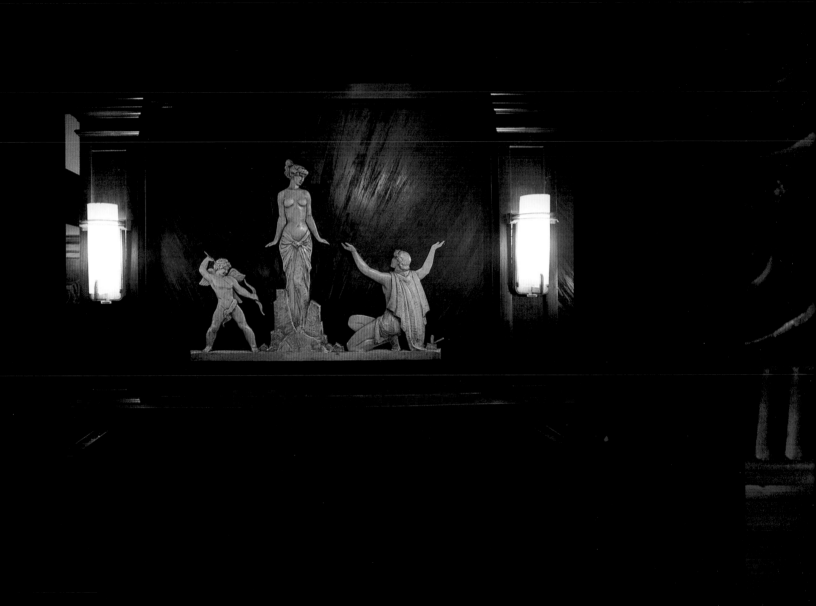

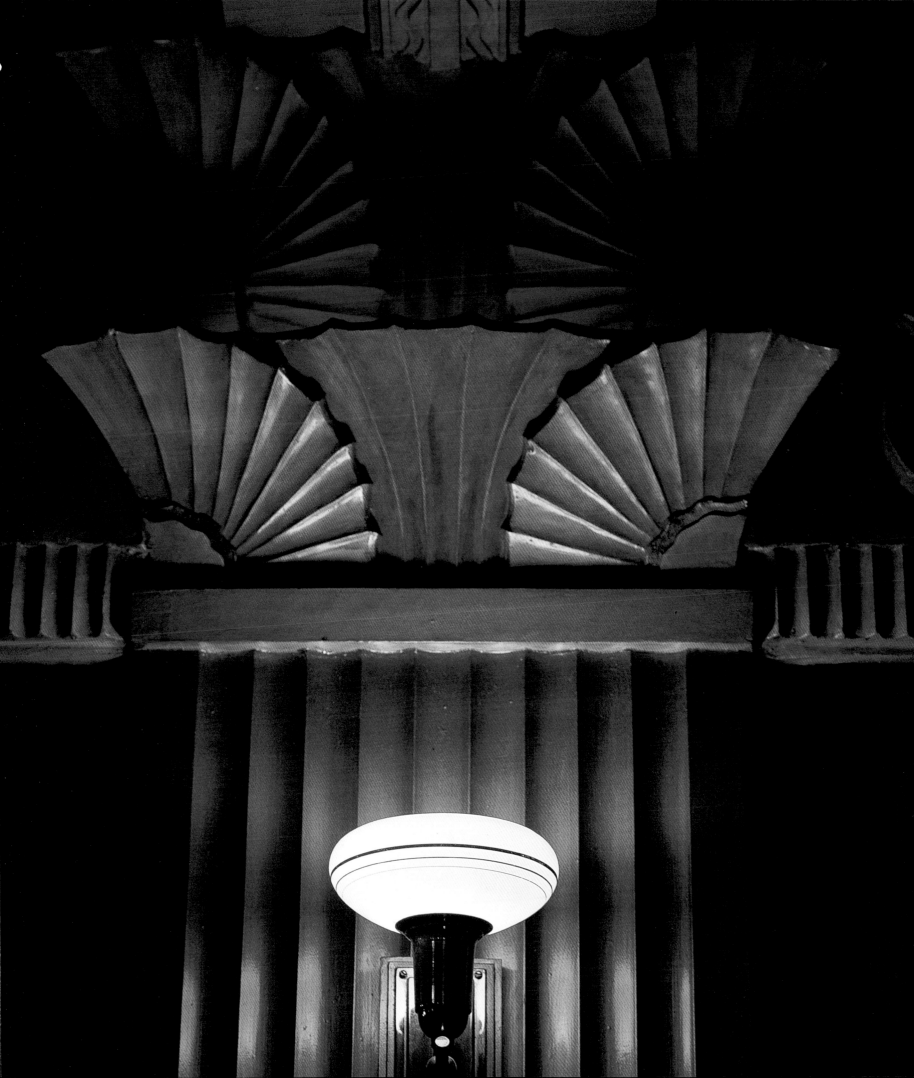

PLATE 53
CIVIC ARCADE,
CONVERTED TO AN ARCADE IN 1939
11 Newcomen Street, Newcastle, New South Wales
Architects: Jeater, Rodd and Hay
A modest, but quite intact, commercial building, it
started life in 1888 as the Newcastle Corporation
Baths and subsequently became a menswear store.
Its simple, stepped two-storey facade was brought
right up to date by a lively zigzagging frieze, whilst the
L-shaped shopping arcade repeats the stepping of the
facade in its bold ceiling and streamlined mouldings
above display cases. Mirrors between the display
cases are engraved with linear motifs, including a
leaping kangaroo.

PLATE 54
BLOCK COURT, 1930
288 Collins Street, Melbourne, Victoria
Architect: Harry Norris
At the end of the 1920s, the renowned architect,
Harry Norris, inserted a stylish and modern shopping
arcade into a building from the 1890s. The result
demonstrated that the new was quite compatible with
the old. Its characteristic Art Deco features include
ceilings embellished with cornices and centrepieces
decorated with floral and zigzag motifs – a decorative
theme that is extended to the bronze friezes and
spandrel panels.

PLATE 55
MYER EMPORIUM, 1933
314–336 Bourke Street, Melbourne, Victoria
Architects: H. W. and F. B. Tompkins
The Bourke Street facade of this massive department
store is characterised by its length, which is balanced
by vertical piers between window bays – a common
device in many large city buildings in the 1920s and
1930s. The piers modulate the facade through the
rhythm established by their varying widths. Verticality is
further reinforced by the subtle vertical flutings in
spandrel panels. The facade is relatively unusual for a
large city building because it was finished cement
render, a proprietary product called 'Snowcrete'.

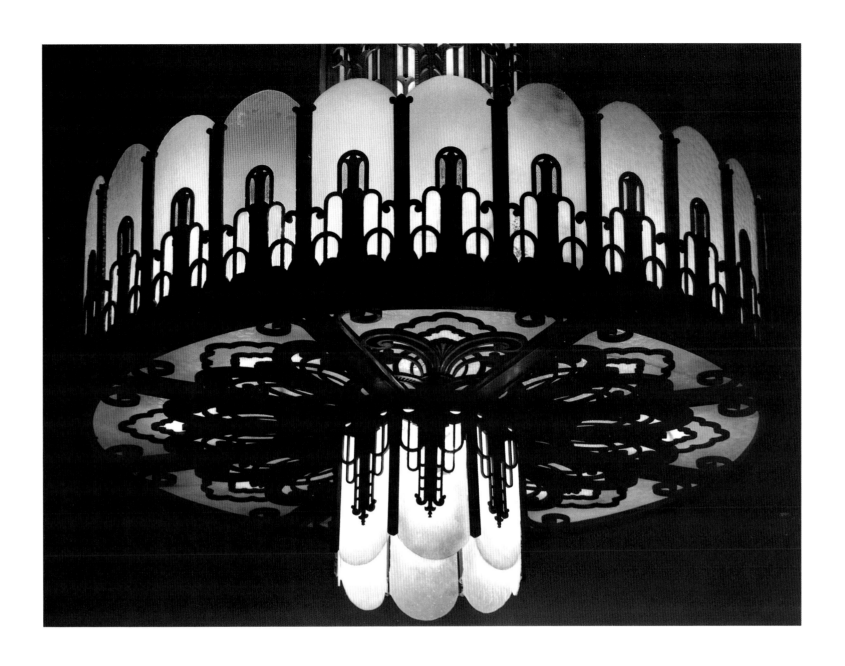

PLATE 56
MYER EMPORIUM – THE MURAL HALL, 1933
314–336 Bourke Street, Melbourne, Victoria
Architects: H. W. and F. B. Tompkins
One of three colossal chandeliers which were designed to provide up to ten
different lighting effects. Almost two-and-a-half metres high and more than a
metre wide, it incorporates a frozen fountain – one of the archetypal Art Deco
motifs which, amongst other things, symbolised youth. The hall contains ten mural
paintings by Mervyn Napier Waller representing women and their achievements
in art, opera, drama, dance, literature, fashion and sport. Two pageants depict
beautiful women and famous women throughout history. Happily, this vibrant
interior is protected by the Historic Building Preservation Council.

PLATE 57
**MYER EMPORIUM – THE MANNEQUIN
STAIRWAY, 1933**
314–336 Bourke Street, Melbourne, Victoria
Architects: H. W. and F. B. Tompkins
Elegant models, displaying the latest European styles
available at Myer's store, descended this dignified
stair to delight onlookers in the dining room below.
The 'Staybrite' stainless steel balustrading lent a touch
of additional glamour. The famous hall became the
meeting place for many Melburnians to dine and
be entertained and diverted by exhibitions, displays,
fashion parades, choirs, bands and concerts. It is
the last-surviving room of its type in the country.

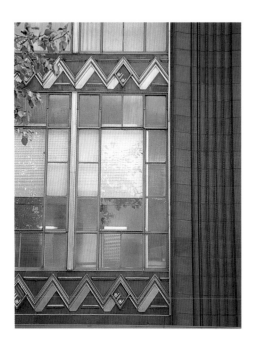

PLATE 58
**DAVID JONES DEPARTMENT STORE
(FORMERLY BUCKLEY AND NUNN
MEN'S STORE), 1934**
310 Bourke Street, Melbourne, Victoria
Architects: Bates, Smart and McCutcheon
Awarded Royal Victorian Institute of Architect's Street
Architecture Award for 1934
This fine building not only features an outstanding
application of architectural terracotta, but also a
curtain wall of tall steel-framed windows with
syncopated spandrel panels modulated by a dynamic
zigzag form decorated by small, regularly spaced
coloured panels.

PLATE 59
ALBERTO'S OF ROME, 1932
Brisbane Street, Launceston, Tasmania
Architect: Colin Philp
An Art Deco facade by one of Launceston's major
architects, who contributed much to the city during
the 1930s. The building is unique in the whole
of Tasmania, if not Australia, because of its
characteristically Art Deco exterior detailing
which is executed in chrome-plated metal.

PLATE 60

YORK HOUSE

354 Oxford Street, Paddington, New South Wales
A surprising Art Deco intrusion into a largely Victorian
shopping precinct, the first floor of York House is
characteristic of many smaller scale commercial
buildings of the 1930s, with features such as
stepping, discreet geometric decoration and lettering
integrated into the design of the facade. Its colourful
appearance dates to a refurbishment during the
1980s.

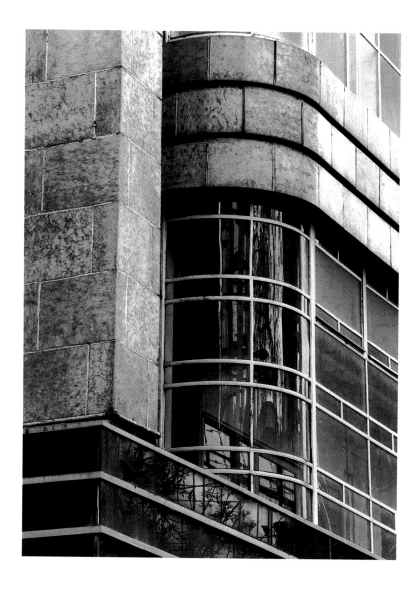

PLATE 63 (below)
FORMER McPHERSON'S BUILDING, 1935
546 Collins Street, Melbourne, Victoria
Architects: S. P. Calder, and Reid and Pearson
Erected as a warehouse, office and showroom for a large hardware merchandising concern, its exterior expression consists of horizontal bands of glass, terracotta and structural glass. The building is thought by some to be the finest example of the International Style in Melbourne, reflecting the influence of the modernist German architect, Eric Mendelsohn.

PLATE 61 (opposite page)
RECONSTRUCTION OF GLASS SALVAGED FROM THE FORMER SYDNEY COUNTY COUNCIL OFFICES AND SHOWROOM
Re-created at the Powerhouse Museum,
Harris Street, Ultimo, New South Wales
The Sydney County Council offices and showroom were designed by the Architects Branch of the City Engineering Building Surveyors Department and originally installed in the Queen Victoria Building in George Street, Sydney, in 1935.

PLATE 62 (above)
DUTTONS
525–531 Church Street, Richmond, Victoria
This beautiful facade uses stepped ornamentation in a classical assembly of symmetry and is gently contrasted with the modern, asymmetrical logo above the entry. Jeffrey Dutton is a car dealer specialising in modern and vintage sports models. The huge showroom has a good collection of racing memorabilia from the 1930s and a coffee shop recreated in the style of the 1950s.

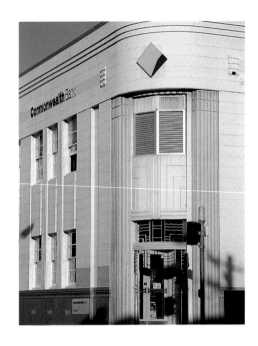

PLATE 64a (opposite left)
COMMONWEALTH BANK, CIRCA 1936
83 Pacific Highway, Roseville, New South Wales
Architects: Department of the Interior
PLATE 64b (opposite bottom right)
COMMONWEALTH BANK, CIRCA 1936
31 Hall Street, Bondi Beach, New South Wales
Architects: Department of the Interior
Terrazzo appeared as flooring in the entry porches of
many commercial buildings such as shops and bank
branches. Consisting of marble chips laid in cement
mortar and then ground and polished, its appeal lay in
a relatively inexpensive cost combined with the
potential to create colourful motifs such as this.

PLATE 65 (above)
COMMONWEALTH BANK, CIRCA 1936
83 Pacific Highway, Roseville, New South Wales
Architects: Department of the Interior
One of a large number of branch buildings erected
throughout the country for the Commonwealth Bank
in the 1930s. The buildings were designed as quite
severe stripped classical prisms, overlain with Art
Deco decoration in key locations, and are remarkable
as a consistent, easily identifiable group of buildings
which still exist in a large number.

PLATE 66 (opposite right)
**PEPPERINA, FORMERLY THE BOWERY COFFEE
SHOP, 1944**
37 Bolton Street, Newcastle, New South Wales
Architect: A. C. Castleden
The terrazzo flooring in the entry porch provides a fine
example of the colourful abstract geometries designers
were able to realise with this inexpensive material.

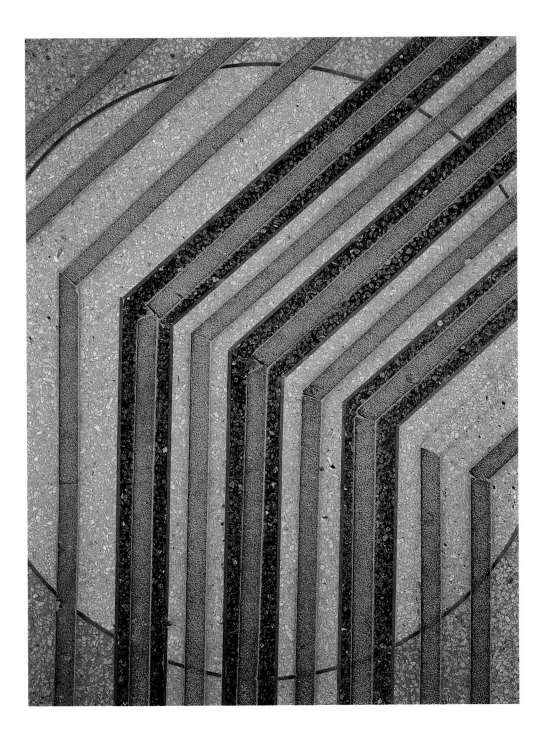

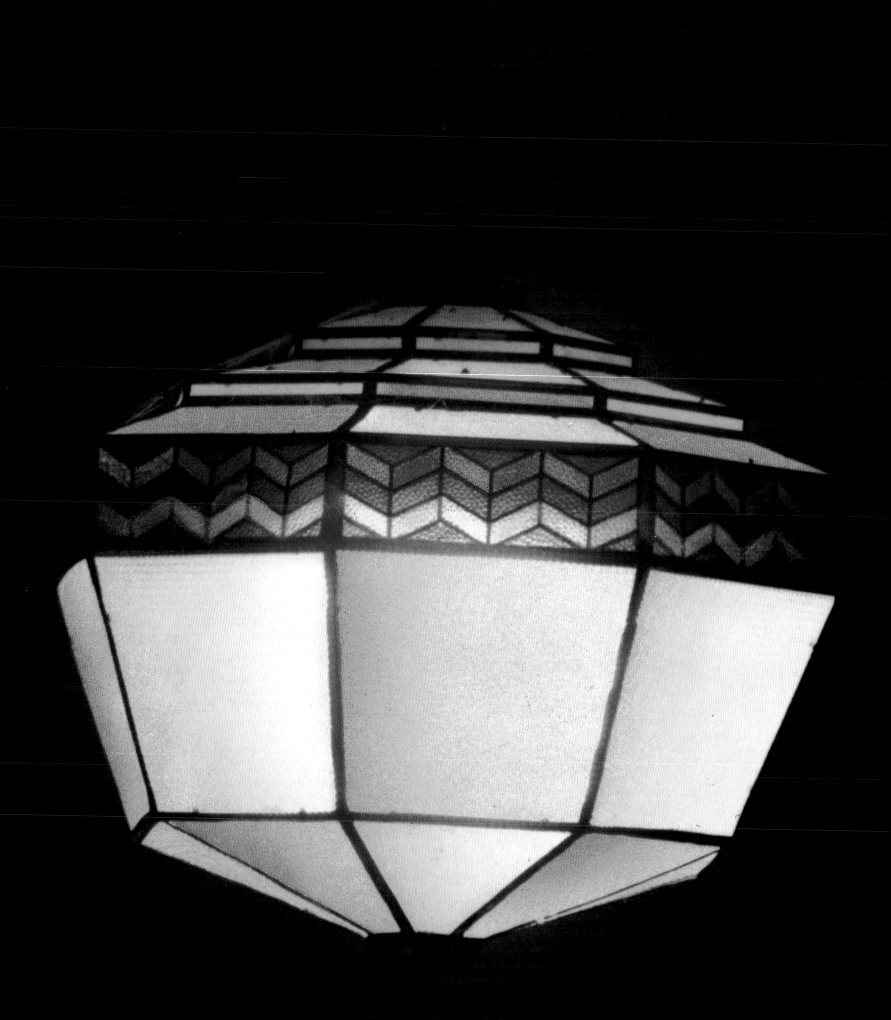

PLATE 67
NATIONAL FILM AND SOUND ARCHIVE
(FORMERLY AUSTRALIAN INSTITUTE OF
ANATOMY), 1930
McCoy Circuit, Acton, Australian Capital Territory
Architects: W. Hayward Morris in association with
Robert Casboulte
A platypus, made from coloured glass, is located in
the laylight over the main entrance hall of the building.

More than any other buildings, the public buildings of the inter-war period were unified by a basic underpinning of classicism which relied extensively on well-considered proportion brought up to date by refined and simplified forms. The judicious application of Art Deco embellishments lent the architecture a broader, more meaningful contemporary relevance. Not only was this architecture employed for government buildings and those representing the community, such as town halls, it was seen as a fitting expression of public sentiment. This was most clearly expressed in war memorials and funerary structures.

The second half of the 1930s, when the economy was once again on a more secure foundation, witnessed the construction of numerous town halls across the country (plates 76–84). In a sense, this was an extention of the works which the municipalities had created during the Depression in an effort to provide gainful work for the unemployed. This time, however, civic pride was being extolled, an echo of the 1870s and 1880s when many fine town halls were built throughout the country. Several important anniversaries took place during the 1930s and provided impetus for expressions of civic pride. Melbourne celebrated its centenary in 1934, whilst the sesquicentenary of white settlement and the foundation of Sydney were celebrated in 1938. Amongst other things, this resulted in two fine commemorative pavilions being erected at the Royal Agricultural Society's grounds only a few kilometres to the south-east of Sydney's city centre (plate 89). The architects of these vast halls managed to create tall, wide spaces bathed in natural light and at the same time enclose the structures in simple but assured Art Deco shells.

As mentioned in the introductory essay, many of the major public buildings in Canberra were informed by the combination of stripped classical and Art Deco styles. These served a multiplicity of functions: schools, museums, the Patents Office and even the first National Library (which, sadly, has been demolished). The quiet elegance of these buildings still informs the central parts of the city (plates 67–71 and 85), complemented by monuments such as that erected in honour of King George V in Parkes Place (designed by Rayner Hoff in 1937 but executed posthumously), and the Australian War Memorial (plate 10).

Indeed, the war memorials stand out as the most consistent and moving of all the public monuments and buildings erected during these years. Although fine memorials were erected across the country, Sydney is fortunate to possess two of the finest, which enjoy a special relationship. These are the Archibald Fountain (plates 72 and 73) and the Anzac Memorial (plates 74 and 75), located at the northern and southern ends of Hyde Park respectively.

The park had suffered a massive dislocation as a result of excavations along its full length to construct the underground railway, the first stage of which opened in 1926. A competition for the design of a refurbished park was held to reassure the populace that the damage was to be put right and, as a result of areas set aside in the winning entry, independent moves ensured that the two memorials were placed at either end. By a striking coincidence the siting of both was plagued by indecision and the search for an appropriate location. Whilst they expressed different aspects of the First World War – the Archibald Fountain expressing French and Australian friendship and participation, and the Anzac Memorial the sacrifice by the citizens of New South Wales – they are linked by an axial alignment and by symbolism, and of course by the disciplining order of classicism.

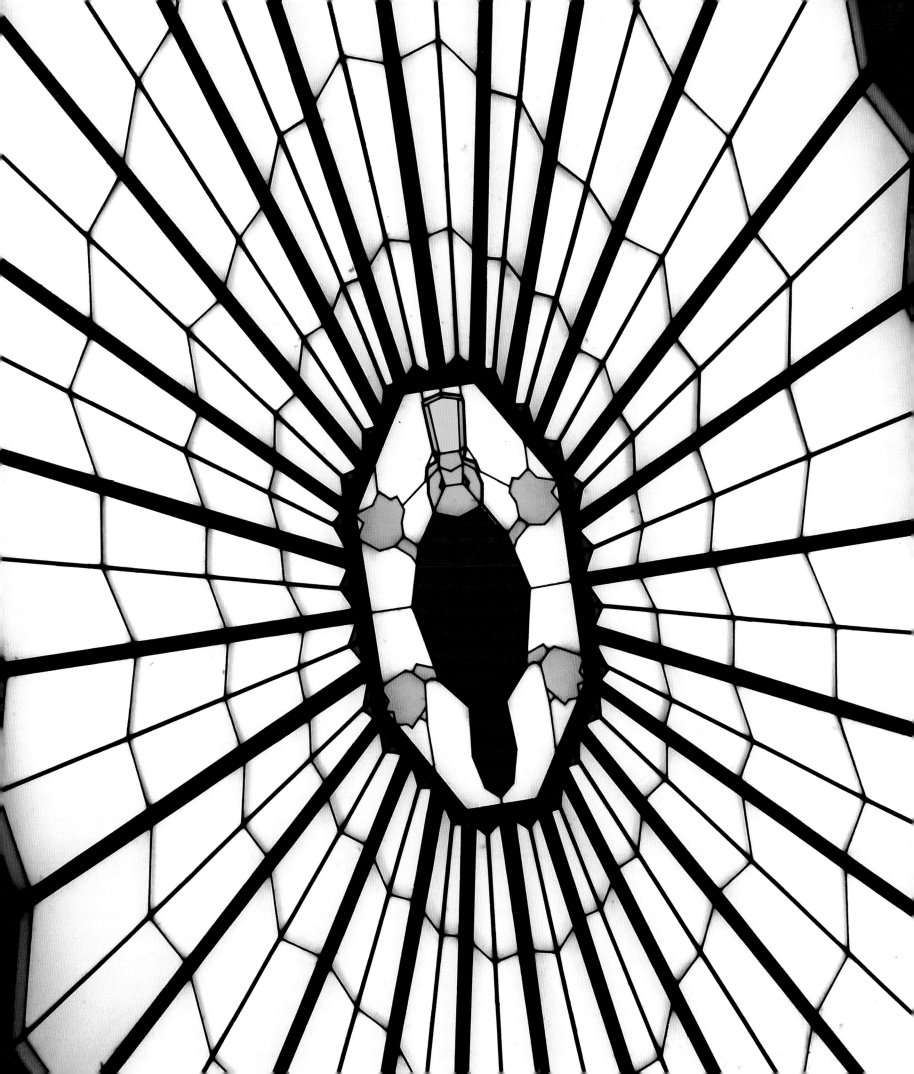

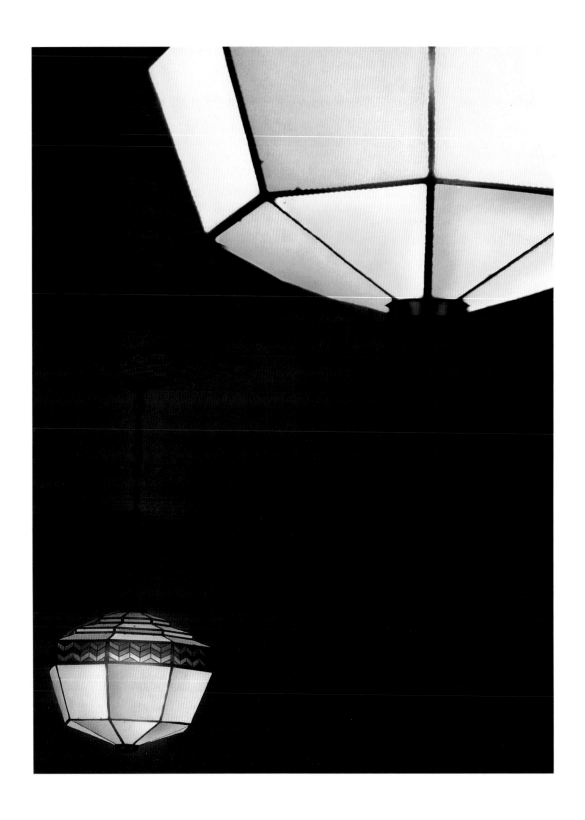

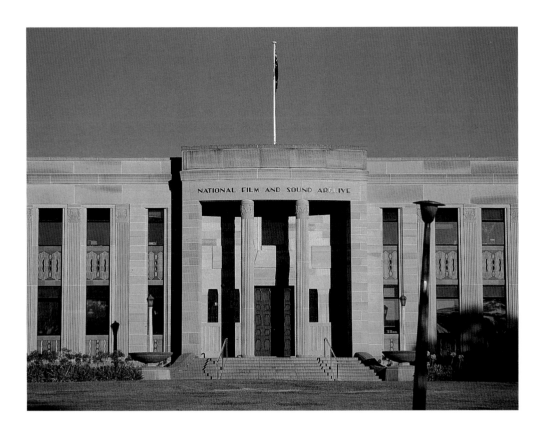

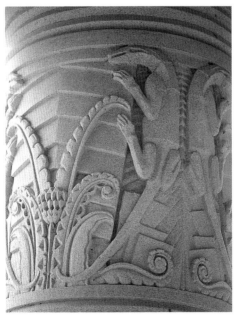

PLATE 68 (opposite page)
NATIONAL FILM AND SOUND ARCHIVE (FORMERLY AUSTRALIAN INSTITUTE OF ANATOMY), 1930
McCoy Circuit, Acton, Australian Capital Territory
Architects: W. Hayward Morris in association with Robert Casboulte. One of the suspended light fittings to be found in the museum wings. Its faceted shape and chevron-patterned banding tie it firmly into an Art Deco context.

PLATE 69 (below left)
NATIONAL FILM AND SOUND ARCHIVE (FORMERLY AUSTRALIAN INSTITUTE OF ANATOMY), 1930
McCoy Circuit, Acton, Australian Capital Territory
Architects: W. Hayward Morris in association with Robert Casboulte. Detail of the colourful spandrel panels, influenced by Aboriginal artworks.

PLATE 70 (above left)
NATIONAL FILM AND SOUND ARCHIVE (FORMERLY AUSTRALIAN INSTITUTE OF ANATOMY), 1930
McCoy Circuit, Acton, Australian Capital Territory
Architects: W. Hayward Morris in association with Robert Casboulte. The building's design is characterised by its refined classical proportions and Palladian composition. However, specific local reference is to be found in the main hall – the black marble used to line the floor and which forms pilasters was locally quarried on the Acton flats. The flats have since been submerged by Lake Burley Griffin.

PLATE 71 (below right)
NATIONAL FILM AND SOUND ARCHIVE (FORMERLY AUSTRALIAN INSTITUTE OF ANATOMY), 1930
McCoy Circuit, Acton, Australian Capital Territory
Architects: W. Hayward Morris in association with Robert Casboulte. Stone goannas sinuously entwined between waratahs and ferns, forming the capitals of the colossal columns and pilasters on the main facade, refer to the collection of comparative anatomy which the building once housed, and illustrate the 'educative' role that aspects of Art Deco design imparted.

ARCHIBALD FOUNTAIN, PRESENTED TO THE CITY OF SYDNEY ON 14 MARCH 1932

Hyde Park North, Sydney, New South Wales
Sculptor: Francois Sicard
Supervising architect: B. J. Waterhouse

In his will, Jules François Archibald, co-founder of the important magazine, *The Bulletin*, left a bequest for the purpose of 'providing some beautiful bronze symbolical open air memorial by a French artist' to commemorate the friendship between France and Australia during the First World War. The result of the bequest was the erection of the Archibald Fountain in Hyde Park, a group of figurative bronze statuary above a series of water-filled basins which was created by the academic French sculptor, François Sicard, and completed in 1932. The mythological figure of Apollo, who stands at the top of the fountain, and the subsidiary figures of Diana, Pan and Theseus have allegorical intent.

PLATE 72 (above right)
ARCHIBALD FOUNTAIN – DIANA, 1932

Sicard considered Diana to be the goddess of purity and peaceful nights. Watching over mortals, she is a symbol of charity as well as a representation of poetry and harmony. In short, she is a symbol of the benefits of civilisation. The figures of Pan and Theseus, respectively, represent the fruits of agriculture and the sacrifice of the individual to preserve civilisation.

PLATE 73 (opposite page)
ARCHIBALD FOUNTAIN – APOLLO, 1932

The commanding figure of Apollo is taken to be an image of the arts ('Beauty and Light'). His extended arm suggests his protection and also the spreading of his benefits throughout nature – the warmth and light of the sun, a symbol of life in itself. The rays of the sun are depicted by the jets of the fountain, whilst horses' heads represent the chariot in which Apollo rode across the sky.

ANZAC MEMORIAL, 1934

Hyde Park South, Sydney, New South Wales

Architect: C. Bruce Dellit; sculpture by Rayner Hoff

Dedicated on 24 November 1934 by the Duke of Gloucester

In the description of his conception of the design for the memorial, Bruce Dellit included the following:

> The arts of war and the arts of peace have successfully held man's imagination down the ages
> ... In this twentieth century it has been realised all too late that warfare – such as that which, by
> the vastness of its conflagration has still, after sixteen years of peace, left burning embers of
> destruction – is no thing of glamour and no cause for glorification. On the contrary, it has at last
> been realised that here is a scourge illimitable in its potentialities for destruction and appalling
> in its tragic consequences ... And yet there is another aspect of the matter ... war brings to the
> surface not only the grosser instincts of man, but also his greater ones – his nobility, his courage
> and those combative characteristics, both aggressive and defensive, wherein lies that most
> sublime of all – self-sacrifice for duty ... In the contemplation of these facts were born the
> thoughts which led to the development of the Anzac Memorial design, a design which is
> intended to express with dignity and simplicity neither the glory and the glamour of war, but
> those nobler attributes of human nature which the great tragedy of nations so vividly brought
> forth – Courage, Endurance, and Sacrifice.
>
> (C. Bruce Dellit, 'The Conception of the Memorial Design', *The Book of the Anzac Memorial, New South Wales*,
> Beacon Press, Sydney, 1934, p. 45.)

PLATE 74 (opposite page)

ANZAC MEMORIAL, 1934

Hyde Park South, Sydney, New South Wales

Architect: C. Bruce Dellit; sculpture by Rayner Hoff

Dedicated on 24 November 1934 by the Duke of Gloucester

The central sculpture group in the memorial's Hall of Silence – *Sacrifice* – was conceived by Sydney's major sculptor of the inter-war period, Rayner Hoff. It forms the nucleus of the memorial. The ensemble rises from a bronze base resembling the sun, symbolising eternal flames, and with dramatic power portrays the recumbent figure of a dead Anzac, his soul departed from his body. It is borne aloft on a shield and sword, representing the vanquished enemy, supported by the figures of three women – the dead hero's mother, wife and sister. His wife holds an infant who symbolises the future generations for whom the Anzac's sacrifice was made.

PLATE 75 (right)

ANZAC MEMORIAL, 1934

Hyde Park South, Sydney, New South Wales

Architect: C. Bruce Dellit; sculpture by Rayner Hoff

Dedicated on 24 November 1934 by the Duke of Gloucester

This, one of the major Australian buildings of the 1930s, represents a fusion of stripped classicism and the Art Deco style. Dellit answered the problems of a complex and unusual brief by designing the memorial as a tall, domed hall, circular in plan and contained within a severe, square, stepped structure pierced by high arched windows, rising above a low podium which originally contained office space and meeting rooms. A comprehensive program of decorative sculpture and other embellishments gives specific meaning to the building. Clad in grey-pink granite and incorporating cast stone sculpture and bronze relief panels, the monument is a remarkable unity of conceptual expressive architecture. Inside, the Hall of Memory is illuminated by amber glazed windows, one on each side, engraved with a motif depicting the symbol of the Australian Imperial Force. At all times of the day, the gleaming bronze surface of this shrine is bathed in golden sunlight – the hope of tomorrow.

PLATE 76 (top left)
TOWN HALL, CIRCA 1939
Campbell Town, Tasmania
Architects: Attributed to H. S. East and Roy Smith

PLATE 77 (top centre)
PETERSHAM TOWN HALL, 1938
Corner of Crystal and Frederick Streets, Petersham,
New South Wales
Architects: Rudder and Grout

PLATE 78 (top right)
PETERSHAM TOWN HALL – LIGHT FITTING, 1938
Corner of Crystal and Frederick Streets, Petersham,
New South Wales
Architects: Rudder and Grout

PLATE 79 (middle left)
TOWN HALL – INTERIOR, CIRCA 1939
Campbell Town, Tasmania
Architects: Attributed to H. S. East and Roy Smith

PLATE 80 (middle centre)
GUILDFORD TOWN HALL, 1937
Perth, Western Australia
Architects: Eales and Cohen

PLATE 81 (middle right)
GUILDFORD TOWN HALL, 1937
Perth, Western Australia
Architects: Eales and Cohen

PLATE 82 (bottom left)
HEIDELBERG TOWN HALL, 1937
Upper Heidelberg Road, Heidelberg, Victoria
Architects: Peck and Kemter in association with
Leith and Bartlett

PLATE 83 (bottom centre)
**HEIDELBERG TOWN HALL –
MUNICIPAL OFFICES, 1937**
Upper Heidelberg Road, Heidelberg, Victoria
Architects: Peck and Kemter in association with
Leith and Bartlett

PLATE 84 (bottom right)
MALACHI GILMORE HALL, 1937
Oberon Street, Oberon, New South Wales
Architect: Virgil Cizzio

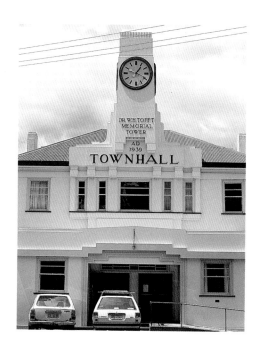

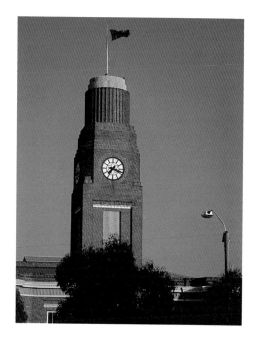

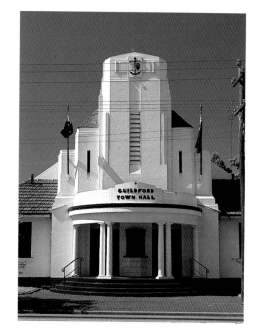

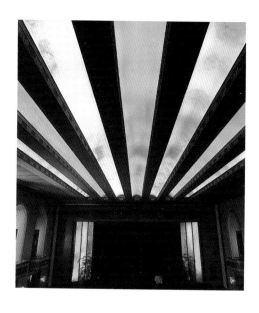

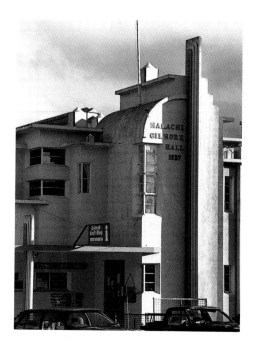

PLATE 85 (top left)
CANBERRA SCHOOL OF ART
(FORMERLY CANBERRA HIGH SCHOOL), 1940
Childers Street, Canberra, Australian Capital Territory
Architects: Department of Works – Charles Whitley

PLATE 86 (top centre)
UNITED DENTAL HOSPITAL,
FIRST STAGE COMPLETED IN 1940
Chalmers Street, Sydney, New South Wales
Architects: Stephenson and Turner

PLATE 87 (top right)
ROBERT GARRAN OFFICES
(FORMERLY PATENTS OFFICE)
Kings Avenue, Barton, Australian Capital Territory

PLATE 88 (middle left)
GEELONG COURT HOUSE, 1938
Corner of Little Malop and Gheringhap Streets,
Geelong, Victoria
Architect: Percy Everett, Chief Architect,
Public Works Department of Victoria

PLATE 89 (middle centre)
SESQUICENTENARY PAVILION, 1938
Royal Agricultural Society Showground, Moore Park,
New South Wales
Architects: Trenchard, Smith and Massey;
glazing by Wunderlich Limited

PLATE 90 (middle right)
AUSTRALIAN CORPS OF SIGNALS
(NOW OCCUPIED BY THE AUSTRALIAN
ARMY BAND), 1935–1936
29 Albert Road Drive, Albert Park, Victoria
Architect: J. MacKennal, Works Director,
Department of the Interior

PLATE 91 (bottom left)
BERESFIELD CREMATORIUM, 1937
Anderson Drive, Beresfield, New South Wales
Architect: Louis S. Robertson and Son

PLATE 92 (bottom centre)
EASTERN SUBURBS CREMATORIUM,
OPENED 8 MAY 1938
Military Road, Matraville, New South Wales
Architect: Louis S. Robertson and Son

PLATE 93 (bottom right)
WORONORA CREMATORIUM,
OPENED APRIL 1934
Linden Street, Sutherland, New South Wales
Architect: Louis S. Robertson and Son

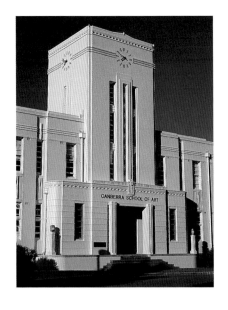

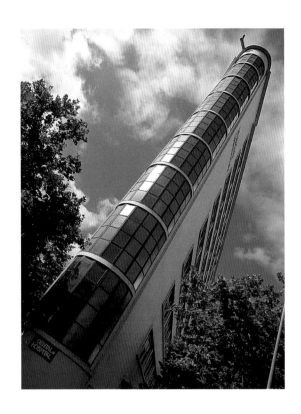

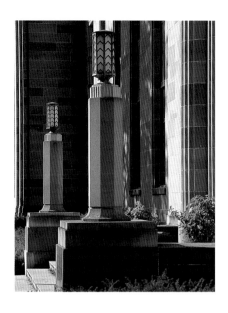

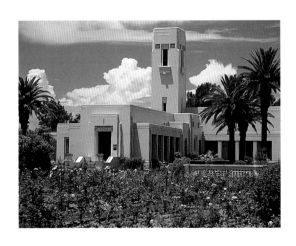

Whatever their external appearance, whether Spanish Mission, Georgian Revival, flat-roofed modern or simply a restrained bungalow, many houses of the 1930s were allied by the existence of at least some internal Art Deco detailing. Geometric cornices and light fittings, stepped plastic electrical switches, fireplaces and utility rooms, such as kitchens and bathrooms, announced the style's presence. Not only that, but houses built after the Second World War also perpetuated this tradition of design and established a strong visual continuity with the late 1930s. Stepped chimneys, horizontal banding on walls and porches with parapets extending well above the eaves line were all a part of the vocabulary of the 1930s which remained popular well into the 1950s. This forms an interesting contrast with their tall brethren, blocks of flats. Although the Art Deco style found ample fulfilment in many of these buildings, its influence was all but spent when their construction revived in the late 1940s.

As in other countries, the wealthy engaged architects to design houses in a variety of styles, many of them conservative. The Georgian Revival and Old English, with dark half timbering and picturesque chimneys and roofs contrasting oddly with red textured bricks, were firm favourites. However, grand exceptions did occur, such as 'Burnham Beeches' near Melbourne (plates 107–109) and 'Everglades' in Leura, one of the string of townships along the main western highway traversing the Blue Mountains to the west of Sydney (plate 106). The house itself is austere from the outside, consisting of roughly rendered walls and a hipped tiled roof. It was designed by C. P. Sorenson and completed around 1936. Wide steel-framed windows, shallow continuous canopies over some windows and a gently curved, cantilevered bay window at the rear of the dwelling, however, provide important clues as to stylistic derivations. Inside, a rich display of finishing and detailing is to be found. A curved stair sweeps upwards to the bedrooms on the first floor, served by a splendid tiled bathroom with mottled cream and brown wall tiles, darker mottled brown floor tiles and dominated by a large faceted bath positioned centrally in the space. Another bathroom is even more spectacular, finished in tones of black and vermilion.

Downstairs, some original furnishings still survive, particularly built-in cabinets housing a writing desk and the like. The living room is dominated by a wide fireplace with a shallow mantel and an arched niche in the chimney breast which originally contained that most Deco of household adornments, a bronze statuette of a twisting and stretching woman. It also contains a built-in cocktail cabinet which additionally held a radio and stored china. A dining room is decorated with murals depicting branches of blossom on the ceiling, and figures in relief on one wall depict various stages in the growth and preparation of foodstuffs.

The real glory of the property, however, is external. The house at 'Everglades' commands beautiful mountain views and is situated within extensive grounds which fall away to a gully. The gardens were also designed by Sorenson and continue to delight visitors with their combination of formal and informal elements, and objects placed within the landscape. These include a little amphitheatre formed by shrubbery and dominated by a shallow pool of water behind which stand the remains of a splendid Victorian structure, transplanted to an almost bucolic setting. Elsewhere, a stone fountain takes the form of a whimsical head of Bacchus, set into an arched niche. The textures of leaf and branch contrast with random, dry rubble walls and expanses of lawn, whilst a large swimming pool and what were originally squash courts beyond provided strenuous recreation for the householders and their guests. The outdoors are brought close to the house by means of flagged terraces and balconies.

House and gardens are unified by decorative wrought iron – some of the finest in this country from the 1930s, and also attributed to Sorenson. Inside, curved iron volutes form the balustrading for the main stair, whilst panels set into walls around the paved courts adjacent to the house depict the adventures of a small dog chasing a peacock. The front pedestrian gate depicts Adam and Eve, whilst external balustrading around the house forms simple geometric patterns. Perhaps the finest of the wrought iron encloses a viewing platform overlooking a waterfall, and consists of a bold zigzagging pattern of overlapping chevrons in true Art Deco formation.

Houses such as 'Burnham Beeches' and 'Everglades', surrounded as they are by lovely gardens and grounds, remain as reminders of the gracious living that was available to those with money during the 1930s. It is no coincidence that they were created by very successful businessmen, key figures in an age dominated by the machinations of the economy.

PLATES 94 to 102

RESIDENCE ON THE NORTH SHORE OF SYDNEY, NEW SOUTH WALES, 1943

Double doors open onto a foyer featuring a grand spiral staircase with a large domed ceiling and chandelier overhead. The large proportions and decorative scale of the foyer create a dramatic effect which further enhances the beauty of the staircase. Accommodation on this level comprises a gracious dining room conveniently served by a butler's pantry, a spacious living room with beautifully curved walls and curving light troughs, a sitting room and a ballroom with polished floorboards, a bar, large etched mirrors and decorative frosted glass doors. A kitchen, laundry, study and staff accommodation complete the ground floor. The upper level comprises a landing that opens onto a terrace overlooking a twelve-metre tiled swimming pool, and also gives access to a large master suite which includes a bedroom, bathroom, dressing room and another terrace overlooking extensive private gardens. There are three additional bedrooms and a bathroom, all executed in authentic Art Deco splendour. Guests can also be entertained on a floodlit tennis court or in the well-stocked wine cellar. Unfortunately, the house could no longer resist the pressure of time and, after forty years of permanent occupancy, was recently sold and all its custom-made furniture auctioned separately.

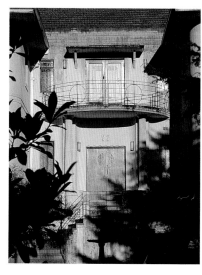

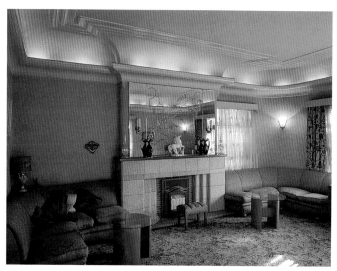

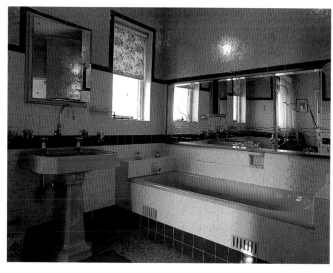

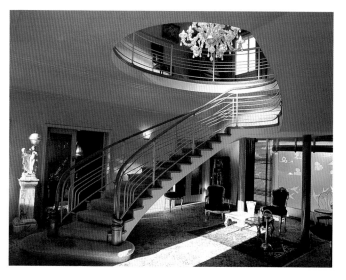

PLATE 103
**RESIDENCE ON THE NORTH SHORE OF SYDNEY,
NEW SOUTH WALES, 1943**
This leadlight window situated inside the garage has
been designed as a stylised geometric flower.

PLATE 104 (opposite page)
'MAHRATTA', 1941
Upper North Shore of Sydney, New South Wales
Architect: Douglas Agnew
Originally built for Mr T. A. Field, 'Mahratta' subsequently served as a training centre for one of the large banks but has since changed hands. One of the bathrooms in the house is still quite original, and includes this enclosing and sculptural shower recess. The cream-toned ceramic tiles are very typical of the 1930s – tiling in bathrooms was absolutely *de rigueur* for any bathroom of the period.

PLATE 105 (above)
'MAHRATTA', 1941
Upper North Shore of Sydney, New South Wales
Architect: Douglas Agnew
A richly veined marble fireplace with reeded sides and horizontal reeding over the firebox is somewhat incongruously embellished with a circular plaque graced by a ballerina. The slender bricks lining the firebox and forming the hearth are characteristic of the period.

PLATE 106
'EVERGLADES', 1936
Leura, New South Wales
Designer: C. P. Sorenson
'Everglades' was built for Henri Van de Velde, managing director of Felt and Textiles
(Australia) who made, amongst other items, Feltex Carpets. Its largely intact interior
includes this fine bathroom, characteristic of those found in the houses of the wealthy
during this period. The ceramic wall tiles are exceptional because of their rich
and intense colouring, as is the luxurious bath which dominates the space.

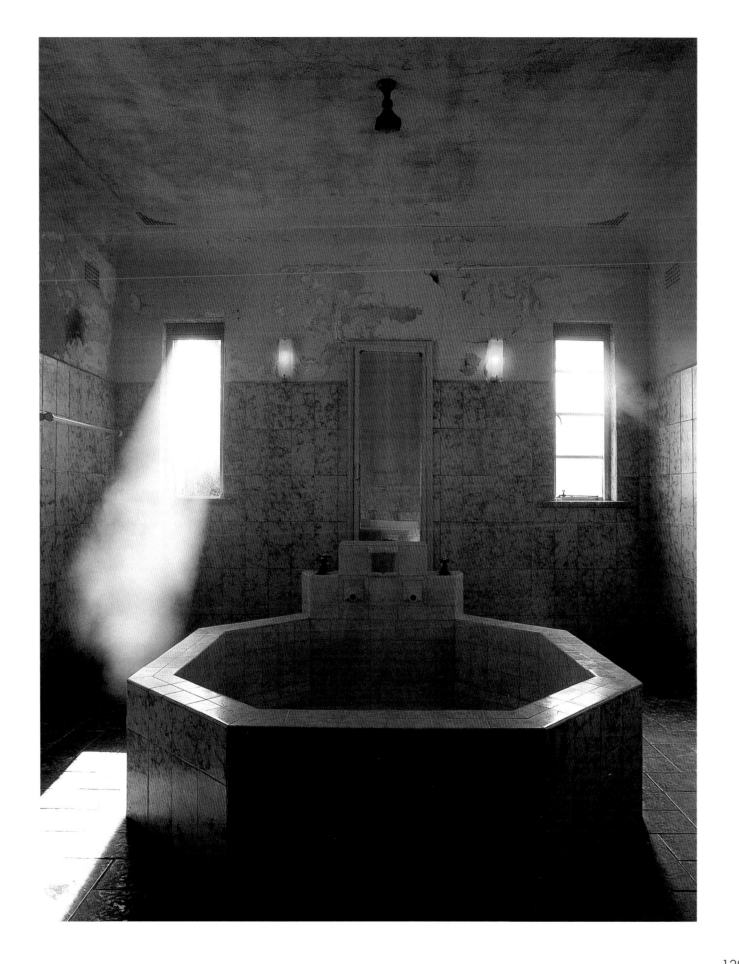

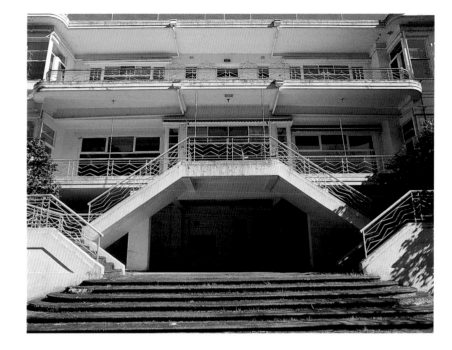

PLATE 107
'BURNHAM BEECHES', 1933
Sherbrook Forest, Victoria
Architect: Harry Norris
This residence was built for the pharmaceutical mogul,
Alfred Nicholas. Architect Norris designed a streamlined three-
storey mansion reminiscent of a large ship. The most frequently
used Art Deco motif, the zigzag, forms the basis of the decorative
wrought iron balustrading surrounding terraces and balconies,
as seen here at the back of the house.

PLATE 108
'BURNHAM BEECHES', 1933
Sherbrook Forest, Victoria
Architect: Harry Norris
The main stair, with its hammered iron balustrading capped by
a chrome-plated handrail, turns through almost three-quarters of
the elliptical space which it occupies to reach the first floor.
It is encircled by an ambulatory enclosed by large plate-glass
windows separated by simple piers. From here, one commands
extensive views of the rolling mountainous forest through a
sweep of more than one-hundred-and-eighty degrees.

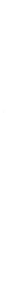

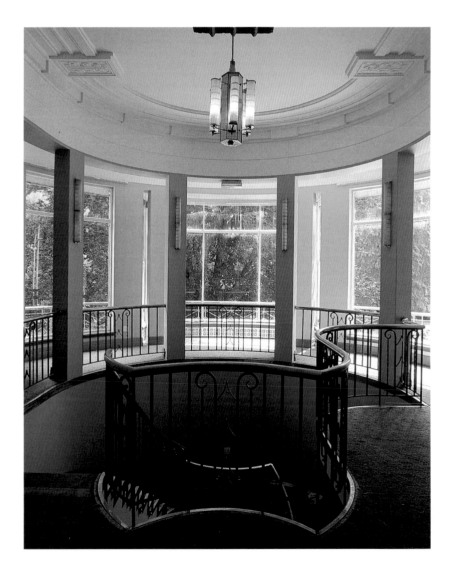

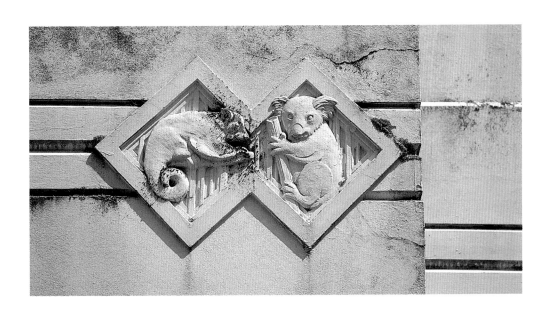

PLATE 109
'BURNHAM BEECHES', 1933
Sherbrook Forest, Victoria
Architect: Harry Norris
The exterior of the house, constructed of reinforced concrete, was originally painted white and is decorated with a series of moulded panels depicting possums and koalas. Using the latest in modern ornamentation and up-to-date materials, no other example of domestic architecture in Victoria at this time excited so much public interest and comment.

PLATE 110
RESIDENCE IN KILLARA, NEW SOUTH WALES, 1939
Architect: J. Aubrey Kerr
After some negotiating, Genevieve bravely agreed to
pose for this shot in the comfort of her elegant home.

PLATE 111 (opposite page)
RESIDENCE
Corner of Homer and Minnamora Streets,
Earlwood, New South Wales
This detail highlights what has been termed
the 'Oceanliner' style. Forward motion is created by
the wave in the wall which forms the fence against
the ship's bow, and the intersecting middle line is the
waterline. The tubular steel railing completes
the nautical effect.

PLATE 112 (above)
RESIDENCE
Hawkin Drive, St Lucia, Queensland
The elevator grille inside this private home
shows a circle with a triple lightning bolt in a slashing
diagonal pattern made from chromium-plated metal.

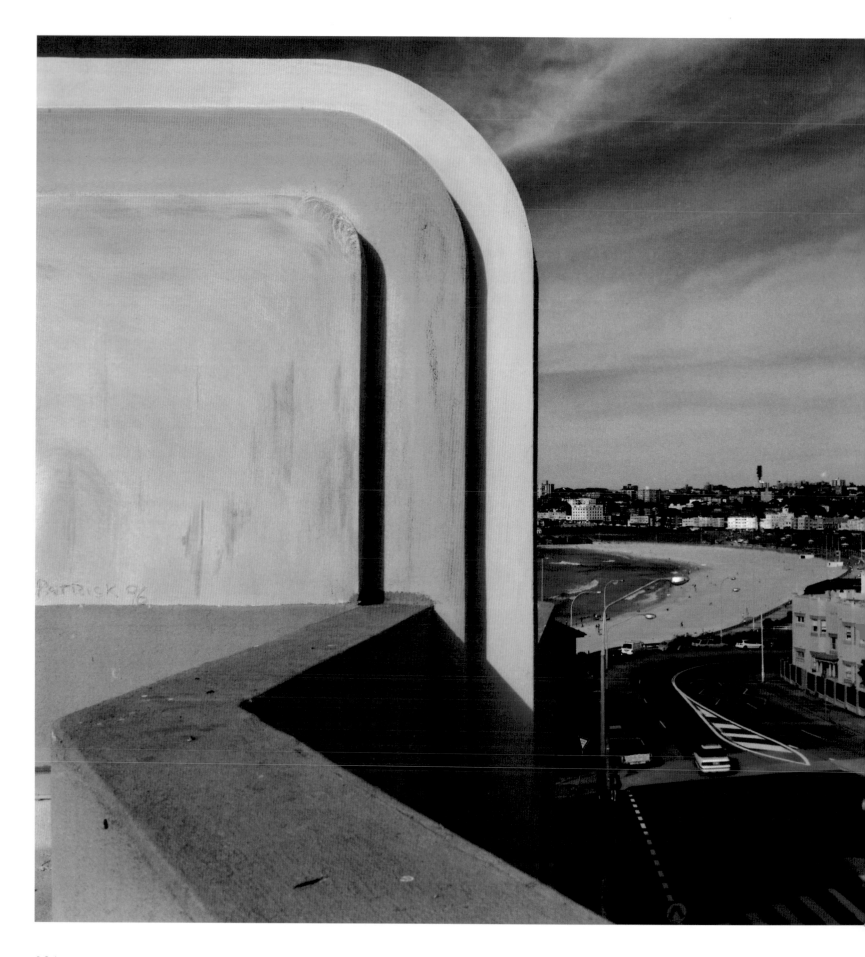

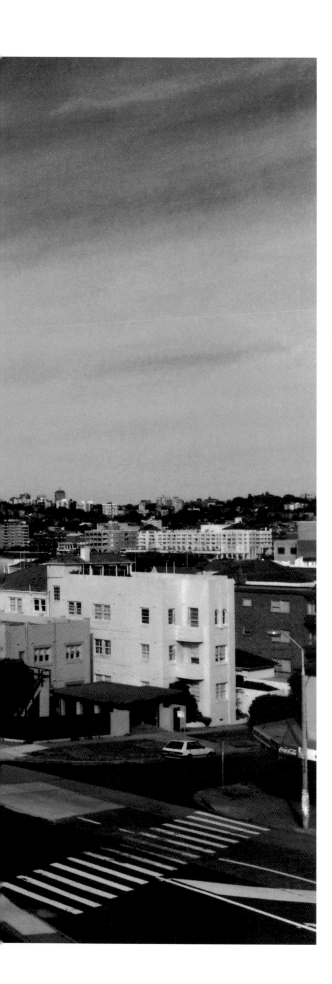

PLATE 113
BLOCK OF FLATS
35 Campbell Parade, Bondi Beach, New South Wales
This finial, reminiscent of the world of the comic strip hero, Buck Rogers, proudly stands overlooking Bondi Beach.
One of the more popular of Sydney's metropolitan beaches, the locality experienced enormous growth in the
1930s. Attempts are under way by the local municipal council to encourage a unified colour scheme for
buildings – similar in effect to the gelato-like colours of Miami Beach, Florida, in the United States.

PLATE 114 (above)
BLOCK OF FLATS
Corner of Bourke and Foley Streets,
Darlinghurst, New South Wales
The sleek, streamlined design of this small
inner-city block of flats is reinforced in a
characteristic manner by slim canopies
above the heads of the windows. Curved
glass in corner windows ably assists the
building to slide around a tight corner.

PLATE 115 (opposite page)
BLOCK OF FLATS
57 Ramsay Street, Haberfield,
New South Wales
The positive golden glow of the rising sun
is one of the most enduring of Art Deco
images, used in many different guises. It is
therefore a happy coincidence that Australia
is blessed with abundant sunshine. The motif
has been used to good effect in this leadlight
window which illuminates the stairs serving
the flats.

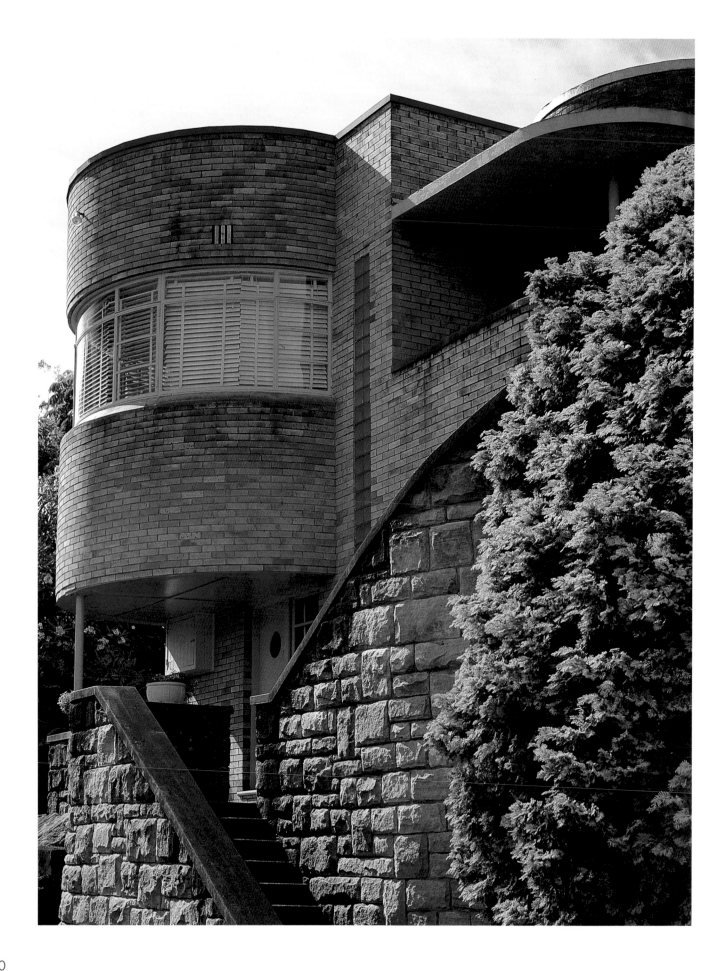

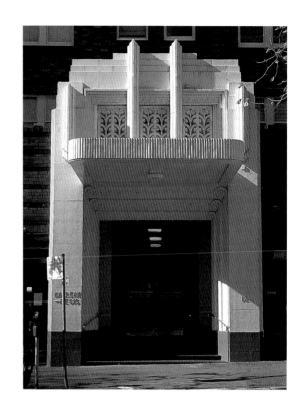

PLATE 117
'MACLEAY REGIS', 1939
12 Macleay Street, Potts Point, New South Wales
Architects: Eric Pitt and C. C. Phillips
'Macleay Regis' is one of the very largest of the tall apartment
blocks built in the adjacent localities of Potts Point and Elizabeth
Bay. Its H-shaped plan allows for maximum sunlight to
penetrate into each apartment. Its solid brick bulk is relieved by
small quadrant-shaped balconies with elegant pipe railings. At
ground level, the building announces its presence by a
commanding Art Deco–style portal – the finest in the area.

PLATE 116 (left)
RESIDENCE
The Boulevarde, Cammeray, New South Wales
A smaller suburban home built on a steeply falling site, the
confident horizontal parapets conceal a cautious tiled hipped
roof. The house is quite dramatic with its bold curved forms and
slashing diagonal stair, and because of the materials used in its
construction – rusticated sandstone, pale bricks, steel-framed
windows – it is visually rich.

PLATE 118
'TIBERIUS'
Corner of Albert and Eastern Roads, South Melbourne, Victoria
An ornamental gate to a block of flats enlivened by hunter and prey – a
muscular big cat and an agitated, archetypal Art Deco deer. This motif is
repeated throughout the building on walls and mantelpieces within the flats.

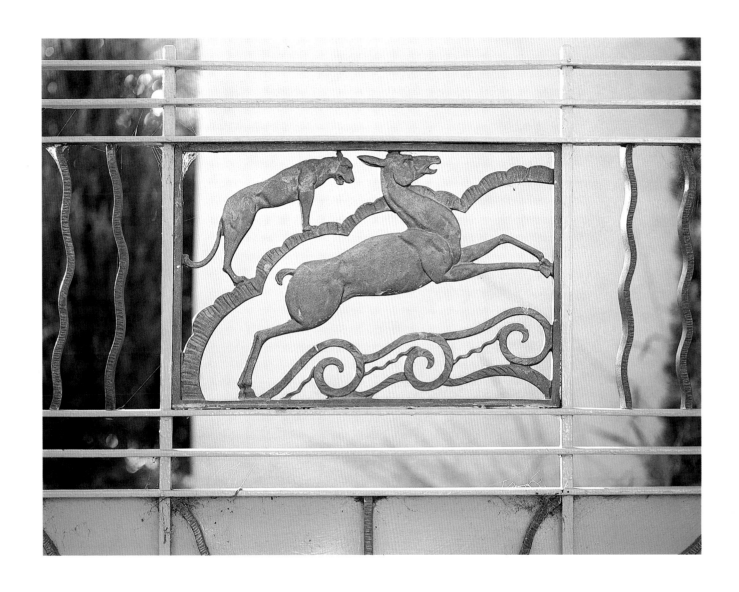

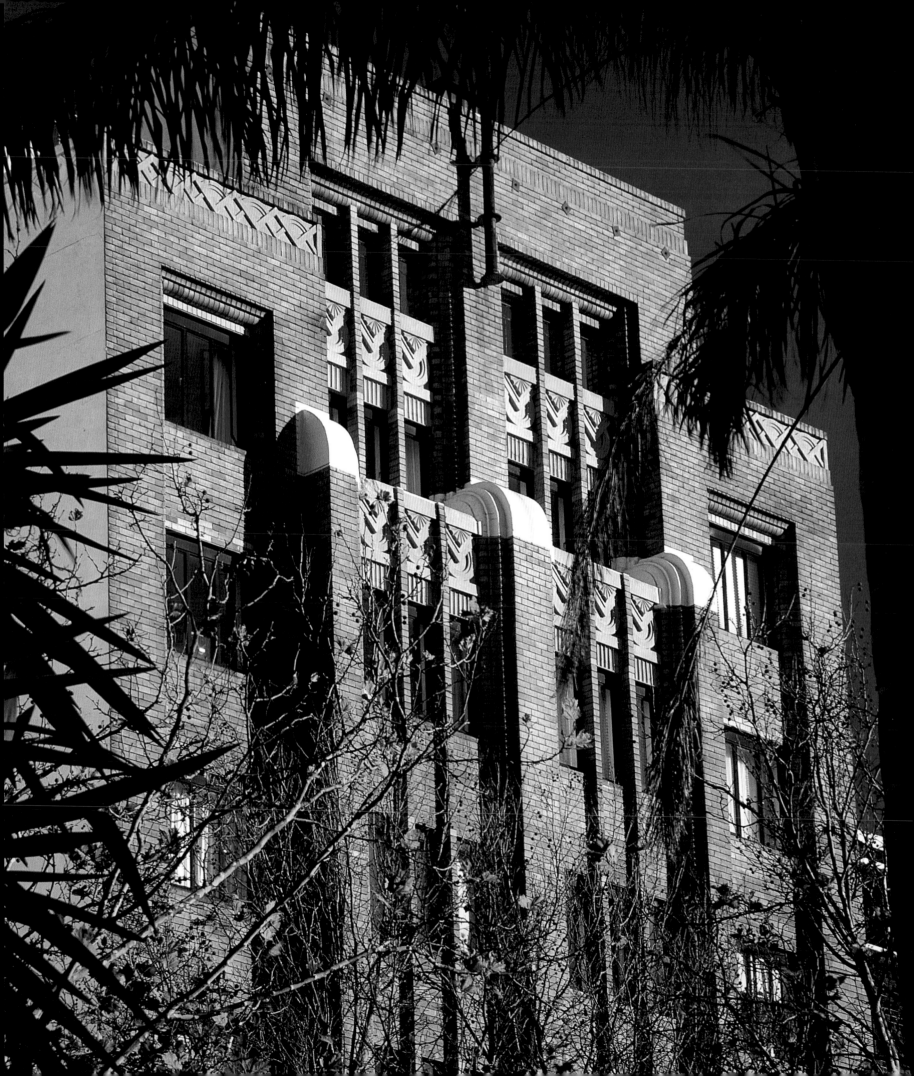

PLATE 119 (below)
'REDLANDS'
23 Bradley Street, Randwick, New South Wales
A stylish doorknocker incorporates two of the most
common Art Deco motifs, the stepped ziggurat and
the radiating lines of the rising sun.

PLATE 120 (opposite page)
'CAHORS', 1940
117 Macleay Street, Potts Point, New South Wales
Architects: Joseland and Gilling
'Cahors' is another of the large apartment blocks in
this locality. Its then-fashionable blond brickwork rises
above an entry portal lined with large pale blue
terracotta tiles. High above, a geometric screen
creates skyline interest and prosaically conceals
machinery on the roof.

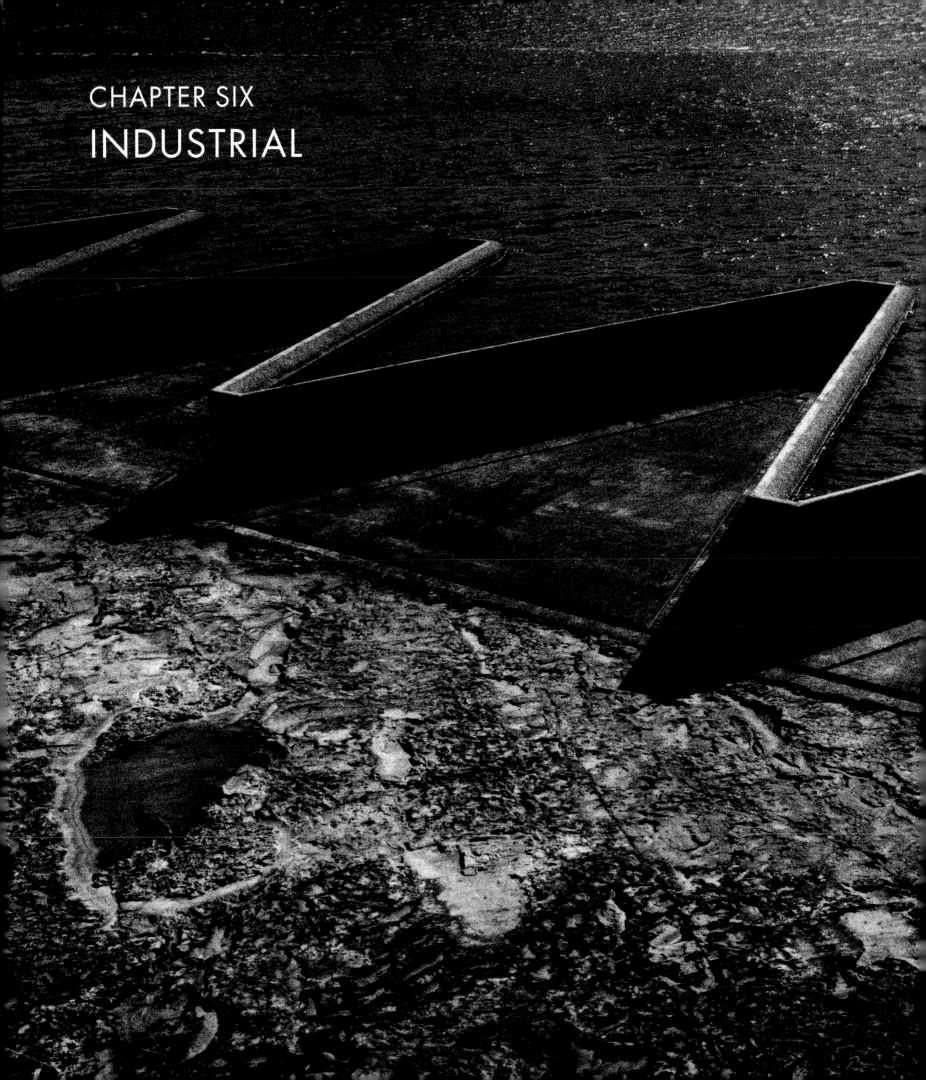

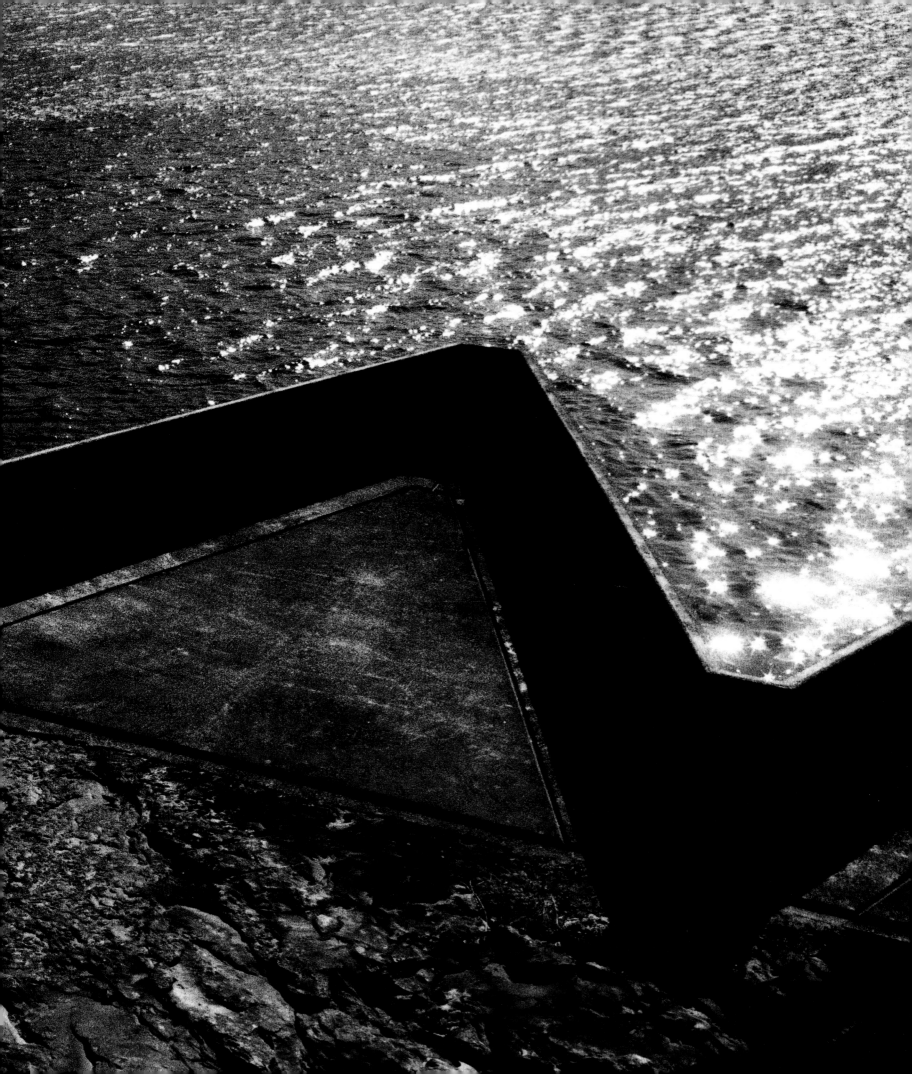

The architecture and structures of manufacturing and industry, more than any others of the inter-war period, were marked by the guiding influence of engineers. The very great beauty which emerged in mighty projects such as the Sydney Harbour Bridge and even the small-scale factory resulted from the exploitation of materials and technology used in a rational, economical fashion. Here, the Art Deco style was almost incidental, a final embellishment which simply highlighted the position that these various projects held as modern structures. Amongst the finest industrial undertakings of the period was the series of dams constructed in various parts of New South Wales.

Large cities depending on unfailing rivers or other sources of supply did not need to store as much water for their populations as did Sydney, which has a history of erratic water supply. The construction of streamlined dams between 1907 and 1960 for the Upper Nepean River Scheme display a designer's eye for beauty made possible by engineering skill and much-needed hard labour. The record drought which occurred between 1934 and 1942 brought the emergent metropolis perilously close to a complete water shortage. Funds were made available for the relief of unemployment and the development of areas under the Metropolitan Water Sewerage and Drainage Board's control. In this way, the Warragamba Emergency Scheme was financed and staffed. Four years of almost superhuman effort, from 1937 to 1940, not to mention all the resources of the Water Board, averted the worst possible crisis for Sydney – a total failure of water supply – but drastic restrictions were imposed.

In 1941, the Water Board adopted a resolution making Warragamba Dam the most urgent of its construction works (plate 145). The beautiful Warragamba Gorge, to the south-west of Sydney, was chosen as the most suitable site for a narrow gravity dam that could impound a tremendous quantity of water and solve Sydney's water supply shortfall forever. The dam wall is 351 metres long, curves steeply for a height of 142 metres and is punctuated by two stripped classical towers housing service lifts which gently glide into the cyclopean concrete mass. The five release gates at the crest are separated by piers rising from the wall which support the road bridge above. A suspension bridge was built to provide pedestrian access to the work site from the township built to house the workers. It is one of the largest domestic supply dams from this period in the world, holding 2,057,000 megalitres, or four times the capacity of Sydney Harbour.

Restrained energy is unleashed in the hydro-electric station at the downstream end of the east bank training wall, providing fifty megawatts to fifty-thousand homes.

In the years between the Depression and the carnage of the Second World War, the desire to build rather than destroy was given meaningful expression in an industry that normally enjoyed little esteem. Built to be beautiful under trying circumstances, and with all the scars of construction having long since healed and receded, the dam is a highly visible and much-appreciated contribution to a young nation's resources.

Note: This text has been derived from Margo Beasley, *The Sweat of their Brows – 100 Years of the Sydney Water Board, 1888–1988*, Water Board, Sydney, Illawarra, Blue Mountains, 1988.

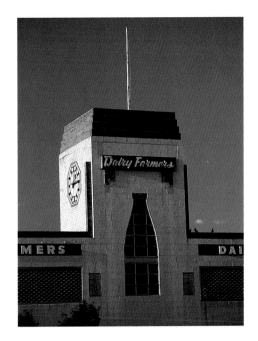

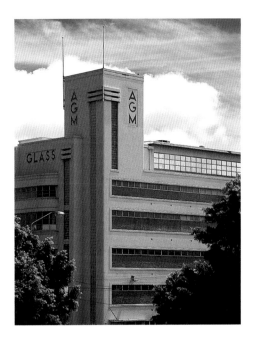

PLATE 121 (above)
SEWER VENT, LINCOLN STREET, HIGHGATE,
PERTH, WESTERN AUSTRALIA, 1941
Designed by the Metropolitan Water Supply
and Drainage Board

PLATE 122 (above right)
DAIRY FARMERS DEPOT, 1938
924 Hunter Street, Newcastle, New South Wales
Architect: A. C. Likely

PLATE 123 (above far right)
INCINERATOR, 1937
Thebarton, South Australia
Architect: Walter Burley Griffin

PLATE 124 (right)
JOHN FAIRFAX AND SONS LIMITED GENERAL
STORE (FORMER WESTCOTT-HAZELL BUILDING),
513–519 Wattle Street, Ultimo, New South Wales

PLATE 125 (left)
OAK DAIRY
Hunter Street, Muswellbrook, New South Wales

PLATE 126 (far right)
AGM BUILDING, 1941
South Dowling Street, Alexandria, New South Wales
Architect: Australian Glass Manufacturers

PLATE 127 (opposite page)
INCINERATOR, 1937
Pyrmont, New South Wales
Architect: Walter Burley Griffin
Photograph courtesy of Fairfax photo library
This, the finest of all of Burley Griffin's incinerators, was finally demolished in the early 1990s to make way for a nondescript block of flats. Its low horizontals were balanced by a tall rectilinear flue, but the most outstanding element of the building was its rich decoration, which was varied across the building. Betraying Griffin's awareness of Mayan architecture, its incised geometries enlivened large surfaces through contrasts and repetitions of pattern and a wealth of complex textural juxtapositions.

PLATE 128 (below)
FORMER TOP DOG FACTORY, 1949
800 Pittwater Road, Dee Why, New South Wales
Architects: Spencer and Bloomfield
This, one of the finest manufacturing buildings erected in New South Wales, is (at time of writing) undergoing major modifications and refurbishment. The building is an interesting reflection of the influence of Dudok's architecture, which informed so much of Australia's architecture during the 1930s and 1940s. Its composition, a pleasing and subtle combination of rectilinear horizontal and vertical masses highlighted by clean surfaces of painted cement render, is emphasised and counterpointed by voids resulting from bands of windows. A wide curved bay at one end completes the ensemble.

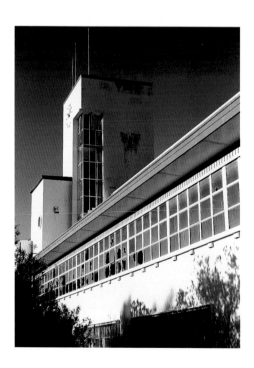

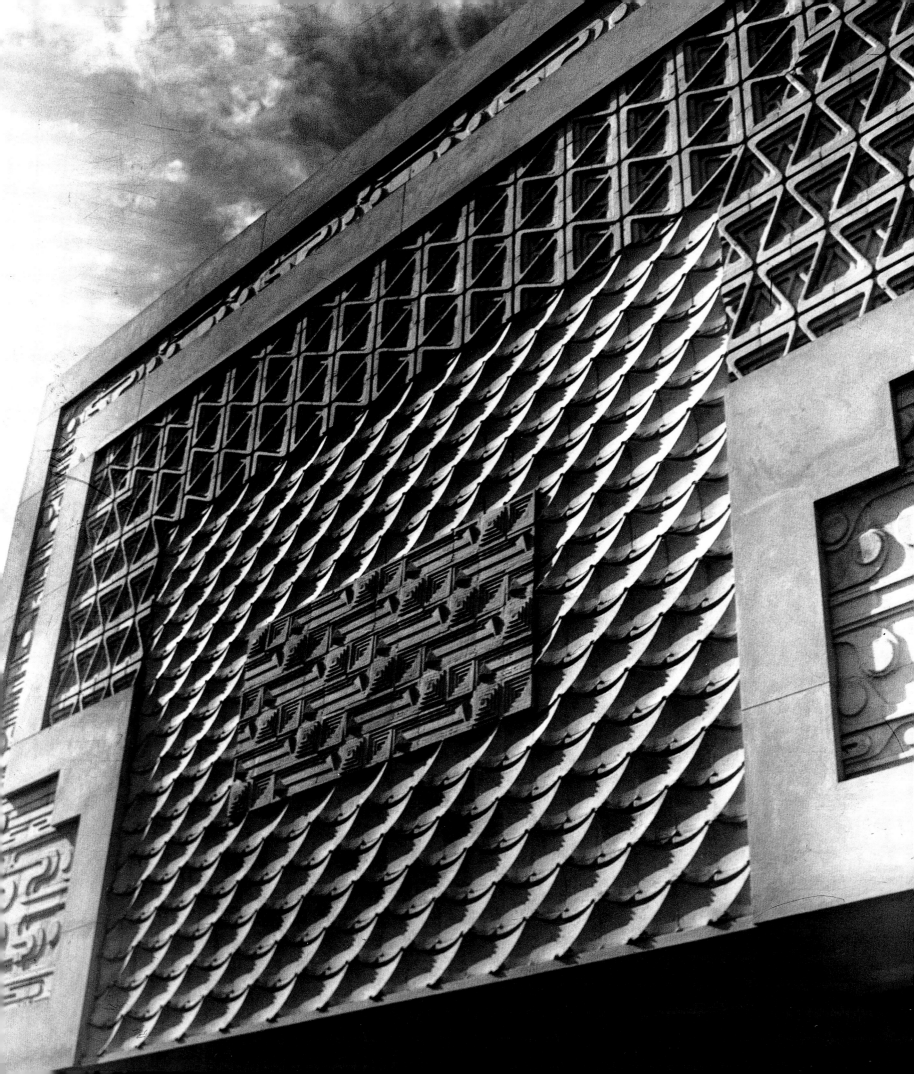

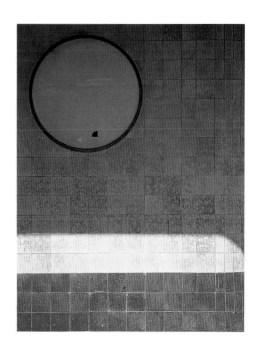

PLATE 129 (above)
**JOHN FAIRFAX AND SONS LIMITED GENERAL
STORE (FORMER WESTCOTT-HAZELL BUILDING),**
513–519 Wattle Street, Ultimo, New South Wales

PLATE 130 (opposite page)
**FORMER TOP DOG FACTORY –
BUS SHELTER, 1949**
800 Pittwater Road, Dee Why, New South Wales
Architects: Spencer and Bloomfield

PLATE 131 (right)
KEABLE FACTORY AND OFFICE, 1938
187–189 A'Beckett Street, Melbourne, Victoria
Architect: Edward Bilson

PLATE 132 (far right)
SYDNEY AUCTIONEERS AND VALUERS
3–7 The Crescent, Annandale, New South Wales

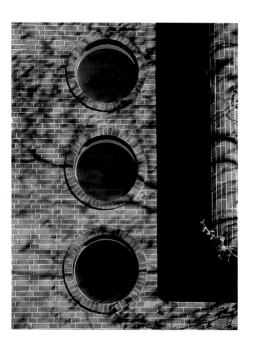

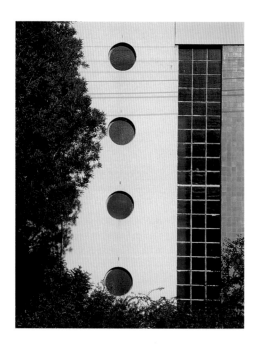

These four images reveal the variety achieved in Art Deco architecture even when using the same basic elements. All approach the status of industrial-age sculpture and reveal the importance of light moving across surfaces. The geometric abstraction of plane and circle unites the four disparate structures and in the case of the John Fairfax and Sons Limited General Store this is achieved by juxtaposing tile and painted render. The bus shelter contrasts solid with dark circular void, framed by three-dimensional circles, whilst the sensuous sophistication of the Keable Factory and Office exploits the texture and modular properties of brick. Repetition and contrast serve the building occupied by Sydney Auctioneers and Valuers – a line of portholes in a smooth expanse is effectively counterpointed by the grid of mauve tiles.

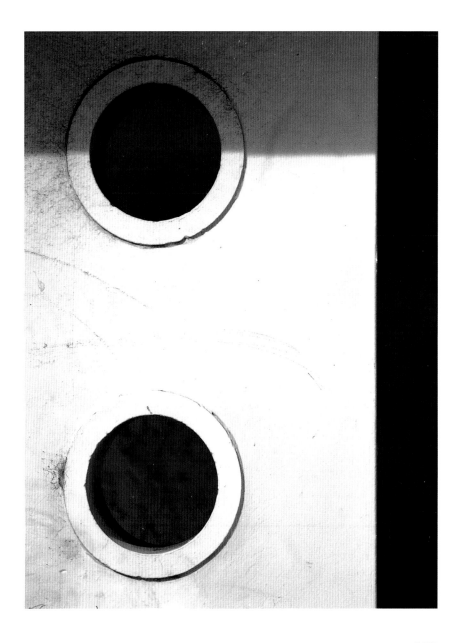

PLATE 133
SYDNEY HARBOUR BRIDGE,
OPENED TO THE PUBLIC ON 19 MARCH 1932
Designed by J. J. C. Bradfield, New South Wales Government Chief Engineer,
in association with Dorman Long and Co. who were responsible for construction
This powerful, internationally acknowledged work and major industrial feat symbolises the era between the wars and
the triumph and optimism of modern technology, proving that there need be no conflict between art and engineering.
Rather – in this beloved popular icon – they merge into one as the massive steel sections join to create a silhouette
which might almost be a giant sunrise over the waters below.

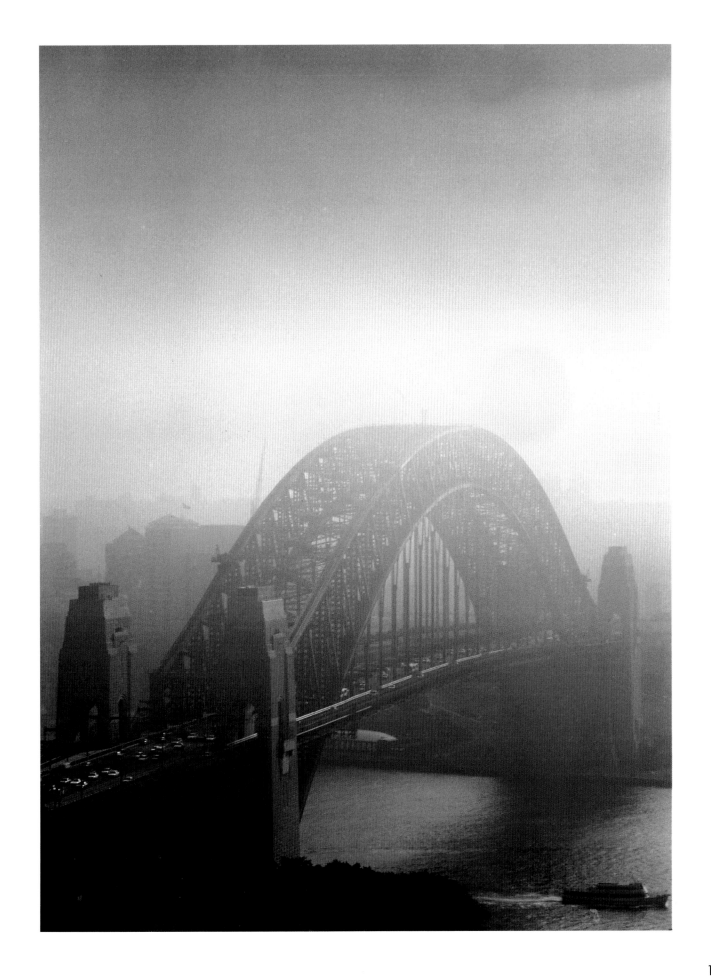

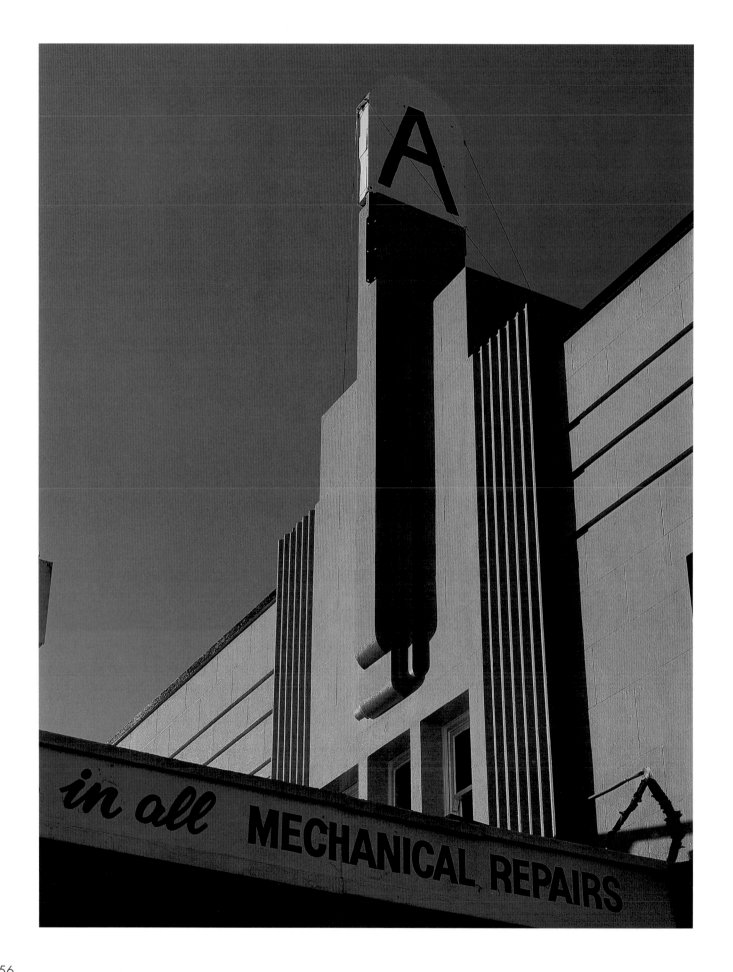

PLATE 134 (opposite page)

ABRAHAM'S SERVICE STATION

Corner of Parramatta Road and Sloan Street,
Summer Hill, New South Wales

At the dawning of the motor age, modern service
stations appeared all over the urban landscape.
Like their picture theatre and hotel counterparts,
they were imbued with a great deal of imaginative
architecture. A stepped tower with triple horizontal
banding cleverly incorporates the initials of the
business on its crest to create an arresting identity.

PLATE 135 (above left)

TRU-MOLD TYRES

205–207 Queens Parade, Clifton Hill, Victoria

In an industry in which competition was rapidly
increasing, young architects were encouraged to
give free reign to their fantasy to manufacture a kind
of disposable 'pop' architecture. At a busy traffic
junction in suburban Melbourne, streamlined
ornament, perhaps emulating tyre treads, is used
to attract the passing motorist's attention.

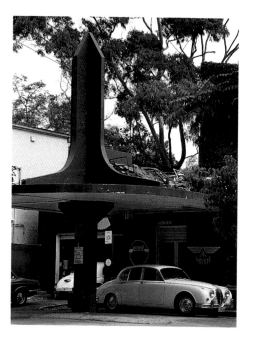

PLATE 136 (bottom left)

FORMER HAHN AUTOMOTIVE SERVICES

117 Cleveland Street, Darlington, New South Wales

An overhanging canopy topped by a soaring rocket-
like spire gives this building great presence and
expresses an optimism about technology and progress.
But the short lifespan of the small independent service
station operators, selling many brands of petrol, soon
came to an end after the Second World War with the
introduction of bigger stations, tied to one company,
who offered uniformed attendants, clean rest rooms
and many bonus offers to take the major share of
business. Those very few left standing are now
decaying roadside cultural icons of the romantic
era of rubber and petroleum.

PLATE 137

FORMER METROPOLITAN WATER SEWERAGE
AND DRAINAGE BOARD BUILDING, 1940

339–341 Pitt Street, Sydney, New South Wales

Architects: H. E. Budden and Mackey

These three bronze relief sculptures above the main entry of the building are the result of a competition won by Stanley Hammond of Melbourne. They represent, in a mildly allegorical form, the exploitation of water resources. That in plate 137A is inscribed 'The Noblest of the Elements is Water' and symbolises the early efforts of pioneers to ensure a reliable water supply. Plate 137B, 'The Progress of Mankind', symbolises the abundance provided by the Water Board, whilst plate 137C represents industry and progress ably assisted by the control of water. Its inscription reads 'Pure Water is the Best of Gifts that Man to Man May Bring'.

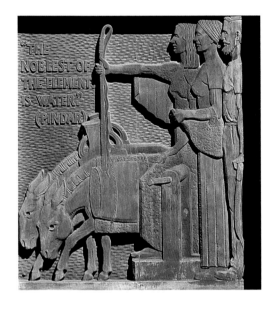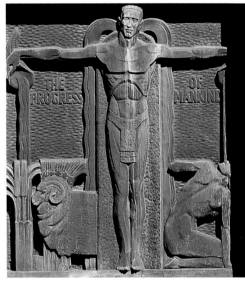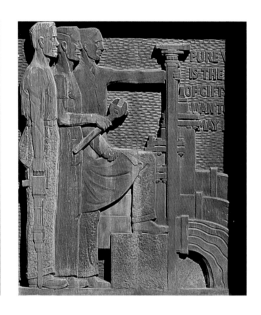

PLATE 138 (top left)
CORDEAUX DAM,
CONSTRUCTED BETWEEN 1919 AND 1926
West of Towradgi, New South Wales
Designed by the Department of Public Works in
association with the Metropolitan Water Sewerage
and Drainage Board
Howard Carter's discovery of Tutankhamen's tomb in
1922 ensured that the world would remember the
ancient civilisation of Egypt for many years to come.
Four years after this momentous event, the Cordeaux
dam was enhanced by Egyptian-revival gates at both
ends of the dam wall. These consist of portals
supported on columns resembling bound papyrus, set
between monumental battered pylons.

PLATE 139 (top centre)
AVON DAM,
CONSTRUCTED BETWEEN 1920 AND 1927
East of Yanderra, New South Wales
Designed by the Department of Public Works
in association with the Metropolitan Water
Sewerage and Drainage Board
A similar Egyptian idiom was chosen for the Avon
Dam, but here, the gates – reminiscent of a small
Egyptian temple – impart a vaguely neoclassical
feeling. A degree of authenticity is achieved through
the design of the columns, the heavy beam over, and
the battered pylons. It is almost as if the supply of water
is equated with a place where eternity is to be found.

PLATE 140 (top right)
NEPEAN DAM – THE SPILLWAY,
CONSTRUCTED BETWEEN 1925 AND 1935
East of Yanderra, New South Wales
Designed by the Department of Public Works in
association with the Metropolitan Water Sewerage
and Drainage Board
The flood-retaining spillway wall snakes away into the
distance like an attenuated and streamlined monolith.
Even here, the battered plane and the coping along its
top evoke the monumentality of the ancient Egyptian
culture.

PLATE 141 (middle)
WORONORA DAM – THE SPILLWAY,
CONSTRUCTED BETWEEN 1927 AND 1941
Near Eckersley, New South Wales
Designed by the Department of Public Works in
association with the Metropolitan Water Sewerage
and Drainage Board
The exigencies of engineering efficiency created a
zigzagging form recalling one of the primary
decorative motifs of the Art Deco style.

PLATE 142 (bottom left)
BURRINJUCK DAM,
CONSTRUCTED BETWEEN 1907 AND 1956
West of Goodradigbee, New South Wales
Designed by the engineers of the Department of
Water Resources in association with the Department
of Public Works
Construction started in 1907 to provide water for the
Murrumbidgee Irrigation Scheme, and was largely
completed by 1925. Construction on enlargement of
the spillway and other works were commenced in the
1930s and finally completed in 1956.
 This was the first major dam built for irrigation in
New South Wales under the Murrumbidgee Irrigation
Scheme. Construction started in 1907, but due to
delays caused by the shortage of labour and materials
during the First World War, the original design was
not completed for twenty years. After massive flooding
in 1925, alterations and improvements to the dam
began in the 1930s, but work was again disrupted
because of the Second World War. The regular
incisions designed as part of the structure of the dam
way impart a serene classical character, but, like so
many buildings of the 1930s, the faceting at their
apexes hints at Art Deco stylism.

PLATE 143 (bottom centre)
BURRINJUCK DAM – THE POWER STATION, 1935
West of Goodradigbee, New South Wales
Designed by the engineers of the Department of
Water Resources in association with the Department
of Public Works
The Burrinjuck power station turbines look like a set
abandoned from Fritz Lang's dystopic 1927 movie
classic, *Metropolis*. The eventual and widespread use
of electricity inspired the expression of many artists.

PLATE 144 (bottom right)
KEEPIT DAM – THE RELEASE VALVES,
ERECTED BETWEEN 1939 AND 1960
Fifty-six kilometres west of Tamworth near
Gunnenbene, New South Wales
Designed by the engineers of the Department of
Water Resources in association with the Department
of Public Works
Although construction of this dam extended beyond
the inter-war period, elements of the aesthetics of the
1930s are firmly in evidence. Witness to this are the
lines inscribed into the concrete – parallel streamlines
and vertical 'finials'. That the nautical imagery of
tubular steel railings was equally a part of the
architecture of industry is borne out by the testament of
the spare metal walkway.

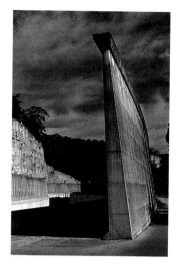
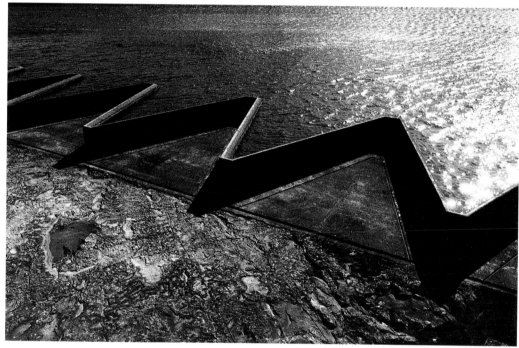
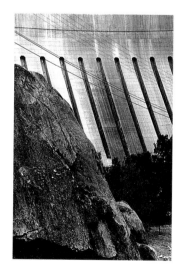

PLATE 145
WARRAGAMBA DAM,
CONSTRUCTED BETWEEN 1941 AND 1960
Warragamba, New South Wales
Designed by the Department of Public Works
in association with the Metropolitan Water Sewerage
and Drainage Board

> At dawn the river has a dream-like air;
> A bird's call echoes, with a liquid sound
> A fish leaps up towards its prey.
> A rare and lovely calm is on the scene …

Eric R. Irvine, *The Reticulator*, 15 October 1938
(Quoted in Margo Beasley, *The Sweat of their Brows –*
100 Years of the Sydney Water Board, 1888–1988, Water
Board, Sydney, Illawarra, Blue Mountains, 1988.)

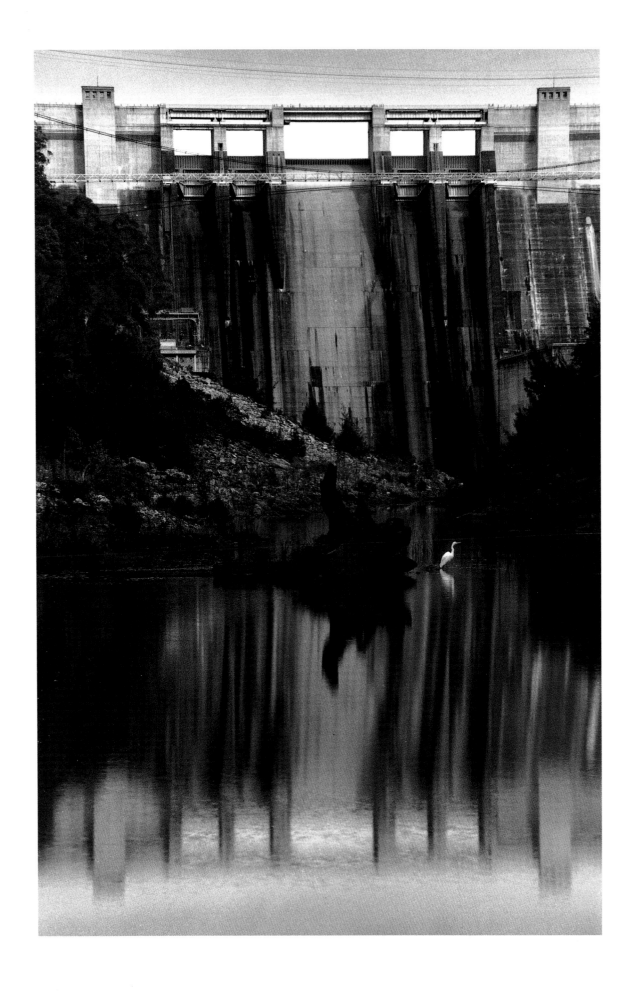

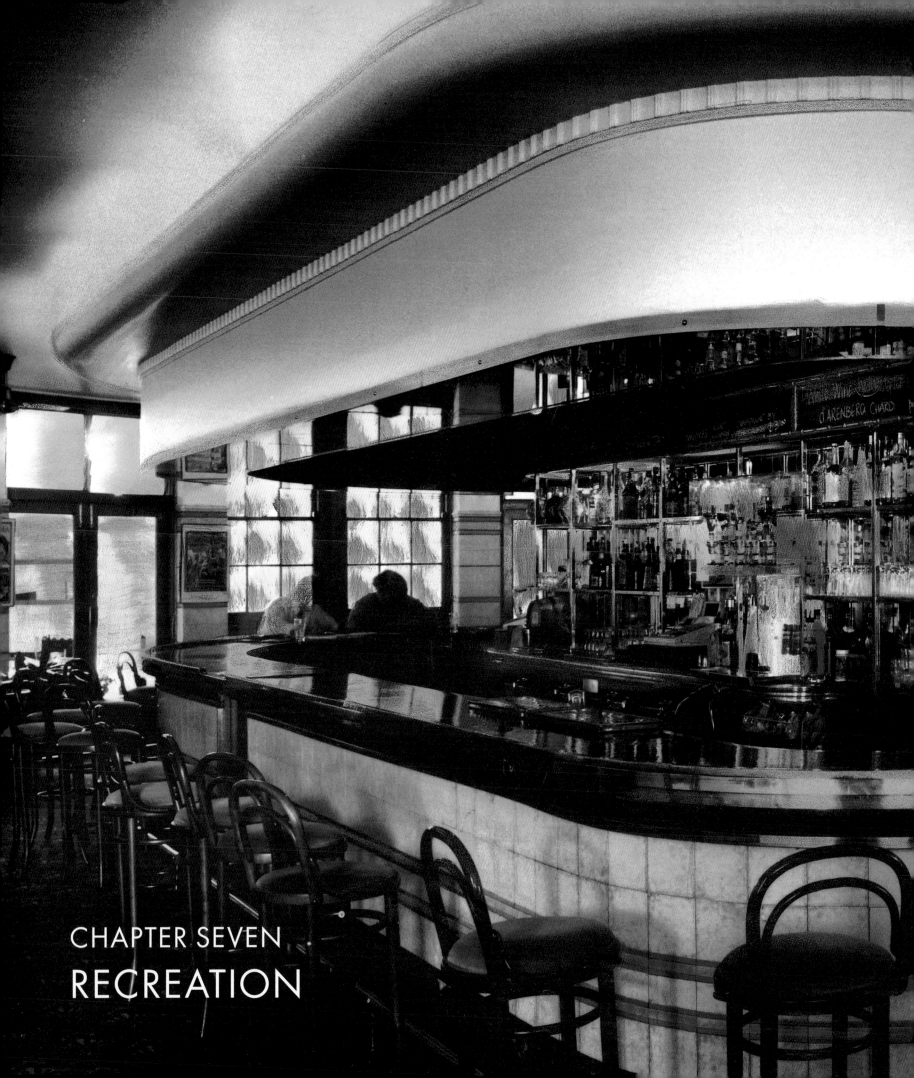

CHAPTER SEVEN
RECREATION

Apart from the various buildings erected for recreation – pubs, swimming pools, sporting facilities, even cinemas – perhaps none holds a warmer place in the sentiments of many Sydneysiders than the harbourside amusement complex known as Luna Park (plates 169–170).

The first Luna Park, built in 1903 on Coney Island in New York, had a legacy which began with the great international rivalry expressed by international expostions following the Great Exposition of 1851 in London. The Columbian Exposition in Chicago, held during 1893 and 1894 included exhibits arranged along a mile-long midway where exotic buildings competed for the visitor's attention – a street in Cairo, an Egyptian temple, a Persian palace, a Japanese market and a Turkish village. This assortment of indigenous architectural styles and their impermanent methods of construction proved to have an enormous influence on the design of the amusement park.

At the onset of the twentieth century, the popularity of these parks derived in part from their owners' capacities to invoke change quickly and adapt the latest technological innovations, in the form of spectacles and rides. Shut away from the sordid turmoil and clatter of city streets, one could experience almost any part of the universe – certainly a great novelty before film, television and inexpensive global travel became accessible. Such was the impact of the amusement park phenomenon that the concept soon spread around the world, and eventually six amusement parks were built in Australia. Australia's first was built in St Kilda, Victoria, followed by Glenelg in South Australia, Manly in New South Wales, Scarborough Beach in Western Australia, Redcliff in Queensland, and, of course, Sydney's Luna Park.

When applications were sought for the site located beneath the Sydney Harbour Bridge at harbourside Lavender Bay – which had contained workshops built for the construction of the bridge – it was not without initial resistance. The mayor of Willoughby, a neighbouring municipality, claimed that 'the amusement park would deteriorate property and attract an undesirable element into the area'. One Reverend Calder elaborated further: 'If a Luna Park of any description were erected here it might become a menace to the morals and well-being of the people. There would be nightly orgies which could not be checked.' But the desperate need for distraction prevailed and hundreds of skilled tradesmen, many of whom had previously worked on the Harbour Bridge, lined up outside the gates of the construction site for the contractors, Stuart Bros, to make a selection.

Luna Park was officially opened to the public on 4 October 1936. The colossal face and towers forming the main entry to the park were illuminated by brightly coloured neon lights rented from Ray Neon and laughter was broadcast from the base of the towers. Amongst the

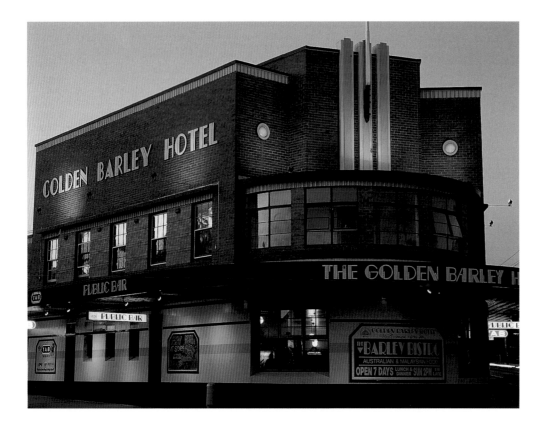

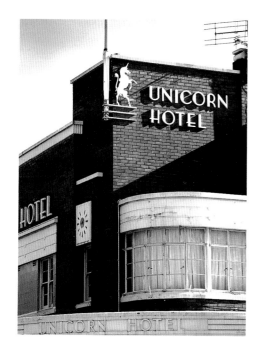 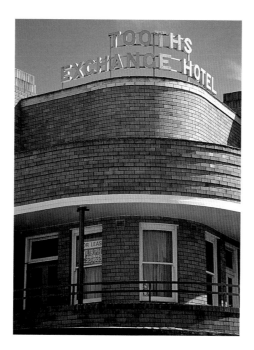 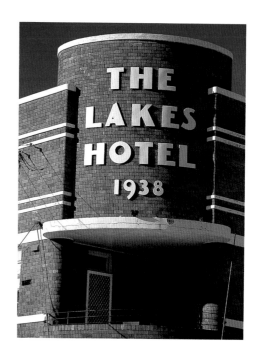

countless rides and games to be enjoyed were the Big Dipper, River Caves, Goofy House, Noah's Ark, Tumble Bug, Penny Arcade, Dodgem Building and Speedboat Rides around Lavender Bay. In its heyday during the war years, a dance hall decorated in the Art Deco style was added, floating out on the bay on a large pontoon. On Saturday nights, young crowds caught ferries from Circular Quay in the city centre to dance to the beat of Jim Coates and his Rhythm Boys and Fred Smiteley with the Luna Park Band.

The park manager, David Atkins, claimed that he introduced communal bathing beauty competitions into Australia. From 1936 until 1942, a parade was held on the bandstand every year to reveal up to three-hundred entries of 'sun-tanned redheads, brunettes and blondes' – and all attracted huge crowds. It would appear that the Mayor of Willoughby and the Reverend Calder were proved correct when during the war Luna Park was frequented by women who would stand in the bright lights and be seen disappearing into the darkness under the bridge accompanied by servicemen.

On the night of 9 June 1979, a disastrous fire broke out in the Ghost Train, claiming the lives of six children and one adult. Ever since, the park has been plagued with threats of demolition by property developers and commercial interests, and countless closures and reopenings. In the shadow of the Sydney Harbour Bridge, Luna Park still has an enviable location on one of the world's most spectacular sites. With the fairy lights of Sydney's smiling face, magically reflected on the lapping surface of the harbour waters at night, it would indeed be tragic to have it all dismantled and lost forever.

Note: This text is derived from Sam Marshall, *Luna Park: Just for Fun*, Chapter and Verse, Sydney, 1995. Used with permission.

PLATE 147 (above left)
UNICORN HOTEL, 1942
106 Oxford Street, Paddington, New South Wales
Architects: R. M. Joy and Pollitt

PLATE 148 (above centre)
EXCHANGE HOTEL, 1942
327 High Street, Maitland, New South Wales
Architects: Pitt and Merewether

PLATE 149 (above right)
THE LAKES HOTEL, 1938
Corner of Gardeners Road and Macquarie Street,
Mascot, New South Wales
Architect: J. G. Dalziel

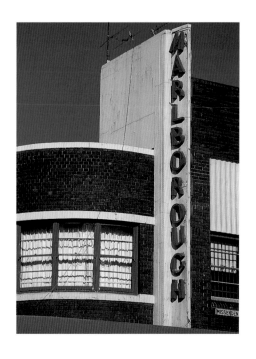
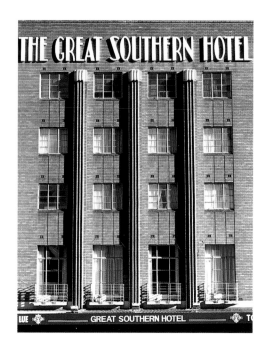
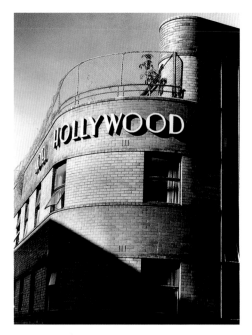
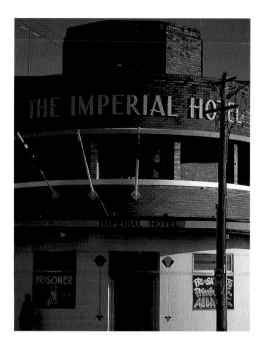

PLATE 150 (opposite top left)
MARLBOROUGH HOTEL, 1940
145 King Street, Newtown, New South Wales
Architect: John M. Hellyer

PLATE 151 (opposite top right)
GREAT SOUTHERN HOTEL, 1940
723 George Street, Sydney, New South Wales
Architect: Virgil Cizzio

PLATE 152 (right)
FORMER UNITED KINGDOM HOTEL, 1938
199 Queens Parade, Clifton Hill, Victoria
Architect: J. H. Wardrop

PLATE 153 (opposite bottom left)
HOTEL HOLLYWOOD, 1942
2 Foster Street, Surry Hills, New South Wales
Architect: John M. Hellyer

PLATE 154 (opposite bottom right)
IMPERIAL HOTEL, 1940
35 Erskineville Road, Erskineville, New South Wales
Architect: Virgil Cizzio

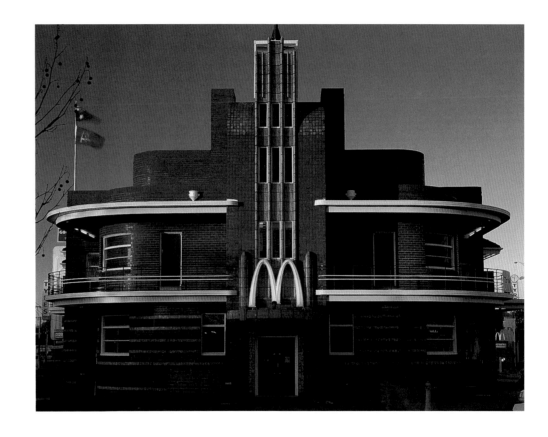

PLATE 155
NELSON HOTEL, 1939
232 Oxford Street, Woollahra, New South Wales
Architects: Rudder and Grout

In the 1930s, graphics took on a sleek and seductive modern look that celebrated the increasingly mechanised way of life. The Nelson Hotel is advertised in geometric style, etched and painted onto obscured glass and framed by the ubiquitous triple lines. This type of signage was found in many hotels.

PLATE 156 (left)
NELSON HOTEL, 1939
232 Oxford Street, Woollahra, New South Wales
Architects: Rudder and Grout

During the inter-war years, pubs became notorious for what was termed the 'six o'clock swill', a wry reference to early closing hours and the rush to drink before pubs shut for the night. The public bar was designed to accommodate this particularly frantic activity, whilst the saloon bar, a separate space, was somewhat more comfortable and relaxed. The saloon at the Nelson is a rare intact survivor from this era of Australia's pub culture.

PLATE 157
SEVEN SEAS HOTEL, 1938
Corner of Cowper and Gipps Streets, Carrington, New South Wales
Architects: Pitt and Merewether
Although many hotels have been stripped of their original ornamental
features to accommodate changing commercial demands, glazing in
windows and doors has often escaped the onslaught of change. This
staircase window shows a fanciful episode from Australia's maritime
history, centred on a compass and the recurring Art Deco motif of the
rising sun. Along with other nautical images found throughout the
building, it reinforces the theme established by the name and location
of this portside hotel in suburban Newcastle and reflects the fact
that a substantial source of its income once came from sailors and
waterside workers.

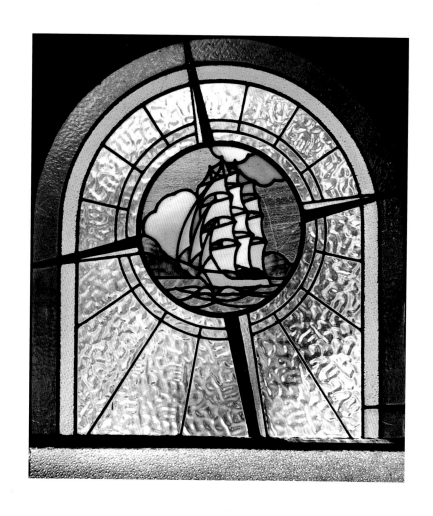

PLATE 158

FORMER UNITED KINGDOM HOTEL, 1938

199 Queens Parade, Clifton Hill, Victoria

Architect: J. H. Wardrop

To provide light and space, the architect,
J. H. Wardrop, incorporated these modern windows,
designed in an abstract composition of vertical and
horizontal rectangles and lines. They are reminiscent
of the work of the Dutch artist Piet Mondrian,
a member of the radical art movement known as
De Stijl, one of whose aims was to create a language
of form and colour applicable to every sphere of life.

PLATE 159
CRITERION HOTEL, 1936
Corner of Pitt and Park Streets, Sydney,
New South Wales
Architects: Copeman, Lemont and Keesing
Many hotels were constructed with decorative
fanlights and highlights over doors and windows
during the 1930s, and the Criterion is no exception.
A variety of textured obscure glasses has been used
in these chevron-shaped leadlights, which are
both decorative and functional.

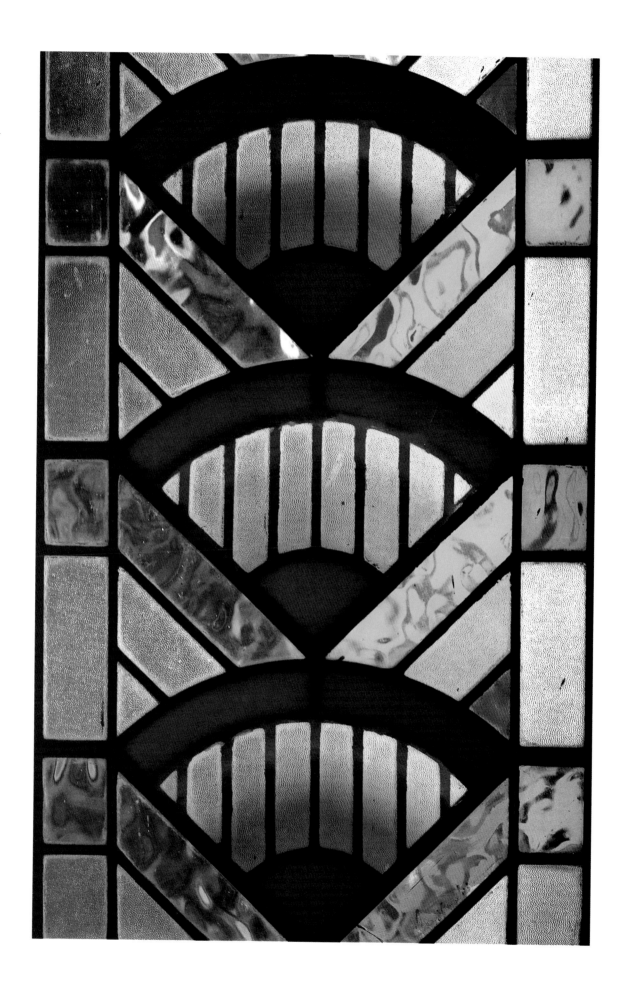

PLATES 160A and 160B (opposite top)
CARLTON HOTEL, 1937
21 Malop Street, Geelong, Victoria
Architect: N. E. Schefferle
This building is considered to be the best of four Art
Deco hotels in the centre of Geelong. As with so many
hotels of the time, the necessities have been designed
with a degree of panache. Modern lettering and
graphics – in this case the ubiquitous triple lines placed
asymmetrically – stylishly direct patrons to their
respective conveniences.

PLATE 161 (opposite bottom)
**TATTERSALLS CLUB, CONSTRUCTED 1925–26;
EXTENDED 1938–39 AND 1949**
206 Edward Street, Brisbane, Queensland
Architects: Hall and Prentice/Hall and Phillips
One of Brisbane's finest Art Deco interiors is to be
found in the prestigious social and sporting Tattersalls
Club. The building is an example of imported English
traditions translated into local terms, and the club
provides luxuriously appointed facilities such as a
barber's shop, Turkish baths, a card room, reception
rooms and a library. Somewhat incongruously, a
Cosmetics Room was also included in what was at
that time a traditional gentlemen's club.

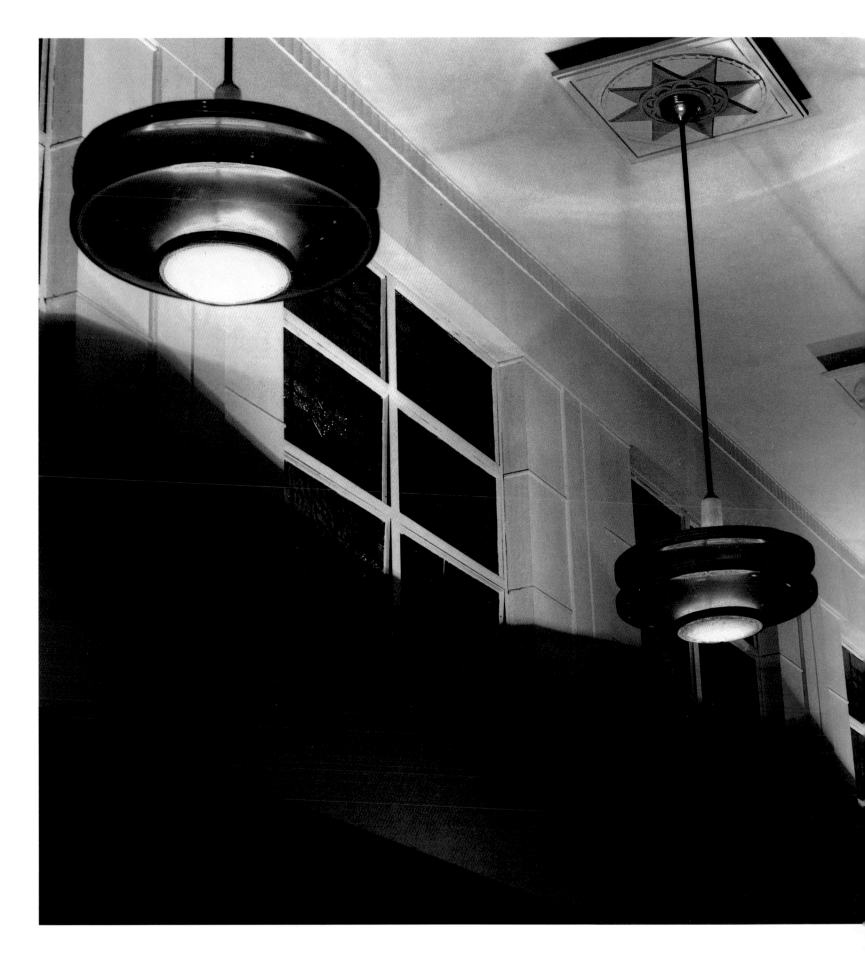

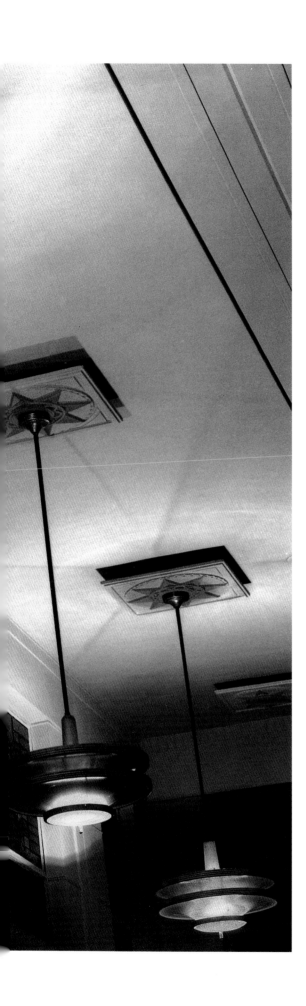

PLATE 162
TATTERSALLS CLUB – THE DINING ROOM;
CLUB CONSTRUCTED 1925–26; EXTENDED 1938–39 AND 1949
206 Edward Street, Brisbane, Queensland
Architects: Hall and Prentice/Hall and Phillips
The dining room at the Tattersalls Club is enhanced by grey and white marble walls, timbers such as Queensland
maple and silky oak, and murals portraying racehorses. The stripped classical space is given a stimulating contrast
by flush finished ceiling-mounted luminaries that are circular in shape and of a totally modern appearance.

PLATE 163

NORTH SYDNEY OLYMPIC SWIMMING POOL, OPENED 4 APRIL 1936

Alfred Street, Milsons Point, New South Wales

Architects: Rudder and Grout

When completed, this was the amongst the largest swimming complexes erected in Australia, located in the very shadows of the newly opened Sydney Harbour Bridge and the contemporary Luna Park. It originally consisted of two fully filtered pools lined in cream and green tiles – an Olympic-size pool with a diving tower at one end and lighting below the level of the water, and a children's pool. It also included a grandstand, changing facilities for men and women situated beneath the grandstand, a tall entry pavilion with decorative glazing and a refreshment kiosk. Today, it remains relatively unchanged. An arcaded screen faces the harbour, decorated with stylised swordfish and rather glum frogs which are to be found enhancing other parts of the complex as well.

PLATE 164

MANUKA SWIMMING POOL, OFFICIALLY OPENED IN JANUARY 1931

Manuka Circle, Griffith, Australian Capital Territory

Architects: E. H. Henderson and H. G. Connell

This important leisure facility, which at the time was the only expansive body of water for many miles, is given a festive Mediterranean character by means of stuccoed walls and colourful terracotta roof tiles. The main entry pavilion, however, imparts some sense of occasion to those frequenting the pool. Its elegant, rectilinear mass is reinforced by fine proportions, whilst appropriate 'seaside' decoration, such as sea-shell medallions and wave-patterned glazing, tells those arriving that this is a place to enjoy carefree bathing.

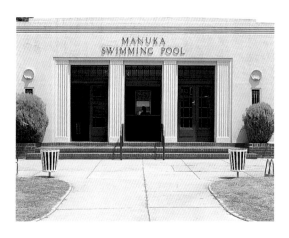

PLATE 165 (opposite page)

MANUKA SWIMMING POOL, OFFICIALLY OPENED IN JANUARY 1931

Manuka Circle, Griffith, Australian Capital Territory

Architects: E. H. Henderson and H. G. Connell

The interior of the pool is symmetrically arranged with changing and showering facilities, and generous concourses to allow for congregations of people. Contemporary commentators were struck by the relatively large amount of car parking adjacent to the pool, a comment on the vast distances already evident in the fledgling city, and unusual in a time of restricted car ownership.

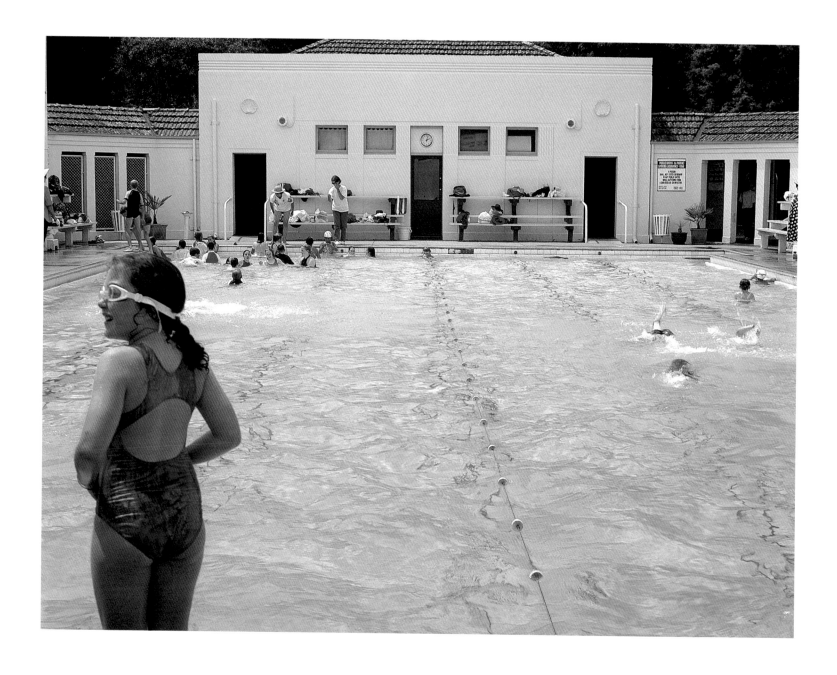

PLATE 166 (right)
SPORTS PAVILION, 1935
Princess Park, Royal Parade, Parkville, Victoria
A simple plaster rendition of a heroic male figure
holding an Olympic torch aloft adorns the gate of the
sports pavilion. It celebrates the intrinsic role which
sport played – and continues to play – in the lives
of many Australians.

PLATE 167 (opposite page)
**GLENFERRIE SPORTS
GROUND GRANDSTAND, 1938**
Linda Crescent, Hawthorn, Victoria
Architects: Stuart P. Calder
in association with Marsh and Michaelson
The grandstand is unique in Victoria because of
its bold and confident architecture which fully exploits
the curvilinear streamlined Moderne. The sweeping
cantilevered canopy over the seating, a dynamic
tour de force, is firmly tied into the cylindrical brick
tower at one end. The complex incorporates such
typical elements as glass bricks, curved corners
and bands of windows in what is one of the
country's finest recreational structures.

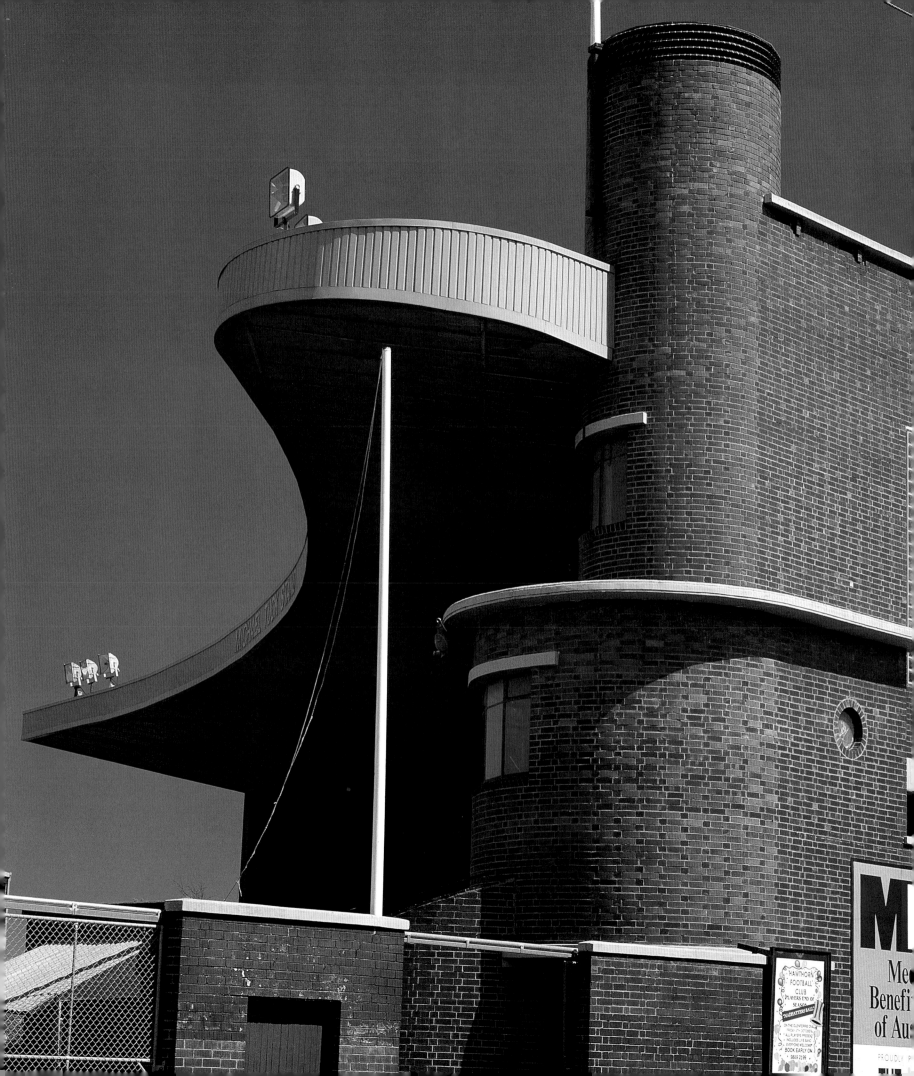

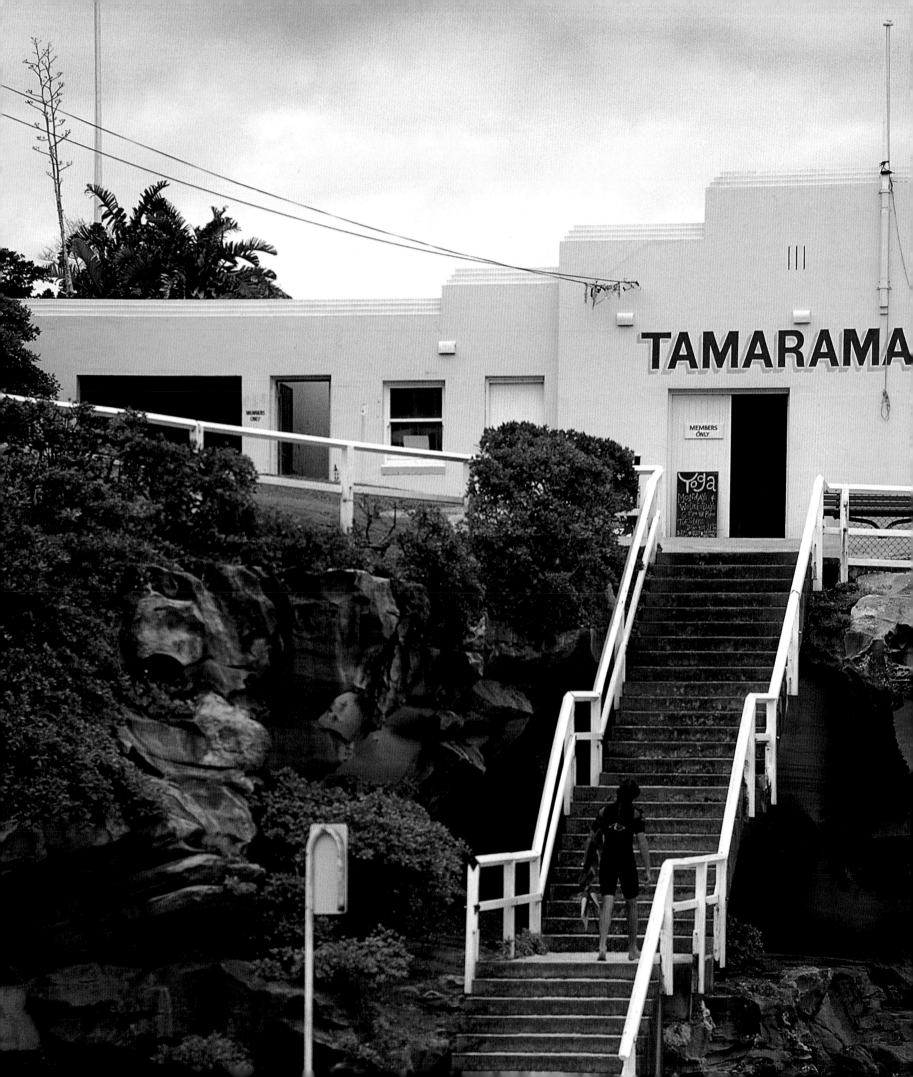

PLATE 168

TAMARAMA SURF LIFE SAVING CLUB, 1940

Tamarama Beach, New South Wales

Architect: George S. Carson

The Tamarama Surf Life Saving Club was founded in 1906. The cult of sun, sand and surf which developed during the 1920s and 1930s found architectural expression in buildings to house the surf life saving clubs stationed at beaches. The club at Tamarama, located on the coast to the east of Sydney, is distinguished by an informal asymmetry reinforced by the stepping of its parapet. The clean expanses of wall and simple modern massing seem ideally suited to the healthful activities of the beachgoer.

PLATE 169 (below)
LUNA PARK – CONEY ISLAND, 1935
Milsons Point, New South Wales
Artistic conception: Rupert Browne
Construction: Stuart Bros
Exotic foreign cultures and their architecture merged
with a carnival atmosphere to provide a rare visual
treat when overseas travel was beyond the reach of
many. Built in a fantasy Moorish style with an onion
dome, Coney Island (popularly known as Funny Land)
was a humanly scaled amusement pavilion within
Luna Park. Entertainments inside included the Joy
Wheel, Turkey Trot, Barrels of Fun, distorting mirrors,
peep shows, Giggle Palace and slippery dips.

PLATE 170 (opposite page)
LUNA PARK – JUST FOR FUN, 1935
Milsons Point, New South Wales
Artistic conception: Rupert Browne
Construction: Stuart Bros
When they first appeared, amusement parks were
virtually the only popular mass entertainment
available. Although six were built around Australia,
none is more Art Deco than Sydney's Luna Park. Its
trademark smiling face, this one erected as late as
1994, has a tiara-like aurora radiating from its
forehead and is balanced by stepped scalloped
towers inspired by the Chrysler Building in New York.
The vertical triple bands running up their flanks are
highlighted by a continuous zigzagging pattern.

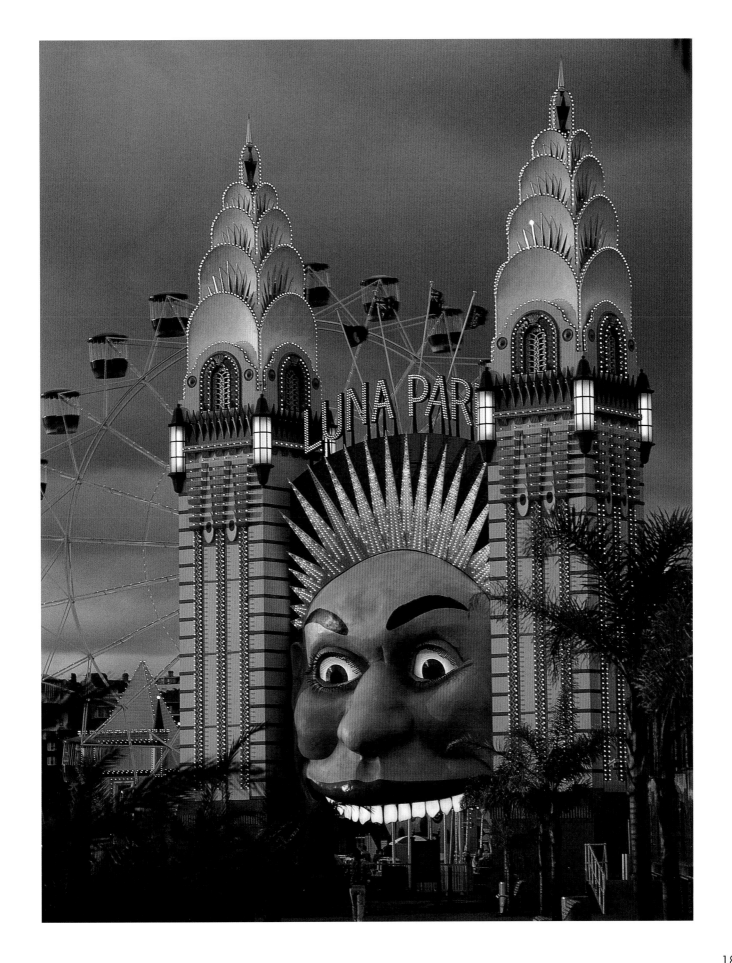

CHAPTER EIGHT
CINEMAS

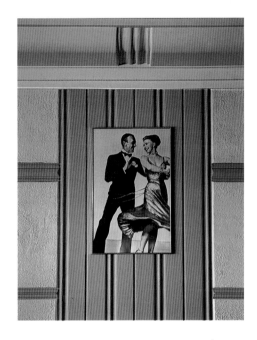

To a greater extent than even the numerous pubs constructed in the 1930s, the cinemas were the most complete experience of modern architecture for many people of the era. An experience of the wider world, if indeed stilted and glamorised, was gained from the cinema. With American movies dominating local screenings, the infiltration of American expectations, language and consumer goods became widespread. In all this, the buildings were important because they provided relatively lavish surroundings, complete with the new technologies of air-conditioning and imaginatively designed electric lighting, for all members of the community. Life in the suburbs of major cities and towns was enhanced, and given some degree of focus and community by their presence. This inadvertently diminished the importance of the major city centres, traditionally the sources of organised entertainment and culture.

Probably no building type of the inter-war period evokes as much passion today as these cinemas, erected in such a large number in city, suburb and town. This is reflected in the relatively large number of books and articles published on them in recent years and the formation of specialist societies which document and analyse them. Yet probably no building type has seen such depredation due to the changing fortunes of fashion and technology. Hardly any which survive remain in original condition. Many more stand as gaunt relics, recalling the architectural and cinematic pleasures which once drew regular and enthusiastic crowds, their tired facades no longer related to the activities now taking place inside. Still more have been lost as the major shift in mass entertainment away from the movies made their very reason for existence redundant and their operation an economic burden on straitened owners.

The tragic fate of Brisbane's Rialto Theatre (plates 181–183), located on Hargrave Road in West End, graphically underscores the processes of decay and wilful attrition that have affected so many buildings from the past. At the same time, the history of the building reflects the strong continuity such buildings enable us to maintain with the past. Originally built in 1926, its exterior reflects the upgrading many buildings underwent during the 1930s as a result of efforts to remain abreast of rapidly changing aesthetics. It was the site for the first radio broadcast in Brisbane and was one of the earliest silent film and vaudeville theatres in that city. The Rialto was able to resist the impact of television in the 1950s and 1960s by screening Greek films, and during the 1970s it was purchased by the Greek Society for exclusive screenings. It later changed hands several times, serving as a venue for a diverse array of entertainments. In 1995, the Rialto was damaged by a severe storm and due to the loss of roofing, its interior became exposed to the elements in all of their capriciousness. At the time the photographs appearing in this book were taken, the theatre was in a very sorry state, indeed – not only had weather wrought more damage, but wilful and thoughtless vandalism exacerbated this attrition. Although the facade still remains, the interior of the building has since been gutted to make way for a shopping centre.

Organisations such as the National Trust of Australia, represented by State branches, the Australian Heritage Commission, responsible for the Register of the National Estate, and the various State Heritage Councils recognise in varying degrees the importance of buildings such as the Rialto. However, truly protective legislation is limited and until such time as the broader public perceives all inter-war architecture, including the few remaining cinemas, as valuable historic and community resources, the processes of destruction will continue to diminish the fabric of our towns and cities – and the richness of our lives.

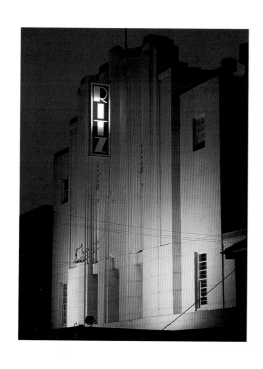 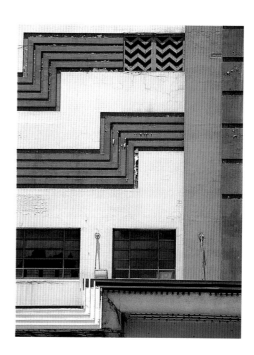

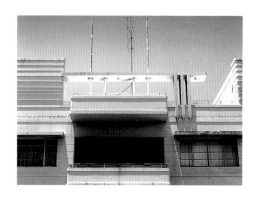

PLATE 175 (opposite page)
**PRINCESS THEATRE, CONSTRUCTED 1911;
RENOVATED 1939**
Brisbane Street, Launceston, Tasmania

PLATE 176 (above)
REGENT THEATRE, OPENED 26 DECEMBER 1957
Keira Street, Wollongong, New South Wales
Architect: Reginald Magoffin

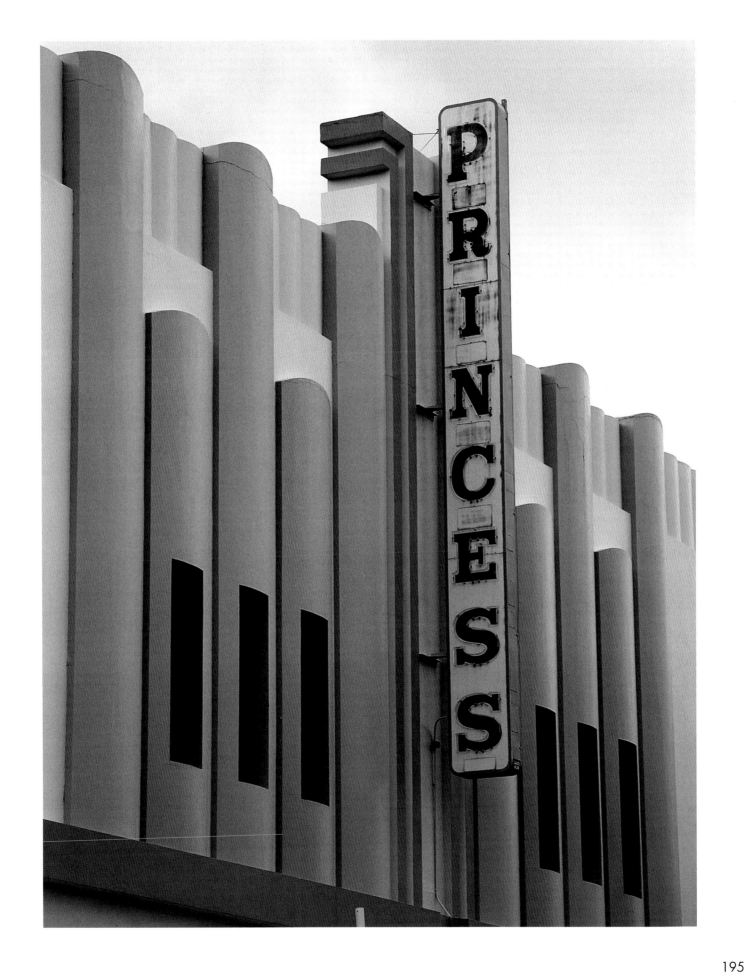

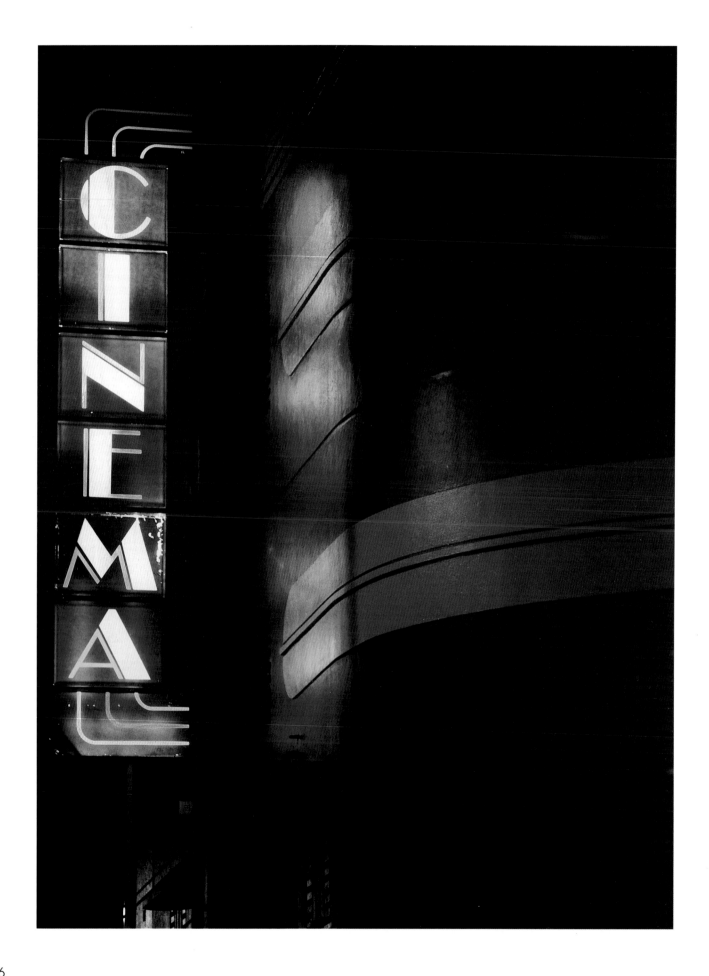

COLLAROY CINEMA, 1938
1097 Pittwater Road, Collaroy, New South Wales
Architect: J. C. Rennie Bartle

PLATE 178 (opposite page)
ROXY THEATRE, OPENED 6 FEBRUARY 1930
George Street, Parramatta, New South Wales
Architects: Herbert and Wilson in association with
Moore and Dwyer

PLATE 179 (above)
DETAIL FROM THE 1930s KINGS CINEMA
Re-created at the Powerhouse Museum,
Harris Street, Ultimo, New South Wales

PLATE 180
REGENT CINEMA, OPENED 21 AUGUST 1935
7 Church Street, Mudgee, New South Wales
Architect: Douglas Smith

PLATE 181 (above)
RIALTO THEATRE, CIRCA 1925
West End, Brisbane, Queensland

PLATE 182 (opposite top)
RIALTO THEATRE, CIRCA 1925
(theatre shown in decay)
West End, Brisbane, Queensland

PLATE 183 (opposite bottom)
RIALTO THEATRE, CIRCA 1925
(theatre shown in decay)
West End, Brisbane, Queensland

PLATE 184
FORMER ORION THEATRE, 1936
Beamish Street, Campsie, New South Wales
Architect: P. Gordon Craig
In many instances, the elaborate facade of a suburban
cinema hid from view the prosaic structure which
contained the budget-conscious luxury of the interior.
The simple facade, symmetrically divided by a
stepped and fluted panel, is decorated with a frieze
of conventionalised sunbursts rising above curling
volutes, perhaps one reason why the Orion was
known as 'The Theatre of the Stars'.

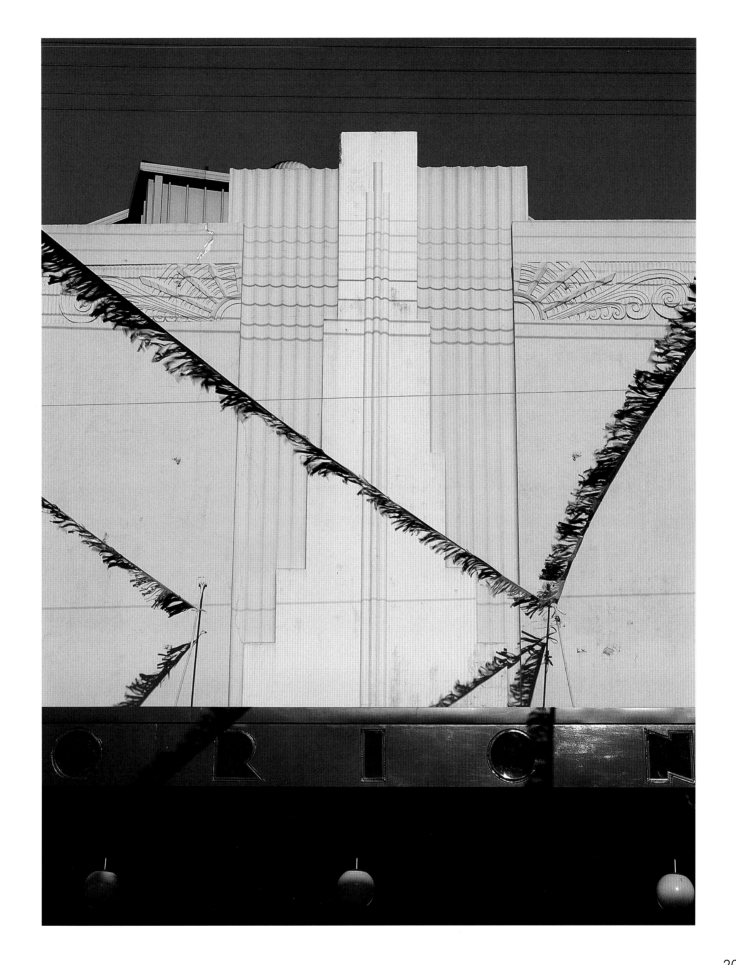

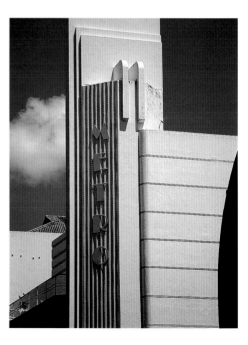

PLATE 186
**METRO (FORMERLY THE MINERVA),
OPENED MAY 1939**
40 Orwell Street, Kings Cross, New South Wales
Designed by C. Bruce Dellit; construction supervised
by Guy Crick and Bruce Furse; interior decoration
designed and supervised by Dudley Ward
The Minerva originally opened as a live theatre –
the first performance taking place on 18 May 1939 –
and began screening movies some three months later.
Only in 1950, however, did it became a full-time
cinema. Its exterior is one of the finest surviving in
Australia, dominated by a tall expressionist tower
on its corner, which effectively contrasts with the
overlapping planes of the rest of the exterior,
embellished with fine horizontal banding.

PLATE 185 (opposite page)
CIVIC THEATRE, OPENED 27 JULY 1938
144 Kelly Street, Scone, New South Wales
Architects: Guy Crick and Bruce Furse
This small, stylish country cinema by the prolific team
of Crick and Furse is doubly unusual because of its
intact fabric and because it still functions successfully
as a cinema. Its curved elements, linear ornamentation
and balance of asymmetrical horizontal and vertical
components are very characteristic of Crick and
Furse's work at the end of the 1930s. It is the
last remaining, completely intact cinema by this
important firm in the State.

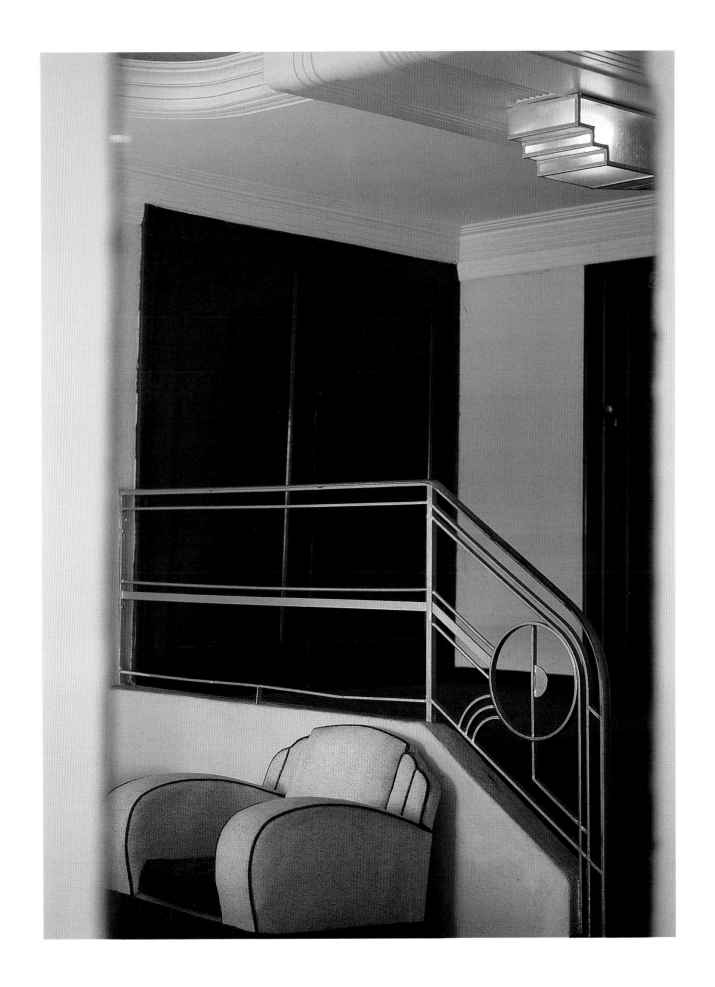

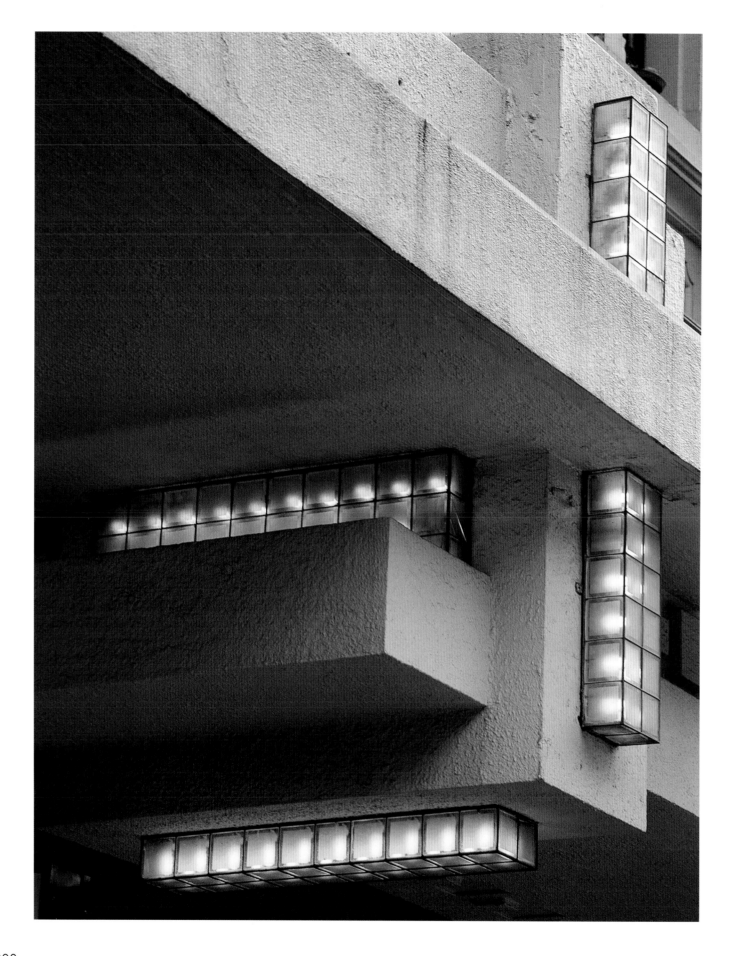

PLATE 187 (opposite page)
CAPITOL THEATRE, 1924
109–117 Swanston Street, Melbourne, Victoria
Architect: Walter Burley Griffin
Although the theatre has been reduced and diminished over its life, it still retains an
important lobby and part of the auditorium. Arguably one of the finest cinemas in the
world, it encapsulates, in a series of exciting and dynamic spaces, the magnificence
of Burley Griffin's cubistic and crystalline geometric ornament.

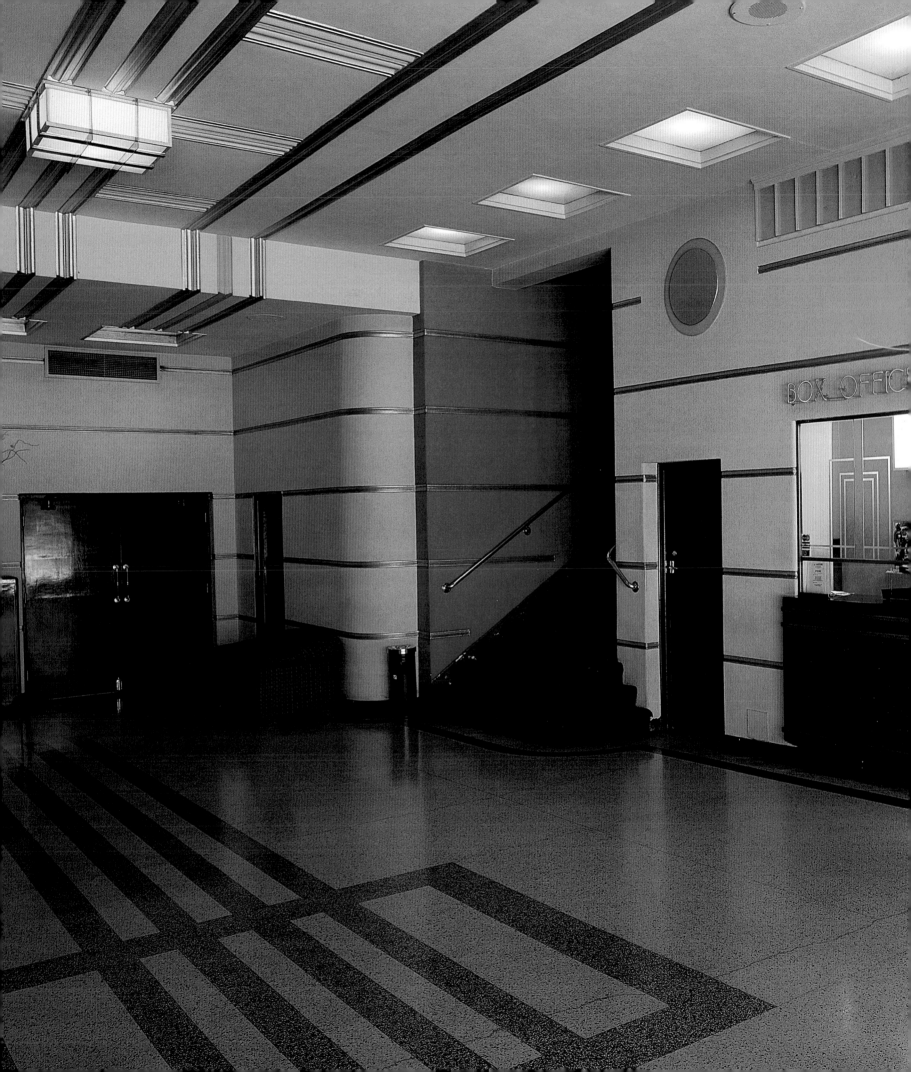

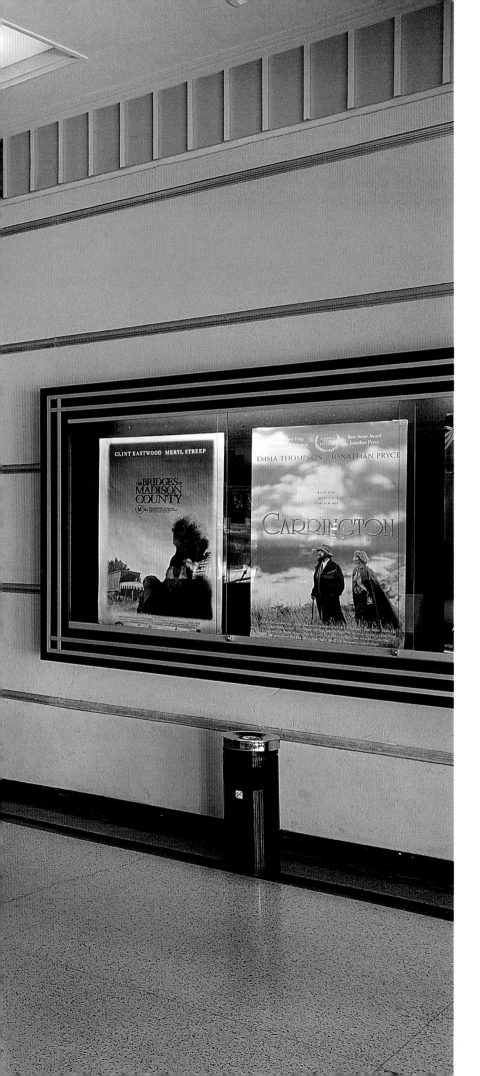

PLATE 188
ASTOR THEATRE, 1938
Beaufort Street, Mount Lawley, Perth, Western Australia
Architects: Baxter-Cox and Leighton (William T. Leighton)
The interiors of cinemas were at times more stylish than their exteriors. The linear
motifs in the flooring of the Astor are echoed by the streamlines racing along the
walls, and reinforced by the ceiling's moulded plaster decoration.
The Astor's facade, almost classical in its clearly defined massing, is relieved by
streamlined horizontal bands incised onto the surfaces of the walls – a device
commonly employed in buildings of the later 1930s throughout the country.

PLATE 189
ASTOR THEATRE, 1936
1–9 Chapel Street, St Kilda, Victoria
Architect: P. Morton Taylor
The Astor's generally rectangular form contrasts with
contemporary cinemas where more streamlined forms
were adopted. When it opened in April 1936, the
auditorium was equipped with a Western Electric
Sound System and the seats had built-in earphone
sockets. The neon signs add a festive mood to what is
a fine and intact example of cinema design in
metropolitan Melbourne.

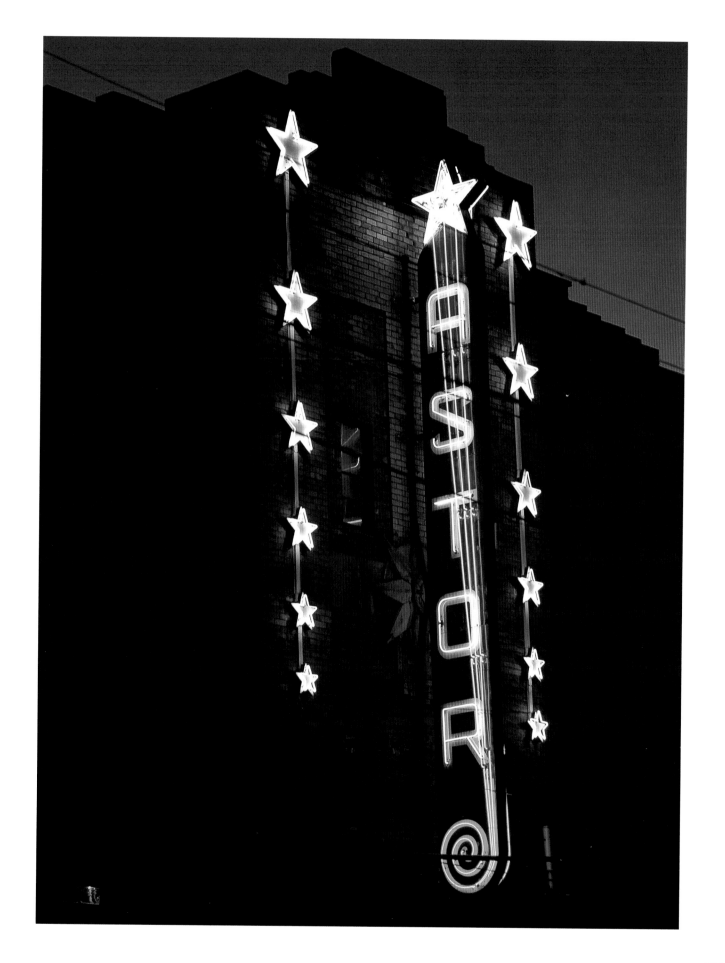

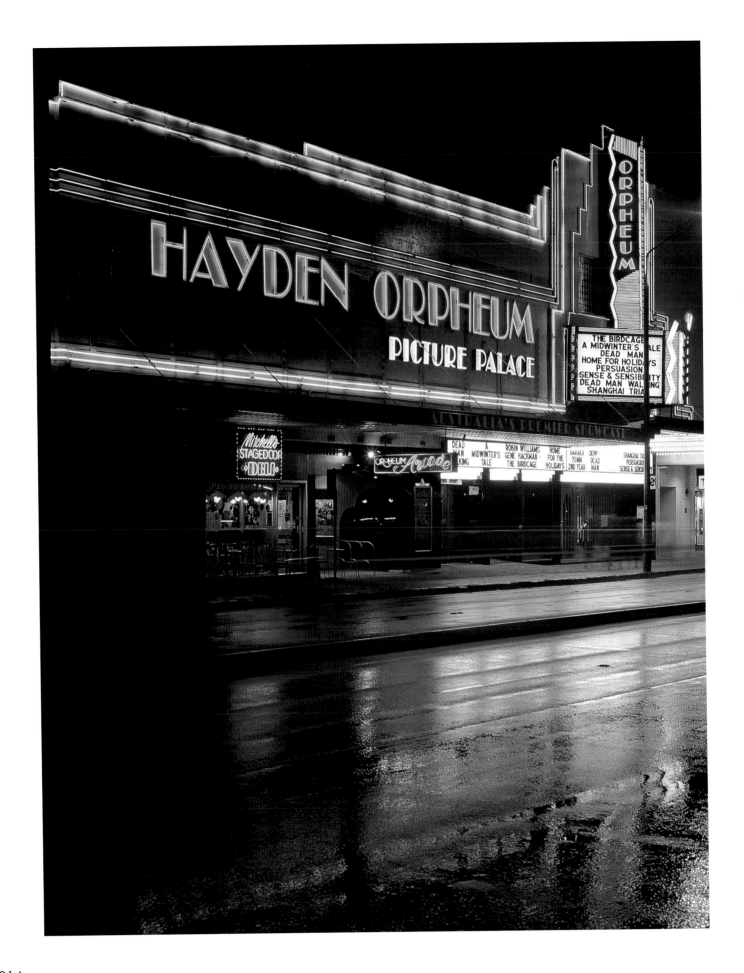

214

PLATE 190

HAYDEN (FORMERLY CREMORNE) ORPHEUM, 1935

380 Military Road, Cremorne, New South Wales
Architect: G. N. Kenworthy; refurbishment in 1987
by John Love

After a long period of neglect, the Orpheum was
refurbished and reopened in 1987 by its owner,
Mike Walsh. This picture palace offers the moviegoer
an Art Deco experience in a lavish Hollywood-style
interior with the added luxury of ushers dressed in
period garb. The facade's horizontality is emphasised
at night by a lively neon sign bearing the name of
the theatre. It follows the stepped section along the
parapet to highlight the entry below and advertise
the selection of movies showing.

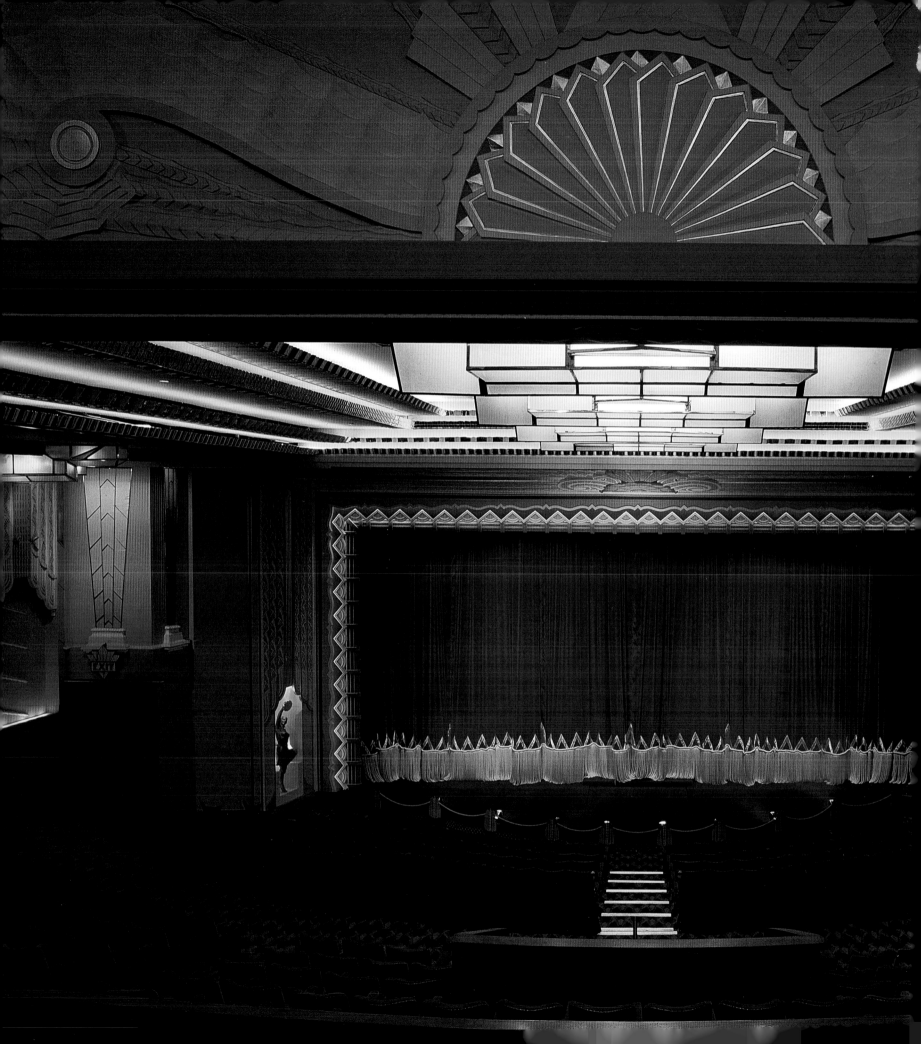

PLATE 191
HAYDEN (FORMERLY CREMORNE) ORPHEUM – MAIN AUDITORIUM, 1935
380 Military Road, Cremorne, New South Wales
Architect: G. N. Kenworthy; refurbishment in 1987 by John Love
The lighting scheme in this auditorium, designed to seat 1750 patrons, was once
described as 'poetical in conception, representing the wane of the moon and the rise of the
sun to the full light of day'. On either side of the proscenium are alcoves containing statues
of Atalanta, the ancient Greek virgin huntress of divine descent renown for her fleetness of
foot. On Saturday nights, a 1927 Wurlitzer Organ emerges from beneath the stage to
entertain patrons before the screening of the main feature film.

217

PLATE 192 (below)
HAYDEN ORPHEUM – AUDITORIUM 3, 1991
380 Military Road, Cremorne, New South Wales
Design and glasswork by Hendrickson Design Artists;
artistic conception by John Love
The spirit of independence and freedom in the 1930s
manifested itself in images of young and liberated
women at play in advertising and fashion illustration.
The slender figure of a cabaret entertainer evokes the
mood of life in the fast lane – cocktail parties, cigarette
smoking and masquerade balls.

PLATE 193 (opposite page)
HAYDEN ORPHEUM – AUDITORIUM 4, 1996
380 Military Road, Cremorne, New South Wales
Design and glasswork by Hendrickson Design Artists;
artistic conception by John Love; fibreglass sculpture
by Laszlo Biro
The first Art Moderne cinema to be built in Australia
in fifty years, the 'Virgona' cinema has two fibreglass
sculptures of ballet dancers facing the screen (named
Myrtle and Chaz) who leap across the universe in a
motion of bright concentric circles. This kinetic work
of art shows the relevance of streamlined design in
its archetypal form, capturing the imagination of
the people, just as it did in its heyday of the 1930s
and 1940s.

BIBLIOGRAPHY

'The A.C.A. Building, Sydney', *Building*, 12 February 1936, vol. 57, no. 342, pp. 14–22.

'Adereham Hall', *Glass*, 1 September 1934, vol. 2, no. 1, pp. 23–28.

W. V. Aird, *The Water Supply Sewerage and Drainage of Sydney*, Sydney, 1961.

A. H. Albertson, 'Inspired By Nature', *The American Architect*, February 1930, vol. 137, no. 2580, pp. 34–35, 94.

An Architectural Guide to the City of Hobart, The Royal Australian Institute of Architects (Tasmanian Chapter), Hobart, 1984.

Art in Australia, third series, 1 August 1922, no. 1.

Bill Bachman, 'Country Art Deco', *This Australia*, Autumn 1984, vol. 3, no.2, pp. 52–54.

Patricia Bayer, *Art Deco Architecture*, Thames and Hudson, London, 1992.

Margo Beasley, *The Sweat of Their Brows – 100 Years of the Sydney Water Board, 1888–1988*, Water Board, Sydney, Illawarra, Blue Mountains, 1988.

Robin Boyd, *Australia's Home*, Penguin Books Australia, Melbourne, 1968.

Carla Breeze, *Pueblo Deco*, Rizzoli, New York, 1990.

John R. Brogan, *101 Australian Homes Designed by John R. Brogan*, Building Publishing Company Limited, Sydney.

Building, 12 February 1927, vol. 39, no. 234, p. 68.

Building, 12 April 1930, vol. 46, no. 272, p. 47.

Building, 12 October 1936, vol. 59, no. 350.

Susan Bures, *The House of Wunderlich*, Kangaroo Press, Sydney, 1987.

Graeme Butler, 'Mitchell House', *Historic Environment*, 1981, vol. 1, no. 3, pp. 21–28.

Canberra: An Architectural Guide to Australia's Capital, The Royal Australian Institute of Architects (Australian Capital Territory Chapter), Canberra, 1982.

'Canberra High School, Acton, Canberra, A.C.T.', *Building*, 24 June 1940, vol. 66, no. 394, pp. 15–19.

'The Case for Modernity: Modern Furnishing Designs at Burdekin House', *The Home*, 1 November 1929, vol. 10, no. 11, pp. 53–59.

Ken Charlton and Rodney Garnett, *Federal Capital Architecture: Canberra 1911–1939*, National Trust of Australia (Australian Capital Territory), 1984.

John Stephen Clark, *Art Deco Cinema Series Part 1: The Minerva*, Australian Theatre Historical Society, New South Wales, 1993.

'The Commonwealth Bank, Sydney: Its Architectural Importance', *Building*, 12 April 1933, vol. 52, no. 308, pp. 38–45.

Harvey Wiley Corbett, 'The American Radiator Building New York City', *The Architectural Record*, May 1924, vol. 55, pp. 473–477.

'Continental Curves Characterise the Facade of New Hotel Erected at Broadway, Sydney', *Decoration and Glass*, 1 January 1937, vol. 2, no. 9, pp. 42–46, 80.

Mary Carolyn Davies, 'Street of Dreams', *Safe Home Planning*, Bebarfalds Limited Home Planning Bureau, Sydney, 1927.

Decoration and Glass, 1 November 1936, vol. 2, no. 8.

C. Bruce Dellit, 'The Conception of the Memorial Design', *The Book of the Anzac Memorial, New South Wales*, Beacon Press, Sydney, 1934.

C. Bruce Dellit, 'Modern Movement in Design', *Art in Australia*, third series, 15 August 1934, no. 55, pp. 67–69.

C. Bruce Dellit, 'Modern Architecture – Whither is it Leading?', *The Sydney Morning Herald*, 13 July 1936, p. 17.

C. Bruce Dellit, 'The Future Psychology of Architecture', *Architecture*, 1 August 1936, vol. 25, pp. 190–191.

Nicholas Draffin, *The Art of M. Napier Waller*, Sun-Academy Series, n.d.

Alastair Duncan, *American Art Deco*, Thames and Hudson, London, 1986.

Alastair Duncan, *Art Deco*, Thames and Hudson, London, 1988.

Ron Facius, 'Identifying Art Deco', *Trust News*, National Trust of Australia (Western Australia), September 1993, p. 3.

J. M. Freeland, *The Australian Pub*, Melbourne University Press, Melbourne, 1966.

J. M. Freeland, *The Making of a Profession*, Angus and Robertson, Sydney, 1971.

'Furniture and Decoration – Bebarfalds Display', *Building*, 12 April 1930, vol. 46, no. 272, pp. 62–64.

Bill Gammage and Peter Spearritt (eds), *Australians: 1938*, Fairfax, Syme and Weldon Associates, Sydney, 1987.

Fiona Gardiner, Register of Significant Twentieth Century Architecture: Queensland, 1988.

David Gebhard, 'The Moderne in the U.S. 1920–1941', *Architectural Association Quarterly*, July 1970, vol. 2, no. 3, pp. 4–20.

Leon Gellert, 'The Modern Interior Decoration', *The Burdekin House Exhibition Catalogue*, Committee of the Burdekin House Exhibition, Sydney, 1929.

Vyonne Geneve, 'The Vulnerability of Our Art Deco Theatres', *Kino*, June 1989, vol. 28, pp. 6–12.

Vyonne Geneve, 'Artist of the Month: William G. Bennett (1896–1977)', *Waltzing Moderne*, July–August 1992, vol. 5, no. 4, p. 10.

Vyonne Geneve, 'The Royal W.A. Institute for the Blind to Celebrate its 100th Anniversary in 1995', *Waltzing Moderne*, August–September 1994, vol. 7, no. 4, pp. 6–7.

Philip Goad, 'Best Overend – Pioneer Modernist in Melbourne', *Fabrications*, June 1995, vol. 6, pp. 101–124.

Carol Hardwick, The Influence of Art Deco on Architecture in Victoria, Master of Architecture thesis, University of Melbourne, 1980.

Carol Hardwick, 'Art Deco Architecture', *This Australia*, Winter 1982, vol. 1, no. 3, pp. 16–23.

W. E. J. Harrison, 'Burnham Beeches: A Wonder House In The Hills', *The Australian Home Beautiful*, 1 March 1934, vol. 12, no. 3, pp. 6–14, 60.

Bevis Hillier, *Art Deco*, Studio Vista, London, 1968, reprinted 1973.

Stephanie Holt, 'Woman About Town: Urban Images of the 1920s and 1930s', *Art and Australia*, Summer 1995, vol. 33, no. 2, pp. 232–243.

The Home, 1 February 1928, vol. 9, no. 2, p. 53.

John M. Howells and Raymond M. Hood, 'The Tribune Tower, Chicago', *The Architectural Forum*, October 1925, vol. 43, no. 4, pp. 185–190.

Ada Louise Huxtable, *The Tall Building Artistically Reconsidered: The Search for a Skyscraper Style*, Pantheon Books, New York, 1984.

Inventory of Significant Buildings of the 1930s in W.A., compiled by the National Trust of Australia (W.A.), Heritage Council of Western Australia and the Australian Heritage Commission.

Clytie Jessop, 'Introduction', *The Thirties and Australia*, exhibition catalogue, National Trust, 1980.

Donald Leslie Johnson, *The Architecture of Walter Burley Griffin*, The Macmillan Company of Australia, South Melbourne, 1977.

Donald Leslie Johnson, *Australian Architecture 1901–51: Sources of Modernism*, Sydney University Press, Sydney, 1980.

P. Herbert Jones (ed.), *Cremation in Great Britain*, 3rd edn, The Pharos Press, London, 1945.

'Keeping In Step With Progress: Buckley & Nunn's Men's Store', *Building*, 12 February 1934, vol. 53, no. 318, pp. 23–25.

Michael D. Kinerk, Dennis W. Wilhelm, Barbara Capitman, *Rediscovering Art Deco U.S.A*, Viking Studio Books, New York, 1994.

Kino 51, March 1995.

Dan Klein, Nancy A. McClelland, Malcolm Haslam, *In the Deco Style*, Thames and Hudson, London, 1991.

Jean McAuslan, 'Designing the Hall of Memory Mosaic', *The Australian Antique Collector*, January–June 1990.

K. H. McConnel, 'The Trend of Present-Day Architecture in Sydney and Abroad', *Architecture*, 1 June 1930, vol. 19, pp. 424–427.

Stuart Macintyre, *The Oxford History of Australia Volume 4: 1901–1942 – The Succeeding Age*, Oxford University Press, Melbourne, 1986.

Peter McNeil, 'Decorating the Home: Australian Interior Decoration Between the Wars', *Art and Australia*, Summer 1995, vol. 33, no.2, pp. 222–231.

Katrina Mahon, 'Deco Rating High', *Australian House and Garden Classic Design*, Spring/Summer 1985–86, no. 11, pp. 37–43.

'The Manchester Unity Building, Melbourne: An Epoch-Making Achievement', *Building*, 12 September 1932, vol. 51, no. 301, pp.54–64a.

John Margolies, *Pump and Circumstance*, Bulfinch Press, New York, 1993.

'Marine Influence in a Sydney Home', *The Sydney Morning Herald*, 30 September 1937, p. 24.

Sam Marshall, *Luna Park – Just For Fun*, Chapter and Verse, Sydney, 1995.

'Melbourne Takes to Flats', *The Home*, 1 April 1936, vol. 17, no. 4, p. 30.

'Modern Art in Window Display at David Jones', *The Home*, 2 September 1929, vol. 10, no. 9, pp. 54–55.

'The Modern Newspaper Office in Sydney: The "Evening News" Building', *Architecture*, June 1926, vol. 15, no. 6, pp. 11–12.

'Modernism in Melbourne', *Trust News*, National Trust of Australia (Victoria), February 1995, pp. 17–20.

Ian Molyneux, *Looking Around Perth*, Wescolour Press, Perth, 1981, p. xviii.

W. Robert Moore, 'Capital Cities of Australia', *The National Geographic Magazine*, December 1935, vol. 68, pp. 667–722.

Edwin Bateman Morris, 'Our New Public Buildings', *Architecture*, June 1934, vol. 69, no. 6, pp. 313–326.

'Municipality of Manly: Architectural Competition for New Town Hall and Municipal Offices', *Architecture*, 1 April 1928, vol. 17, no. 4, pp. 75–79.

'The New Prudential Building, Sydney', *Building*, 24 June 1939, vol. 64, no. 382, pp. 16–27, 100a.

'North Sydney Olympic Pool', *Building*, 12 May 1936, vol. 58, no. 345, pp. 30–36.

North Sydney Olympic Pool 50th Anniversary Celebrations 1936–1986, North Sydney Municipal Council, Sydney.

Geraldine O'Brien, 'Reopen Luna Park', *Sydney Morning Herald*, 2 September 1996.

Richard Oliver, *Bertram Grosvenor Goodhue*, The Massachusetts Institute of Technology Press, Cambridge, Massachusetts, in association with the Architectural History Foundation, New York, 1983.

'Orion Theatre, Campsie, Sydney', *Building*, 13 April 1936, vol. 58, no. 344, pp. 22–24.

'The Orpheum Theatre, Cremorne, Sydney', *Building*, 12 October 1935, vol. 57, no. 338, pp. 12–17.

Michael Page, *Sculptors in Space: South Australian Architects 1836–1986*, The Royal Australian Institute of Architects (South Australian Chapter), Adelaide, 1986.

'Past Buildings as Seen in the Future', *Mercury* (Hobart), 24 February 1996.

'Perth "Minimum" Flats', *Decoration and Glass*, 1 July 1936, vol. 2, no. 3, pp. 7–11.

'The Petersham Town Hall', *Building*, 24 August 1938, vol. 62, no. 372, pp. 32–39.

Ralph O. Phillips, The Skyscraper in Sydney, Bachelor of Architecture thesis, University of Sydney, 1931.

Charles Pickett, *Refreshing! Art off the Pub Wall*, Allen and Unwin, Sydney, in association with Powerhouse Publishing, Sydney, 1990.

Henry Pook, *Building a Dream? A Social History of Australia in the Twenties*, Oxford University Press, Melbourne, 1987.

Ambrose Pratt and John Barnes, *The National War Memorial of Victoria*, 3rd edn, W. D. Joynt, Melbourne, 1936.

'Railway Building, Wynyard, Sydney', *Building*, 12 June 1936, vol. 58, no. 346, pp. 14–24.

Leslie Rees, 'Sydney After 9 Years', *The Home*, July 1936, vol. 17, no. 7.

Cervin Robinson and Rosemarie Haag Bletter, *Skyscraper Style: Art Deco New York*, Oxford University Press, New York, 1975.

Jill Roe (ed.), *Twentieth Century Sydney: Studies in Urban and Social History*, Hale and Iremonger, Sydney, in association with the Sydney History Group, 1980.

Safe Home Planning, Bebarfalds Ltd Home Planning Bureau, Sydney, 1927.

David Saunders, '… so I decided to go overseas', *Architecture Australia*, February–March 1977, vol. 66, no. 1, pp. 22–28.

'Savoy Katoomba N.S.W.', *Decoration and Glass*, 1 March 1937, vol. 2, no. 11.

Frank Scarlett and Marjorie Townley, *Arts Décoratifs 1925: A Personal Recollection of the Paris Exhibition*, Academy Editions, London, 1975.

'Sculptural Competition Conducted by the Sydney Water Board', *Journal of the Royal Victorian Institute of Architects*, July 1939, vol. 37, no. 5, p. 135.

Geoffrey Searle (ed.), *Australian Dictionary of Biography 1891–1939*, vols 10 and 11, ed. Geoffrey Searle, Melbourne University Press, Melbourne, 1986, 1987.

R. W. Sexton, *The Logic of Modern Architecture*, Architectural Book Publishing Company, Inc., New York, 1929.

Peter Shaw and Peter Hallett, *Art Deco Napier: Styles of the Thirties*, Reed Methuen, Auckland, 1987, pp. 36–37.

Peter Spearritt, *Sydney Since the Twenties*, Hale and Iremonger, Sydney, 1978.

Ian and Maisy Stapleton, 'C. Bruce Dellit 1900–1942 and Emil Sodersten 1901–1961', *Architects of Australia*, ed. Howard Tanner, The Macmillan Company of Australia, South Melbourne, 1981.

Maisy Stapleton, 'Between the Wars', *The History and Design of the Australian House*, ed. Robert Irving, Oxford University Press, Melbourne, 1985.

Robert A. M. Stern, Gregory Gilmartin and Thomas Mellins, *New York 1930*, Rizzoli, New York, 1987.

Andrew Stuart-Robinson, The Architecture of C. Bruce Dellit, Fine Arts Essay, University of Sydney, 1976.

Howard Tanner, 'Interior Design in the 20th Century', *Historic Interiors*, ed. Maisy Stapleton, Sydney College of the Arts Press, Sydney, 1983.

Florence M. Taylor, 'Freak Architecture: Its Contempt for Sentimental Association and Correct Principles', *Building*, 12 October 1925, vol. 37, no. 218, pp. 68–76.

Daniel Thomas, 'Art Deco in Australia', *Art and Australia*, March 1972, vol. 9, no. 4, pp. 338–351.

Ross Thorne, *Cinemas of Australia via USA*, Architecture Department, University of Sydney, 1981.

Ross Thorne and Kevin Cork, *For All The Kings Men*, Australian Theatre Historical Society, New South Wales, 1994.

Ross Thorne, Les Tod and Kevin Cork, *Movie Theatre Heritage Register for New South Wales 1896–1996*, Department of Architecture, University of Sydney, 1996.

Nancy J. Troy, *Modernism and the Decorative Arts in France*, Yale University Press, New Haven, 1991.

Nancy D. Underhill, *Making Australian Art 1916–49*, Oxford University Press, Melbourne, 1991.

Maggie Valentine, *The Show Starts on the Sidewalk*, Yale University Press, New Haven, 1994.

Elizabeth Vines, *Streetwise: A Practical Guide for the Revitalisation of Commercial Heritage Precincts and Traditional Main Streets in Australian Cities and Towns*, National Trust of Australia (New South Wales), Sydney, 1996.

Sonya Voumard, 'A Thoroughly Moderne Return', *Sydney Morning Herald*, 2 April 1996.

Ralph T. Walker, 'A New Architecture', *The Architectural Forum*, January 1928, vol. 48, pp. 1–4.

Waltzing Moderne, March–April 1995, vol. 8, no. 3, pp. 8–9.

Granville Wilson and Peter Sands, *Building a City: 100 Years of Melbourne Architecture*, Oxford University Press, Melbourne, 1981.

Richard Guy Wilson, Dianne H. Pilgrim and Dickran Tashjian, *The Machine Age in America 1918–1941*, Harry N. Abrams, Inc., New York, 1986.

Ernest Wunderlich, *All My Yesterdays: A Mosaic of Music and Manufacturing*, Angus and Robertson, Sydney, 1945.

'Wyldefel Gardens', *Decoration and Glass*, 1 July 1936, vol. 2, no. 3, p. 8.

Sue Zelinka, *Tender Sympathies*, Hale and Iremonger, Sydney, 1991.

Oswald L. Ziegler (producer), *Australia 1788–1938*, Simmons Limited, Sydney, 1938.

FILES

Graeme Butler, Caringal Flats, Royal Australian Institute of Architects (Victorian Chapter).

Queensland Heritage Register, Department of Environment: Tattersalls Club, File No. 600093 and McWhirters, Brisbane, File No. 600214.

South Brisbane Area Heritage Study, Department of Development and Planning, Brisbane City Council: Rialto Picture Theatre.

South Melbourne Urban Conservation Study, Allom Lovel Sanderson Pty Ltd, Conservation Architects, for Department of Administrative Services, Construction Group, Army Signal Depot; Designation A Citation No. 200.

Maisy Stapleton, The Sydney Metropolis: An Art Deco Vision, The Thirties and Australia, National Trust exhibition, 19 June – 13 July 1980.

Twentieth Century Buildings in Tasmania: Department of Urban Design, University of Tasmania; Royal Australian Institute of Architects (Hobart Chapter); Catherine Baker, Launceston.

WALKING GUIDES

An Architectural Guide to the City of Hobart, Royal Australian Institute of Architects (Tasmanian Chapter).

Art Deco Walk, City of Melbourne, Society Art Deco, Victoria (Inc.).

Burrinjuck Dam, Department of Water Resources.

Dam Good Times, Water Board.

Keepit Dam, Department of Water Resources.

Twentieth Century Buildings in Geelong, Society Art Deco, Victoria (Inc.).

West Melbourne Walk, Society Art Deco, Victoria (Inc.).

LIST OF PLATES

Front cover **Detail from the 1930s Kings Cinema** Re-created at the Powerhouse Museum, Harris Street, Ultimo, New South Wales

Back cover **Luna Park – Just for Fun, 1935** Milsons Point, New South Wales

p. 2 **Former MLC Building, 1938** Corner of Martin Place and Castlereagh Street, Sydney, New South Wales

p. 8 **Rialto Theatre, circa 1925** West End, Brisbane, Queensland

CHAPTER ONE: ART DECO ARCHITECTURE IN AUSTRALIA

p. 15 Plate 1 **Transport House (formerly Railway House), 1936** 19 York Street, Sydney, New South Wales. Architects: H. E. Budden and Mackey. Awarded Sulman Medal and RIBA Medal

p. 19 Plate 2 **AFT House (formerly Delfin House), 1940** 16 O'Connell Street, Sydney, New South Wales. Architect: C. Bruce Dellit

p. 21 Plate 3 **Former Transport House, 1938** Corner of Macquarie and Phillip Streets, Sydney, New South Wales. Architects: H. E. Budden and Mackey; relief sculptures of Mercury designed by Rayner Hoff

p. 25 Plate 4 **Mc Whirters – department store, 1931** Corner of Wickham and Brunswick Streets, Fortitude Valley, Queensland. Architects: Hall and Phillips

p. 26 Plate 5 **Coffee Shop in the Savoy Theatre complex, 1937** 6–32 Katoomba Street, Katoomba, New South Wales. Architects: Guy Crick and Bruce Furse

p. 28 Plate 6 **Luck's Corner, 1937** Corner of George and Paterson Streets, Launceston, Tasmania. Architect: Thomas Tandy, Jnr

p. 30 Plate 7 **'Mahratta', 1941** Upper North Shore of Sydney, New South Wales. Architect: Douglas Agnew

p. 32 Plate 8 **'Burnham' Flats** Corner of Latrobe Terrace and Skene Street, Geelong, Victoria

p. 35 Plate 9 **'Caringal' Flats, 1951** Toorak, Victoria. Architect: John William Rivett

p. 38 Plate 10 **Australian War Memorial, opened in 1941** Anzac Parade, Campbell, Australian Capital Territory. Architects: Emil Sodersten in association with John Crust (both Sydney-based); mosaics in the Hall of Memory by Mervyn Napier Waller

p. 41 Plate 11 **Former Australian Corps of Signals (now occupied by the Australian Army Band), 1935–1936** 29 Albert Road Drive, Albert Park, Victoria. Architect: J. MacKennal, Works Director, Department of the Interior

p. 43 Plate 12 **Mc Murray Family Mausoleum, 1938** Waverley Cemetery, Waverley, New South Wales

p. 46 Plate 13 **Builders Steel Form Supply Company** David Street, Richmond, Victoria

p. 49 Plate 14 **Burrinjuck Dam – the spillway, alterations circa 1930** West of Goodradigbee, New South Wales. Designed by the engineers of the Department of Water Resources in association with the Department of Public Works

p. 50 Plate 15 **Former incinerator, 1935** Small Street, Willoughby, New South Wales. Architect: Walter Burley Griffin

p. 53 Plate 16 **Petersham Inn, 1938; extended in 1940** Corner of Parramatta Road and Phillip Street, Petersham, New South Wales. Architects: Rudder and Grout; extension by L. J. Soden

p. 56 Plate 17 **Gateway, 1935** Alfred Street, Milsons Point, New South Wales. Artistic concept: Rupert Browne

p. 59 Plate 18 **Sports Pavilion** Princess Park, Royal Parade, Parkville, Victoria

p. 60 Plate 19 **Civic Theatre, 1938** 114 Kelly Street, Scone, New South Wales. Architects: Guy Crick and Bruce Furse

p. 62 Plate 20 **Piccadilly Theatre, opened 23 October 1940** Corner O'Connell and Childers Streets, North Adelaide, South Australia. Architects: Evans, Bruer and Hall in association with Guy Crick

p. 65 Plate 21 **Piccadilly Theatre, opened 10 March 1938** Hay Street, Perth, Western Australia. Architects: Baxter-Cox and Leighton

CHAPTER TWO: OFFICE BUILDINGS

p. 69 Plate 22 **Amalgamated Wireless (Australasia) Limited (AWA) Building, 1939** 47 York Street, Sydney, New South Wales. Architects: D. T. Morrow and Gordon in association with Robertson and Marks; decorative mosaics and relief sculpture by Otto Steen

p. 68 Plate 23 **Amalgamated Wireless (Australasia) Limited (AWA) Building, 1939** 47 York Street, Sydney, New South Wales. Architects: D. T. Morrow and Gordon in association with Robertson and Marks; decorative mosaics and relief sculpture by Otto Steen

p. 70 Plate 24 **Museum of Contemporary Art (formerly Maritime Services Board building), designed circa 1936** George Street North, Sydney, New South Wales. Architects: Maritime Services Board – D. H. Baxter and W. H. Withers; decorative murals and sculpture by Norman Carter, Lyndon Dadswell and R. Emerson Curtis

p. 70 Plate 25 **Museum of Contemporary Art (formerly Maritime Services Board building), designed circa 1936** George Street North, Sydney, New South Wales. Architects: Maritime Services Board – D. H. Baxter and W. H. Withers; decorative murals and sculpture by Norman Carter, Lyndon Dadswell and R. Emerson Curtis

p. 70 Plate 26 **City Mutual Life Building, 1936** Corner of Hunter and Bligh Streets, Sydney, New South Wales. Architect: Emil Sodersten; relief sculpture designed by Rayner Hoff

p. 71 Plate 27 **City Mutual Life Building, 1936** Corner of Hunter and Bligh Streets, Sydney, New South Wales. Architect: Emil Sodersten; relief sculpture designed by Rayner Hoff

p. 72 Plate 28 **AFT House (formerly Delfin House), 1940** 16 O'Connell Street, Sydney, New South Wales. Architect: C. Bruce Dellit

p. 72 Plate 29 **AFT House (formerly Delfin House), 1940** 16 O'Connell Street, Sydney, New South Wales. Architect: C. Bruce Dellit

p. 72 Plate 30 **Century Building, 1940** Corner of Swanston and Little Collins Streets, Melbourne, Victoria. Architect: Marcus Barlow

p. 73 Plate 31 **Newspaper House, 1933** 247–249 Collins Street, Melbourne, Victoria. Architects: Stephenson and Meldrum; mosaic by Mervyn Napier Waller

p. 74 Plate 32 **Mitchell House, 1937** Corner of Lonsdale and Elizabeth Streets, Melbourne, Victoria. Architect: Harry Norris

p. 75 Plate 33 **Mitchell House – the elevator bank, 1937** Corner of Lonsdale and Elizabeth Streets, Melbourne, Victoria. Architect: Harry Norris

p. 75 Plate 34 **Former MLC Building, 1938** Corner of Martin Place and Castlereagh Street, Sydney, New South Wales. Architects: Bates, Smart and McCutcheon; recent work by Lucas Stapleton

p. 75 Plate 35 **Former MLC Building, 1938** Corner of Martin Place and Castlereagh Street, Sydney, New South Wales. Architects: Bates, Smart and McCutcheon; recent work by Lucas Stapleton

p. 75 Plate 36 **Grace Building, opened on 3 July 1930** York, King and Clarence Streets, Sydney, New South Wales. Architects: D. T. Morrow and Gordon

p. 75 Plate 37 **Manchester Unity Building, opened on 1 September 1932** 220–226 Collins Street, Melbourne, Victoria. Architect: Marcus Barlow

p. 75 Plate 38 **Manchester Unity Building, opened on 1 September 1932** 220–226 Collins Street, Melbourne, Victoria. Architect: Marcus Barlow

p. 76 Plate 39 **Former Metropolitan Water Sewerage and Drainage Board Building, 1940** 339–341 Pitt Street, Sydney, New South Wales. Architects: H. E. Budden and Mackey

p. 77 Plate 40 **Former Metropolitan Water Sewerage and Drainage Board Building, 1940** 339–341 Pitt Street, Sydney, New South Wales. Architects: H. E. Budden and Mackey

p. 78 Plate 41 **Pacific House, circa 1930** 181 Pitt Street, Sydney, New South Wales. Architects: D. T. Morrow and Gordon

p. 79 Plate 42 **Former ACI Building, 1941** William Street, Sydney, New South Wales. Architects: Stephenson and Turner

p. 78 Plate 43 **Hydro-Electric Commission Building, 1938** Corner of Davey and Elizabeth Streets, Hobart, Tasmania. Architects: A. and K. Henderson, Melbourne. Archival photograph courtesy of *The Mercury*, Hobart

p. 78 Plate 44 **Hydro-Electric Commission Building, 1938** Corner of Davey and Elizabeth Streets, Hobart, Tasmania. Architects: A. and K. Henderson, Melbourne

p. 81 Plate 45 **T. & G. Building, 1938** 115 Collins Street, Hobart, Tasmania. Architects: A. and K. Henderson, Melbourne

p. 80 Plate 46 **Holyman House, 1936** 52–60 Brisbane Street, Launceston, Tasmania. Architects: H. S. East and Roy Smith (R. S. Smith)

p. 82 Plate 47 **Elmslea Chambers, 1934** 17–19 Montague Street, Goulburn, New South Wales. Architect: L. P. Burns

p. 83 Plate 48 **Elmslea Chambers, 1934** 17–19 Montague Street, Goulburn, New South Wales. Architect: L. P. Burns

p. 85 Plate 49 **former Nesca House, 1939** Corner of King and Auckland Streets, Newcastle, New South Wales. Architect: Emil Sodersten

CHAPTER THREE: COMMERCIAL BUILDINGS

p. 89 Plate 50 **Paragon Cafe – the cocktail bar, 1934 and 1936** 65 Katoomba Street, Katoomba, New South Wales. Architect: Henry White; original 1925 section fitted out by the firm of H. and E. Sidgreaves; two dining rooms by White added – the Banquet Hall (1934) and the Blue Room (1936)

p. 91 Plate 51 **Paragon Cafe – an ornamental light fitting, 1934 and 1936** 65 Katoomba Street, Katoomba, New South Wales. Architect: Henry White; original 1925 section fitted out by the firm of H. and E. Sidgreaves; two dining rooms by White added – the Banquet Hall (1934) and the Blue Room (1936)

p. 90 Plate 52 **Paragon Cafe – the coffee shop, 1934 and 1936** 65 Katoomba Street, Katoomba, New South Wales. Architect: Henry White; original 1925 section fitted out by the firm of H. and E. Sidgreaves; two dining rooms by White added – the Banquet Hall (1934) and the Blue Room (1936)

p. 92 Plate 53 **Civic Arcade, converted to an arcade in 1939** 11 Newcomen Street, Newcastle, New South Wales. Architects: Jeater, Rodd and Hay

p. 92 Plate 54 **Block Court, 1930** 288 Collins Street, Melbourne, Victoria. Architect: Harry Norris

p. 92 Plate 55 **Myer Emporium, 1933** 314–336 Bourke Street, Melbourne, Victoria. Architects: H. W. and F. B. Tompkins

p. 93 Plate 56 **Myer Emporium – the Mural Hall, 1933** 314–336 Bourke Street, Melbourne, Victoria. Architects: H. W. and F. B. Tompkins

p. 95 Plate 57 **Myer Emporium – the Mannequin Stairway, 1933** 314–336 Bourke Street, Melbourne, Victoria. Architects: H. W. and F. B. Tompkins

p. 96 Plate 58 **David Jones Department Store (formerly Buckley and Nunn Men's Store), 1934** 310 Bourke Street, Melbourne, Victoria. Architects: Bates, Smart and McCutcheon. Awarded Royal Victorian Institute of Architect's Street Architecture Award for 1934

p. 97 Plate 59 **Alberto's of Rome, 1932** Brisbane Street, Launceston, Tasmania. Architect: Colin Philp

p. 99 Plate 60 **York House** 354 Oxford Street, Paddington, New South Wales

p. 100 Plate 61 **Reconstruction of glass salvaged from the former Sydney County Council offices and showroom** Re-created at the Powerhouse Museum, Harris Street, Ultimo, New South Wales

p. 101 Plate 62 **Duttons** 525–531 Church Street, Richmond, Victoria

p. 101 Plate 63 **Former McPherson's Building, 1935** 546 Collins Street, Melbourne, Victoria. Architects: S. P. Calder, and Reid and Pearson

p. 103 Plate 64a **Commonwealth Bank, circa 1936** 83 Pacific Highway, Roseville, New South Wales. Architects: Department of the Interior

p. 103 Plate 64b **Commonwealth Bank, circa 1936** 31 Hall Street, Bondi Beach, New South Wales. Architects: Department of the Interior

p. 102 Plate 65 **Commonwealth Bank, circa 1936** 83 Pacific Highway, Roseville, New South Wales. Architects: Department of the Interior

p. 103 Plate 66 **Pepperina, formerly the bowery coffee shop, 1944** 37 Bolton Street, Newcastle, New South Wales. Architect: A. C. Castleden

CHAPTER FOUR: PUBLIC BUILDINGS

p. 107 Plate 67 **National Film and Sound Archive (formerly Australian Institute of Anatomy), 1930** McCoy Circuit, Acton, Australian Capital Territory. Architects: W. Hayward Morris in association with Robert Casboulte

p. 108 Plate 68 **National Film and Sound Archive (formerly Australian Institute of Anatomy), 1930** McCoy Circuit, Acton, Australian Capital Territory. Architects: W. Hayward Morris in association with Robert Casboulte.

p. 109 Plate 69 **National Film and Sound Archive (formerly Australian Institute of Anatomy), 1930** McCoy Circuit, Acton, Australian Capital Territory. Architects: W. Hayward Morris in association with Robert Casboulte.

p. 109 Plate 70 **National Film and Sound Archive (formerly Australian Institute of Anatomy), 1930** McCoy Circuit, Acton, Australian Capital Territory. Architects: W. Hayward Morris in association with Robert Casboulte.

p. 109 Plate 71 **National Film and Sound Archive (formerly Australian Institute of Anatomy), 1930** McCoy Circuit, Acton, Australian Capital Territory. Architects: W. Hayward Morris in association with Robert Casboulte.

p. 110 Plate 72 **Archibald Fountain (Diana), presented to the City of Sydney on 14 March 1932** Hyde Park North, Sydney, New South Wales. Sculptor: Francois Sicard. Supervising architect: B. J. Waterhouse

p. 111 Plate 73 **Archibald Fountain (Apollo), presented to the City of Sydney on 14 March 1932** Hyde Park North, Sydney, New South Wales. Sculptor: Francois Sicard. Supervising architect: B. J. Waterhouse

p. 112 Plate 74 **Anzac Memorial, 1934** Hyde Park South, Sydney, New South Wales. Architect: C. Bruce Dellit; sculpture by Rayner Hoff. Dedicated on 24 November 1934 by the Duke of Gloucester

p. 113 Plate 75 **Anzac Memorial, 1934** Hyde Park South, Sydney, New South Wales. Architect: C. Bruce Dellit; sculpture by Rayner Hoff. Dedicated on 24 November 1934 by the Duke of Gloucester

p. 115 Plate 76 **Town Hall, circa 1939** Campbell Town, Tasmania. Architects: Attributed to H. S. East and Roy Smith

p. 115 Plate 77 **Petersham Town Hall, 1938** Corner of Crystal and Frederick Streets, Petersham, New South Wales. Architects: Rudder and Grout

p. 115 Plate 78 **Petersham Town Hall – light fitting, 1938** Corner of Crystal and Frederick Streets, Petersham, New South Wales. Architects: Rudder and Grout

p. 115 Plate 79 **Town Hall – interior, circa 1939** Campbell Town, Tasmania. Architects: Attributed to H. S. East and Roy Smith

p. 115 Plate 80 **Guildford Town Hall, 1937** Perth, Western Australia. Architects: Eales and Cohen

p. 115 Plate 81 **Guildford Town Hall, 1937** Perth, Western Australia. Architects: Eales and Cohen

p. 115 Plate 82 **Heidelberg Town Hall, 1937** Upper Heidelberg Road, Heidelberg, Victoria. Architects: Peck and Kemter in association with Leith and Bartlett

p. 115 Plate 83 **Heidelberg Town Hall – municipal offices, 1937** Upper Heidelberg Road, Heidelberg, Victoria. Architects: Peck and Kemter in association with Leith and Bartlett

p. 115 Plate 84 **Malachi Gilmore Hall, 1937** Oberon Street, Oberon, New South Wales. Architect: Virgil Cizzio

p. 117 Plate 85 **Canberra School of Art (formerly Canberra High School), 1940** Childers Street, Canberra, Australian Capital Territory. Architects: Department of Works – Charles Whitley

p. 117 Plate 86 **United Dental Hospital, first stage completed in 1940** Chalmers Street, Sydney, New South Wales. Architects: Stephenson and Turner

p. 117 Plate 87 **Robert Garran Offices (formerly Patents Office)** Kings Avenue, Barton, Australian Capital Territory

p. 117 Plate 88 **Geelong Court House, 1938** Corner of Little Malop and Gheringhap Streets, Geelong, Victoria. Architect: Percy Everett, Chief Architect, Public Works Department of Victoria

p. 117 Plate 89 **Sesquicentenary Pavilion, 1938** Royal Agricultural Society Showground, Moore Park, New South Wales. Architects: Trenchard, Smith and Massey; glazing by Wunderlich Limited

p. 117 Plate 90 **Australian Corps of Signals (now occupied by the australian army band), 1935–1936** 29 Albert Road Drive, Albert Park, Victoria. Architect: J. MacKennal, Works Director, Department of the Interior

p. 117 Plate 91 **Beresfield Crematorium, 1937** Anderson Drive, Beresfield, New South Wales. Architect: Louis S. Robertson and Son

p. 117 Plate 92 **Eastern Suburbs Crematorium, opened 8 May 1938** Military Road, Matraville, New South Wales. Architect: Louis S. Robertson and Son

p. 117 Plate 93 **Woronora Crematorium, opened April 1934** Linden Street, Sutherland, New South Wales. Architect: Louis S. Robertson and Son

CHAPTER FIVE: DOMESTIC ARCHITECTURE

p. 123 Plates 94 to 102 **Residence on the North Shore of Sydney, New South Wales, 1943**

p. 125 Plate 103 **Residence on the North Shore of Sydney, New South Wales, 1943**

p. 126 Plate 104 **'Mahratta', 1941** Upper North Shore of Sydney, New South Wales. Architect: Douglas Agnew

p. 127 Plate 105 **'Mahratta', 1941** Upper North Shore of Sydney, New South Wales. Architect: Douglas Agnew

p. 129 Plate 106 **'Everglades', 1936** Leura, New South Wales. Designer: C. P. Sorenson

p. 130 Plate 107 **'Burnham Beeches', 1933** Sherbrook Forest, Victoria. Architect: Harry Norris

p. 130 Plate 108 **'Burnham Beeches', 1933** Sherbrook Forest, Victoria. Architect: Harry Norris

p. 131 Plate 109 **'Burnham Beeches', 1933** Sherbrook Forest, Victoria. Architect: Harry Norris

p. 133 Plate 110 **Residence in Killara, New South Wales, 1939** Architect: J. Aubrey Kerr

p. 134 Plate 111 **Residence** Corner of Homer and Minnamora Streets, Earlwood, New South Wales

p. 135 Plate 112 **Residence** Hawkin Drive, St Lucia, Queensland

p. 136 Plate 113 **Block of flats** 35 Campbell Parade, Bondi Beach, New South Wales

p. 138 Plate 114 **Block of flats** Corner of Bourke and Foley Streets, Darlinghurst, New South Wales

p. 139 Plate 115 **Block of flats** 57 Ramsay Street, Haberfield, New South Wales

p. 140 Plate 116 **Residence** The Boulevarde, Cammeray, New South Wales

p. 141 Plate 117 **'Macleay Regis', 1939** 12 Macleay Street, Potts Point, New South Wales. Architects: Eric Pitt and C. C. Phillips

p. 143 Plate 118 **'Tiberius'** Corner of Albert and Eastern Roads, South Melbourne, Victoria

p. 145 Plate 119 **'Redlands'** 23 Bradley Street, Randwick, New South Wales

p. 144 Plate 120 **'Cahors', 1940** 117 Macleay Street, Potts Point, New South Wales. Architects: Joseland and Gilling

CHAPTER SIX: INDUSTRIAL

p. 149 Plate 121 **Sewer vent, Lincoln Street, Highgate, Perth, Western Australia, 1941** Designed by the Metropolitan Water Supply and Drainage Board

p. 149 Plate 122 **Dairy Farmers Depot, 1938** 924 Hunter Street, Newcastle, New South Wales. Architect: A. C. Likely

p. 149 Plate 123 **Incinerator, 1937** Thebarton, South Australia. Architect: Walter Burley Griffin

p. 149 Plate 124 **John Fairfax and Sons Limited General Store (former Westcott-Hazell Building)** 513–519 Wattle Street, Ultimo, New South Wales

p. 148 Plate 125 **Oak Dairy** Hunter Street, Muswellbrook, New South Wales

p. 149 Plate 126 **AGM Building, 1941** South Dowling Street, Alexandria, New South Wales. Architect: Australian Glass Manufacturers

p. 151 Plate 127 **Incinerator, 1937** Pyrmont, New South Wales. Architect: Walter Burley Griffin. Photograph courtesy of Fairfax photo library

p. 150 Plate 128 **Former Top Dog Factory, 1949** 800 Pittwater Road, Dee Why, New South Wales. Architects: Spencer and Bloomfield

p. 152 Plate 129 **John Fairfax and Sons Limited General Store (former Westcott-Hazell Building)** 513–519 Wattle Street, Ultimo, New South Wales

p. 153 Plate 130 **Former Top Dog Factory – bus shelter, 1949** 800 Pittwater Road, Dee Why, New South Wales. Architects: Spencer and Bloomfield

p. 152 Plate 131 **Keable Factory and Office, 1938** 187–189 A'Beckett Street, Melbourne, Victoria. Architect: Edward Bilson

p. 152 Plate 132 **Sydney Auctioneers and Valuers** 3–7 The Crescent, Annandale, New South Wales

p. 155 Plate 133 **Sydney Harbour Bridge, opened to the public on 19 march 1932** Designed by J. J. C. Bradfield, New South Wales Government Chief Engineer, in association with Dorman Long and Co. who were responsible for construction

p. 156 Plate 134 **Abraham's Service Station** Corner of Parramatta Road and Sloan Street, Summer Hill, New South Wales

p. 157 Plate 135 **Tru-Mold Tyres** 205–207 Queens Parade, Clifton Hill, Victoria

p. 157 Plate 136 **Former Hahn Automotive Services** 117 Cleveland Street, Darlington, New South Wales

p. 159 Plate 137 **Former Metropolitan Water Sewerage and Drainage Board Building, 1940** 339–341 Pitt Street, Sydney, New South Wales. Architects: H. E. Budden and Mackey

p. 161 Plate 138 **Cordeaux Dam, constructed between 1919 and 1926** West of Towradgi, New South Wales. Designed by the Department of Public Works in association with the Metropolitan Water Sewerage and Drainage Board

p. 161 Plate 139 **Avon Dam, constructed between 1920 and 1927** East of Yanderra, New South Wales. Designed by the Department of Public Works in association with the Metropolitan Water Sewerage and Drainage Board

p. 161 Plate 140 **Nepean Dam – the spillway, constructed between 1925 and 1935** East of Yanderra, New South Wales. Designed by the Department of Public Works in association with the Metropolitan Water Sewerage and Drainage Board

p. 161 Plate 141 **Woronora Dam – the spillway, constructed between 1927 and 1941** Near Eckersley, New South Wales. Designed by the Department of Public Works in association with the Metropolitan Water Sewerage and Drainage Board

p. 161 Plate 142 **Burrinjuck Dam, constructed between 1907 and 1956** West of Goodradigbee, New South Wales. Designed by the engineers of the Department of Water Resources in association with the Department of Public Works

p. 161 Plate 143 **Burrinjuck Dam – the power station, 1935** West of Goodradigbee, New South Wales. Designed by the engineers of the Department of Water Resources in association with the Department of Public Works

p. 161 Plate 144 **Keepit Dam – the release valves, erected between 1939 and 1960** Fifty-six kilometres west of Tamworth near Gunnenbene, New South Wales. Designed by the engineers of the Department of Water Resources in association with the Department of Public Works

p. 163 Plate 145 **Warragamba Dam, constructed between 1941 and 1960** Warragamba, New South Wales. Designed by the Department of Public Works in association with the Metropolitan Water Sewerage and Drainage Board

CHAPTER SEVEN: RECREATION

p. 166 Plate 146 **The Golden Barley hotel, 1939** 165–169 Edgeware Road, Marrickville, New South Wales. Architects: R. M. Joy and Pollitt

p. 167 Plate 147 **Unicorn Hotel, 1942** 106 Oxford Street, Paddington, New South Wales. Architects: R. M. Joy and Pollitt

p. 167 Plate 148 **Exchange Hotel, 1942** 327 High Street, Maitland, New South Wales. Architects: Pitt and Merewether

p. 167 Plate 149 **The Lakes Hotel, 1938** Corner of Gardeners Road and Macquarie Street, Mascot, New South Wales. Architect: J. G. Dalziel

p. 168 Plate 150 **Marlborough Hotel, 1940** 145 King Street, Newtown, New South Wales. Architect: John M. Hellyer

p. 168 Plate 151 **Great Southern Hotel, 1940** 723 George Street, Sydney, New South Wales. Architect: Virgil Cizzio

p. 169 Plate 152 **former United Kingdom Hotel, 1938** 199 Queens Parade, Clifton Hill, Victoria. Architect: J. H. Wardrop

p. 168 Plate 153 **Hotel Hollywood, 1942** 2 Foster Street, Surry Hills, New South Wales. Architect: John M. Hellyer

p. 168 Plate 154 **Imperial Hotel, 1940** 35 Erskineville Road, Erskineville, New South Wales. Architect: Virgil Cizzio

p. 171 Plate 155 **Nelson Hotel, 1939** 232 Oxford Street, Woollahra, New South Wales. Architects: Rudder and Grout

p. 170 Plate 156 **Nelson Hotel, 1939** 232 Oxford Street, Woollahra, New South Wales. Architects: Rudder and Grout

p. 173 Plate 157 **Seven Seas Hotel, 1938** Corner of Cowper and Gipps Streets, Carrington, New South Wales. Architects: Pitt and Merewether

p. 175 Plate 158 **Former United Kingdom Hotel, 1938** 199 Queens Parade, Clifton Hill, Victoria. Architect: J. H. Wardrop

p. 177 Plate 159 **Criterion Hotel, 1936** Corner of Pitt and Park Streets, Sydney, New South Wales. Architects: Copeman, Lemont and Keesing

p. 179 Plates 160a and 160b **Carlton Hotel, 1937** 21 Malop Street, Geelong, Victoria. Architect: N. E. Schefferle

p. 179 Plate 161 **Tattersalls Club, constructed 1925–26; extended 1938–39 and 1949** 206 Edward Street, Brisbane, Queensland. Architects: Hall and Prentice/Hall and Phillips

p. 180 Plate 162 **Tattersalls Club – the dining room; club constructed 1925–26; extended 1938–39 and 1949** 206 Edward Street, Brisbane, Queensland. Architects: Hall and Prentice/Hall and Phillips

p. 182 Plate 163 **North Sydney Olympic Swimming Pool, opened 4 April 1936** Alfred Street, Milsons Point, New South Wales. Architects: Rudder and Grout

p. 182 Plate 164 **Manuka Swimming Pool, officially opened in January 1931** Manuka Circle, Griffith, Australian Capital Territory. Architects: E. H. Henderson and H. G. Connell

p. 183 Plate 165 **Manuka Swimming Pool, officially opened in January 1931** Manuka Circle, Griffith, Australian Capital Territory. Architects: E. H. Henderson and H. G. Connell

p. 184 Plate 166 **Sports Pavilion, 1935** Princess Park, Royal Parade, Parkville, Victoria

p. 185 Plate 167 **Glenferrie Sports Ground Grandstand, 1938** Linda Crescent, Hawthorn, Victoria. Architects: Stuart P. Calder in association with Marsh and Michaelson

p. 186 Plate 168 **Tamarama Surf Life Saving Club, 1940** Tamarama Beach, New South Wales. Architect: George S. Carson

p. 188 Plate 169 **Luna Park – Coney Island, 1935** Milsons Point, New South Wales. Artistic conception: Rupert Browne. Construction: Stuart Bros

p. 189 Plate 170 **Luna Park – Just for Fun, 1935** Milsons Point, New South Wales. Artistic conception: Rupert Browne. Construction: Stuart Bros

CHAPTER EIGHT: CINEMAS

p. 193 Plate 171 **Ritz Cinema, 1937** 43 St Pauls Street, Randwick, New South Wales. Architect: A. M. Bolot

p. 193 Plate 172 **Piccadilly Theatre, opened 23 October 1940** Corner O'Connell and Childers Streets, North Adelaide, South Australia. Architects: Evans, Bruer and Hall in association with Guy Crick

p. 192 Plate 173 **Cygnet (formerly Como) Theatre, 1938** 16 Preston Street, South Perth, Western Australia. Architects: Baxter-Cox and Leighton

p. 193 Plate 174 **Royal Theatre, opened 16 June 1924; remodelled 1939** 669 Hunter Street, Newcastle, New South Wales. Architect: Charles Bohringer (1924 and 1939)

p. 195 Plate 175 **Princess Theatre, constructed 1911; renovated 1939** Brisbane Street, Launceston, Tasmania

p. 194 Plate 176 **Regent Theatre, opened 26 December 1957** Keira Street, Wollongong, New South Wales. Architect: Reginald Magoffin

p. 196 Plate 177 **Collaroy Cinema, 1938** 1097 Pittwater Road, Collaroy, New South Wales. Architect: J. C. Rennie Bartle

p. 199 Plate 178 **Roxy Theatre, opened 6 February 1930** George Street, Parramatta, New South Wales. Architects: Herbert and Wilson in association with Moore and Dwyer

p. 198 Plate 179 **Detail from the 1930s Kings Cinema** Re-created at the Powerhouse Museum, Harris Street, Ultimo, New South Wales

p. 201 Plate 180 **Regent cinema, opened 21 August 1935** 7 Church Street, Mudgee, New South Wales. Architect: Douglas Smith

p. 202 Plate 181 **Rialto Theatre, circa 1925** West End, Brisbane, Queensland

p. 203 Plate 182 **Rialto Theatre, circa 1925** (theatre shown in decay). West End, Brisbane, Queensland

p. 203 Plate 183 **Rialto Theatre, circa 1925** (theatre shown in decay). West End, Brisbane, Queensland

p. 205 Plate 184 **Former Orion Theatre, 1936** Beamish Street, Campsie, New South Wales. Architect: P. Gordon Craig

p. 207 Plate 185 **Civic Theatre, opened 27 July 1938** 144 Kelly Street, Scone, New South Wales. Architects: Guy Crick and Bruce Furse

p. 206 Plate 186 **Metro (formerly the Minerva), opened May 1939** 40 Orwell Street, Kings Cross, New South Wales. Designed by C. Bruce Dellit; construction supervised by Guy Crick and Bruce Furse; interior decoration designed and supervised by Dudley Ward

p. 208 Plate 187 **Capitol Theatre, 1924** 109–117 Swanston Street, Melbourne, Victoria. Architect: Walter Burley Griffin

p. 210 Plate 188 **Astor Theatre, 1938** Beaufort Street, Mount Lawley, Perth, Western Australia. Architects: Baxter-Cox and Leighton (William T. Leighton)

p. 213 Plate 189 **Astor Theatre, 1936** 1–9 Chapel Street, St Kilda, Victoria. Architect: P. Morton Taylor

p. 214 Plate 190 **Hayden (formerly Cremorne) Orpheum, 1935** 380 Military Road, Cremorne, New South Wales. Architect: G. N. Kenworthy; refurbishment in 1987 by John Love

p. 216 Plate 191 **Hayden (formerly Cremorne) Orpheum – main auditorium, 1935** 380 Military Road, Cremorne, New South Wales. Architect: G. N. Kenworthy; refurbishment in 1987 by John Love

p. 219 Plate 192 **Hayden Orpheum – Auditorium 3, 1991** 380 Military Road, Cremorne, New South Wales. Design and glasswork by Hendrickson Design Artists; artistic conception by John Love

p. 218 Plate 193 **Hayden Orpheum – Auditorium 4, 1996** 380 Military Road, Cremorne, New South Wales. Design and glasswork by Hendrickson Design Artists; artistic conception by John Love; fibreglass sculpture by Laszlo Biro

INDEX

Note: Page references to photographs are indicated by italics.

A

Aboriginal art as decorative source 31–32, 47
Abraham's Service Station, Summer Hill, NSW *156–157*
Adelaide 28, 40, 44, 68
Agnew, Douglas (architect)
 'Mahratta', NSW 30–31, *126–127*
Albertson, Wilson and Richardson (American architects)
 Former Northern Life Tower, Seattle 29
Alexandria, NSW 55
Alfred Nicholas Memorial Gardens 51
Amsterdam School 17
Anthony Hordern's (department store) 24
Architects Branch of the Sydney City Engineering Building
 Surveyors Department
 Former Sydney County Council Offices and Showroom
 100–101
Architectural design Atelier, University of Melbourne 20
Art Deco Style 16–18, 22–25, 28, 32, 34, 40, 48, 52, 54–55,
 57, 61, 63, 88, 106, 120, 148, 167
Art Nouveau 16
Atkins, David 167
Australian Architects 18, 28–29
Australian Broadcasting Commission 15
Australian Glass Manufacturers
 AGM Building, Alexandria, NSW *149*
Australian Institute of Anatomical Research 46
Australian War Memorial, Canberra 31, *38–39*, 39, 44

B

Bank of New South Wales 88
Barlow, Marcus (architect)
 Century Building, Melbourne 39, *72*
 Howey Court, Melbourne 36
 Manchester Unity Building, Melbourne 32–33, 36, *75*
 Mitchell House, Melbourne 39
Bates, Smart and McCutcheon (architects)
 Former Buckley and Nunn Men's Store *42–43*, 96
 MLC Building, Sydney 68, *74–75*
Baxter, D. H., and W. H. Withers (Maritime Services Board)
 Museum of Contemporary Art (former Maritime Services Board
 Building), Sydney 70
Baxter-Cox and Leighton (architects)
 Astor Theatre, Mt Lawley, NSW *210–211*
 Cygnet Theatre, South Perth *192*
 Piccadilly Theatre, Perth *64–65*
Beard Watson and Company 24, 27
Bebarfalds 27
Bel Geddes, Norman 18
Bennett, William G. (architect)
 Applecross town hall, Applecross, WA 46
 Beverley town hall, Beverley, WA 46
 Kalgoorlie Pool, Kalgoorlie, WA 61
Best, Marion Hall 27
Bilson, Edward (architect)
 Keable factory and Office, Melbourne *152*
Bindoff, H. W. 27
Biro, Laslo 219
Blue Mountains, NSW 120
Boas, Harold (architect)
 Gledden Building, Perth 40
Bohringer, Charles (architect)
 Royal Theatre, Newcastle, NSW *193*
Bolot, A. M. (architect)
 Ritz Cinema, Randwick, NSW *193*
Bondi Beach, NSW *102–103* (Commonwealth Bank),
 136–137 (flats)
Botany Cemetery, NSW 45

Boulder, WA 64
Bradfield, J. J.
 Sydney Harbour Bridge 15, 55, *56*, 61, 148, *154–155*,
 166–167
Brisbane 28, 44, 53, 68
Britain and England 14, 18, 20
Brogan, John R. (architect)
 101 Australian Homes 49
 'Wyldefel Gardens' 54
Broken Hill, NSW 43
Brooks Robinson and Company 23
Browne, Rupert
 Luna Park *56*, *188–189*
Buchanan, S. H., and Cowper (architects)
 Queensland National War Memorial, Brisbane 44
Budden and Mackellar (architects)
 David Jones Department Store, Elizabeth Street, Sydney 42
Budden, H. E., and Mackey (architects)
 Former Railway House (Transport House), Sydney *15*, *21*,
 37–39
 Former Metropolitan Water Sewerage and Drainage Board
 Building, Sydney *76–77*, *158–159*
Builders Steel Form Supply Company, Richmond, Victoria *46*
Building 23
Bunbury, WA 64
Burdekin House Exhibition 24–26
'Burnham' Flats, Geelong, Victoria *32*
Burns, L. P. (architect)
 Elmslea Chambers, Goulburn, NSW 40, *82–83*

C

Calder, Stuart P., in association with Marsh and Michaelson
 (architects)
 Glenferrie Sports Ground Grandstand, Hawthorn, Victoria
 184–185
Calder, Stuart P., in association with Reid and Pearson (architects)
 Former McPherson's Building, Melbourne *101*
California Bungalow style 18, 49
Cammeray, NSW – residence *140–141*
Campsie, NSW 63
Canberra 14, 23, 28, 44, 46, 48, 106
'Caringal' Flats, Toorak *34–35*
Carson, George S. (architect)
 Tamarama Surf Life Saving Club, Tamarama, NSW *186–187*
Carter, Norman
 Artwork, Museum of Contemporary Art (former Maritime Services
 Board Building) 70
Castleden, A. C. (architect)
 Pepperina (former Bowery Coffee Shop), Newcastle, NSW
 102–103
Chicago 32
 Columbian Exposition of 1893 166
Chicago Tribune Competition 33–34
Circular Quay 167
Cizzio, Virgil (architect)
 Great Southern Hotel, Sydney *168*
 Imperial Hotel, Erskineville, NSW *168*
 Malachi Gilmore Hall, Oberon, NSW 45–46, *114–115*
Clare, E. P. (Principal Government Architect, WA)
 Royal Western Australian Institute for the Blind, Maylands, WA
 47–48
Claridge, Philip, Colin Hassell and Jack H. McConnell (architects)
 Bank of New South Wales Building, Adelaide 40
Coles, G. J. 20
Commercial Gothic style 34, 42
Commercial Palazzo style 18, 20, 34, 40
Commonwealth Bank 43, 88
Constructivism 17
Copeman, Lemont and Keesing (architects)
 Criterion Hotel, Sydney *176–177*

Cottesloe, WA 54
Craig, P. Gordon (architect)
 Orion Theatre, Campsie, NSW 63–64, *204–205*
Cremorne, NSW 63
Crichton, McKay and Haughton (New Zealand architects)
 Bank of New Zealand Building, Napier, New Zealand 31
Crick, Guy (architect)
 Piccadilly Theatre, North Adelaide (in association with Evans,
 Bruer and Hall) 62–63, *193*
Crick, Guy and Furse, Bruce (architect) 63
 Civic Theatre, Scone 60–61, 64, *206–207*
 Metro (formerly Minerva) Theatre *206*
 Savoy Theatre, Katoomba, NSW *26*, 27
Crowle, WA 54
Curtis, R. Emerson
 Artwork, Museum of Contemporary Art (former Maritime Services
 Board Building) 70

D

Dadswell, Lyndon
 Artwork, Museum of Contemporary Art (former Maritime Services
 Board Building) 70
Dalziel, J. G. (architect)
 Lakes Hotel, Mascot, NSW *167*
Darlinghurst, NSW 52, *138* (flats)
David Jones (department store) 24, 27, 42
Dellit, C. Bruce (architect) 20, 49
 AFT House (former Delfin House), Sydney *19*, 72
 Anzac Memorial, Sydney 22, 44, 106, *112–113*
 Metro (formerly Minerva) Theatre *206*
de Maistre, Roy 24, 27
Department of Health 47
Department of the Interior/Department of Works
 Former Australian Corps of Signals, Albert Park, Victoria
 (J. MacKennal, Works Director) 40, *41*, *116–117*
 Former Canberra High School (Charles Whitley) 48, *116–117*
 Commonwealth Bank
 Bondi Beach, NSW *102–103*
 Roseville, NSW *102–103*
Department of Public Works (NSW) and the Metropolitan Water
 Sewerage and Drainage Board
 Avon Dam, Yanderra, NSW *160–161*
 Cordeaux Dam, Towradgi, NSW *160–161*
 Nepean Dam, Yanderra, NSW *160–161*
 Warragamba Dam, Warragamba, NSW 148, *162–163*
 Woronora Dam, Eckersley, NSW *160–161*
Department of Water Resources and Department of Public Works
 (NSW)
 Burrinjuck Dam, Goodradigbee, NSW 49, *160–161*
 Keepit Dam, Gunnenbene, NSW *160–161*
Depression 15–16, 20, 23, 27–28, 36, 57, 63, 68, 106, 148
Devon House, Perth 40
Dorman Long and Co. 154
Dudok, W. M. (Dutch architect) 48, 57
Duke of Gloucester 44
Duncan, Alastair 16
Duttons, Richmond, Victoria *101*

E

Eales and Cohen (architects)
 Guildford town hall, WA 46, *114–115*
Earlwood, NSW – residence *134–135*
East, H. S. and R. S. Smith (architects)
 Campbell Town town hall, Tasmania *114–115*
 Holyman House, Launceston *80*
Elizabeth Bay, NSW 52
Empire Games 61
Evans, Bruer and Hall (architects)
 Piccadilly Theatre, North Adelaide (in association with
 Guy Crick) 62–63

Evening News, The 20
Exposition Internationale des Arts Décoratifs et Industriels Modernes
 16–18, 22–24, 27, 34, 36, 88
Expressionism 18

F

Federal Capital Commission 28, 47
Feint, Adrian 24
Ferris, Ralph 22
First World War 14–16, 18, 46, 49, 55, 106
Fitzroy, Victoria 54
Fowell and McConnel (architects) 29
 Manly Town Hall 24
 British Medical Association Building, Sydney 29, 36
France 16, 17, 23
Fremantle, WA 64

G

Gellert, Leon 24
Georgian Revival style 49–50, 88, 120
Geraldton, WA 64
Germany 16, 18, 23
Glenelg, SA 166
Goodhue, Bertram Grosvenor (American architect)
 Nebraska State Capitol 33
Gordon McKinnon and Sons (architects)
 'Aderham Hall' 52–53
Goulburn, NSW 40, 54, 68
Grace Bros (department store) 27
Great Exhibition of 1851, London 166
Grey, Molly 27
Griffin, Walter Burley (architect) 18
 Canberra 23
 Capitol Theatre, Melbourne 61, 208–209
 Pyrmont (NSW) incinerator 150–151
 Thebarton (SA) incinerator 149
 Willoughby (NSW) incinerator 50

H

Haberfield, NSW – flats 138–139
Hahn Automotive Services, Former, Darlington, NSW 157
Hall and Phillips (architects)
 McWhirters department store, Fortitude Valley, Queensland 25
Hall and Prentice/Hall and Phillips (architects)
 Tattersalls Club, Brisbane 178–179, 180–181
Hammond, Stanley
 Former Metropolitan Water Sewerage and Drainage Board
 Building, Sydney – relief sculpture 158–159
Healesville, Victoria 46
Hellyer, John M. (architect)
 Hotel Hollywood, Surry Hills, NSW 168
 Marlborough Hotel, Newtown, NSW 168
Henderson, A. & K. (architects)
 Hydro-Electric Commission Building, Hobart 40, 78
 T. & G. Society buildings 68
 Hobart 80–81
Henderson, E. H. (Principal Architect of the Department of
 the Interior) 20
Henderson, E. H. in association with H. G. Connell (architects)
 Manuka Pool, Manuka (ACT) 59, 182–183
Hendrickson Design Artists
 Cremorne Orpheum, Cremorne, NSW – glasswork 218–219
Hennessy, Hennessy and Co. (architects) 29, 37
 Former ACA Building (Charles Plaza), Sydney 37–38
 ACA Building, Melbourne 37
 Colonial Mutual Life Society buildings 68
 'Lawson Flats' (in association with Reginald Summerhayes) 54
 Prudential Building, Sydney 29
Herbert and Wilson in association with Moore and Dwyer (architects)
 Roxy Theatre, Parramatta, NSW 199
Hill, R. and Taylor, A. J. (architects)
 Johnstone Shire Hall, Innisfail 46
Hobart 28, 40, 48, 68
Hockings and Palmer (architects)
 Rockhampton town hall, Rockhampton, Queensland 46

Hoff, Rayner *21, 22, 44*
 Anzac Memorial, Sydney *112–113*
 City Mutual Life Building, Sydney *70*
 King George V Memorial, Canberra 106
Holland 17, 18, 23
'Holmwood', East St Kilda 24
Home, The 23–25
Hood, Raymond (American architect) 33
Howells, John Mead (American architect) 33
Hunter Valley, NSW 64

I

Innisfail, Queensland 46
International Style and Modernism 18

J

Jaye, Margaret 27
Jeater, Rodd and Hay (architects)
 Civic Arcade, Newcastle *92*
John Fairfax and Sons Limited General Store, Ultimo,
 NSW *149, 152*
Joseland and Gilling (architects)
 'Cahors', Potts Point, NSW *144–145*
Joy, R. M. and Pollitt (architects)
 Golden Barley Hotel, Marrickville, NSW *166*
 Unicorn Hotel, Paddington, NSW *167*

K

Kaad, Peter, in association with Frank W. Turner (architects)
 Rural Bank Building, Sydney 37–38
Kalgoorlie, WA 61, 64
Katoomba, NSW 88
Kenworthy, G. N. (architect)
 Orpheum Theatre, Cremorne, NSW 63–64, *214–215,*
 216–217
Kerr, J. Aubrey (architect)
 Residence, Killara, NSW *132–133*
Kings chain of cinemas 63
Kings Cross, NSW 52
Kohler, Edward
 Sculptural detail, Karrakatta Cemetery crematorium 31
Krantz, Harold A. (architect)
 Flats in Perth 54

L

Lalique glassware 27
Launceston, Tasmania 28
Le Corbusier (French architect) 17
Leighton, William (architect; see also Baxter-Cox and Leighton) 64
Leura, NSW 120
Likely, A. C. (architect)
 Dairy Farmers depot, Newcastle, NSW *148*
Loewy, Raymond 18
Louis S. Robertson and Son (architects)
 Beresfield Crematorium, NSW 45, *116–117*
 Eastern Suburbs Crematorium, NSW *116–117*
 Woronora Crematorium, NSW 45, *116–117*
Love, John
 Cremorne Orpheum, Cremorne, NSW – refurbishment
 216–217, 218–219
Lucas Stapleton (architects)
 MLC Building, Sydney – recent work *74–75*
Luna Park, Coney Island, New York 166
Luna Park, Milsons Point, NSW *56, 57, 61, 166–167, 188–189*

M

McCarter and Nairn (Canadian architects)
 Marine Building, Vancouver 29
Mackellar and Partridge (architects)
 David Jones department store, Sydney 42
MacKenzie, Sir Colin 46–47
McMichael and Harris (architects)
 Savings Bank of South Australia, Adelaide 40
Magoffin, Reginald (architect)
 Regent Theatre, Wollongong, NSW *194*

Mahoney, Marion 23
Mallet-Stevens, Robert (French architect) 17
Manly, NSW 24, 166
Manufacturers House, Tamworth 40
Maori art 31
Marsh and Michaelson (architects)
 Australasian Natives Association Building, Melbourne 31
Maylands, WA 47
Mediterranean style 49, 59
Melbourne 14–15, 20, 24, 27–28, 34, 36, 39–40, 42, 44–45,
 47, 51–53, 68
 Centenary 106
Melnikov, Constantin Russian architect) 17
Mendelsohn, Erich (German architect) 18, 48
Metropolitan Water Sewerage and Drainage Board (Sydney) 148
Metropolitan Water Supply and Drainage Board (Perth)
 Sewer vent, Highgate, WA *149*
Middle Park, Victoria 53
Milne, Kenneth (architect)
 Former Kelvin House (Security House), Adelaide 40
Monel metal 43
Morris, Edwin 32
Morris, W. Hayward in association with Robert Casboulte (architects)
 National Film and Sound Archive (Australian Institute of
 Anatomy), Acton, ACT 31, 46–47, 106, *107–109*
Morrow, D. T., and Gordon (architects) 33
 AWA Building, Sydney (in association with Robertson and Marks)
 68–69
 Grace Building, Sydney 33, 36, *75*
 Pacific House, Sydney *78*
Myer Emporium, Melbourne 24, 43, 88, 92–93, 94–95

N

Napier, New Zealand 31
National Museum of Australian Zoology 47
Newcastle, NSW 34, 54, 68
New Farm, Queensland 53
New South Wales 50, 55, 63, 106, 148
New York 32–33
New Zealand 68
Nicholas, Alfred 50, 130
Nicholas and Company 50–51
North Adelaide, SA 63
Norris, Harry (architect)
 Block Court, Melbourne *92*
 'Burnham Beeches' 31, 50–51, 120–121, *130–131*
 Coles store, Melbourne 20, 42
 Mitchell House, Melbourne 39, *74–75*

O

Oak Dairy, Muswellbrook, NSW *148*
Oakley and Parkes (architects)
 Yule House, Melbourne 39
Oberammergau 54
Old English style 49, 54, 120

P

Paterson, George 22
Peck and Kemter in association with Leith and Bartlett (architects)
 Heidelberg town hall, Victoria 114–115
Pellew and Moore, Broken Hill 43
Perth 15, 40, 45, 47, 51, 54, 64
Philip B. Hudson, Wardrop and Ussher (architects)
 Shrine of Remembrance, Melbourne 44
Philp, Colin (architect)
 Alberto's of Rome, Launceston 96–97
Pitt and Merewether (architects)
 Exchange Hotel, Maitland, NSW *167*
 Seven Seas Hotel, Carrington, NSW *172–173*
Pitt, Eric and C. C. Phillips (architects)
 'Macleay Regis', Potts Point, NSW *141*
Plottel, Joseph (architect)
 Footscray town hall, Footscray, Victoria 45
Porcelain enamelled steel 43, 88
Port Adelaide town hall, SA 45

Potts Point, NSW 52, 54
Powell, Cameron and Chisholm (architects)
 Narembeen town hall, Narembeen, WA 46
Preston, Margaret 24, 31
Princes Park, Parkville, Victoria 59, 184
Princes Theatre, Launceston, Tasmania 195
Proctor, Thea 27
Proserpine, Queensland 28
Public Works Department, Tasmania
 Ogilvie High School, Newtown 48
Public Works Department of Victoria
 Geelong Court House (Percy Everett, Chief Architect) 116–117
Pynor, Henry (architect) 24

Q
Queensland 46, 57

R
Randwick, NSW – 'Redlands' flats 145
Ray Neon 166
Redcliff, Queensland 166
Rees, Leslie 16
Rennie Bartle, J. C. (architect)
 Collaroy Cinema, Collaroy, NSW 196
Rialto Theatre, West End, Queensland 192, 202–203
Richmond, Victoria 46
Robert Garran Offices (former Patents Office), Barton, ACT 106, 116–117
Roberts, Hera 24
Robertson and Marks (architects)
 Former Asbestos House (Hardie House), Sydney 34
 AWA Building, Sydney (in association with D. T. Morrow and Gordon) 68–69
Rosenthal, Samuel (architect)
 Country cinemas in WA 64
 Radio cinema, Geraldton, WA 64
Rudder and Grout (architects)
 Nelson Hotel, Woollahra, NSW 170–171
 North Sydney Olympic Pool 61, 182
 Petersham Town Hall 45–46, 114–115
Rural Bank of New South Wales 88

S
St Kilda, Victoria 46, 166
St Lucia, Queensland – residence 135
Saarinen, Eliel 33
Scarborough Beach, WA 166
Schefferle, N. E.
 Carlton Hotel, Geelong, Victoria 178–179
School of Mines (Adelaide) 20
Scone, NSW 61, 64
Seabrook, Norman
 Macpherson Robertson Girls High School, Melbourne 48
Seattle, Washington 29
Second World War 15, 20, 120, 148
Sicard, Francois
 Archibald Fountain 106, 110–111
Sidgreaves, H. and E.
 Paragon Cafe, Katoomba, NSW 89–91
Smith, Douglas (architect)
 Regent Cinema, Mudgee, NSW 201
Sorenson, C. P.
 'Everglades', Leura, NSW 120–121, 128–129
Sodersten, Emil (architect) 49
 Australian War Memorial (in association with John Crust) 38–39, 45, 106
 City Mutual Life Building, Sydney 29, 37, 39, 70–71
 Former Nesca House, Newcastle 84–85
 'Segenhoe' 54
South Africa 68
South Australia 20, 55
South Melbourne 53, 142
Spain, Colonel Alfred (architect) 20
Spain and Cosh (architects) 20

Spanish Mission style 49–50, 120
Spencer and Bloomfield (architects)
 Former Top Dog Factory, Dee Why, NSW 150, 153
Stainless steel 43, 51
Steen, Otto
 Artworks on AWA Building, Sydney 68
Stephenson and Meldrum (architects)
 Newspaper House, Melbourne 72–73
 St Vincents Hospital, Fitzroy, Victoria 47
Stephenson and Turner (architects)
 Former ACI Building, Sydney 78–79
 United Dental Hospital, Sydney 116–117
Streamlining/Streamlined Moderne 27, 42, 51, 57
Stripped classicism 48, 59, 106
Summerhayes, Reginald (architect)
 Karrakatta Cemetery – crematorium chapel 31, 45
 'Lawson Flats' (in association with Hennessy, Hennessy and Co.) 54
Sweden 23
Sydney 14–16, 20, 24, 27, 34, 39–40, 44–45, 52–53, 57, 68, 148
 Department stores 27
 Hyde Park 106
 Sesquicentenary 15, 106
 Sydney Harbour 148
 Sydney Technical College 20
 Underground railway 55
 University of Sydney, Chair of Architecture 20, 22
Sydney Auctioneers and Valuers, Annandale, NSW 152
Synthetic stone 22, 68

T
Tamworth, NSW 34, 40
Tandy, Thomas Jnr (architect)
 Luck's Corner, Launceston 28
Tasmania 50, 57, 64
Taylor, H. Vivian, Soilleux and Overend (architects)
 'Cairo Flats' 54
Taylor, P. Morton (architect)
 Astor Theatre, St Kilda, Victoria 212–213
Terracotta 15, 23, 25, 34, 39–40, 42, 68
Terrazzo 27, 43, 51, 88
Tompkins, H. W. and F. B. (architects)
 Myer Emporium, Melbourne 92–93, 94–95
Trenchard, Smith and Massey (architects)
 Sesquicentenary Pavilion, Moore Park, NSW 106, 116
Tru-mold Tyres, Clifton Hill, Victoria 157

U
United States of America 16–18, 20, 22–23, 28, 31–33, 42, 192
Upper Nepean River Scheme, NSW 148

V
Van De Velde, Henri 128
Vancouver 29
Victoria 55
Vitrolite 43, 88

W
Walker, Ralph (American architect) 22
Waller, Mervyn Napier 38, 39, 44
 Mural Hall, Myer Emporium, Melbourne 88, 93
 Newspaper House, Melbourne 72–73
Ward, Dudley (architect)
 Metro (formerly Minerva) Theatre 206
Warden, Sidney (architect)
 Hotel Broadway, Sydney 57
Wardrop, J. H. (architect)
 Former United Kingdom Hotel, Clifton Hill, Victoria 169, 174–175
Warragamba Emergency Scheme 148
Waterhouse, B. J. (architect)
 Archibald Fountain (supervising architect) 106, 110–111

Waterloo, NSW 55
Waverley Cemetery, NSW 43
West Perth 54
Western Australia 28, 54, 57, 64
Wheat family 64
White, Henry (architect) 61, 63
 Paragon Cafe, Katoomba, NSW 89–91
 State Theatre, Sydney 63
Wilkinson, Leslie (architect) 20, 22, 50
Williams, E. A. (New Zealand architect)
 Ministry of Transport Building, Napier, New Zealand 31
Willoughby, NSW 54
Wilson, William Hardy (architect) 50
Wilson, Neave and Berry (architects) 50
Woods, Bagot, Jory and Laybourne Smith (architects) 40
 South Australian National War Memorial 44
Wright, Frank Lloyd (American architect) 23
Wunderglaze 22–23
Wunderlich, Ernest 22–23, 88
Wunderlich Limited 22–23, 25, 39

Y
York House, Paddington, NSW 98–99